The book's contributions to theology are many: it bridges the disciplinary study of practical theology and the arts, challenges and amends theology as it has been constructed, gives ample space to showing practical theology at work, and works across differences of international location and religious tradition.

—*Bonnie Miller-McLemore, Vanderbilt University*

W. Alan Smith and Ruth Illman have identified a movement within theology that bridges disciplines as diverse as art history, ethnography, and justice and peace studies. Their methodology making sense of this development is truly momentous.

—*Kimberly Vrudney, University of St. Thomas, USA*

# Theology and the Arts

This book brings the emerging fields of practical theology and theology of the arts into a dialogue beyond the bias of modern systematic and constructive theology. The authors draw upon postmodern, post-secular, feminist, liberation, and dialogical/dialectical philosophy and theology, and their critiques of the narrow modern emphases on reason and the scientific method, as the model for all knowledge. Such a practical theology of the arts focuses the work of theology on the actual practices that engage the arts in their various forms as the means of interpreting and understanding the nature of the communities and their members, as well as the mechanisms through which these communities engage in transformative work, to make persons and neighborhoods whole.

This book presents its theological claims through the careful analysis of several stories of communities around the world that have engaged in transformational practices through a specific art form, investigating communities from Europe, the Middle East, South America, and the United States. The case studies explored include Jewish, Christian, Muslim, Druze, indigenous, and sometimes agnostic subjects, involved in visual art, music, dance, theatre, documentary film, and literature. *Theology and the Arts* demonstrates that the challenges of a postmodern and post-secular context require a fundamental rethinking of theology that focuses on discrete practices of faithful communities, rather than one-dimensional theories about religion.

**Ruth Illman** is Director of the Donner Institute for Research in Religious and Cultural History, associated to Åbo Akademi University in Åbo, Finland. She is committed to research on interreligious dialogue and the role of the arts in this dialogue, cultural encounters and peace research. Illman has published widely in journals such as the International Journal of Public Theology, the Journal of Contemporary Religion, and Studies in Interreligious Dialogue. Her book entitled Art and Belief: Artists Engaged in Interreligious Dialogue was published in 2012. You find her website at: http://web.abo.fi/instut/di/english/ruth.html

**W. Alan Smith** is Professor of Religion and Philosophy at Florida Southern College. An ordained minister, he has been active in regional and general levels of work in the denomination as well as in higher education. He was most recently the executive secretary of the Religious Education Association. He is the author of numerous articles in journals including *Religious Education*, *Teaching Theology and Religion*, and the *Forum on Public Policy*.

# Routledge Studies in Religion

# Theology and the Arts

Engaging Faith

**Ruth Illman and W. Alan Smith**

NEW YORK AND LONDON

First published 2013
by Routledge
711 Third Avenue, New York, NY 10017

Simultaneously published in the UK
by Routledge
2 Park Square, Milton Park, Abingdon, Oxon OX14 4RN

*Routledge is an imprint of the Taylor & Francis Group,
an informa business*

*Library of Congress Cataloging-in-Publication Data*

Illman, Ruth.
    Theology of the arts : engaging faith / by Ruth Illman and W. Alan
Smith. — First [edition].
        pages cm. — (Routledge studies in religion ; 29)
    Includes bibliographical references and index.
    1. Arts and religion.    I. Smith, W. Alan.    II. Title.
    NX180.R4I45 2013
    201'.67—dc23
    2013002024

ISBN: 978-0-415-84370-6 (hbk)
ISBN: 978-0-203-75414-6 (ebk)

Typeset in Sabon
by Apex CoVantage, LLC

Printed and bound in the United States of America by Publishers Graphics,
LLC on sustainably sourced paper.

**For our children:**

**Nathaniel and Skye Noel Smith**
**Mirjam, Ester and Noomi Lillhannus**
**and for Alan's grandson Logan Smith**

# Contents

# Acknowledgments

Writing a book is an adventurous journey, and writing a book with two authors can at times be an even greater challenge. A chance meeting in the summer of 2008, when each of us presented a paper during the Oxford Round Table held at Jesus College, University of Oxford, was our entrance ticket to this memorable journey. In Oxford, we discovered a distinct similarity in our research profiles, marked by an interest in the arts: in ethical perspectives, dialogue, and theological approaches of a practical character. During the years to come, we also discovered the effects of our distinct *differences*: living on different continents, belonging to different generations, having different academic backgrounds, genders, mother tongues, experiences—to name a few. At this point, where the journey has reached the important milestone of publication—although this, of course, is far from the end of the dialogical process for a hermeneutical study—we wish to express our deep gratitude to those persons that have helped us along on this unconventional and explorative journey.

First, we thank Canon Brian Mountford, vicar of the University Church of St Mary the Virgin in Oxford and host for the session of the Oxford Round Table where our paths crossed in 2008. Canon Mountford has enthusiastically encouraged and helped us during the working process, a support that has been of utmost value for us. We would also like to thank all those researchers and colleagues who have commented on our work, offering valuable critique and generous suggestions for further development, at conferences and seminars during the years we have been involved in this writing process. In particular, members of the Society for the Arts in Religious and Theological Studies (SARTS), the Association for Practical Theology (APT), and the Religious Education Association (REA) have become valued respondents to our project.

Second, we wish to thank our respective departments—the *Department of Religion and Philosophy at Florida Southern College* in Lakeland, Florida; and the *Donner Institute for Research in Religious and Cultural History* in Åbo, Finland—for hosting our working sessions at times when working together in cyberspace needed to be complemented by eye-to-eye meetings. We are both privileged to be surrounded by wise and thoughtful colleagues,

who never hesitate to share an analytic conversation or a good laugh; thank you for your support and friendship. Furthermore, we have each benefited from substantial dialogue with additional colleagues from other academic departments and librarians on our respective campuses, as well as very helpful input from theology and philosophy students at Florida Southern College. We also thank the academic reviewers who offered knowledgeable and constructive comments to our manuscript at an early stage as well as our publisher, Laura D. H. Stearns; and our editorial contact, Lauren Verity, at Routledge, who have provided the professional assistance and guidance needed in finalizing and publishing this book.

Last, we thank the two ultimate heroes of this journey, our spouses Dee Smith and Mats Lillhannus, who have been our copilots on this journey. Thank you for taking care of logistics and supplies at times when traveling has been time consuming, tiresome and thorny, and for listening to our endless travel tales along the way.

Preliminary versions of the chapters included in this book have in many cases been presented at conferences and in previous publications over the years. Alan has presented an earlier version of chapter 4 at *Meadville Lombard Theological School* in Chicago in February, 2012. A draft version of chapter 5 was presented to the *Annual Meeting of the Religious Education Association* in Dallas, Texas, November 2009. A similar version of chapter 7 was presented in August 2012 at the *Theatrical Theology—Conversations on Performing the Faith conference in St. Andrews*. He also presented the theoretical outline now included in chapters 1 to 3 as a paper to the Oxford Round Table on Religion and Science: Shaping the Modern World at Harris Manchester College in July 2011. Ruth has included analyses of the art projects presented in chapters 6, 8 and 9 in her book *Art and Belief. Artists Engaged in Interreligious Dialogue* (London: Equinox Publications, 2012). In this study, however, the analytical focus is directed toward the individual artists and their worldviews rather than the art projects as in this study, and the theoretical emphasis is different—discussing interreligious dialogue rather than practical theology. Thus, the chapters presented in this book build on the same empirical material and argument only to a limited extent.

<div align="right">

Ruth Illman & W. Alan Smith
Åbo and Lakeland, December 2012

</div>

# Introduction
## A Prelude

Charles Schulz, who drew the comic strip *Peanuts* from 1950 until his death in 2000, addressed theological issues frequently enough in his strip to elicit a book entitled *The Gospel According to Peanuts*.[1] Two entries in the corpus of his work stand out. In one, Charlie Brown and his baseball team are on the field against their perennially "invisible" opponents, and Charlie Brown is looking predictably unhappy.

CHARLIE BROWN: Nine home runs in a row! Good grief! What can I do? We're getting slaughtered again, Schroeder . . . I don't know what to do. Why do we have to suffer like this?

SCHROEDER: "Man is born to trouble as the sparks fly upward."

CHARLIE BROWN: What?

LINUS: He's quoting from the book of Job, Charlie Brown, seventh verse, fifth chapter. Actually, the problem of suffering is a very profound one, and . . .

LUCY: If a person has bad luck, it's because he's doing something wrong, that's what I always say!

SCHROEDER: That's what Job's friends told him. But I doubt it . . .

After more dialogue about the nature of suffering, Charlie Brown concludes the strip this way:

CHARLIE BROWN: Good grief! I don't have a ball team. I have a theological seminary![2]

The second example of Schulz's theological insight comes in the person of Charlie Brown's younger sister, Sally. The small blonde, wise beyond her years (despite her frequent malapropism), has been asked by her teacher to choose a topic for her research paper. The response is telling:

SALLY: My topic today is the purpose of theology. When discussing theology, we must always keep our purpose in mind. Our purpose as students

is understandably selfish. There is nothing better than being in a class where no one knows the answers.[3]

Schulz's insight is clear. The place of theology is not limited to the intellectual debates of academia or the "hallowed halls" of the buildings associated with theological study. Rather, theological issues like the nature and purpose of suffering, grace, salvation, doctrine, and the "meaning of life" are part of the fabric of life that can be experienced on a sandlot baseball field as significantly as in a formal classroom discussion or sermon. In *Peanuts*, theological topics emerge in the midst of lived life—even for a group of elementary school-aged children. And, as Sally Brown's comment suggests, positivistic doctrinal claims (a particular legacy of "modernism")—or truth presented as a series of absolute theological propositions—often run contrary to the ways individuals experience the exigencies of living a life of faith in a complex and changing world. No one seems to have "the answers" to theology's most enduring questions. It may be claimed that *Peanuts* is an early example of *post*modern thought in the United States.[4] The fact that its challenges to the modern worldview came through an otherwise "safe" medium (the comic strip) and through the voices of children (albeit hardly "typical" children) makes its insights remarkable.

## RETHINKING THEOLOGY AND THE ARTS

University of Chicago theologian Don Browning lamented something of the joy Sally Brown seems to have taken in her evaluation of the open-ended nature of theology. "The discipline of theology has had few friends even in the church. To admit in academic circles that one is a theologian has been, in recent years, to court embarrassment."[5] In fact, the term "theology" has become so identified with the formal, intellectual enterprise conducted in academic circles that theology as a discipline is frequently considered inaccessible to the layperson.

In an influential article, Edward Farley argued that the emergence of the "clerical paradigm" for theology during the Romantic period (specifically as a part of Schleiermacher's advocacy for theology as a faculty among the sciences) came at the expense of theology as *habitus*.[6] Farley traced a movement from theology as critical reflection upon the practices of persons within religious communities experiencing the self-disclosing God (*habitus*); through theology under the influence of the "modern" emphasis on scientific thinking (theology as a science); toward theology taking its place in the modern university on a par with other academic sciences; and, like those other sciences, in the service of preparing specialists within the discipline—clergy as the "doctors of the church" (theology in the clerical paradigm).[7] Similarly, Robin Lovin claimed that theological reflection has been distorted by this fixation on theology as the sole prerogative of the professional prepa-

ration of the clergy and urged that this limited understanding of theology be rejected.[8]

Theology as *habitus*, which Farley claimed is the essence of theology, is theology as "knowledge of the self-disclosing God."[9] Religious educator Thomas Groome likewise identified a distinction between a distanced, intellectual knowledge *about* God (represented by the Greek term *ginôskein*) and an intimate, personal knowledge *of* a self-disclosing God (referring to the Hebrew term *yada*).[10] The approach to theology Farley advocated is "practical" in the sense of its attention to *praxis*—a dialogue between the Enlightenment ideals of theory and practice in which each interacts generatively with the other.[11] There is an emerging consensus building upon Farley's claims that all theology is, ultimately, practical theology.[12] As the second decade of the 21st century begins, theology is increasingly understood as moving beyond the static propositional science that dominated the 19th and early 20th centuries. There have been myriad challenges to the theology characteristic of the modern era. Each points, in its own way, toward a common claim that an effective theology must engage the *practices* of communities of faith toward the end of transformation of persons and of society.[13]

With the increasingly steady call to develop a theology that overcomes the legacy of the Enlightenment, new forms of epistemology have emerged alongside the ontological and metaphysical claims of modern thought. The "clergy paradigm" itself implied a purely ecclesiological interest while assuming an intellectual, objective, logical understanding of knowledge, truth, and reality. Most academic studies—in past as well as present—nevertheless tend to emphasize discursive dimensions of faith at the expense of the other aspects of human religiosity.[14] In this modern epistemology, less scholarly attention has been given to practical, creative, and interpersonal approaches to the study of religion than to the doctrinal and systematic forms of theology. As a result, scant mention has been made of the theoretical and methodological development of the several "relational" forms of theological thinking.[15] Thus, much of current theological research rests heavily on a rather limited understanding of the nature, dimensions, and parameters of religion and theology.

Jewish theologian Richard Rubenstein claimed that systematic theology, especially since the Enlightenment, has been a fundamentally Christian enterprise.[16] At the very least, modern systematic and constructive theology has built upon Christianity as the paradigm for religions in general by emphasizing the intellectual dimensions of religious traditions and the search for systematic developments of theological claims. However, the systematic approach to theological thinking so common in the 20th century is *not* characteristic of other non-Christian religious and theological thought.[17] One must also question whether this form of theology is truly representative of 21st-century Christianity itself.[18]

The idea that religion is a clearly delineated sector of human life, separated from economic, cultural, political, and social considerations has

further obstructed the development of a theology appropriate to our time in history.[19] The modern tendency to assign each academic discipline to its limited and discrete intellectual "ghetto" has had a corresponding effect on the understanding of religious diversity and pluralism. Each religious tradition is expected to operate within a monolithic unity of creed, conduct, and belief that is clearly separated from the faith claims, ways of knowing, and practices of other persons of faith.

These presuppositions are all problematic in the religiously plural context of today. For many religious persons, faith is an integrated part of, not a differentiated sector attached to, their human reality and everyday life. Furthermore, the processes of globalization, secularism, and post-secularism ensure that the traditional limits and forms of the religious landscape are challenged by new ways of understanding both religion and theology. Indeed, "doing" theology in our contemporary world is an activity intrinsically shaped and affected by historical, social, cultural, political, and economic factors.[20]

There is an increasing awareness that the arts—as loci for inventive and holistic theological thinking—can serve as significant complements to the predominant text-centered character of modern theology. Classical arts and popular culture are often employed in the service of religious and spiritual traditions. In the media-saturated contemporary setting, worldviews are formed, compiled, assessed, and shared through the mechanisms of popular culture. A growing number of people seek moral instructions and spiritual awareness in the lyrics of popular music or on the Internet—that is, outside the "box" of traditionally religious sources.[21] The academic disciplines have nevertheless shown what Ninian Smart calls a "relative neglect of the visual, musical, and literary dimensions of religious consciousness." Neglect of this kind results from a preoccupation with doctrinal and intellectual aspects of faith that Smart claims are characteristic of the way Western theologians and scholars have been educated in their disciplines.[22]

The inclusion of the imaginative elements into theological discussion can help theology move beyond the simple gathering and comparison of information to which it devolves all too easily. When theology honors the arts and the imagination, it can become a context for entering into and participating in a relationship with God, the self, and the religious other. Kate Siejk proposes that, by adding such creative elements to the context of theological dialogue, one may recognize that the "heart of religious faith is found not only in doctrines and creeds but in liturgy, religious drama, art, music, and poetry."[23] Such symbolically dense, embodied, and imaginative contexts for communication may provide new channels for understanding, self-assessment, and coexistence. Within the context of the arts, imagination can enrich and complement formal instruction, and the whole person—not just the head, but also heart, hands, voice, ears—can be engaged in the communication.[24] The arts have the ability to touch us, not only as rational beings, but as complex, experiencing subjects with feeling, attitudes,

memories, and hopes for the future. Within the arts, it becomes evident that the encounter with religion and the religious other are not merely intellectual challenges, but also ethical and practical ones: a "major challenge to mind and heart" as Abraham Joshua Heschel formulates it.[25]

## AIMS OF THE BOOK

A central thesis developed in this book is that the arts can provide support for and a mechanism that enables the emergence of a practical theology in which *habitus* can, once again, allow all persons of faith to practice theology. The aim of the study is therefore to create a critical and creative approach to the study of theology in order to meet the challenges set by our contemporary circumstances. Practicing theology, it is argued, is not merely a cognitive enterprise; it engages one emotionally and empowers ethical practice.[26] Among the contemporary critical approaches to theology feminist critique, postmodern and post-secular thinking, and also hermeneutical discourse offer helpful starting points for the development of the kind of practical theology of the arts we envision.

Several themes emerge as a practical theology of the arts develops. First, the modern fascination with "metanarratives"—sweeping sets of linked stories that attempt to describe all knowledge and truth under the "umbrella" of a shared worldview—has been countered by Jean François Lyotard and others whose work has been described as "postmodern." In place of the modern emphases upon the authority of the self, human reason, the "certainties" of the scientific method, and the dominance of a Western, male, Christian (if not predominantly Protestant,) and "white" hegemony, postmodern thinkers have emphasized the "decentering" of these traditional loci of authority.

Feminist theologies, third world "liberation" theologies, and hermeneutical approaches to philosophy and theology share with one another a rejection of the very "centers" upon which modern theology was based. In place of dogmatic statements of absolute "truth," these recent theologies emphasize an "experienced" truth that emerges out of the dialogue characteristic of each community of faith, an appreciation for an intentional form of listening to the voice of the "other" that makes it "safe" for that "other" to experience authentic personhood, and a commitment to the "practices" of theological insights toward the end of transformation of persons, communities, and society as a whole. The turn from grand narratives to practice makes way for a theology that acknowledges the impact of economic and political power, gender and sexuality, ethnicity and historical hegemonies on the church and its development, bringing attention to persons and places that previously were placed in the margins of theological thinking. More importantly, John W. de Gruchy claims, contemporary practical theologians working with the arts need to challenge these hegemonies in their work.

The "church exists for the sake of transforming the world and not the other way around," he asserts. Therefore, theology must be a form of "cultural criticism," protesting in an astute way against "that which is in inimical to human life and the common good."[27]

A significant challenge to conventional theological thinking is also presented by the increasing skepticism toward secularization as well as toward the so-called religion of reason represented by the modern era. This vague pattern of change, often described as a shift from secular to post-secular, has been described by Inger Furseth as a move from "finding truth" to "finding oneself."[28] Furseth claims that religious identity appears as a personal project of development in a post-secular world: a flexible identification with ideas, expressions, and sentiments suiting the personal outlook on life. Interest in emotional and experiential dimensions of faith has been increasing, and consequently many choose to call themselves "spiritual" rather than "religious." Religion seems institutionalized, old-fashioned, and rigid—spirituality is experienced as open, experiential, and appealing.[29] The "emergent church" movement within American Protestantism can be seen as a contemporary example of this move away from the institutionalized church and toward an emphasis upon personal, "lived" spiritual experience.[30]

An additional line of inquiry that becomes relevant in the current study is the significance of the other as a partner in intersubjective dialogue. Taking our lead from a number of approaches to hermeneutical philosophy and theology, we contend that practical theology and the arts share a commitment to the belief that truth and meaning emerge from committed dialogue between persons and communities. The arts are the "work and witness" of relationships that take form in the realm of "the between," as Martin Buber contends.[31] A practical theology of the arts reflects the notions of interpersonality, responsibility, and otherness developed in the work of such thinkers as Martin Buber, Hans-Georg Gadamer, Emmanuel Levinas, and Knut E. Løgstrup. In sum, the aim of this book is to

- Discuss contemporary theological research on the arts, especially focusing on critical perspectives acknowledging the role of gender, pluralism, and postmodern/post-secular perspectives on theological thinking.
- Discuss the emerging literature in practical theology and evaluate the current direction of dialogue on theology that takes seriously the role of *praxis* and faith that is embodied in the critical practices of communities of truth from multiple religions and in a variety of international cultures.
- Develop a practical approach to theology and the arts on the basis of the research by incorporating perspectives from dialogue philosophy, hermeneutics, and other relational ways of addressing theological research.
- Make these theoretical reflections truly practical by analyzing seven empirical case studies we refer to as *études*: projects where the arts have

become integral in practicing a responsible and interpersonal theology that empowers transformational communities of truth toward greater justice, hope, understanding, respect, and integrity.

## METHODOLOGICAL APPROACH

Central to each of these theological precedents is the concept of *praxis* as the key to a practical theology of the arts. Drawing upon a long philosophical history beginning with Aristotle, developing in the work of Karl Marx, and finding more recent expression in such scholars as Paolo Freire, Hans-Georg Gadamer, Jürgen Habermas, and others, praxis is a distinctive form of epistemology. It is a way of knowing that can be characterized as "knowledge-for-the-sake-of-transformation." As an alternative to the Cartesian "theory-practice" dichotomy, praxis emphasizes the ways that practice reinterprets and challenges the claims made by theory, whereas new theory always requires the development of new practices. Rather than a static, positivistic "absolute" truth, praxis circumscribes a constantly moving, dynamic interaction in which theory and practice redefine one another in a swirling, spiraling interaction. As the subjects in dialogue engage one another and listen to each person's claims to truth concerning their shared subject matter, they *too* become transformed.

Hans-Georg Gadamer's hermeneutics have informed both the theoretical and the methodological approach of this book, which builds on qualitative research methods and hermeneutical analysis. For Gadamer, encountering a text or a person always includes interpreting. In his approach, humans as historical beings understand reality as active, reflective subjects within a given tradition. Thus, pre-understandings (or prejudice) are inseparable parts of every worldview.[32] Such pre-understandings should not be seen as a burden; rather they are necessary conditions for understanding: "a person who does not accept that he is dominated by prejudices will fail to see what is shown in their light. [. . .] To stand within a tradition does not limit the freedom of knowledge but makes it possible."[33]

From this point of departure, Gadamer develops his significant understanding of hermeneutics as a *fusion of horizons* (Horizontverschmeltzung).[34] Here, understanding is regarded as the result of a dialogical process through which two separate horizons of understanding are brought together. Past, present, and future are all included in this dialogue because the interpretations they amount to are always made by individuals with historical, social, and cultural assumptions and individual characteristics.[35] The notion of fusion does not imply that the different horizons merge completely, losing their individual identities in the process. Quite the contrary: through the hermeneutical dialogue, the other can be understood *as other*.[36] If one were to draw the fusion Gadamer describes as Venn diagrams, one would have two circles—each representing a partner in dialogue, complete with her own

understanding of the shared subject matter—that overlap one another with the fusion of their dialogue identified as the common area. Each would still have her own identity represented by the remainder of the circle, but new understanding would be formed as the two perspectives "fuse" in the inter- section. The "otherness" of the dialogue partner and his/her voice on the subject matter requires a critical reexamination of one's own voice. What emerges from this kind of dialogue is always new understanding, and a new understanding that requires significantly new practice as well. Understanding, therefore, is not a simple technique or method; it is a comprehensive striving to become familiar with a perspective that is other than one's own, trying to comprehend how human life can appear viewed from another horizon.[37]

Searching for understanding as a complement to mere theoretical descriptions of human life and thought is a central objective of hermeneu- tic research.[38] Hermeneutic research builds on interpersonal encounters. Understanding can be seen as an element of the researcher's comprehensive way of orientating her/himself in the world.[39] It is a reciprocal, human pro- cess of interpretation, which contains personal pre-understandings, as well as encounters with the other and her/his horizon of understanding. Under- standing implies realizing what makes something meaningful for someone else. Different persons experience such dimensions differently. As Charles Taylor puts it, "Meaning is [ . . . ] for a subject, of something, in a field."[40]

In our research on religion and the arts, we seek to build our claims on a comprehensive understanding of human beings and their relationships to one another as well as to the divine as formed by interaction, knowl- edge, context, history, emotions, and attitudes—as cultural beings as well as unique, experiencing subjects. In this context, meaningful findings can be attained through subject-bound interaction and perception.[41] A critical hermeneutical study should build on the fruitful combination of explana- tions and interpretations: that is, relating interpretation and explanation to each other in a process of attentive listening and critical distance.[42] Theol- ogy is *practical* when its purpose and method are both dialogical in nature. When one takes the partner in dialogue seriously and respects the other as a *person*, the voice of the "other" is honored as one *hears* that person's claim to truth. We believe the arts are uniquely gifted at this kind of practical dia- logue. Nevertheless, we acknowledge the fact that respecting the voice of the "other" and "hearing" another "to speech" are complex processes within hermeneutical epistemology. Researchers need to be aware of their own hori- zons. This personal position, which constitutes the lens through which the research is perceived, includes individual experiences and attitudes as well as gender and ethnicity, but also situational frames of reference such as the political, social, cultural, and institutional contexts in which the researcher is embedded.[43] To regard one's engagement with theory and empirical mate- rial simply as a "dialogue of equals" would thus be too innocent an account of the knowledge creation process described in this book.[44] The hermeneutic process can be illustrated by an upward and forward moving spiral rather

than by the classical image of the closed and confused circle. In this process, the researcher can reach a deepened understanding of her/his field through "controlled subjectivity" in data collection and theoretical reflection, transparently described practices of research, and an open dialogue with other scholars in the field.[45]

To briefly describe our own perspectives on the theme, a few biographical notes may be needed. Alan Smith is an ordained minister in the Christian Church (Disciples of Christ) and teaches both religion and philosophy courses at Florida Southern College in the United States. He has been developing his interests and skills in practical theology and theology of the arts vicariously through the careers of his wife, two children, and loved ones who have continued to be committed to the arts. Ruth Illman comes to this research field from a Scandinavian academic perspective outside practical theology, more precisely comparative religion or religious studies, where she has been profoundly influenced by Jewish dialogue philosophy and hermeneutical research. She works as the director of the Donner Institute for Research in Cultural and Religious History in Åbo, Finland. In her private sphere, she is a member of the Evangelical-Lutheran Church of her home country, Finland, and has found an interest in religion and the arts through her husband, who is a musician, specializing in early music.

This study is thus the fruit of collaboration between two rather dissimilar researchers, representing different geographic and academic "homes," different genders, and age groups—a veritable fusion of horizons. To further illustrate the character of our work, the initial studies that led to what we are presenting here began with scholarship conducted independently by the authors. The authors had been investigating the communities they had encountered through their individual academic networks for several years before a chance meeting in the summer of 2008 when each presented a paper during the Oxford Round Table held at Jesus College of the University of Oxford. To their surprise, they discovered a marked similarity of interest in the arts and of theological approach, and the collaboration began to grow from that point until the present.

The second part of the book presents a series of studies of forms of the arts that have contributed to the transformation of communities. Each empirical study is an example of hermeneutical praxis; each étude demonstrates the back-and-forth, to-and-fro quality of hermeneutical dialogue. The outcomes of each account demonstrate the true "practicality" of hermeneutical praxis and some of the ways that a practical theology of the arts can contribute to personal and societal transformation. Truly dialogical interaction among partners always results in something new, unique, and—frequently—unexpected and shocking. Inspired by the methodological claims of Patti Lather, we have sought to "read against ourselves," allowing our own differences to surprise us and make us unsettled. Such a method provides a tangible strategy for preserving the multiplicity of voices in the material and moving against tendencies of reductionism and self-sufficient normativity.[46]

## THE EMPIRICAL MATERIAL

Because our understanding of theology is a "practical" one, we have not limited our reflections to the conceptual and systematic claims of theology. Rather, we have focused upon a series of examinations of discrete projects around the world that demonstrate the role of the arts in enabling the "practices" of theology within what Parker Palmer calls "communities of truth."[47] Furthermore, we are not interested in generalized patterns of thought and behavior emerging from the field of theology and the arts but rather strive to give in-depth accounts of particular situations and contexts where individuals and groups engage in meaningful conversations with one another and with the other. This approach can be described as favoring life-world orientations to principle ones. In relation to such an emphasis, working with particular case studies seems the most fruitful option. As Hans-Günter Heimbrock and Peter Meyer contend, case studies offer an analytic context in which the "complexity of mutual connections of human beings within a specific field, the individual ways of producing and responding to meaning and the existence of various relevant dimensions of meaning" can be explored.[48] By using case studies, we are able to illuminate dimensions that are imperative to this study, such as subjectivity, the fundamental role of experience, interpersonal understanding, and social meaning-making processes.

As mentioned above, we refer to our seven empirical case studies as études: a metaphor from the world of music where an étude (French for *study*) denotes a musical composition, usually short, designed to give practice in a specific musical skill. Likewise, each of the études we have analyzed in part 2 demonstrates the characteristics of a practical theology of the arts: Each is defined by a specific time, spatial context, and practice; each setting engages in critical intersubjective dialogue; each project begins with a contextual examination of the stories of that specific community or dialogical practice; each engages in praxis by focusing its work on the practices implied by theological and philosophical reflection; each set of stories demonstrates a community that listens intently to the voice of the other; each integrates a specific form of the arts as a means of personal and community transformation; and each chapter showcases a community in which attention to the emergence of truth through the arts also leads to a greater sense of personhood for those who have served as partners in a shared dialogue.

We have collected stories of communities from Peru, to Jerusalem and Jenin, to Philadelphia, to San Francisco, to Scandinavia and Continental Europe, and multiple other locations. Many of the communities are intentionally Christian, others are Jewish, some are Muslim, or indigenous, a few are intentionally interreligious—and some rarely pay much direct attention to specifically religious discussion. We cover the arts from indigenous textile arts, to urban murals, music, literature, theatre, film, and dance. In each of these examinations, we ask the same set of epistemological and practical questions outlined above. The driving issue behind each of these

investigations is, "How has this particular form of the arts helped give voice to practices that lead to personal and community transformation?"

## OUTLINE OF THE BOOK

The first part of the book establishes our primary claims in presenting a "practical theology of the arts." Following the introduction, chapter 1 offers an examination of postmodern, feminist, and third world liberation theologies and a number of significant alternatives they have offered to the prevailing theological approaches of modernism. The influences of these forms of theology on the discipline of practical theology are addressed in the latter sections of the chapter. We also give attention to the impact of postmodern, feminist, and liberation theology on the development of contemporary philosophy of the arts and aesthetics, and argue that the arts become a dynamic partner in the dialogue of practical theology.

In chapter 2, we develop our specific claims about a practical theology of the arts. We have been profoundly influenced by the work of Emmanuel Levinas, Martin Buber, Hans-Georg Gadamer, Jürgen Habermas, Paolo Freire, and Knud E. Løgstrup, as well as numerous feminist theologians. There are many common themes connecting these scholars that are emphasized in the chapter. Chapter 3 summarizes the theoretical perspectives presented in the previous two chapters and brings them into dialogue with a number of contemporary perspectives on practical theology and the arts. The chapter is concluded by a presentation of six key themes that sum up the perspective on the research question developed in this book. These key themes are also used to structure the analysis of the empirical case studies, the études, presented in the second section of the book.

The second part of the book begins with the practical theology of the arts we develop in part 1 and uses that understanding of theology as the method of investigation as well as the hermeneutical device in interpreting the role of the arts in each of the communities we have identified. It is in this more "empirical" part of the book that we believe we offer a unique approach to what we propose as a new discipline of theology. We do not wish to make the same mistake as that collection of scholars who wax long and eloquently *about* theology and doctrine. Rather, through these études, we offer real-world examples of what a practical theology of the arts looks like when it is actually being "practiced."

Chapters 4 and 5 look at two forms of "art" that have helped transform discrete communities. A citywide mural program in the urban area of Philadelphia is the focus of chapter 4. Here, blighted, graffiti-ridden buildings in numerous neighborhoods have been brought to a new life through an innovative partnership between the Office of the Mayor of Philadelphia and local artists and community organizers. Because the process of creating the murals began by intentionally listening to what Freire has called the

"generative words" of each particular neighborhood, the images that have been created in each mural reflect the collective voice of the persons who participated in the creative process.[49] Here, art has served as an occasion for community organization as well as a visual artifact reflecting the practice of each neighborhood.

Chapter 5 shifts our attention to the ring of slums that surround Lima, Peru. In a *pueblo joven* named Pamplona Alta, a group of women has found a way to escape the crushing poverty of their environment, organize themselves into a collective that markets as well as produces artworks, and engage in such self-development activities as learning to read and write Spanish and "consciousness raising." The colorful *arpilleras* and *cuadros* made by these "Women's Clubs" are assembled from scraps of material scavenged from dumps and the ever-present litter scattered throughout the village. The stories told in the finished products are taken from the lives and experiences of the women who create them. Some are memories of the homelands left behind to escape terrorists or to find work. Some of the *cuadros* are based on religious themes. Others express the hope the artists have for their own futures. All of these dynamic works of art reflect a process where the women have "heard one another into speech."[50]

In chapter 6, a study of literature as an art form takes us to an analysis of the theologically thought-provoking, humorous and deeply spiritual novellas of the French author Eric-Emmanuel Schmitt, collected under the title *Le Cycle de l'invisible*. Several common features unite the six novellas of the cycle: they all deal with interreligious encounters, and they all focus on praxis and personal involvement. The stories deal with difficult subjects—such as hatred, disease, death, loneliness, envy, genocide, war—but do so in a warm and tender, even humorous way. The encounters often cross several lines of difference simultaneously: religion, culture, generation, attitude, thus underlining the complexity and richness of interpersonal relations. A recurring theme is the young hero full of questions and hesitation who meets an older, wiser, and more reflective person who lives deeply embedded in a religious tradition but still has no intention of converting or forcing her/his own worldview on the young adept.

Chapter 7 represents an extension from the analysis of literature into a discussion of theatre. An innovative movement within the theatre community that is devoted to "unscripted" theatre is represented by "Playback Theatre." This approach to theatre, which has troupes performing throughout the United States, in the United Kingdom, in Europe, Australia, Hong Kong, and elsewhere, is based on the work of Jonathan Fox and his wife, Jo Salas. Rather than a professional acting company that brings a pre-rehearsed play, complete with elaborate set designs, props, and special effects, Playback Theatre features "players" who dress simply and set up a stage with only a few stools, some acoustic instruments, and a few simple props. After some initial interaction between the players and the audience that begins to establish a community between the two groups, a leader (known as the

"conductor") invites individuals from the audience to take a place on an empty stool on stage and tell a story from her/his own experience. The members of the company listen intently to the story and, when ready, develop a spontaneously produced play based upon each story shared by members of the audience. Thus, the play is not imposed from the outside, but emergences from the experience of those who participate in the event of theatre itself.

The next chapter is also an extension of what precedes it. Chapter 8 is a series of reflections on a 2008 documentary film by Cecilia Parsberg entitled *A Heart from Jenin*. The story behind the film begins with the death of a 12-year-old Palestinian boy—shot in 2005—by an Israeli soldier as the boy played in the streets with other children. As the grief-stricken family dealt with the loss of their beloved son, a 13-year-old Israeli girl from the same area was in a hospital awaiting a heart transplant. In an amazing act of generosity, the Palestinian family donated their son's heart to another child—and another family—in need. The chapter explores the significance of "otherness" as a theme in discovering one's own identity as well as the symbolic dimensions of concepts such as gifts and mercy.

The same region of the world is the location of chapter 9 as the role of music is examined. Spanish musician and composer Jordi Savall became fascinated with the significance of the city of Jerusalem as a holy space for Jews, Muslims, and Christians. To carry out this project, Savall invested a significant amount of time in historical and musicological research, but also in creating personal contacts and listening to personal narratives, sampling Muslim, Jewish, and Christian folk tunes from the area, and exploring the ways each of the three major faith traditions conceptualize the significance of the Holy City. The result was a major piece of music entitled *Jerusalem: The City of the Two Peaces*. The initial performance, uniting musicians from all three Abrahamic traditions and from a vast number of countries, was in Savall's native Barcelona, Spain, in April 2008. Savall has emphasized the importance of dialogue as a theme running through his composition and has claimed that the significance of music is the inherent spirituality of its voice. The dialogue that characterizes this musical event has been made intentionally interreligious by recruiting musicians that were themselves Muslim, Christian, and Jewish.

The final art form to be explored is dance. Because dance intentionally combines music, literature, and theatre, chapter 10 draws upon the insights of its preceding chapters. We have turned our attention to the AXIS Dance Theatre of San Francisco for this investigation. Like other major dance companies, AXIS integrates movement, text, rhythm, preparation, and performance as it develops an embodied form of art. What makes AXIS unique among dance companies is its decision to intentionally integrate trained dancers who have lost their ability to use their legs and persons with handicapping conditions who had not previously been trained in dance as performing members of the company. Whereas dance is based on internalizing music and—occasionally—the spoken word into the body, AXIS raises

the question of how that character of dance is changed when the dancer is not "able-bodied."

The concluding chapter summarizes the claims we have made about a practical theology of the arts. This final act of evaluation will rehearse the major arguments proposed in part 1 and illustrated through the several empirical studies in part 2.

## Website

Each of the communities of truth that is analyzed in our études has a strong Internet presence filled with images, sound files, and video footage. As an expression of our attention to dialogue and the faithful practices that characterize a practical theology of the arts, we have created a website that will contain links to each of the communities with whom we dialogue in the book. The reader may access this resource at http://web.abo.fi/instut/di//english/ruthandalan.html. The site will be updated periodically to remain as current as possible with developments in each community.

# Part I

# A Practical Theology of the Arts

# 1 When the Center No Longer Holds
## Challenges to Modernism

Biblical theologian Walter Brueggemann identified the modern theological insistence on reason, universal and positivistic principles, scientific method, and logico-mathematical thinking with a thoroughly male, Western, and largely white cultural hegemony.[1] During the second half of the 20th century and the first decade of the 21st, a number of parallel challenges began to assault these modern assumptions. This chapter focuses on some of the issues that bear significance for the current investigation into art and religion. First, the notions of postmodernism and post-secularity arise as attractive alternative perspectives as the hegemonies, aptly summarized in Brueggemann's description, start to deteriorate. Second, dimensions of power and androcentrism are challenged by critical epistemologies developed within the frames of feminist and liberation theologies. The chapter will conclude with a discussion of art, religion, and truth.

## "CENTER? WHAT CENTER?" THE POSTMODERN CHALLENGE

Jean François Lyotard is credited with outlining the essential claims of postmodernism.[2] According to Lyotard, postmodernism began with a transformed understanding of the nature of knowledge. In what Lyotard calls the "post-industrial world," "knowledge-for-the-sake-of-knowledge" (*theoria*), "knowledge-to-produce-a-product" (*technē*), or even "knowledge-for-living-well" (*poiēsis*) are no longer adequate descriptions of knowing. Rather, knowledge has become little more than a form of discourse that is unattached to questions of meaning or truth. Richard Rorty has claimed that the search for universal moral truth is futile, leaving one with the realization that the only source for moral decision making is the agreement of "everyone in the room"[3] (although, as some have noted, this still leaves open the question of who is admitted to the room in the first place). Also, recent developments within practical theology have been driven by calling into question the hegemony of *theoria* and consequent explorations of *phronesis*—practical knowledge—as a viable route for academic theologians.[4]

The modern worldview operated out of a series of authoritative metanarratives (such as the scientific method or salvation history) that provided the hermeneutical lenses through which persons evaluated truth and meaning. Lyotard and others regard these metanarratives as intellectual constructs and nothing more.[5] Paul Lakeland claims that, in attempting to account for everything, the metanarratives of which Lyotard spoke subsumed the other under its narratives of reality, marginalizing the other in the process.[6]

Sources of authority characteristic of the 19th and early 20th centuries, such as scientism, Church, State, and the "White Anglo-Saxon Protestant" (WASP) male have all had that authority challenged at the end of the 20th and beginning of the 21st centuries. Modern theology's assertions of a solid, universal, dogmatic, and propositional truth of the Christian faith have been challenged by claims to truth emerging from the East, Africa, South and Central America, from women, from other religious traditions, and from multiple sources of authority. As Harold Horell suggests, the "Christian" perspectives that persons "grew up thinking were normative and universal for all Christians, if not all people, are rooted in the specific outlooks, concerns, histories, and social contexts of their respective" communities.[7] Thus, Horell concludes:

> A radical awareness of the historical and bodily situatedness of all human knowledge and doing gives rise to a sense that the resources and traditions of the past are not transhistorical or universal structures of meaning and value, but can be taken as historical examples, raw materials, or even as fragments that need to be selectively and creatively combined in constructing a sense of faith identity that can guide thought and practice in the present.[8]

The center that grounded modern theology can no longer be said to hold the task of theology (or of culture) together—if, indeed, there *is* a center. Carl Raschke claimed the origins of deconstruction—one of several theologies/philosophies emerging out of the postmodern condition—could be found in the belief that "the cathedral of modern intellect is but a mirage."[9] No single form of knowledge is privileged over another. Thus, Gordon Kaufman concluded that theology is "an open and evolving discourse, rather than a set of revealed and tradition-bound doctrines."[10]

## THE POST-SECULAR RETHINKING OF RELIGION

A parallel process of reevaluation is simultaneously under way concerning the role of religion in contemporary societies. The rapid spread of secular worldviews—as well as the ideology of antireligious secularism that sometimes goes along with it—was for a long time seen to represent an irrevocable process leading to the slow decline or even death of religion. Yet, such claims seem superficial and are increasingly called into question.[11]

Even if conventional forms of religious life show a decline in many parts of the world, a vivid interest in religion thrives outside these institutional structures in such forms as immigrant religions, charismatic movements, as well as health and body practices.[12] Such trends suggest an ongoing transformation toward a greater diversity of ideas, values, and practices.[13]

The effects of pluralism have broad implications for contemporary societies and individuals. Globalization and mobility have expanded the understanding of pluralism to include all possible religions, spiritualities, and ideologies—not just different variations of Christianity. For the individual, the "taken-for-granted status" of religion, as Peter L. Berger called it, has dramatically diminished: no matter how pious and devout one may be, one can no longer disregard the obvious fact that different persons take different religious truths for granted.[14] Even if the postmodern condition does not affect one's personal conviction, the awareness of pluralism necessarily changes what it means to be religious today. As Charles Taylor states:

> We live in a condition where we cannot help but be aware that there are a number of different construals, views which intelligent, reasonably undeluded people, of good will, can and do disagree on. We cannot help looking over our shoulder from time to time, looking sideways, living our faith also in a condition of doubt and uncertainty.[15]

Jürgen Habermas proposes the term "post-secular" as a way of describing societies affected by such ruptures in patterns of secularization. In a post-secular society, he argues, the traditional lines between secular and religious seem to evaporate. What many have assumed to be an inevitable evolution of society toward increasing secularity at the expense of religious influences is challenged in his analysis.[16] For Habermas, secular and religious outlooks on life mingle and mix in ways that are conditioned by historical situations and cultural patterns.[17]

The post-secular, however, does not represent a uniform, historical line of development. Neither can it be regarded as a simple retreat to pre-secular times. As Sarah Bracke notes, contemporary religiosity bears significant imprints of modernity, even if the secular values connected to this paradigm are rejected. In the post-secular condition, Bracke contends, the modern "becomes envisionable without the secular."[18] The post-secular discourse is contested, and it can indeed be criticized on the same basis as its secular counterpart. Thus, it tends to assume a linear and monolithic historical development of societies from religious, to secular, to post-secular—a development that makes no sense outside the Western perspective (if, indeed, it is valid from within that perspective).[19] To avoid such oversimplified claims, the term should be understood as offering a critique of overtly confident secularist theories rather than as a plea for the return of religion to a stage, which it once had abandoned.[20] Furthermore, as Judith Butler contends, post-secular processes of transformation do not proceed through "homogeneous,

empty time" but rather form into an interruptive force of "multiple tem-poralities."[21] This metamorphosis should also be understood as including the whole specter of transformative alternatives: from increased orthodoxy and conservatism to liberal rethinking. Hence, it inflicts change not only in relationships between traditions but also within them and depends on an epistemology that no longer inhabits the "modernist, dichotomous dis-course" in which all that is known is known "binarily" as either or.[22]

The end of the modern era has also nurtured a growing skepticism toward the supremacy of rational reasoning. Hence, as discussed above, emotional and experiential dimensions of religiosity appear as attractive alternatives, focusing on action and giving emphasis to subjective traits such as passions, enthusiasm, and feelings in the unmediated, lived experience. Spiritual self-transformation often includes a striving to reach beyond ratio-nality by grounding ones religious outlook in personal experience. By giving precedence to experience over rational reasoning, a religiosity grounded in personal practice is emphasized.[23] In Rosi Braidotti's words, the political no longer equates with the rational and the religious with the irrational: "We are confronting today a post-secular realization that all beliefs are acts of faith, regardless of their propositional content"—even, or especially, when they invoke the superiority of reason, science and technology.[24]

As a consequence of this development, consequently, the secular and the religious (or spiritual) are no longer fashioned as binary opposites or as steps that follow each other as a natural progression of development. The idea of secular and religious as mutually exclusive categories is muddled and confused.[25] Hence, theology must take into account that the elements that constitute pluralism are being continuously transformed themselves as a result of their own dynamic character.[26] Worldviews are no longer always exclusively religious or secular in character. In such a situation, Michael S. Hogue argues, theology necessarily becomes a contextually engaged, "cross-difference enterprise."[27]

When one moves from the societal to the personal level, a different set of questions arises. We live with an increased sense of individualization, an emphasis on personal choice, and a significant decline in the influence of "traditional" religious institutions. The increased popularity of the notion of "spirituality" has become a symbolic repudiation of, and counterpart to, "organized religion." According to Taylor, the popular position of being spiritual but not religious reflects a reaction against and disillusionment with traditional claims of religious authority. Greater significance is attached to so-called soft aspects of religion—personal experiences and relationships—than to the top-down, hierarchical authority of "received truth."[28] As Ingolf U. Dalferth notes, however, shying away from the term "religion" and opt-ing instead for the "less dogmatic and more personal, pluralistic, and open orientation of life" promised by the discourse of spirituality does not in itself guarantee a position that is "less offensive to the secular mind" or to religious others outside the Western sphere of hegemony.[29]

Nevertheless, the images attached to spirituality and its popularity today underline significant characteristics of contemporary religiosity. The shift in perspective has also nurtured a growing skepticism toward the "religion of reason" characteristic of modernism in favor of an emphasis on emotions and felt experiences of faith.[30] Hence, Walter Brueggemann describes the "postmodern imagination" as characterized by a move from the *written* to the *oral*, from the *universal* to the *particular*, from the *general* to the *local*, and from the *timeless* to the *timely*.[31] Despite the contemporary emphasis on the individual as an increasingly important source of authentic religious experience, postmodern fragmentation does not mean that all societies and individuals have separate, solipsistic identities and worldviews. Even with the growing pluralism of our societies, identity formation is always open to, and conditioned by, the influence of one's context. Therefore, the identities we compose out of disparate bits and pieces in the religious marketplace are neither entirely private nor even unique.[32]

As a consequence, contemporary theological research cannot disregard "the fluidity of religious identity, and the porosity of religious tradition" that characterizes its research field today.[33] Horell has identified three primary responses of the Christian faith to the postmodern age: a "counter-contemporary response" that he illustrates with an analysis of the position taken by Stanley Hauerwas and others; a "late modern stance," represented by Edward Farley; and "stances that embrace postmodernity," an approach adopted by Paul Lakeland.[34] Horell's dialogical response to the challenges of the postmodern age is a synthesis of these three "readings" that moves beyond simply recovering the authoritative claims of modernism and theological doctrine, what Farley has called the "deep symbols" of the past, to

> [b]e open to having the practices and understandings of the past altered, changed, and even transformed so that they are relevant to the present day. Our hope must be that through careful discernment we can still be led to draw from the resources of Christian traditions to construct or re-construct patterns and practices of life that authentically address the common experiences of life.[35]

In this situation, the role of the arts emerges as a new central perspective. For many persons, the arts appear as a fascinating and unexplored religious landscape. To experience a musical performance, to watch a film portraying existential questions, to read a captivating novel—is to be invited into a dialogue about meaning and truth. The context of the arts becomes a possible arena for addressing questions of power in relation to religion and knowledge in new and transforming ways that facilitates a formulation of the critical evaluation of the modern project and religion as a rational phenomenon. The arts thus offer a context for what Alejandro R. García Rivera calls "living theology." In his opinion "theology lives in the music, imagery, and cultural symbols of those who must live out that which 'textbook theology' attempts

to understand."[36] Therefore, the call for a theology of art is inescapable; the arts can help theology to see beyond the theoretical frames of the textbook while theology can help the arts to reach a fuller, existential potential.[37]

## FROM THE MARGINS TO CONSTRUCTING A WEB: FEMINIST THEOLOGIES

Paul Lakeland's discussion of the "radical historicists" of postmodernism—Jacques Derrida, Richard Rorty, Julia Kristeva, and especially Michel Foucault—identified a refusal to place the knowing subject at the center of knowledge as a common theme. Their decision to "de-center" knowledge and reject the hegemony of the knowing self is based upon a realization that reason is a "contextual and relative reality, not absolute or transcendental; analysis of reason always shows its conditional nature, especially in terms of power/desire."[38] Knowledge always implies a power relation between oneself and the world. When the metanarratives so representative of modernism are rejected, and the rational self is no longer the arbiter of truth, one is met face to face with the other.[39] The other, that which had been on the *margins* in modernism, now matters. The humanization of the marginal is celebrated dramatically in the work of feminist and third world liberation theologies. Each of these late 20th-century theological approaches represents what Lakeland has called "faithful sociality"—a process in which each community develops its own narrative, expresses its own values, and redistributes power.[40]

Feminist analysis of history and of theology generally begins with the myriad ways women have been marginalized by the thoroughgoing patriarchy of human history. As Rebecca Chopp has stated, "the liberal assumption that the center can hold all is not a principle of inclusion but a strategy of containment."[41] When the center becomes the locus of both truth and identity, the "hold" is not a welcoming embrace, but a controlling "stranglehold." Mary Daly sounded one of the first alarms that generated much of recent feminist theological discussion by claiming, "If God is male, then male is God."[42] Chief among her claims was the belief that exclusively masculine language about God and male images representing God reinforces valuing of the male as dominant over the female, permanently assigning women to the margins of what it means to be human. Some feminists, like Nelle Morton, adopted an iconoclastic approach to theological language by intentionally referring to God as Mother or the Goddess and describing reality from the condition of the woman.[43] Rosemary Radford Ruether began to urge that a change of language and imagery alone was insufficient and issued a call for a new understanding of Christian community she called "women church," which operated out of a model of community beyond the limits of patriarchy.[44] Feminist biblical scholars, like Phyllis Trible[45] and Elisabeth Schüssler Fiorenza,[46] began identifying feminine language and imagery for God in biblical texts as well as presenting challenges to the prevailing patriarchy of traditional scriptural exegesis.

Kristine Kulp identified numerous similarities in feminist ecclesiologies and conceptualizations of Christian community. Like Ruether and others, many women critique theologies that perpetuate the domination of women and other forms of oppression. They also assume that women have always been in the midst of, rather than on the margins of, the life of the church. They critique hierarchical structures and theologies and call for new nonhierarchical models of the church. They tend to emphasize "embodiment" as well as (or sometimes in opposition to) the dominance of the "word" character of traditional theology. Most Christian feminists insist on the church's transformative role in society, and many define "church" more broadly than its institutional form. Rather than thinking universally about the "Church," many feminist theologians utilize ethnographic methods of research to evaluate the ethos and practices of actual communities of faith. They generally apply a "hermeneutics of suspicion" in evaluating the "truth" of any images and models of the church—especially those that privilege male language and leadership styles. Nevertheless, they recognize the crucial importance of finding images and models that empower persons to imagine and live together as a Christian community.[47]

Elsewhere, Rita Nakashima Brock echoed Bonnie Miller-McLemore in describing the characteristic feminist emphasis on relationships as a "living human web," in place of the autonomy and self-actualization that tend to represent the male perspective dominating modernism.[48] Carol Gilligan identified fundamental differences between the ways men and women "develop," claiming men have been socialized to value their independence, to consider personal development as growth in autonomy, and to be directed toward self-actualization. Conversely, Gilligan's clinical studies proposed that women value continuity of relationship and the development of an ability to care and nurture.[49]

Nelle Morton developed a theology that began from within a "web of relationships" among women who "hear one another into speech":[50]

> Feminist imaging aims beyond the dualism of mind/body, nature/history, personal/political, and organic/transcendence. It calls us to perceive the universe from a uniquely feminist stance rather than the internalized masculine perceiving with which we are already familiar. It presupposes that none of us—men or women—have yet come into the full human experience, and cannot without the new emerging feminine imaging.[51]

The kind of "hearing" Morton was describing was one that regards the other as a person of worth whose "speech" matters. In describing her encounter with one particular woman at a women's gathering, Morton realized:

> Then I knew I had been experiencing something I had never experienced before. A complete reversal of the going logic. The woman was saying, and I had experienced, a depth hearing that takes place before

speaking—a hearing that is more than acute listening. A hearing that is a direct transitive verb that evokes speech—new speech that has never been spoken before. The woman who gave me those words had indeed been heard to her own speech.[52]

Morton described women's communities in which women related to one another as *persons* and as *partners* in meaningful dialogue. In regarding one another as fellow subjects, women could empower one another in such a way that each was so encircled with openness and support that the marginalized voice of the suffering woman was evoked by being enfolded in the community. Many of the women Morton described in these groups had been socialized in a way that all previous experience had reinforced cultural patterns that made women silent ciphers on the margins of everything meaningful. Rather than woman as the other who was objectified and marginalized, Morton described communities in which the other was experienced as a subject and was "heard to her own speech." The *horizontal* character of this web emphasizes the egalitarian nature of those who listen so intently to one another that each has a voice that can and must be heard.

Rebecca Chopp and Sharon Welch both emphasized that feminist theology moves beyond the modern idealist, rational, and conceptual theological tradition to focus on the *practices* of theological communities rather than on their ideas and doctrinal statements. Chopp critiqued the church's tendency (especially in its Protestant forms) to emphasize the Word (and, thus, words) over the significance of the Body—in the Eucharist, but in other embodied ways as well. She stated that the Christian message of emancipatory transformation is proclaimed "in the embodied relations of Word and words in the church," and further, that "there must be no illusion that the Word somehow founds community apart from the richness of the body of human existence."[53]

Rita Nakashima Brock, in reflecting on her pilgrimage toward feminist theology, recalls her encounter with Nelle Morton as a turning point in that process. Over several years of regular conversations with Morton, Brock came to her own feminist voice. But Brock also mentions that it was a chance encounter during a search of the World Council of Churches library in Geneva that first brought Morton's work to her attention. She stumbled upon a lecture Morton had delivered in Berlin in 1974 that provided a threshold through which she could begin to express herself as both feminist and Christian. In the lecture, entitled "Toward a Whole Theology," Morton asserts the importance of groundedness and living in touch with one's bodiliness in order to become leaders in the challenge of repairing the breach in the world's wholeness. In one crucial passage, Morton says, "Some of you know how to be at home in your own bodies. You have a theology of the birthing process, of Creation itself. Some of you must teach the rest of us how to plant our feet in the earth and feel the surge of energy from a great source that comes up from down under."[54]

Welch drew upon the insights of postmodern writers like Michel Fou-
cault, as well as liberation theologians like Jon Sobrino and Paolo Freire
to claim that theology must attend to the actual historical practices of faith
communities, rather than simply focusing on their symbols and doctrines.[55]
Both Chopp and Welch discussed feminist challenges to prevailing theology
as "subversive" and "dangerous knowledge" because of the ways it redefines
the nature of power and the relationship between power and knowledge.
Marjorie Agosín, in describing the subversive work of women in Chile
stated, "Women have historically been the ones who guard memory, and
the same women have been placed in minor roles throughout history."[56] Yet,
through the artistic form of the Chilean *arpilleras*, which will be discussed in
chapter 5, women honored the memories of their lost and murdered loved
ones, cried out for justice, and condemned a brutal regime for its crimes
against humanity.

Thus, feminist theology is decidedly practical in nature. Since it is conceived
within an experience that rejects the marginalization and dehumanization of
those oppressed by structures of power as well as the hierarchical, oppres-
sive structures of the church and society that emerged out of modernism,
feminist theology emphasizes relationality, community, embodiment, a hori-
zontal and egalitarian structure, and grounding in the practices of "faithful
sociality" as persons of faith honor one another as persons of worth. Rather
than settling for precision in the ways persons conceptualize and think about
theology, feminist theologians challenge us to transform the nature as well
as the practices of theological communities.

The arts offer a uniquely rich opportunity to experience many of the
contributions of feminist theology. For artists like Judy Chicago and Mir-
iam Shapiro, the woman's body became a metaphor for feminist spirituality
and the "sacred." Much of her recent work has made it clear that Chicago
understands art as *performance* rather than as a product.[57] Likewise, Geor-
gia O'Keeffe frequently found in the structure of flowers an abstraction of
women's organic and reproductive power that opposed the phallic imagery
characteristic of much of an artistic tradition dominated by male imagery
and a masculine "gaze." By focusing on the most basic physical reality of
women's biological structure, such women artists have offered an alternative
claim of human experience.

Robin Jensen understands art as self-disclosure: "Art, after all, isn't some-
thing we merely do; it is the way we live and who we are."[58] Art in its various
forms represents the "horizon" of the artist and her or his spiritual formation.
"This is the role of art—to shape and present to us a vision crafted of experi-
ence, memory, and truth."[59] Sidney Fowler reflects some of the same insight
when he describes prayer as a relationship with God, rather than a conversa-
tion: "Within the relationship, one gazes into the other—discovering details,
emotions, and a deeper knowledge of the other."[60] Bonnie Miller-McLemore
quotes Sallie McFague, who claims that "[a]esthetics is simply another pow-
erful way of arresting our attention. The arts suspend our self-absorption.

They help us 'pay attention to something other than ourselves' and connect us to the participations of the other *as other.*"[61] Likewise, Jeremy Begbie has paid homage to Hans-Georg Gadamer's understanding of one's encounter with the arts, which can be paraphrased, "When we see a great work of art and enter its world, we do not leave home so much as 'come home.'"[62] Begbie summarizes his "theology of the arts" by stating, "Art, I submit, is best construed as a vehicle of interaction with the world: a work of art is an object or happening *through which* we engage with the physical world we inhabit, and *through which* we converse with those communities with which we share our lives."[63]

## NOT JUST PRACTICAL, BUT CONTEXTUAL: LIBERATION THEOLOGY

Liberation theologies, primarily from Latin America but also representative of much of the so-called third world (many prefer to use the term "Two-thirds World") offer additional insight into the postmodern challenge to theology. Leading voices from Latin America included Gustavo Gutierrez, Leonardo and Clodovis Boff, and Ernesto Cardenal.[64] Influenced by a biblical exegetical tradition that tended to focus on the story of the Exodus and the Gospel of Luke's "gospel of the outcast," these scholars and others read biblical stories through third world eyes.[65] Borrowing language from such diverse sources as John Wesley and Karl Marx, liberation theologies often spoke of God's preferential option for the poor as the beginning point of theology.[66]

Robert Schreiter described liberation approaches to theology as a form of contextual theology: "Christians move from social analysis to finding echoes in the biblical witness in order to understand the struggle in which they are engaged or to find direction for the future. Liberation models concentrate on the need for change."[67] The underlying reality in liberation approaches is that the work of God is where the people live and struggle for dignity and attempt to escape from both oppression and dehumanization. The end or purpose of knowledge is *trans*formation, rather than formation. Knowledge for the sake of knowledge alone is not sufficient. As Karl Marx famously said, "The philosophers have only *interpreted* the world in various ways; the point is, to *change* it."[68]

Paolo Freire addressed many of the themes outlined by Schreiter. Beginning with an analysis of power relations that reflected the claims we have seen in postmodern theologies, mixed with Marx's critique of capital and its resultant dehumanization of both slave and master, Freire developed an "education for critical consciousness."[69] Among his most significant claims that affect our analysis here are the principle of "conscientization" (*conscientizaçao*); a critical, problem-posing approach to education; the search for what Freire calls *generative words* and *generative themes*; and engaging persons in critical reflection and action to humanize one's own world.

Freire's concept of conscientization is not limited to the kind of cognitive, rational, and disinterested consciousness characteristic of modernism. Rather, Freire sought to describe a process by which one changes the way one thinks about oneself *in* the world and is subsequently led to engage in critical dialogue with others to *transform* the world in which she or he lives.[70] By being *conscienticized*, one not only understands the self and the community differently; one is empowered to engage in actions that bring about justice, personhood, and a sense of self-identity where oppression and marginalization once stood.

Freire developed a "problem-posing" approach to education to accomplish conscientization among the poor with whom he worked in his native Brazil.[71] He taught teachers to engage learners in dialogue around a shared subject matter. Thus, the teacher and the students become a team in which each holds the other responsible for a process of growth and learning. One clear implication of this approach is the necessity to listen intently enough to hear the other into speech, as Morton claimed. By engaging in intentional dialogue with the communities he worked in, Freire listened to the ways villagers described their experiences, their needs, and their worlds.

Over time, a series of words began to emerge that Freire heard over and over—what he described as *generative words*.[72] Generative words are unique to the consciousness of each particular community. Once he had identified a number of generative words and had confirmed with his partners in education that these did, indeed, describe their world accurately, Freire enlisted their help in drawing pictures that illustrated the words and organized them into generative themes. Following this process, the paintings that had named their own reality and experience became the visual tools Freire used in his teaching. Thus, he taught them to read their *own* world, to identify their own meaningful experience, and—conversely—the truth that their experiences and their reality *mattered*. Consequently, Douglas Wingeier concludes: when persons are encouraged to develop a voice and are valued as subjects, rather than marginalized by oppression and poverty, they can begin to recognize the external as well as the internal forces that have led to their objectification and begin participating in the transformation of their experience and their communities.[73]

If religious realities are to be meaningful they must be translated into generative words, which can help the community to re-mythologize and transform their world.[74] We believe that the arts can play a significant role in this process, enabling the creation of such generative words as called for by Freire. Thus, his claims can be seen as relevant for communities and individuals struggling to find a way to express themselves and to be heard today, decades after his works were first published. Many of the art projects presented in the second part of this book can be understood in light of the discussions on conscientization and generative words presented above.

Bruce Birch reflects on the arts as *midrash* and claims that "the arts can create openings for transformative impact that would not necessarily have

been possible in more traditional forms of exegesis and biblical teaching."[75] Since the arts offer creative opportunities for encounter with texts (especially, for Birch, biblical texts), rather than simply hearing about texts, they produce "a level of openness to and engagement with the text that transcends the traditional, more discursive modes of study" that is "often surprising, revealing, and deeply engaging."[76] Freire's "pedagogy of the oppressed"[77] utilized locally produced works of art that reflected the process of conscientization. Ernesto Cardenal's impressive four-volume collection of Bible studies he led within "base ecclesial communities" in the context of Somoza's brutal Nicaragua contains a textual record of this revolutionary pedagogy. But it is an accompanying volume, edited by Philip and Sally Scharper, which brings the full impact of this process to consciousness. *The Gospel in Art by the Peasants of Solentiname*[78] is filled with the colors, the local images, the lifestyle, and the communities in which Cardenal's exegetical, community-development, and empowering work was performed. The dialogue that characterized Cardenal's approach to engaging persons of the endangered Nicaraguan village in the praxis of reading the biblical narratives of God's liberating attention to the poor and the oppressed as their experience and their empowerment led the villagers to see themselves as persons of worth and to experience the gospel as a word of transformation meant for them. Likewise, the art that was incorporated in that engagement reflected the verbal work and presented the emotional impact of this liberating message in ways that shocked and energized.

Taking the message of the liberation approaches to theology to the 21st century, John W. de Gruchy stresses the vital need for churches to engage with the arts as a transformative and socially awakening power. Too often, he claims, the church has simply disavowed art that has seemed shocking or unconventional, rather than attempting to engage with and understand the message conveyed by the artwork and the artist. In doing so, the church becomes a "self-righteous but ill-informed moral guardian of the aesthetic and of artistic creativity." It may even squander opportunities to condemn (e.g. racism, violence, or sexual abuse) by not noticing that a work of art or an art project is "a form of protest against the ills, the meaninglessness, and the blind hypocrisies of society, rather than support for them."[79]

## THE QUESTION OF TRUTH AND ITS IMPLICATION FOR THE ARTS

In this chapter, we have outlined some of the central theoretical reevaluations that have altered the way religion, in general, and the discipline of theology, in particular, have been envisioned and carried out during the last decades: postmodernism challenging the idea of a singular grand narrative as the basis for understanding religion and the self; post-secularism highlighting the changing role of religion in contemporary societies and rejecting the

tradition of seeing the religious/spiritual and the secular as mutually exclusive categories; feminist theology generating questions of gendered power, marginality and embodiment in theological research; and finally, liberation theology drawing attention to the importance of context and ethical dimensions of conscientization. A feature common to these approaches is a freshly unique understanding of religious truth they imply. The question then arises: what role does the idea of truth play in the field of theology and the arts? This question will be the focus of the concluding section of the chapter.

Within the critical traditions discussed above, the centrality given to the issue of truth in theology is often dismissed as obsolete, resting on the Enlightenment presupposition that religious phenomena can be distinguished, categorized, and formed into a coherent theoretical model pointing toward a single unifying truth at the heart of each tradition—if not a single, absolute TRUTH. Thus, to use Michael Barnes poignant formulation, this approach is limited by its obsession with the "neatness of a comprehensive system."[80] On the other hand, in postmodern thinking, the need to impose a single structure of thought on the infinitely rich field of human religiosity is challenged. Similar critical remarks can be found also among the "dialogue" philosophers (to be discussed at greater length in the following chapter). According to Martin Buber's dialogical principles, one needs to hold inviolably fast to one's own deepest relationship to truth while simultaneously acknowledging the real relationship in which other believers stand to truth, thus showing greater care for living beings than for theoretical abstractions. Perhaps, in the end, neither our truth nor their error will turn out to be quite as we assert it to be?[81]

Thus, a significant shift in focus is discernible in contemporary theological investigations. As Kate Siejk notes, an increasing number of researchers dismiss authoritarian claims to truth as unacceptable or irrelevant to their investigations—not because they support a relativistic worldview but because they attach greater importance to the unfinished and incomplete character of human knowledge and existence. As scholars, she claims, we are involved in "matters of profound, ultimately unfathomable mystery," rather than in a one-dimensional intellectual activity.[82] Creativity and transformation become central notions in such research, where the outcome is no longer seen as a choice between either the victory of convincing the other of your own truth or the defeat of accepting a false compromise. Rather, it becomes an opportunity to render religious *otherness* accessible.

Thus, the meaning of the word "truth" in religious situations needs to be challenged, along with the view of truth as the self-evident cornerstone of our discussions on religious difference and theological epistemologies. To regard different religions simply as rational belief systems with incompatible truth claims implies a problematic distortion of the multifaceted phenomenon under investigation and offers rather limited prospects for our research.[83] The search for an overarching universal rationality and the quest for control through incontestable knowledge constitute ultimate problems weighing down the traditional combination of theology and truth.

By concentrating solely on the issue of truth, such logical views of religion are by necessity reductive. After all, *believing* is not the same as *choosing* the theory of life and death that, after thorough consideration, seems most plausible. It is common to forget the importance of trust in religious faith.[84] Faith is not knowledge; it is not open to independent testing (as science); it does not follow the rules of logic, as Morton noted. Trust and faith find their place in a language of love rather than in a formal, juridical language of right and wrong. As a consequence, truth can be claimed *within* faith rather than *about* it.[85]

Thus, it is entirely possible that things are "thus-and-otherwise" in the world of religions, as Martin Buber claims.[86] This, however, is not a simple relativism that claims "anything goes." Rather, it is an acknowledgment of the complex nature of religious difference within, as well as between, traditions—and of the innate abundance of human religiosity. It is a way of recognizing the tension and appreciating it without feeling the compulsion to resolve it.[87] Against this background, the search for an elevated, isolated, and independent notion of truth applicable to all aspects of all human lives runs the risk of becoming abusive. Under the pretext of truth with a capital "T," separated from the real-life situations where we encounter one another, a number of dubious attitudes toward the religious other can easily be employed—hiding behind it we easily neglect our human responsibility. Even so, the opposite strategy of ignoring the issue of truth altogether is hardly a viable route either in developing a practical theology of the arts. Therefore, what is needed is a critical evaluation of the concept of truth as such.

A dialogical way of understanding the issue of truth within the context of theology and art can start from the interpersonal setting—or in the space between different persons who meet. Truth can be approached not as a product but a process, not as an object or a set of rules but as a dynamic and constantly developing dialogue.[88] Such a conception of truth has interesting implications for our study on religion and the arts. Lyotard pointed out this direction in his discussion of "aesthetic feeling"—a sensation of the "sublime" that cannot be represented (*un differend*)[89] but can only be felt or intuited. This feeling or emotion is always experienced as a surprise or a shock because one experiences it as *different* and *other*. Richard Osmer has also characterized practical theology as containing a moment in which one experiences being "brought up short" by dialogue with the other.[90] This drive to make sense of "being brought up short" by the aesthetic, the sublime, or the spiritual makes a person into a subject, Lyotard claims. By recognizing the voice of the other (a voice that experiences the world and its truth differently than the self, rather than subsuming that voice under a metanarrative), one feels one's own subjectivity and is subsequently led to understand that unsettled self.

Frank Burch Brown emphasizes that *if* language refers to nothing outside itself and its own constructs, the arts *must* pay attention to their social location.[91] All art—and all theology—are culturally and socially conditioned.[92]

Further, he claims, "Since we meet the artwork in the world and encounter a world in each individual artwork, the work of art is not some alien universe into which we are magically transported for a time." Art contains a claim to truth that is different from "science" but certainly not inferior to it. "And is not the task of aesthetics precisely to ground the fact that the experience of art is a mode of knowledge of a unique kind? Art is knowledge and experiencing an artwork means sharing in that knowledge."[93]

Richard Viladesau credits Wassily Kandinsky with turning art's "gaze" from the external to the self and with transforming the task of art from producing an object or a product to creating a philosophical and aesthetic "event." "When the starting point for discourse is event or performance—what one does, rather than a subject or object of the doing—the project becomes self-referential, and one arrives at language about language, philosophy about philosophy, painting about painting."[94] Art as event or performance requires one to give attention to each discrete practice of creating art. Rather than *a* world filled with dogmatic, universal claims of truth, the various forms of the arts present us with *multiple* claims to truth, each of which has its own legitimacy. In the very otherness and difference of postmodernism openings to a quasi-mystical apprehension of reality become present: "But all these very different movements have in common with contemporary art an awareness of historicity, situatedness, and plurality, as well as a self-conscious concern for performance."[95]

Central to Hans-Georg Gadamer's hermeneutical philosophy, introduced in the previous chapter, was his focus on the "horizon" each partner in dialogue brings to the dialectical event.[96] "The horizon is the range of vision that includes everything that can be seen from a particular vantage point."[97] Every experience, every physical sensation, every feeling that has formed a person informs that person's horizon. When one encounters a work of art (of whatever form), the sheer "otherness" of the artist's own horizon "brings one up short" and shocks. Jeremy Begbie claims, "Art has the potential to help us grow in our grasp and understanding of the world we inhabit [ . . . ] The experience of art is a mode of knowing the world, certainly different from conceptual and moral knowledge, but by no means inferior to them."[98] As Robin Jensen says, "Art's purpose is not to imitate life. Art's true function is to externalize, shape, and present a particular view of life and thus to achieve its own reality."[99] The work of art is more than an object and more than *l'art pour l'art*: art forms are expressions of the interior "horizon" of the artists' claims to truth.

Like other 20th-century philosophers and theologians who challenged the approaches associated with modernism, Gadamer rejects the orthodox claims of absolute truth in favor of truth as *interpreted* truth. Hermeneutical philosophy is, for Gadamer, a "practical philosophy."[100] His careful examination of Aristotle's discussion of three distinct ways of knowing resulted in a unique combination of hermeneutics and praxis, which Richard Bernstein claimed was one of Gadamer's major contributions.[101]

To conclude, the focus on truth offers *logical* answers to the question of theological inquiry and religious experience, leaning on rational reasoning and simplifying arguments. This exaggerated interest in the intellectual aspects of theology faces increasing objections today, and we propose addressing the issue of religion and the arts from an alternative angle. The question, we argue, is ethical or existential rather than theoretical; and, therefore, dialogical answers need to replace logical ones. To use David Tracy's formulation: not only does the religious other present us with the challenge of "cognitive ambiguity" but also with "moral ambiguity."[102] In order to form an understanding of religiosity as something more profound than a one-dimensional quest for rational truth, the question of religion and the arts needs to be regarded as an ethical dialogue framed within a global context. By honoring the marginal and taking seriously the voice of those traditionally silenced, postmodern, feminist, and liberation theologians, philosophers and artists have emphasized the significant role of the other. We turn now to a discussion of the other as a key figure in the dialogue that characterizes a practical theology of the arts.

# 2 Otherness and Meaning
## Dialogue and Interpersonal Relatedness

The 20th century was characterized in part by two world wars: trials that brought with them genocide on a scale unprecedented in human history, annihilation of human dignity at large and severe human suffering all over the world. Despite these tragedies, or perhaps because of them, that century also saw the rise of a line of philosophical thinking about the other that can be labeled a "philosophy of dialogue" or "dialogue philosophy." This perspective takes its starting point in the view of humanity as fundamentally relational, intrinsically tied to other human beings. The philosophy of dialogue, Emmanuel Levinas contends, has developed in opposition to the devastating circumstances described above and to "the philosophical tradition of the unity of the I or the system, and self-sufficiency, and immanence."[1] As a contrast, dialogue philosophy portrays interpersonal relations as an essentially ethical matter—a question of being fully present in the encounter with the other, of affirming her uniqueness and responding to her call by acting responsibly. "The fresh interest in practice" within theology today has inspired many researchers to advance studies that place praxis, lived religion, and ethnography on par with traditional, theoretical considerations.[2] In this chapter, we advance the claim that dialogue philosophy, especially in relation to the context of art, offers a fruitful way of expanding such a practically oriented theology.

Several philosophers associated with the tradition of dialogue philosophy have inspired our study on religion and the arts, including Martin Buber, Emmanuel Levinas, and Knud E. Løgstrup. Gadamer's hermeneutical philosophy is also relevant for this discussion. It is important to note that, while developing their philosophical work, Buber and Levinas were both actively engaged in their respective Jewish worship communities, Gadamer remained an active member of the German Lutheran Church like Løgstrup, who was a minister in the Danish Lutheran Church. In Buber's understanding, ethics begins in the realm of the "between": the space of reciprocity and openness created in the meeting of I and Thou. On the other hand, in Emmanuel Levinas's thinking, the "face" of the other calls me from a height.[3] For Levinas, this means that the encounter takes place on an uneven ground where the other dominates and "counts more than myself."[4] Løgstrup's philosophy

resonates well with the ethical themes inherent to Levinas—especially the focus on responsibility and trust as basic conditions of human existence.

## BUBER AND THE SPACE OF THE BETWEEN

Martin Buber's philosophical outline of dialogue rests on an existential foundation, focusing on human beings who meet. "The life of dialogue is not one in which you have much to do with men [sic], but one in which you really have to do with those with whom you have to do," he claims.[5] That is to say, when one engages in the dialogue he describes, one does not deal with human beings in the abstraction; one encounters persons in the flesh. In his understanding, dialogue begins in the realm of the "between": the space of reciprocity and openness created in the meeting of I and Thou.[6] It requires that persons turn toward one another, address each other as other, are truly present to their own selves and toward the partner, and strive toward mutuality. The other then appears to one as a unique individual, and one can acknowledge: "This man [sic] is not my object; I have got to do with him."[7] One cannot objectify or dehumanize a person with whom one stands in an I-Thou relationship.

According to Buber, a person's worldview always includes an other, an opponent in the form of an It or a Thou.[8] The instrumental attitude I-It is supplemented by the relation I-Thou, which represents interpersonal encounters, dialogue, and mutual relationships. The I-Thou relationship is a whole-hearted, attentive engagement of two persons honestly trying to apprehend one another's unique individuality. Dialogue is thus the experience of an immediate and engaging presence illuminated and filled by the other. The I-It attitude, on the other hand, is more distanced and analytic in nature: a reflective, indirect, and categorizing attitude giving our experiences a place in time and space.[9] In this relation, the It is objectified and, thus, dehumanized. As a result, I-It can be interpreted as a way of creating boundaries between the self and the other and I-Thou as a way of crossing or overcoming the very same. For the most part, human relationships reflect the I-It form in which one relates to the other as an object from whom one establishes a distance or barrier that prevents a meaningful relationship among the two.[10] The only relationship that never takes the form of I-It is, according to Buber, our relationship to the Eternal Thou, God.

Buber's philosophical system is often criticized for being simplistic because of what is perceived as a dualistic outlook. Nevertheless, these two attitudes are different but equally important. The two perspectives are not binary opposites but rather complementary aspects of each person's involvement with the surrounding world. There are several ways of saying "It"—ranging from rational analysis to abuse and obliteration—and several ways of saying "Thou"—both in intense, revolutionary experiences and in such "unpretentious yet significant" moments as a glance of a stranger passing by in a busy street.[11] Dialogue thus takes form "between" different persons as they

sincerely engage with one another.[12] The between is not a space existing independently of the encounter: it is a unique instance always reconstituted in the meeting of I and Thou.

Buber's understanding of dialogue requires intentional action. An I-Thou relationship is realized as a consciously chosen attitude. Furthermore, dialogue is not understood solely in linguistic terms that are dependent on words. In dialogue, one does not listen to the echo of one's own voice, but to a response from an other. Reciprocity between persons serves a central role in this experience. Dialogue requires that one reach out toward the distant other, become fully present to the other and to the self, and truly open one's eyes.[13] Not all dialogues meet our preconceived notions of meaningful conversation. Much of what seems to be dialogue is actually something else—"technical dialogue," for example, is solely concerned with promptly exchanging information; or "monologue disguised as dialogue" is characterized by persons who seem to address one another, yet listen only to their own claims to truth while sharing in "faceless" discourses built on platitudes and insincerity. Such a monologue-driven life is not between fellow subjects, but rather outside or beside the interpersonal.[14]

The life of dialogue is, for Buber, a moral one. It requires being present and open to the other and her unique otherness, affirming the interpersonal space of the between. For dialogue to exist, at least two separate parties are needed: different but still able to create community where the integrity of neither party is compromised. Buber describes the "home of dialogue" as creating a space between I and Thou in a way that is reminiscent of what Ludwig Wittgenstein has called "recognizing the humanity in man."[15] This demand constitutes a moral challenge each time one encounters another person: when one has encountered another as a Thou, that person can no longer be treated with indifference and arbitrariness. In dialogue, the I recognizes the humanity of the person standing in front of her—he is not just an abstraction, a human being in general. Thus, Buber's argument facilitates a view of dialogue as an ethical category that involves respect, responsibility, and regard for the other.

When one encounters a Thou, one accepts her in her distinctiveness. Her unique voice is respected and valued. Buber claims that in the encounter, the Thou is experienced as "inseparable, incomparable, irreducible." It is also important to note that one's own distinctive personhood needs to be honored and named in the encounter: the I has its own perspective on the world, as well—"existing but once, single, unique, irreducible."[16] Therefore, Buber emphasizes the "taciturn waiting in the unformed" that preserves the freedom of the other.[17] When one insists that other persons fit neatly and completely into one's own version of truth, one diminishes them and robs them of their dignity as unique selves.

An additional feature central to Buber's dialogue philosophy is an intention to recognize the other as representing "fully and distinctly another perspective on the world," as Raimond Gaita has suggested.[18] Other persons cannot be regarded as mere reflections of the self, nor can one fit others

neatly into one's own preconceived templates; perhaps the other does not want to play the part assigned to her.[19] Reciprocity plays a many-sided role in Buber's dialogue philosophy. Willingness to respond is vital for dialogue to take form between I and Thou, he claims: "Relation is mutual. My *Thou* affects me, as I affect it."[20] Reciprocity is thus significant to Buberian dialogue, but one should be careful of equating reciprocity with similarity. For Buber, it is in fact the *difference* of the partner that makes dialogue possible. Becoming an I for another's Thou is a privilege granted by the other; one cannot demand such a relationship, only intend or strive toward it. Without an equal, active counterpart, an other who can remain other but still maintain a vital voice, the dialogue becomes a monologue.

By taking his starting point in the relationship of the between, Buber emphasizes the interplay between similarities and differences as a central dialogical theme. Despite the identification of the self that takes place in dialogue, the other needs to be allowed to remain other, because dialogue requires difference. The goal of dialogue is not uniformity but increased awareness, respect, and community. It is only in relation to the other that one can truly be independent and free, as it is only against the background of a shared language that one can speak of finding one's own voice. In dialogue with a Thou, the I can find a meaningful context in which to express its separateness.[21]

Therefore, the otherness encountered in dialogue is not estrangement. It is, rather, a relationship in which the I allows the Thou to approach and engage face to face within the complexity of the situation as a valuable asset to be taken seriously. The other is not under one's control—she can always surprise and be different. Buber claims that all real living is meeting.[22] Persons exist as dialogical beings. The dimension that essentially marks the human condition is thus the between: the space between I and Thou in which neither party is dominant. The human condition is, quite simply, the condition of dialogue.

In his essay "Man and his Image Work," Buber reflects on the role of art in dialogue and the ability of art to make available a creative and open space between persons who meet in dialogue. For Buber, truth can be found only in the dialogical relationship between I and Thou. However, the Thou must not necessarily be another person (as shown by his famous example of encountering a tree in *I and Thou*).[23] Art is closely related to the very nature of human beings, Buber argues; the artwork is always the result of an encounter, a dialogue situation.[24] Experiencing a work of art is therefore an existential event: it need not be reduced to information exchange, ideas, or emotions; rather, it can be seen as an encounter with reality itself, irreducible otherness, the other in her otherness.[25] For Buber, art belongs to the realm of the between where it is neither dependent on the arbitrary intentions of the artist nor entirely under the control of the viewer. Only in the shared space of the between, as an element of dialogue, can art become thoroughly meaningful and a relational reality.

## DIALOGUE AND UNDERSTANDING

The interpretation of difference and understanding presented by Buber can be clarified by drawing a parallel to the hermeneutics of Hans-Georg Gadamer, who also stresses the dialogical nature of interpersonal understanding—a conviction that is reflected in his well-known phrase "fusion of horizons."[26] In his master work *Truth and Method* and throughout much of his early work, Gadamer gave his primary attention to the way texts function as "partners" in the emergence of meaning for the one who reads them. The texts might be legal in nature, they may be historical documents, or they could be passages from the Bible. Regardless of the type of text in question, Gadamer insisted the written text represents a particular claim to truth that describes the world from the perspective of the author. In other words, each text expresses the voice of one who describes the world he or she inhabits—what Gadamer calls the "horizon." The horizon—the worldview one perceives from where each particular person stands—is characteristic of what it means to be human. As a self, every experience, every insight, every emotion, every sensory input becomes a part of how one perceives herself or himself within the world.

As has been noted frequently (and criticized by many), Gadamer granted an active role to "prejudices" (or, perhaps better, "prejudgments"): "It is not so much our judgments as it is our prejudices that constitute our being."[27] When one approaches a new experience with a sense of openness and anticipation, one recognizes the significance of the experience before one reflects critically on the meaning of the experience. Each encounter with something external to the self can be understood because of what one already understands as a result of critical reflection upon previous experiences. The horizon is not a geographical location; it is everything that constitutes the way the self opens itself to the claim to truth of the other.

Gadamer's understanding of dialogue has been called intersubjective. Each dialogue takes place when one subject is confronted by the claim to truth of another subject. One brings one's horizon to a subject matter under consideration; so does one's partner in dialogue. Dialogue proceeds as a series of claims that operate back and forth, to and fro between the partners who address a common subject matter from each subject's own horizon of knowledge. The claim to truth of the other, the dialogue partner, the other self is experienced as what Lyotard called *un differend*: that is, a shock, a summons. "The nature of hermeneutical experience is not that something is outside and desires admission. Rather, we are possessed by something and precisely by means of it are opened up for the new, the different, the true."[28]

Thus, understanding has an event character. Understanding is not the operation a subject performs upon an object; it is, rather, an expression of the commonality that exists between the partners in the dialogue. Understanding "happens" for Gadamer when the horizons of the partners in the dialogue fuse, and each understands the subject matter under discussion as a new claim to truth. This kind of dialogue is only possible when each individual

treats the partner as a fellow subject and takes seriously his or her claims. Thus, dialogue takes place in the between when subjects fuse their horizons with the intention that transformation of understanding is to take place.

Gadamer emphasizes the importance of knowing and accepting that dialogue is always conditioned by the value-based, historically formed positions of its participants and that each party has the right to form and maintain a personal perspective.[29] Buber, who emphasizes the importance of personal integrity and a consciously formed identity as the starting point of dialogue, also addresses this idea.[30] Every act of understanding thus begins with self-reflection. This, however, is not an end in itself, but merely a step in the direction of dialogue. One becomes fully human only in relation to another, in dialogue with a dissimilar Thou: "living means being addressed."[31] One cannot force another person into the role of the Thou, but one can turn toward her and reach out to her with open hands in anticipation of meaningful—and transformative—dialogue.

Understanding is a negotiation between two different partners, but the fusion of horizons that Gadamer discusses is neither an abolishing nor a merging of the separate horizons. Each self remains, intact and whole. The dialectical nature of the process facilitates an understanding of the other *as other*. Thus, it can also make one's own position clearer and contextualize the self as situated in time and space. Since the aim of dialogue is to create common ground, it should facilitate mutual understanding without resulting in reducing truth to uniformity. Consequently, fusing two separate horizons of understanding does not require extinguishing either person who participates in the dialogue; rather, each is expanded by recognizing what David Tracy has called "similarity-in-difference."[32] The complex unity of same and other captured in this analogy alludes to the intricate interplay included in interpersonal encounters. Both the acts of uniting and separating require attention if dialogue is to facilitate communities large enough to contain genuine difference. This similarity-in-difference as well as Gadamer's description of the fusion of horizons clarifies the connection between separation and relation included in Buber's philosophy.

In this context, Parker Palmer's reflections on the "spirituality of the teacher" become relevant. Palmer (a sociologist and theologian) claims that to teach is to "create a space where the community of truth is practiced."[33] Community is the "essential form of reality, the matrix of all being . . . *we know reality only by being in community with it ourselves.*"[34] At the center of community is a subject—the reason for the existence of the community— and "*a subject is available for relationship; an object is not.*"[35] The kind of community Palmer describes is a community of truth in which "truth does not reside primarily in propositions."[36] Rather, truth is the "Secret [. . .] that sits in the middle and knows."[37] Truth beckons and summons from within the community of subjects that attends to truth.

Finally, this "community of truth" is not an ideal. It exists only as it is *practiced*. A community dedicated to truth is only true when it engages in

the praxis in which knowledge, understanding, and personhood are trans-formed. Dialogue always results in the emergence of new practices as well as the transformation of theory. Any community in which dialogue can occur must practice respect, value the personhood of fellow subjects, "hear one another into speech" to use Nelle Morton's phrase, embody justice, and engage in reciprocal relationships that allow truth to emerge from the practices of the community. Palmer's discussion indicates a spirituality of teaching (and knowing) that is clearly a practical theology.

Within a dialogical community, truth cannot be seen as the privileged possession of any particular subject. Rather, truth emerges from the dialogue itself as the fusion of participating horizons. Truth is not a concept or an ideal; truth happens as a new understanding of the shared subject matter emerges out of the intersubjective praxis. Palmer's apprehension of truth as a practice that arises in the interpersonal realm of the between offers a tangible elaboration of the philosophical arguments by Buber and Gadamer presented above.

## EMMANUEL LEVINAS AND THE FACE OF THE OTHER

Another 20th-century European philosopher, for whom Martin Buber became an important dialogue partner, was Emmanuel Levinas. Their philosophies bear deep resemblance with one another: Buber's well-known discussion of I-It and I-Thou can be found among the sources of Levinas's claims. But there are also significant differences to be observed between the two. Levinas questions Buber's claim that the relationship between I and Thou rests on reciprocity. For Buber, Levinas contends, "I am to the other what the other is to me," but for Levinas, questioning that initial reciprocity became a central philosophical task.[38]

Levinas's philosophy has often been interpreted as a more radical engagement with the other and with difference—what Levinas referred to as "alterity"—than the position developed by Buber. Alterity describes otherness as a fact to which one is powerless: an unalterable mystery that one can neither grasp nor own. One's relation to alterity is a relation "with what (in a world where there is everything) is never there, with what cannot be there when everything is there."[39] In comparison with Buber, one could argue that Levinas makes an even stronger claim for the right of the other to preserve her otherness. His notion of alterity provides a vital role for the ethical and dialogical character of understanding as reverence for genuine difference:

> The multiplicity of thinking beings, the plurality of consciousnesses, is not a simple fact—some sort of contingency, or a purely empirical "misfortune"—like the effect of some fall or ontological catastrophe of the One. [. . .] Quite to the contrary, beyond the sufficiency of the being-for-itself another possibility of excellence is shown in the human dimension

that is not measured by the perfection of the consciousness-of-self. [This]
would be the principle and the basis—uttered or implicit—of all dialogue.[40]

The other was a key concept for Levinas. Levinas discussed an other that
overcame the instrumental function characteristic of his predecessors. His
other was a real-life encounter with a flesh-and-blood human being. He
claimed that the subject that so dominated modern thought established its
power over the world by reducing everything that appears to something to
be controlled and made into an object of possible knowledge.[41] By reducing
everything external to the self to an other, modern philosophy and theology
reduced everything to the status of an object, with the self as the only subject.

But for Levinas, the other cannot be reduced to an object that functions
primarily to allow the subject to realize or self-actualize itself.[42] Rather, the
other is characterized by its having a "Face."[43] The other is, therefore, also a
self—a *subject*. As face, the other signifies otherwise than one's own powers
and "resists possession, resists my powers. In its epiphany, in expression, the
sensible, still graspable, turns into total resistance to the grasp."[44] Levinas
privileges the *proximate* over the *universal*, a philosophical move that would
only later become central to postmodern thought.[45]

The face always functions as an epiphany because its otherness—its alter-
ity—presents another claim to truth than the one the self brings with it. In
Gadamer's language, each has her own horizon. Thus, Levinas claims the alter-
ity of the other is absolute: the I and the Thou are not embraceable objectively,
there is no *and* possible between them, they form no unity. Nevertheless, dia-
logue is made possible as a bridging of the seemingly paradoxical notions of
distance and relation. Our relation to alterity, to the other as other, is therefore
that of responsibility, and it is—as a result—an ethical relation.[46] It includes the
paradox of affirming distance and proximity, unity and separateness, similarity
and difference—all at once. By reference to Buber's terminology, Levinas con-
tends: "It is precisely because the *You* is absolutely other than the I that there
is, between the one and the other, dialogue."[47] This otherness of the face is not
far away, but close-up, personal, intimate, and face to face. Its challenge to
one's subjectivity is signified "in the fact of summoning, of *summoning me . . .*
to the unresolved alternative between Being and Nothingness, a questioning
which, *ipso facto, summons me.*"[48] What Lyotard and Osmer described as the
"shock" and being "brought up short" characteristic of the arts is also found
in Levinas's understanding of the epiphany of the face.

An additional insight in Levinas's argument is the claim, which he shares
with Buber and Gadamer, that there is an inherently moral dimension in
encountering the face of the other. The other bears the power of the good
that challenges everything the self (the I) understands about its world and
one's place in that world. As Drew Dalton has suggested:

> A subject's power to perceive is revealed therein not to have originated
> in itself, but in the Other. The appearance of the other reveals that it

is not I who measures the world but he [sic] who "measures me with a gaze incomparable to the gaze by which I discover him."[49]

The face as the "me-that-is-not-me" makes it clear that the world is not ordered and organized around the self or the subject's needs, "but primarily oriented toward the otherwise—and available for use *for the sake of the Other*."[50] Consequently, Levinas regards the relation to the other as essentially asymmetrical in character: Buber's reciprocity is countered by the insistence that the I is the servant of the Thou in dialogue.[51] In this occasion, the face of the other summons the self; it judges one and posits one as responsible. Dialogue is the "non-indifference" of the Thou to the I; it is an encounter where the other "counts above all else."[52] The other, who thus dominates the self, is "the stranger, the widow, the orphan," and one is obligated to answer his call.[53] In understanding interpersonal relations, Levinas commences not with the self, but with the other who is never under one's control, always out of reach, always partly a mystery.[54] One's relation to the other, who is one's superior, is thus not a rational act: the face of the other that speaks to one "tolerates only a personal response, that is, an ethical act." Hence, Levinas makes his famous claim that ethics is the first philosophy.[55]

This claim entails a disqualification of reason and truth as exclusively valid routes to understanding—a position that parallels similar claims made by Buber and Gadamer. Pure reason is fundamentally non-dialogical in character: it is like "the silence of inner discourse," and by its absolute claims to truth it has "no one left with whom to communicate." To reach understanding along this path would only be possible in an abstract universe of pure reason where knowledge of the other could be attained prior to or outside the ethical relationship to the other.[56] However, the point of departure in dialogue philosophy is the interpersonal relationship, the fundamental dependency of the self upon the other. Invoking the other as Thou is not made possible through knowledge or experience, but through the proximity and alterity that constitutes the dialogical encounter:

> There perhaps lies the paradoxical message of all philosophy of dialogue, or a way of defining spirit by transcendence, that is, by sociality, by the immediate relation to the other. A relation different from all the ties that are established within a world where thought, as knowledge, thinks to its measure, where perception and conception grasp and appropriate the given and take satisfaction from it.[57]

Dialogue philosophy, as well as the practical theology we propose, is intentionally nondiscursive in nature. While it is based upon an understanding of communication, it is less about telling a set of propositional claims than it is committed to a sharing in the life experiences and horizons of ones with whom one is engaged in meaningful exchange. The forms of communication

criticized by Buber, Levinas, Gadamer, Palmer, and others become hier-
archical and top-down in structure as well as directionality. A dialogical
approach, such as the practical theology of the arts we propose, regards
communication in a horizontal and intersubjective way. Those who engage
in dialogue enter into partnership with one another. There is a radical com-
mitment to egalitarianism when an I and a Thou allow "truth" to emerge
from their interpersonal dialogue.

It is precisely the nondiscursive nature of the arts that makes them a rich
entry point for practical theology. Robin Jensen claims:

> When we consciously attend to an object, especially an art object, we
> will have some kind of reaction to it. [. . .] No matter how we respond,
> we are slightly or significantly different for having had the viewing, or
> the hearing—for having paid attention. Maybe only a single atom of
> our consciousness has shifted; maybe a landslide has taken place in our
> souls. [. . .] Still, something happens. [. . .] Our memories, even our ideas,
> are essentially constructed out of images and colors, spatial relationships,
> smells, sensations, and sounds, more than they are made of words ordered
> into sentences—even when we record and transmit them this way.[58]

New Testament scholar Amos Niven Wilder agrees, stating, "Before the
message there must be the vision, before the sermon the hymn, before the
prose the poem."[59] The arts do not, primarily, present propositions about
the world or about truth. Rather, they "project a vision, one that we must
see to understand, and whose truth lies outside of verbal explanation."[60]

A practical theology of the arts does not reject its roots in systematic,
constructive, and dogmatic theology. Rather, it claims along with Kate Siejk
that "the heart of religious faith is found *not only* in doctrines and creeds but
in liturgy, religious drama, art, music, and poetry"[61] [italics ours]. Richard
Viladesau proposes that one might begin to regard the use of the arts "as
a theological text" that one might read and exegete as one might a biblical
passage or a doctrinal statement.[62] The "gaze of the other" that is inherent
in the arts mirrors the face that confronts one with its own personhood, as
Levinas has claimed. When one encounters a work of art and opens oneself
to its claim to truth, one enters into a relationship with the horizon it pres-
ents. As Sidney Fowler states, "Within the relationship, one gazes into the
other—discovering details, emotions, and a deeper knowledge of the other,"
whether that other is a composer, a sculptor, or the Holy Other.[63]

## KNUD E. LØGSTRUP'S MORAL PHILOSOPHY

Levinas regards the encounter with alterity as an ethical endeavor: an asym-
metrical relationship where the other counts more than the self, and where
the demand for a personal answer manifests itself with certain urgency.

Furthermore, Levinas argues, dialogue is a relationship where the self is vulnerable to its counterpart; it includes a demand for responsibility. Thus, he asks rhetorically: "Is not the very opening of the dialogue already a way for the I to uncover itself, a way for the I to place itself in the disposition of the You?"[64]

This question could be posed within Knud E. Løgstrup's moral philosophy, which is consistent with the ideas of both Levinas and Buber (along with influences from Husserl and Heidegger as well as to Løgstrup's fellow Dane Søren Kirkegaard). Løgstrup's reflections on the ethical demand in dialogical encounters offer an important additional perspective to the question of theology and the arts. Løgstrup's claim that the relationship between I and Thou is inherently asymmetrical in nature has led many researchers to compare his philosophical elaborations with those of Levinas. Indeed, Løgstrup regards the interpersonal as essentially ethical in character and claims that in front of the face of the other, we are ultimately confronted by two alternatives: to care or to destroy.[65] The dimension of power implicated in all dialogues gives rise to an ethical demand to carry responsibility for the other regardless of how he or she chooses to respond to one's call. Svend Andersen argues this asymmetry must, nevertheless, be understood against the background of shared symmetry: for Løgstrup, the dimensions of power and vulnerability coincide with the interpersonal encounter—both dimensions are equally available to the self and to the other.[66] Therefore, Løgstrup's understanding of otherness can perhaps be regarded as a middle position, between the radical alterity proposed by Levinas and the discourse of reciprocity and mutuality applied by Buber.

As with Buber and Levinas, Løgstrup finds a starting point in a relational view of life. Human beings are never isolated: our way of being in the world is at all times related to and dependent on our relationships to others. In communication with the other, the I surrenders itself in trust to the other and consequently moves into the power of her words and actions. In such interdependent relationships, the power dimension inevitably works both ways: having to do with another person means having at least some degree of control over her. Trust puts the other in one's power, but it can also leave the self exposed and defenseless.[67] Encountering the other places one in a vulnerable position and, as Løgstrup argues, the meeting in dialogue between I and the other is always accompanied by a tacit ethical demand: one's existence demands protecting the person who has confided his life into one's hands.[68] Indeed, we "constitute one another's world and destiny."[69]

Løgstrup offers a thorough discussion of the concept of trust—which complements Buber's notions of reciprocity and distance—as well as the proximity and alterity characteristic of Levinas. Trust is part of what it means to be human. Erik Erikson believes the initial "crisis" in an individual's life is the resolution of the dilemma of "basic trust" versus "basic mistrust."[70] Løgstrup believes one's initial attitude toward life and others is one of trust; persons believe one another's word and accept the assertions

of a stranger. A person who trusts with reservations only does so because he has experienced prior violations. If this were not so, human life could hardly exist; it would be impaired and wither away. This insistence on trust as an essential aspect of the interpersonal should not be regarded as a naïve refusal to acknowledge the widespread distrust coloring human relationships in the world. For Løgstrup, trust is not wide-eyed and unrealistic reliance on the nobility of human character—it is a basic trait of communication in general.[71] Trust is a question of regarding other persons, of exposing oneself by reaching out to another and initiating contact. For Løgstrup, trust transforms the interpersonal into interdependence: a relationship of power and vulnerability. Therefore, trust is not the result of our achievements, Løgstrup declares; "it is given."[72] To trust, therefore, one places something of one's own life in the hands of another person.[73]

Trust is thus intrinsically tied to self-surrender and vulnerability: one offers something of oneself to the other by trusting her or by asking for his trust. By making one's expectations of another person known, one simultaneously surrenders oneself to her and reveals one's own vulnerability. If this appeal is not heard, one may consider it meaningless as it has "not been covered by the other person's fulfillment of it."[74] When one anticipates acceptance but instead faces rejection, one might easily devolve into moral reproaches and accusations. Many emotionally loaded conflicts make life seem as clear-cut as black or white.[75] Trust and interdependence are fundamental aspects of interpersonal relationships. Thus, we shape one another's worlds:

> By our attitude to the other person we help to determine the scope and hue of his world; we make it large or small, bright or drab, rich or dull, threatening or secure. We help to shape his world not by theories and views but by our very attitude toward him. Herein lies the unarticulated and one might say anonymous demand that we take care of the life which trust has placed in our hands.[76]

Løgstrup believes art can play an important role in interpersonal encounters. Artistic expressions can facilitate new and unreserved ways of experiencing the world around us.[77] In his book *The Ethical Demand*, Løgstrup dedicates a chapter to the analysis of poetry and ethics. He claims that the transformative power of poetry lies in its ability to make the world, nature, and the other present in a new and different way: "The contradiction in our existence, which poetry reveals, is that we are blind and deaf to the world we live in."[78]

Poetry has a tangible character of interpretation, Løgstrup contends. Therefore, it is especially interesting to examine how the poetic and the ethical are related. The timber and rhythm, beauty and precision of poetic expression not only serve the purpose of filling an aesthetic need. The beauty experienced in poetry, and other forms of art as well, is "revelation and nearness"—the very antithesis of triviality and clearly ethical in nature.[79] Thus, poetry marks a relational approach to the world and to the other,

while its reverse, triviality, is described as making oneself "self-satisfyingly diffuse." To be comfortable with triviality is "to cultivate one another's self-righteousness."[80]

As can be seen by this discussion, Løgstrup highlights the transformative capacity of symbols in art and claims that aesthetic expression can make a person sensitive to realities other than his or her own.[81] This transformative capacity can be found in the special relationship between art and knowledge, he claims, in an argument that bears striking similarity to the discussions of art and truth we propose. One's relation to the world is based on information about things and situations to which we orient ourselves. By naming things and by establishing and determining them, one limits and determines oneself, Løgstrup states. But all this is different in poetry, as poetry discloses openness rather than information: "Here we do not determine ourselves; we are determined."[82]

To understand Løgstrup's argument, parallels can be drawn to Buber's claims about I-It and I-Thou. The It-world, Buber states, is concerned with describing, categorizing, and ordering—it gives the world a clear shape, measures, and boundaries. The Thou-world, on the other hand, cannot be forced into the straightjacket of definitions and measures; it is a world of openness and transformation, reinterpretation, and surprise. Poetry, and art in general, can hence be meaningfully associated with the I-Thou relationship. For Løgstrup, the world of dialogue is an ethical category of interpersonal relatedness, as it is for Buber. The interpretive character of artistic expression, the fluidity and undetermined character of its language occurs in a dialogical space of openness and attentiveness.

## DIALOGICAL UNDERSTANDING AND ART

This chapter has dealt with the concept of dialogue philosophy, primarily in the forms it has been given by the philosophers Martin Buber, Hans-Georg Gadamer, Emmanuel Levinas, and Knud E. Løgstrup. Common to all these approaches is the view of the human as dialogical beings who always stand in relationship to others and to the world. There is no singular I, to use Buber's phrase; there is only the I that is either part of the combination I-It or I-Thou. The basis for understanding is found in the space of the between—the realm of the interpersonal—where truth takes form as a dialogical process of interpretation and where neither I nor the other can reign in sovereignty. Even though the nature of the interpersonal in between and the status of the autonomous other in relation to the self are perceived somewhat differently by each author, they nevertheless agree on the vital description of otherness and alterity as an invaluable and compelling aspect of human relationships and of dialogue as an ethical imperative.

The intricate balance between separateness and unity, unique individuality and shared community, and the responsibility connected to such balancing

can be regarded as the central axis around which the philosophies presented in this chapter evolve. Applying such claims to the contemporary world of plurality and global transformation, Aimee Upjohn Light stresses, makes it necessary to stop thinking in dualistic categories when relating to the other. In a binary discourse of same or different, true or false, difference "must always be identified as a lack." Therefore, she contends, there is a need for exploring the creative ruptures in the traditional, dialogue canopy created by nonbinary ways of approaching the subject.[83]

The question of the religious other can hence be regarded not as a problem to be solved but as a relationship to be explored, taking otherness and the challenge it poses to our visions of self-sufficiency seriously. In the end, such an approach may prove unable to provide a single coherent master narrative of difference and dialogue. On the other hand, as argued in the previous chapter, such monolithic perspectives seem to be inadequate for describing the post-secular and thoroughly pluralist landscape where human interaction with difference takes place today. Our theories and approaches are always value laden, contextually bound, and intertwined with personal pursuits for meaning and understanding. Therefore, shifting attention from religion to religious and from objects to subjects in the analysis can facilitate a theoretically and ethically more nuanced account of the richly varied subject under investigation.[84] This, we believe, is made possible by studying art as an arena for such interpersonal meaning making.

Finally, one can conclude that every work of art offers its own claim to truth. One of Gadamer's major contributions is the extensive discussion of the *text* as a subject in intersubjective dialectic—whether the text is a written work, the message of a symphony, or the conversation of a person. He believed that art contains a claim to truth that is *different* from the kind presented by science, but by no means inferior to it.[85] Richard Viladesau understands dialogue to be characteristic of an aesthetic theology that takes on decidedly practical and ethical dimensions:

> To the extent that we respond to this call positively, the other becomes for us not merely a function of our own existence or an object within the horizon of our minds, but another mysterious 'self' over against our own. [. . .] Dialogue is thus an event of purposely and freely uniting separate persons and is therefore (implicitly, and to different extents) a potential act of love. [. . .] Every true assertion is meant to contribute in some way to the other's being.[86]

Deborah Haynes has said, "I believe that a theology of art must address the theological and ethical dimensions of creativity," which are "always connected to one's past experience, social location, and to various strands of life in the present."[87] The arts are, in her estimation religious and moral acts precisely because of their consequences in the world. "From this point of view, the creative process is also intrinsically religious and moral insofar

as it involves actions for which we are responsible and accountable within a given community."[88] A given work of art offers a world that can challenge and summons one as dramatically as a face-to-face encounter. At times, the arts can engage one in dialogue more effectively and more powerfully than any sermon or theological treatise. Bruce Birch claims that "the arts can create openings for transformative impact that would not necessarily have been possible in more traditional forms of exegesis and biblical teaching."[89] Likewise, Robin Jensen argues that *good* art must continue to challenge the world of those who would view it.[90] A similar claim is made by de Gruchy who notes that art has the ability to affect both our personal and our communities' consciousness. By evoking the imagination, causing us to stop and wonder, art offers genuine channels for transformation.[91] These claims will be discussed further in the following chapter, where a practical theology of the arts is developed from a dialogue among the ideas and interpretations presented in the previous chapters.

# 3   Outlining a Practical Approach to Theology and the Arts

In the previous chapters, the theoretical and methodological foundations for the current study have been presented and discussed. We now turn to an outline of the guiding principles for the current analysis of art as a platform for theological investigation into questions of understanding, dialogue, and otherness. This, we propose, can be described as a *practical theology of the arts*.

## ENGAGING IN PRAXIS: PUTTING THEOLOGY INTO PRACTICE

Practical theology has been a topic of discussion within the field of theology for at least three centuries. It has gained enough interest in contemporary theological circles to generate the Association for Practical Theology and section meetings during the American Academy of Religion Annual Meeting. A similar development is visible in Europe, where most universities offering theological education include a chair in practical theology. Yet, practical theology has been neglected within the larger discussion of theological disciplines, as Don Browning also noted: "The field of practical theology has been throughout its history the most beleaguered and despised of the theological disciplines [. . .] To admit in a major university that one is a practical theologian has been to invite humiliation."[1] Since Schleiermacher's division of the academic study of theology into philosophical theology, historical theology, and practical theology,[2] critics have identified the clear hierarchical relationship among the three forms of theology he developed. Ray Sherman Anderson, for example, suggested, "The bridge connecting practical theology and the older disciplines of 'pure' theology was constructed for one-way traffic."[3] Nevertheless, as Robin Lovin claimed, practical theology provides an "understanding of how faith can guide action in contemporary circumstances. That important task is trivialized when practical theology is reduced to a set of useful skills for the working minister. [. . .] All theology must be practical theology."[4] More recently, Mary McClintock Fulkerson has claimed that theology has *always* been practical in some sense.[5]

In her introduction to the recent *Wiley-Blackwell Companion to Practical Theology*, Bonnie J. Miller-McLemore identified four *enterprises* that have

characterized approaches to practical theology: practical theology as a separate *discipline* (or, perhaps, subdiscipline) within the larger field of theology; practical theology as an *activity* of faith among believers; practical theology as a *method* of studying theology in practice; and practical theology as a *curricular* area of study within a seminary setting.[6] Practical theology is, in her estimation, "a general way of doing theology concerned with the embodiment of religious belief in the day-to-day lives of individuals and communities. It engages personal, ecclesial, and social experiences to discern the meaning of divine presence and to enable faithful human response."[7]

Friedrich Schweitzer traced the emergence of practical theology to the work of Friedrich Schleiermacher. He criticized an instrumental understanding of practical theology as a method of *application* that reduces all theological tasks to tools for transmitting the central claims of what has become known as *systematic* theology. He also discussed deficiencies in practical theology as a theology of action, as theological aesthetics, and as a theology of *habitus* (as has been proposed by Edward Farley).[8] Consequently, Schweitzer argued for reclaiming the expressive function of practical theology as the fundamental task of the discipline, which he described as a "critical hermeneutics of culture."[9]

Another recent discussion of practical theology and its contributions to theology more broadly defined has been Paul Ballard and John Pritchard's *Practical Theology in Action*, which describes the subject of a Christian practical theology to be, "the practice of the Christian community in the world."[10] They regard the primary task of practical theology to be "to focus the whole theological enterprise on the demands, hopes, fears and actual practices of the community of faith so that its life in the world may be faithful to the gospel and relevant to its time."[11] In their analysis, Ballard and Pritchard reject practical theology as *applied theology* (a common understanding of what it means to be *practical*) and practical theology as *critical correlation* (represented by Paul Tillich, David Tracy, and Don Browning). They are more receptive to praxis models that regard faith as transformative activity. In the final analysis, Ballard and Pritchard favor a synthesis of praxis approaches (in various forms of liberation theology) and a revised form of practical theology as *habitus*, which they define as "a disposition of mind and heart characterized by informed Christian wisdom."[12]

An advantage of the approach Ballard and Pritchard suggest is its emphasis on the integrative character of practical theology. Theology cannot be a purely conceptual and speculative enterprise; "theology starts where God is to be found, in the concrete reality of the immediate situation."[13] Theology is always embodied in the practices of persons of faith—the whole people of God—as they engage with the wider life of society. Robert Mager identifies three assumptions about practice that illustrate the integrative character of the discipline: practice is central to practical theology, practice is best understood in terms of action, and a theological understanding of action cannot function without the contributions of both human and social sciences.[14]

It is not sufficient to know *about* God. Knowledge *of* God is always grounded in the actions of faithful communities of persons who live out of the indwelling presence of God. This encounter with God who is present as the other who summons from the midst of human experience calls persons within communities of faith and communities of truth to practices that actualize their experience of that presence in face-to-face, real-world situations. Practical theology, then, engages body, mind, spirit, the other, and the wider community in a dialogical relationship with an immanent as well as a transcendent God. Norbert Mette claims that practical theology must reflect on God's becoming practical, God's becoming beautiful, God's being alive in practice.[15] The community of truth that Parker Palmer discusses is one that regards the claims of the other—including those of the divine other—in the midst of a community that listens so intently to the voice of the other who summons one into dialogue that truth may emerge from the dialogue.[16] For Ballard and Pritchard, truth is encountered only in doing and becomes present in the grounded, immediate actions of the community of truth. Likewise, religious faith and/ or spirituality are actualized only when they result in a way of living that is reflected through its practices as well as its characteristic ways of knowing.[17]

Joyce Ann Mercer shares this attention to the practices of faithful communities in her feminist practical theology of childhood:

> A central feature of practical theology as a discipline and as a method for doing theological work is *praxis* or the mutual engagement of theory and practice for the sake of emancipatory action in the world. That is, practical theology as a *praxis*-centered theology intends to be put to work in the lives, communities, and situations of people. It is not a theology centered on abstract questions asked as some form of academic exercise with no engagement in the real lives of people. Practical theology involves strategies and tactics of transformation. Practical theology creatively and constructively develops alternative visions and practices for human actions that work toward justice and the reign of God in particular situations of struggle.[18]

Like many of the feminist theologians discussed in chapter 1, Mercer sees feminism as "theology that takes as a central concern the liberation of women, together with others, from various forms of injury."[19] She maintains that, although theology itself is socially constructed and as such is subject to the power dynamic characteristic of modernist hegemony, a praxis-centered feminist practical theology is one that participates in God's transformative work of love and justice.[20]

Denise Ackermann also offers a feminist approach to practical theology and contends that women's ways of knowing arise out of practices rather than theoretical constructs; these practices emerge as women tell their own stories of resistance and hope within communities of faith.[21] Ackermann claims that women doing theology together can result in the birth of a new

kind of practical theology that is based upon collaboration, sustained action for justice, reparation as well as renewal, a demand for accountability, and a community of persons empowered by love, hope, and passion.[22] A feminist practical theology is, for Ackermann, a "feminist theory of *praxis* in which a hermeneutic of liberation and healing [. . .] is at the core."[23]

In our view, a practical theology of the arts begins with attention to a synthesis of praxis-centered theologies that humanize as well as liberate and a community-based lifestyle in which *habitus* moves from mere good deliberation and wise judgment to actions and practices that complete an agent's intention in the real world.[24] As Robert Schreiter claimed:

> [P]raxis is the ensemble of social relationships that include and determine the structures of social consciousness. Thus thought and theory are considered sets of relations within the larger network of social relationships. Theory represents a dialectical moment within practice, as does action. Theory's task is to illumine the exact nature of those social relationships. By so doing, theory can point to false and oppressive relationships within the social fabric. This pointing to false and oppressive relationships brings them to awareness, which is the first step toward transforming them.[25]

A practical theology, then, does not consist in propositional claims or positivistic statements of doctrine as much as it does in critical reflection on living as persons of faith whose practice requires that existing theory be retooled, and whose retooled theory raises implications for new practices in order to be faithful. Rebecca Chopp summarized praxis as:

> [A] dialectical unity of three symbiotic dimensions or moments: an active dimension which includes and engages all the intentional historical activities of agent subjects in time and place; a reflective dimension that uses critical and social reasoning, analytical and social remembering, creative and social imagining to reflect critically upon one's own and one's society's action; and a creative dimension which leads to further 'right action' in the world.[26]

Practical theology is dialectical; transformational; and engages in descriptive/empirical, interpretive, normative, and pragmatic tasks.[27] As such, practical theology draws from the insights of postmodern theology, dialogue philosophy, hermeneutical theology, liberation and feminist theology, religious education, and pastoral care in what Bonnie Miller-McLemore has called a "living human web" of relationships and systems "through ministries of compassionate resistance, empowerment, nurturance, and liberation."[28] The web is not simply one that involves those within a closed system of like-minded persons. Nor is the web of practical theology one that restricts its dialogue partners to those within the clergy-paradigm or within

the confines of Christian religious experience. The majority of those writing on practical theology write from a Christian perspective; this does not limit the discipline to that faith community. Since practical theology focuses on religious experiences and practices grounded within the context of the particular community rather than an idealized or hypothetical community, a variety of religious and/or spiritual communities can engage in practical theology. Ackermann describes the interreligious nature of the South African Circle in which she has been involved as one of the strengths in what she understands as the character of a feminist practical theology.[29]

An inclination toward the practical can be found among the dialogue philosophers discussed in chapter 2. Richard Bernstein claims that, for Gadamer, "what is most distinctive about our being-in-the-world is that we are dialogical beings."[30] Gadamer understood prax*is* as the way universal moral principles are brought into dialogue with concrete historical experiences, encompassing a transformative interplay between action and reflection.[31] Because understanding is dialectical, one's *praxis* is always affected by one's *theoria*; one's *theoria* is inevitably transformed by one's *praxis* an ongoing dialectic that ideally aims toward Gadamer's concept of fusion of horizons.[32]

Sally Brown identifies several criticisms of Gadamer's philosophical hermeneutics. Jürgen Habermas engaged Gadamer in a long-standing debate over what Habermas considered Gadamer's uncritical attitude toward tradition, authority, and effective historical consciousness. He believed these claims by Gadamer obscured the roles of power, politics, and other dominating traditions in the development of what Habermas called emancipatory reason in his theory of communicative action. Similarly, several feminist scholars have identified Gadamer's approach as too individualistic as well as overly optimistic about the role of tradition. Many feminists argue that all interpretation is done within a community of interpreters rather than functioning as an isolated act of understanding. Gadamer responded to these critiques by claiming that human existence itself is inescapably historical, concretely situated, and interpretive in nature. Brown insists that Gadamer's enterprise was a descriptive, rather than a prescriptive, one.[33]

Charles Gerkin and Thomas Groome are among recent practical theologians who have been influenced by Gadamer's hermeneutical philosophy. Gerkin incorporated Gadamer's image of understanding as a to-and-fro, back-and-forth engaging of question and correction into his discipline of pastoral theology. Gerkin's description of the interdisciplinary nature of practical theology as a multidimensional "living human document" has been influential in Miller-McLemore's "living human web" of relationships.[34] Groome developed Gadamer's insights—under the influence of Freire's pedagogy of the oppressed—to propose a "*praxis* way of knowing," which he described as:

> A relational, reflective, and experiential way of knowing in which by
> critical reflection on lived experience people discover and name their

own story and vision and, in a Christian education context, the Story and Vision of the Christian community. It thus combines the knowing which arises from present lived experience with what was known by Christians here before us. Since a *praxis* way of knowing always has the purpose of promoting further *praxis*, the knowing which arises from a reflective/experiential encounter with the Christian Story and Vision seems capable, by God's grace, of sponsoring people toward intentionally lived Christian faith.[35]

Brown describes Groome's discussion of Christian religious education as "shared Christian *praxis*" as fundamentally hermeneutical in its scope. For Groome, "*Praxis* is the starting point of critically reflective conversation in his multistage approach with revised (and revisable) *praxis* as its goal." At every level of personal and community experience, faithful learning is thoroughly intentional and practical and engages each person with his or her world at every level of personal and communal experience.[36]

Also Buber's philosophy is frequently criticized for being all but praxis oriented: that is, for being abstract and idealistic. Eric J. Sharpe contends that Buber should be credited for introducing the individual perspective into the predominantly theoretical understanding of dialogue, but claims that this simultaneously makes Buber insensitive to the context of concrete dialogues—including power relations, political, and economic realities. Buber is also criticized for his vague and romanticizing language that resembles poetry and mysticism rather than academic writing, turning it into an unrealistic enterprise oblivious to social, cultural, and economical influences, power relations, and gender issues.[37] Nevertheless, this critic ignores many of the viewpoints presented by Buber himself as well as the nuanced tradition of dialogue philosophy that has developed since then. In fact, Buber maintains that dialogue is always contextual as a person "gains his world by seeing, listening, feeling, forming": that is, through personal reflection and interaction with the surrounding community.[38] In line with the hermeneutic tradition, Buber regards language as an inevitable context of human understanding and dialogue: "language does not reside in man but man stands in language and speaks out of it."[39] In Buber's view, hence, the situation in which dialogue occurs cannot be disregarded, including both the surrounding circumstances and the individuals' personal decisions.[40] Dialogue is an aspect of ordinary human interaction—not an extraordinary event. Human beings can therefore only be understood as subjects *in* the world, in what they do and where they stand.

Thus, the notion of praxis can be regarded as central to Buber and the other dialogue philosophers presented in this study. Furthermore, as noted in the previous chapter, the ethical perspective is central to this line of thought. For Buber, this includes a tangible spiritual dimension. In his view, you cannot reach another person if you exclude God, but neither can you reach God if you turn your back to the people around you.[41] In the beginning is

the deed, one could therefore argue along with Kwame Anthony Appiah; it is practices—not principles—that enable persons to live together in peace:

> Conversations across boundaries of identity—whether national, religious, or something else—begin with the sort of imaginative engagement you get when you read a novel or watch a movie or attend to a work of art that speaks from a place other than your own. [. . .] I stress the role of the imagination here because the encounters, properly conducted, are valuable in themselves. Conversation doesn't have to lead to consensus about anything, especially not values; it's enough that it helps people get used to one another.[42]

In our view, thus, praxis is not a static application of *real* theological, theoretical, academic work—as Schleiermacher's organization of theology had implied. Rather, praxis is a process "in which agent subjects reflect critically on their social/historical situation and present action therein."[43] In addition to the role of praxis at the center of practical theology, we propose a robust focus on what Palmer calls the community of truth and others refer to as a community of faith as (again, in Palmer's terms) being engaged in "clearing a space" where persons can develop those habits, tools, and skills "that will enable something of the divine reality to be discerned and acknowledged."[44] When one identifies the work of theology within the context of lived spiritual experience, one cannot regard the work of *practical* theology in particular as the task of providing methods or skills to apply the *real* theological work of systematic theology. Rather, the task of practical theology is that of training the mind and heart of those within the community that experiences the holy in the midst of its everyday context and to so indwell that community's social reality that its experience becomes a *habitus*.[45]

Edward Farley's discussion of theology as habitus was outlined in our introduction. Farley was critical of the modernist agenda of Schleiermacher that bracketed critical reflection on practices within a community of faith that allowed for the emergence of knowledge of a self-disclosing God (habitus) to a position of secondary (and, arguably, marginal) importance while giving preference to what ultimately became a clerical paradigm that saw practical theology as *applied* ways of transmitting the normative doctrines derived from historical and biblical theology.[46] Friedrich Schweitzer criticized Farley's understanding of habitus as a misinterpretation of Schleiermacher's reformation of theology that relied too exclusively on the immediate experience of the presence of God in the context of the community. Schweitzer saw Farley's claims as requiring a choice between habitus and the "rules of art" that Schleiermacher based on the natural sciences— a choice Schweitzer regarded as misleading.[47] Bonnie Miller-McLemore, Jean-Guy Nadeau, and Emmanuel Lartey each respond to Schweitzer's critique, with Lartey identifying it as little more than "who understands Schleiermacher better."[48]

Terence Kennedy claims that Aristotle and Alisdair MacIntyre argue that it is only as one makes a conscious and deliberate choice to act in a way that accords with the virtues that one lives virtuously—in fact, deliberate choice is necessary for the resulting actions to become habitual. It is only as a choice becomes realized in actions—in praxis—that the choice is virtuous. It is only as choice becomes regular, consistent, and a part of the lifestyle of the individual—a part of one's habitus—that virtue moves from the ideal to the practical.[49] Kennedy sees practices as integral to the existence of virtue: "The tradition of virtue is transmitted rhetorically precisely by its being exercised."[50] While both Aristotle and MacIntrye see the ethical choice of adopting a lifestyle of habitus as personal, Kennedy argues, "practice is social activity whereby the community as agent transmits its values by inserting and integrating them into its public institutions."[51] The aim of practical theology as habitus is "so to indwell the social reality that it becomes a 'habitus.'"[52]

In a recent book, Jeanne Stevenson-Moessner discusses practical theology as a "spiritual symphony" that "puts faith in action and action in faith."[53] Stevenson-Moessner is among several authors writing on practical theology who make frequent reference to the arts, either as a tool for discussing practical theology or as an analogy or metaphor representing practical theology. Ballard and Pritchard locate an artistic method of theological reflection as a middle way between a theology of praxis and theology as habitus. That can allow persons to enter into theological reflection with an affective heart as well as with a cognitive mind.[54] But, what shape might a practical theology *of* the arts take? In what ways might the arts prove useful in a critical, creative reflection on theological practice? This work represents an initial step in the development of just such an approach to theology.

## BEING ENGAGED BY THE ARTS

In recent years, several excellent books have begun to propose a "theology of the arts."[55] Periodicals such as *ARTS: The Arts in Religious and Theological Studies* and *Images* celebrate this emerging emphasis as well.

One early 20th-century proponent of the significance of the arts for theology was Paul Tillich. In his *Theology of Culture*, Tillich identified the essential elements of any work of art as "subject matter, form, and style."[56] For Tillich, form "is the ontologically decisive element in every artistic creation—as in any other creation [. . .] It is due to their form that they are creations. It is due to their style that [the arts] have something in common."[57] In every style of the arts, the ultimate concern of a human group or period is manifest. Elsewhere, Tillich summarized four levels of what he saw as the necessary relationship between theology and the arts: the power of art to express the universal; art forms that directly express the "ground of being" or "ultimate concern"; art forms that express intentionally religious content

(such as paintings that interpret passages of Scripture); and art forms in which religious subjects are presented in a recognizably religious style.[58]

Jeremy Begbie appreciates Tillich's attention to the arts as a way of approaching theology, but he is also critical of what he considers an essentially docetic Christology that emerges from Tillich's systematic theology.[59] Begbie claims Tillich's Christology is overwhelmed by the general theological scheme in which it is set.[60] His own understanding of a theology of the arts begins with a relational understanding of the Trinity that takes its bearings "from a more rigorous concentration on the incarnation, crucifixion and resurrection of the Son of God."[61]

More recently, Wilson Yates has summarized the conclusions from the "Arts in Theological Education" study (published in 1987), which showed that there was a significant inclusion of the arts in theological education in the period of the study; that this interdisciplinary theological discussion addressed a range of art forms (with music and literature the most common subjects of study); that the arts could contribute to ministry and theological education in a variety of ways; and that theological interest by means of the arts might be focused theoretically, analytically, or practically.[62] Perhaps more significantly, Yates offered 10 ways the arts are important to theology:

- As "sources in identifying and understanding the religious questions of human existence."
- For "understanding the spiritual character of a particular culture."
- As "sources of prophetic judgment and protest against human injustice and idolatry."
- As "documents and sources for understanding the nature of historical and contemporary faith."
- To "inform the process of creating theology."
- To "provide forms central to liturgy and worship."
- To "provide essential means for communicating the meaning of the Christian faith to the church and to the world."
- To "play essential roles in the professional and spiritual growth of students by helping them develop their intuitive mode of knowing."
- To "serve as structures through which people encounter the presence of God. That is to say, the arts can serve as a means of grace."
- To "pose to theology the need to explore certain fundamental questions that come out of theology's encounter with the arts."[63]

Imbedded in Yates's list, one hears echoes of themes commonly expressed in practical theology as well. In her response to Schweitzer's keynote address, Miller-McLemore notes that the divisions of modern theology that marginalized practical theology parallel a "modern disjointing of truth, beauty and goodness."[64] David Hume was representative of an Enlightenment fear that anything expressive of feelings was somehow inherently antirational and

uncritical; as Hume said, "nothing is more dangerous to reason than flights of the imagination."[65] This devaluation of the intellectual contributions of the arts, religion, and women left few options for members of the clergy or for educated women than to turn to the arts and literature as the only areas of public life they could influence.[66]

Jeremy Begbie has been a major advocate for a theology of the arts for the past few decades. Two of his books, in particular, have established his intention to "propose a cognitive understanding of art [ . . . ] which sees art as capable of affording general knowledge of reality beyond the confines of human self-consciousness and therefore as in principle open to clarification, elucidation and assessment."[67] With Tillich, Begbie argues that, at their best, the arts are capable of "reflecting the character of a culture or age in a unique and professional way." He agrees with George Steiner that there is, at some level, a fundamental encounter with transcendence in the experience of the creative character of the arts.[68] In *Resounding Truth: Christian Wisdom in the World of Music*, Begbie focuses especially on his own artistic form of music, which he claims is especially adept at enabling persons to access the spiritual dimension of human experience of the holy.[69]

Begbie's theology of the arts is also fundamentally a practical theology that is not principally about doctrines, dogma, or propositions. Rather than assigning the theological task to a limited set of expert practitioners (professionally trained theologians and the clergy), he defines theology as the work of faith that can and should be practiced by all Christians. Theology is the "disciplined thinking and re-thinking of the Christian gospel for the sake of fostering a wisdom that is nourished by, and nourishes, the church in its worship and mission in the world."[70] The key phrase in the statement is "fostering a wisdom," which attunes nicely with the approach to habitus suggested by Kennedy. For Begbie, wisdom is a way of practical knowing that equips persons and communities with the "ability to discern what is happening in real, down-to-earth situations in a way that is faithful and true to God."[71] He claims that the arts, like theology, always occur in the context of community and are less like a text than a set of practices.

Likewise, Richard Viladesau claims, "If we take seriously the idea that revelation is the communication of God's self to humanity in such a way that we actually share the divine nature, then a purely propositional view of revelation seems clearly inadequate. That is, revelation cannot be seen simply as a matter of information about God; it must instead be understood primarily as an interpersonal event, as the communication of God's own life."[72] Furthermore, Viladesau contends that art "embodies revelation."[73] Just as practical theology cannot be understood simply as the moment of theology that applies the normative—some would say pure—work of theology but becomes the occasion for theology as habitus, so, "art should not be conceived as something to be added on to a theological message to make

it palatable or more easily understood, but as an intrinsic part of theology's nature and object."[74] Robin Jensen concurs:

> Art isn't at all like dogmatics. It isn't even very much like constructive theology. Visual art, like poetry, doesn't restate propositions or even directly parallel them. It projects a vision, one that we must see to understand, and whose truth lies outside of verbal explanation. Good art *is* about truth—a truth that transcends visually coded symbols in a catechism or the literalistic reproduction of a biblical story.[75]

Paul Ballard and Pamela Couture introduce their 2001 book *Creativity, Imagination and Criticism: Christian Thinking in the Service of Church and Society* with the claim that the arts are ways "to reach into the deep realities of human existence" and claim "It is time, therefore, for the whole of practical theology to rediscover in a stronger way the 'artistic dimension' in our lives and to see it as a source of understanding and a means of grace."[76] Bernard Reymond, who writes about theatre, identifies four functions of the arts as they relate to practical theology: art improves, deepens, and extends the palette of human aesthetics and makes persons more sensitive to diverse realms of reality; art enriches and colonizes the imaginative side of human minds and contributes to the social construction of reality; art assumes a prophetic function and works as a resistant and innovative force in the world; and art is particularly able to make persons sensitive to the transcendent or spiritual dimensions of existence.[77]

At their most basic level, the arts summons person to see reality differently. Ballard states: "Working within the cultural patterns of the day the artist always, in some sense, brings to the work of art a vision, a perspective, asking the beholder to look afresh at what may be a familiar reality."[78] Like an artist, a practical theologian helps persons see new alternatives for engaging with the world by her or his attention to the immediate reality and the concreteness of the situation made visible and understandable through that agent's "gaze."[79] Begbie refers to Anthony Thiselton's summary of Gadamer's position on the arts as "not merely a matter of subjective consciousness but of ontological discourse."[80] The arts do not challenge the world *in general* as much as they question each person's own self-understanding that is revealed, illuminated, and challenged. For Gadamer, "The work of art has its true being in the fact that it becomes an experience changing the person who experiences it."[81]

Mette challenges practical theologians to "teach us how to see, for [practical theology] is not primarily concerned with something that has to be achieved, but with something that is already given, with 'grace,' with character."[82] Emmanuel Lartey quotes Edward Robinson in claiming that the value of aesthetic dimension of theology is that the arts offer a new way of looking at the world that is absent in dogmatic theology.[83] The gaze of the artist and the focused activity of the practical theologian both begin with

the otherness of the claim to truth being brought as a summons that "brings us up short," as Osmer phrases it.[84] The inherent spirituality at the heart of artistic experience calls persons from attention to their own subjectivity to engage with another subject who sees the world differently from themselves. Miller-McLemore claims that aesthetics and the arts, like practical theology as habitus, arrest one's attention and suspend one's self-absorption. They help us pay attention to truth claims external to ourselves and help connect persons to the particularities of the other *as other*.[85]

Frank Burch Brown has suggested that one major function of the arts is that

> a work of art can be loved in God when it has become, itself, a medium whereby God *becomes present* to us. [. . .] Art not only allows itself to be blessed or dedicated or shared, religiously. As something that can engage us wholly, the arts can also enact faith and love, vivifying and in a real sense 'converting' religious concerns sensuously and imaginatively, letting one taste and savor sacred delight.[86]

Artist and theologian Deborah Haynes offers three propositions concerning the relationship between theology and the arts: first, "Theology can provide the arts with insight about vocation and, specifically, about the vocation of the artist [. . .] that urges engagement and commitment to the world in order to bring about the political, social, and cultural transformation necessary for the embodiment of values such as peace, love, and justice." Second, "Theological doctrines related to prophecy, revelation, and sacrament can serve as a resource for the arts." And, third, "Theology itself, as the discipline that aims to articulate religious doctrines about God, the divine and the sacred, can aid the arts."[87] Each of her propositions is fundamentally practical in nature. Each points to the performative character of both the arts and practical theology that presents an alternative to the predominantly discursive character of modern theology.

As the arts and theology engage one another in the praxis of a dynamic dialogue, they do so in the context of faithful persons within a "space where the community of truth can be practiced."[88] Each community of truth is encountered by the otherness of the rich diversity of horizons represented by its members and a myriad of opportunities for God to become present among its circle. Jeanne Stevenson-Moessner has taken note of the plurality of voices and horizons in each community and has compared the complex interaction among those voices to the layers of voices in a symphony.[89]

Within a community of truth, one is not encountered by ideas *about* truth; one is engaged with a rich tapestry of faces that embody claims to truth. One can ignore, deny, minimize, and marginalize *ideas* one finds unacceptable. It is much more difficult (not impossible—but certainly more difficult) to bracket a *person* whose eyes gaze into one's own eyes with a call, a summons, that shocks and calls one up short. Both the nature of art and the claims of practical theology point toward the dialogue that characterizes this

kind of community. Since each community is composed of its own unique combination of members, and each member has her or his own particular horizon and prejudices, it is inappropriate to assume each community will reach exactly the same understanding of meaning and truth—and this is precisely the conclusion reached by postmodern philosophers and theologians. As a practical theology of the arts, the task of the community is to empower its members to engage one another as fellow subjects who meet one another face to face, hear one another into speech, open themselves to the claims to truth that will be experienced in the back-and-forth, to-and-fro of praxis, practice the experience of the holy within the community habitually, and make themselves vulnerable enough to allow the process itself to result in the transformation of the persons who constitute the community as well as the community itself.

Such an approach to the emergence of meaning within the community of truth is necessarily contextual. Both practical theology and the wide variety of theologies of the arts suggest it is within the context of such dialogical, intersubjective communities that one might best be met by a God who desires nothing more than the fullness of humanity freed from oppression and open to the richness of God's blessings within the community of truth.

In this context, the question of the religious other can be regarded not as a problem to be solved but as a relationship to be explored, taking otherness and the challenge it poses to our visions of self-sufficiency seriously. In the end, such an approach may prove unable to provide a single coherent narrative of otherness and interpersonal dialogue. On the other hand, as argued in the previous chapter, such monolithic perspectives seem to be inadequate for describing the post-secular and thoroughly pluralist landscape where human interaction with difference takes place today. One's theories and approaches are always value laden, contextually bound, and intertwined with personal pursuits for meaning and understanding. Therefore, shifting attention from religion to religious and from objects to subjects in the analysis can facilitate an account of the richly varied subject under investigation that is more ethically nuanced than many that have preceded it.[90]

## KEY THEMES

We have claimed that the essence of theology is to be found in the practices of individuals and of "communities of truth" that honor the voices of those whom society has marginalized, clear spaces that allow meaning to emerge from a horizontal dialogue among persons of worth, and engage in acts of courage that transform the communities in which they exist. We are convinced that, as Jeremy Begbie has claimed, this represents "a restoration of God's original intention for us."[91] We believe our proposal represents a positive development from the prevailing propositional nature of modern theology.

However, if we were to end our discussion with what we have offered in the preceding chapters, little new ground would have been broken in our work. To be a truly "practical" theology, we cannot limit our discussion to the "theoretical" claims of the first section of the book. Our understanding of the role of the arts in enabling communities to engage in what we are identifying as practical theology began with our encounters with seven remarkable communities that were engaged in their own unique versions of practical theology that had been empowered by each community's use of a particular art form.

Therefore, the second part of the book is composed of a series of studies that investigate communities of truth around the world that have engaged in the kind of transformative practices through the use of one of the art forms that we are identifying as a practical theology of the arts. As we have analyzed these empirical settings, we have identified seven major themes that emerge from each to form the essential character of a practical theology of the arts. In this book, each of the seven themes is exemplified by one of the art projects analyzed for this study in the subsequent chapters we have chosen to call études. We recognize that the seven themes are also descriptive of what it means to be human in a much broader sense. We propose that a "practical theology of the arts"

- Is *"embodied."* No art form is purely conceptual in nature; each form of the arts gives some physical, visceral, or sensate form to concepts and ideas, allowing thought to be experienced as well as understood. Likewise, as practical theology, one is enabled to experience the holy through liturgy, prayer, or community, as well as through rational thought and doctrinal reflection. The complexity of interreligious relationships in Israel/Palestine is thorny enough at a conceptual and theological level, involving Jewish, Christian, Muslim, Druze, and secular claims and visions to mention but a few. When left at that level, it can be descriptive of hypothetical conflict with no real-life consequences and no *pathos*. But, when one experiences Cecilia Parsberg's documentary *A Heart from Jenin* the inherent conflicts of a war-torn region move from the hypothetical to the deeply personal, and the basis for a real hope for reconciliation is embodied in this very practical theological reflection. In this film, the bleeding heart of a dead child becomes the vehicle of the embodied theology of peace and hope her film develops.
- Has a *"face."* Theology is not practiced with people in general; theology is practiced face to face as one encounters another as an other and gazes into the claim to truth one experiences in the full personhood of that partner. It is in the face of the real-life, flesh-and-blood persons one experiences in a community of truth that one encounters the absolute other, whom we know as God. Likewise, when one handles the rough, bumpy fabrics that are woven into *arpilleras* and *cuadros* from Peru, one experiences no idealized view of Peru *in general*, but the claim to

truth of the real member of the "Women's Club" whose experience of the world—in all its messiness and meanness—is embodied in the vibrant colors and layers of fabric depicting the scene she has created from scattered and abandoned scraps of material with her own hands. The product one might purchase is that particular woman's experience and her world, made with her own hands.

- *Acknowledges the "voice" of those who had been silenced.* Many urban areas in the United States and elsewhere have become blighted by vandalism, abandoned and wrecked buildings, and "tagging" (a stylized form of graffiti that frequently identifies gang territories). Much of the despair that hangs over the neighborhoods of cities like Philadelphia is the emotional response to the lack of power to transform poverty, violence, and a culture of drugs and gangs. Residents of neighborhoods like Gray's Ferry feel like they have no voice. Professional artists have developed an innovative and extensive program that transforms abandoned and tagged buildings through the creation of murals that express the experience of each community of persons and their unique stories. Through the arts, the voice long-since silenced by oppression and the loss of identity has been restored to a community that had forgotten how to speak its word of truth. The transformation of the buildings pales in comparison with the transformation of a community when its members are truly heard to speech.

- *Is accomplished through "dialogue."* Little is more characteristic of being human than communication between persons. But dialogue is more than simple communication and is not restricted to the spoken word alone. Rather, dialogue is an attitude that permeates all aspects of a person's relation to herself and her reality. Dialogue requires partnership, respect of the other, intense and intentional listening to the voice of the dialogue partner that will hear her into speech, and a commitment to the process of the dialogue that will allow truth to emerge from the ways the partners deal with their shared subject matter and with one another. The dialectical character of this partnership is such that something new emerges from the committed intersubjective exchange of persons. The novellas of Eric-Emmanuel Schmitt (*Le Cycle de l'invisible*) are linked by humor and spiritual insight. But most of all, each story in the cycle is driven by the dialogue that takes place between its main characters—a dialogue that leads to transformation of relationships, of community, and of self. A practical theology of the arts is one that embraces dialogue and the dialectical process as the key to practices that transform meaning, truth, and the nature of the community and those who compose it.

- Proceeds from and is characterized by the *practice of theology* embodied through the arts. Such a practical approach lies at the heart of Catalan composer Jordi Savall's concert project "Jerusalem: The City of the Two Peaces." This concert does not present the history of the

holy city in an idealized, abstract, and artistic way but rather steps into and reenacts the multifaceted and conflict-ridden path of time in a thoroughly concrete fashion. By seeking personal contacts with musicians from the entire Mediterranean area—Jews, Muslims, and Christians alike—Savall formed the interreligious ensemble that since 2008 has toured the world with this extraordinary musical dialogue. As an expert in early music, he focused on the history of Jerusalem and tried to bring to life the emotions, dreams, and visions for the future expressed throughout centuries in folk music and poetry as well as in theological traditions evolving around the central axis of Jerusalem in the Abrahamic religions. Thus, he engaged in what Paolo Freire has called *conscientization*: a coming to consciousness about one's place in the world in such a way that one engages in practices within the community of truth and faith that transform both self and community in lasting ways. Savall's composition contained the voices of those whose identities have been formed in a shared city: a commitment to the practices of Jerusalem that was embodied by his culturally and religiously varied musical ensemble.

- *Clears a space* that facilitates the emergence and ongoing practice of a community of truth. Parker Palmer's seminal phrase describing the task of teaching is characteristic of a practical theology of the arts as well. The Playback Theatre and its various local manifestations have stripped the practice of theatre of most of its traditional pretensions. Elaborate sets and colorful costuming have been replaced by a bare set, some scattered (mostly acoustic) musical instruments, a handful of plastic milk crates and bar stools, and simple monochromatic clothing. The lighting and sound are basic. The script is nonexistent. All of the elements of traditional theatre that suggest claims to truth from the outside being imported to the receptive audience (what Freire refers to as the "banking method" of teaching) have been removed. What is left is an open space and an opening, receptive spirit that invites the voices and faces of the audience to share their own stories and nurtures the emergence of truth from that which is shared. Once one has committed oneself and one's community to the emergence of truth and the subsequent practices that truth demands, one of the most significant first acts one can perform is to remove those trappings of the expected and the mundane that block both this emergence and its requisite practices.
- Finally, a theology that is genuinely *committed to true transformation*. A practical theology of the arts is not content to think about the nature of God and the implications of that nature for human existence (nor does it believe that any other approach to theology does so). Rather, as the young philosopher Karl Marx suggested in the last of his "Theses on Feuerbach," the point is not to "interpret the world in various ways; the point is to change it."[92] This is the dialectic required by attention to praxis. When those who founded San Francisco's Axis

Dance Company made the decision to integrate dancers with a variety of handicapping conditions into every aspect of the performing company—from concept, through choreography, rehearsal, performance, and assessment—they did so with the intention of honoring the voices of persons who have traditionally been excluded from this form of the arts. The company is committed to the transformation of the common and public conception of the art of dance as well as opening a space where dancers who cannot walk or are wheelchair bound can begin to see themselves as dancers.

## INTERLUDE: A PAUSE BEFORE THE ÉTUDES

There is something serendipitous or "grace-filled" about our experiences with the communities we have analyzed in the following études. An encounter with the composer Jordi Savall occurred because Ruth's spouse is a scholar of early European music, leading to an encounter with Savall's powerful composition based on the significance of Jerusalem for the three Abrahamic faith communities that we analyze in chapter 9. The inspiration for chapters 4 and 5 came from two presentations delivered in a session of the Society for the Arts in Religious and Theological Studies during the 2007 American Academy of Religion meeting in San Diego, California. The focus of chapter 8 developed as Ruth met the filmmaker Cecilia Parsberg at a Nordic conference, where she presented her work. Thus, we came to discover the remarkable story she depicts of mercy and forgiveness within the horrors of present-day Palestine. Alan experienced the "unscripted" approach to theatre in chapter 7 when "True Story Theatre" led a plenary session of the Religious Education Association in Boston, Massachusetts, in 2007, utilizing a unique approach of developing spontaneous plays based on stories shared by members of the audience. The literary examples of interreligious dialogue presented in the short stories of French author Eric-Emmanuel Schmitt in chapter 6 was encountered in Ruth's academic discipline of Comparative Religion. Alan's daughter, a professional actress and lifelong dancer, introduced him to San Francisco's Axis Dance Company and the company's commitment to "physically integrated dance" that led to the topic in chapter 10.

In each case, a particular community allowed engagement with an art form to lead to transformative practice that humanized, liberated, and embodied the life of what Parker Palmer has called a "community of truth."[93] In each instance, we discovered a striking similarity of dialogical method that linked the practices of these communities with one another. None of the communities used art purely for the sake of art itself; nor was art regarded as a mere ornament added to the "real work" of theology or the discovery of "ultimate truth." Rather, in each instance an art form served as the means of engaging in the practices of faith, truth, and meaning that we have identified with the emerging field of "practical theology." It was only after identify-

ing the convergence of themes in these seven études that we began to make the connections with practical theology that led to our development of a "practical theology of the arts." We worked from our experience with the art communities toward theological reflection, not the other way around. This approach to creating knowledge bears close resemblance to Daniel S. Shipani's characterization of the case study method as used within practical theology.[94]

Each of the seven études can be read as an independent illustration of what the authors understand as a "practical theology of the arts." We have intentionally selected an "emergent theme" (persons familiar with the work of Erik Erikson will recognize this terminology) that is particularly significant in each of the études. But we have also taken care to represent the dialogical character of the theology we are proposing by bringing each of these emergent themes into dialogue with the remaining themes we have identified as characteristic of a "practical theology of the arts." We believe the intersubjective, dialogical, transformational, praxis approach to these études serve as a substantial introduction to ways a "practical theology of the arts" can move from yet another theoretical, propositional theological reflection toward an intentional "practice" of communities of truth and faith through the engaging power of the arts.

# Part II
# Études

# 4 Art as Community Practice
## Murals from the Voice of the Community

## A BRIEF BACKGROUND

What is now Philadelphia's "Mural Arts Program" (MAP) began in 1984 as one part of a citywide Anti-Graffiti Network. Mayor Wilson Goode devoted energy and money to ridding the city of the graffiti its artists called "tagging" as well as the gang territory marking it indicated. One of the first persons hired to head up this effort was a young graduate of Stanford who had been trained in the Los Angeles mural tradition inspired by Diego Rivera and WPA (Works Progress Administration) artists like Thomas Hart Benton. Jane Golden was asked to redirect the energies of the "taggers" from what the city leaders considered destructive graffiti to constructive murals.[1]

In 1996, the Mural Arts Program was moved from a "feel good" program with little definition to a home in the Mayor's Office of Community Services. The mission of the program changed from eradicating urban blight to using the arts to transform individuals and the communities in which they lived.[2] The Mural Arts Program worked with the Department of Human Services, the Philadelphia School District, the Department of Corrections, and numerous additional government agencies. Its programs included the "Big Picture," which offered after-school and summer community art instruction that were then incorporated into the murals; "Mural Corps," in which high school students learned basic job skills, communication skills, and leadership skills; ArtWORKS! and ARTscape, two programs directed toward truant and delinquent youth referred to MAP by the Department of Human Services and the court system; and the "Healing Walls" project that brought together prisoners—many of whom are "lifers" in maximum security units—community members, victims of crime, victim advocates, and artist mentors trained in community education.[3] As one person associated with MAP has claimed:

> In some ways, MAP has become more about changing lives than about art. Don't get me wrong: the art we're producing is still beautiful and inspiring and important to us. But the changes I see in the people we work with are also beautiful and inspiring and important. I've seen art

provide comfort to troubled lives. I've seen art inspire people to change and do better. I've seen art become a way to rebuild community. And I've seen art serve as a tool of redemption.[4]

One mural entitled "Forgiveness" was the result of a 2003 shooting in Southwest Philadelphia precipitated by an argument over an Allen Iverson basketball jersey or jealousy over a girlfriend—no one is really sure. Nineteen-year-old Kevin Johnson was paralyzed in the attack. Johnson's mother, Janice Jackson-Burke, was driven by revenge, until her injured son encouraged her to forgive the attackers: "I don't hate them," he said a couple of years later. "I found it in my heart to forgive them."[5] When one of the assailants was released in 2006, Golden arranged for the victim and the attacker to meet and reconciliation began. The mural that reflected Johnson's attitude of forgiveness involved a collaboration of lifers at Graterford Prison; juveniles at St. Gabriel's Hall and the city's House of Corrections; women in a North Philadelphia shelter; students from MAP; and residents of Johnson's neighborhood, including his family members. The design for the mural emerged from group discussions about violence, revenge, drugs, hopelessness, forgiveness, and reconciliation. Some of the images were rendered in the prison on parachute cloth, which was later attached to the wall on site. Eric Okdeh, the professional artist responsible for the mural, did not develop the design unilaterally; he worked collaboratively with the stakeholders in the community. Johnson died of complications from his injuries in the midst of the discussions that led to the completed mural. The images in the finished product (which was dedicated in October 2007) reflect the community's response to Johnson and the attack that injured him—but even more—its response to Johnson as a person and his attitude of forgiveness.[6]

## HONORING THE VOICE THROUGH ART

Among the insidious effects of poverty, marginalization, and isolation in major urban areas like Philadelphia is the stifling sense that one's voice will never be heard over the din of traffic, violence, and despair. Each individual has an inherent need to speak his claim to truth and to have others respect her enough as a person to hear what she has to say. The experience of growing up surrounded by poverty; walking down streets that suffer from disrepair and governmental neglect; living with the constant threat of violence, drugs, and prostitution contributes to a sense that one will never break free of that environment. The environment that characterizes far too many neighborhoods is one in which the voice of the individual as well as the collective voice of the community itself can be ignored and silenced.

Philadelphia's Mural Arts Program honors the voices of the persons who participate in its comprehensive approach to community organization, dialogue, and shared development. The murals that transform the walls of

abandoned and damaged buildings into statements of a community's self-expression witness to an intentional decision to listen carefully to the voices of those who participate and hear them into their own speech.[7] Once the persons in a neighborhood have committed themselves to participation in MAP, the program's leaders establish regular meetings to listen to the collective—and frequently conflicting—discussions of the problems, frustration, hopes, and dreams that constitute life in that particular community. The intentionality of regarding persons who have had few receptive dialogue partners throughout their lifetimes as persons whose opinions and voices are valued validates the residents as persons.

The first obstacle the MAP team must overcome in each community is the thick level of mistrust that can characterize persons in such communities. When the members of a MAP team are artists, outsiders, and those who partner with governmental agencies, the levels of mistrust are palpable. By operating in a way that is consistent with the *conscientization* approach of Paolo Freire in Brazil, teams led by people like Jane Golden enter into partnership with the residents of a neighborhood that honors the voices and the experiences the residents bring to the dialogue. The MAP teams' commitment to hearing what is being said by their dialogue partners from the neighborhoods establishes a relationship that can "clear a space where the community of truth can be practiced."[8]

## FROM GRAFFITI TO MURALS

The claim has been made that graffiti arose as a protest against billboards and commercialization in the same way that Andy Warhol's *Brillo Soap Pads* and *Campbell's Soup Cans (Tomato)* used the iconic work of the advertising and media industries to protest the meaninglessness of ubiquitous commercial images. Frederic Jameson claims that "Andy Warhol's work in fact turns centrally around commodification," which Warhol then uses as "powerful and critical political statements."[9] Golden supports the connection between Jameson's analysis of Warhol's work and how graffiti functions: "Each draws from the shallow passions of consumer society and the advertising that derives from it. Both art forms emphasize words and distinctive letter forms as pictorial elements."[10] It is the sense of marginalization that drives "taggers" to target "offending" billboards and the culture of branding in poor urban neighborhoods like those in Philadelphia.

In addition to this act of protest, there is the unmistakable use of graffiti to express gang identity and the marking of territory. Another function of graffiti has been the painting of memorial walls to honor those who have been killed in gang related or other forms of violence.[11] As Golden states, "In impoverished neighborhoods, people see graffiti as a symbol of hopelessness—a manifestation of the forces threatening their survival. They have to worry about their kids getting shot, and the fact that quite literally every

exterior surface is covered with graffiti is a reminder that their neighborhood is out of control."[12] One reason graffiti has become such a prominent feature of deteriorating urban areas is that graffiti artists revel in doing something dangerous and secretive.[13] "If it's graffiti, it's got to be painted with spray paint, and not just any spray paint—it's a point of pride to steal the paint."[14]

Even though MAP began as a governmental effort to beautify the urban environment and to neutralize, if not reverse, the effect of the gang identity city officials associated with graffiti, the program has become a form of public art that attempts to reflect the *voice* of those in the Philadelphia communities where the murals have been developed. Where graffiti "tagged" commercial symbols with a dramatic "NO!" and protested abandoned buildings, violence, and poverty with visual counterclaims, the murals developed by Golden and her associates transformed ugliness and neglect with beauty and hope. As Brendan Lowe has pointed out, the murals created by MAP are pro-art, not anti-graffiti.[15] "A beautiful landscape mural can be a sign that people care and that things can change."[16] The murals produced through MAP employ some of the nation's best-known mural artists, many of whom began their careers as "taggers" recruited by Jane Golden and others with MAP. From the beginning of the organization, MAP has taken the attitude that "they as artists simply facilitated the community's mural-making, claiming no pride of ownership."[17]

## COMMUNITY ART, RATHER THAN PUBLIC ART

In his foreword to *Philadelphia Murals and the Stories They Tell*, Timothy W. Drescher emphasizes that early U.S. murals were an example of public art, in which an artist like Thomas Hart Benton would create artwork that reflected a public theme; these works would then be installed in a public place like a post office or a public library as a top-down gift from the government to the community. MAP represents what Drescher calls a "democratic creative process" in which the "just plain folks" of a community "express themselves and have a say in what they wanted to see every day in their neighborhoods."[18] In Drescher's distinction, public art comes from a recognized artist from outside the community and reflects public or national themes. On the other hand, community art like that represented by MAP emerges from intentional dialogue within communities and neighborhoods and reflects the experience of those within each particular community by honoring the voices of the "just plain folks" whose experience is depicted in the murals. Drescher continues:

> In seemingly endless community meetings, MAP demonstrates respect for people who are largely excluded from government and traditional vehicles of public expression such as the mass media. Nevertheless, these people know what they believe and have strong opinions about

what should (and should not) be represented on the walls of their communities. MAP's greatest strength is in knowing how to listen during sometimes raucous community meetings, derive useful unifying kernels from often vaguely stated wishes, and turn them into positive visual images worthy of wall-scale public expression.[19]

The website for MAP includes links for a community that wishes to request a mural that results in a seven-page application packet. The instructions for the packet indicate the extent to which the community and its constituents must be included in approved projects: there must be evidence of community support for the mural and a written commitment to participate in its rendering; those applying must commit to at least two community meetings with MAP staff, artist, and neighbors living nearest the wall chosen for the project; the application must justify the significance of the project, artistically, but also symbolically for the community; the applicants must commit to maintain the property adjacent to the wall; and the applicants must "sell" this as a creative, important, and innovative project.[20]

## PEACE WALL, GRAY'S FERRY

In 1997, the South Philadelphia neighborhood known as Gray's Ferry was the site of nationally publicized racial unrest. Jane Golden and Lillian Ray began holding a series of community meetings with sparse attendance and little energy. Then, they began knocking on doors and speaking with children and adults on the streets. They seemed to be competing with two opposing community groups: one largely Caucasian, the other predominantly African American. Mutual animosity seemed to be the only thing the two groups had in common. Through the tireless effort of the two MAP leaders, a new group called "Grays Ferry United" was formed with the mission of bringing the neighborhood back together. The idea of a mural as an answer to the neighborhood tension seemed shallow to many, but Golden and Ray pressed on with meeting after meeting.

Members of the community met to discuss the issues that led to the tension. Some shared images that symbolized their frustration and anger; others brought ideas and designs that demonstrated their hope for a renewed community. Some wanted explicitly religious imagery. Others suggested more metaphorical images. As the dialogue progressed, the idea of "lending hands" to one another began to emerge as a shared theme; heads began nodding in agreement. In the midst of the dialogue, Ray suggested a mix of hands—young, old, multiple colors—as a visual image that seemed to represent what she heard from the participants.

When the group met again a couple of weeks later, Golden brought several sketches, based on images that emerged from the dialogue from the previous meeting, and solicited the input of the group. "I see murals as a

sort of autobiography of the city," she said. "Murals provide people with a voice. It's their statement, their history, their future."[21] The residents of Gray's Ferry loved the idea of the hands because it symbolized the diversity of the community as well as the amount of hard work that would be required for the troubled community to reconcile. Photographs were taken of numerous hands from those in the neighborhood. Golden, Ray, and others manipulated these images into an artist's design then projected the design on a wall, 22-feet high by 40-feet wide. The large-scale projected image was sketched on the walls of the building and then painted by a partnership that included Golden, Ray, their coworkers from MAP, and members—young and old, black and white—of the neighborhood. Peace workshops were held with neighborhood children of all races, and these workshops resulted in three mini-murals the children painted in area recreation centers. Each of the mini-murals was the end result of the same kind of interactive, participatory community process as the larger community mural; each mini-mural became a visual expression of the shared experience of transformation characteristic of that recreation center and its shareholders. By regarding the voices shared in these almost endless meetings and dialogues, the finished product became a visualized reflection of those voices and the persons who shared them.

When the mural was finished in December 1997, the entire community gathered for a formal dedication of the project. The juxtaposition of the diverse hands with a white dove and the words "Blessed are the peacemakers, for they shall be called the children of God" led Ray to declare, "The mural was a symbol of the love that was here in Grays Ferry, as opposed to the hate. It's utopia."[22]

## HEALING WALLS

Crime is an ever-present concern in many urban areas, and Philadelphia is no different from its peer cities. As Maureen O'Connell states: "Philadelphia is not always a city of brotherly love. It recently registered the highest number of homicides in the nation."[23] Through MAP programs like ARTscape! and artWORKS, dozens of young offenders have been led to use art to reflect on the lifestyle and personal choices that had put them in the corrections system. A part of both programs has been bringing some of the students to Graterford Prison, one of the largest maximum security prisons in the nation, where they engage in dialogue with inmates as well as create collaborative art together.[24] In 1992, the long-standing program led to an idea: the creation of a mural that would bring together inmates, youth in the various MAP programs, victims of crime, and the communities that had been harmed by the actions of the inmates.

The idea was not without its problems. There was fear and distrust throughout the attempted partnership. Kathy Buckley, director of victims' services for the Office of the Victim Advocate, liked the idea of bringing together these groups. For victims or their families, such contact could be

another step in their healing. "It's hard to see offenders, some of whom have committed heinous crimes, are also human beings," she says. "And for offenders, it's seeing 'Oh. We're not totally hated by these people.'"[25]

The inmates sketched, detailed, and painted the images they had developed in collaboration with the youth and with MAP artists on parachute cloth and similar fabrics in a process similar to the one used in the "Peace Wall" in Gray's Ferry. Under the supervision of prison officials and case workers, the leaders of MAP engaged a broken collection of hurting, dehumanized persons in an intentional process of listening to the voice of the other that resulted in the creation of a statement of mutual transformation. The finished fabric was then attached to a wall outside the Walls with gel mastic and sealed.

The emotional limitations of the project took a bit more work to solve than the physical ones. The original design met the needs of the inmates, but the families of the victims and the members of the community where the "Healing Wall" would be set felt the design only told the story from the perspective of the inmates—and rightly so. The solution was a second design process and a second Healing Wall, this one symbolizing the victims' journey. The continuous dialogue in this developing community led inmates and victims to realize that both communities had been guilty of objectifying the other. David DiGuglielmo, superintendent of Graterford Prison, had his doubts about the project when it began. But following the completion of the murals, he said, "I don't think sitting in a room and listening to a bunch of offenders talk does a lot of good, but this added a whole new dimension. The artwork is a medium to helping let down barriers. Art and creativity brings things out of people they may not be aware of."[26]

But something still seemed unresolved to Golden: what about the youth from the detention centers? She and others on the MAP leadership team organized another dialogue group that targeted this constituency. The result of this effort was the creation of the "Balanced and Restorative Justice Project," which gave this set of youth a venue to express what they experienced in their dialogue on the Healing Walls project. A third mural project, designed in *this* program, was completed a few months later, in 2005.[27]

## EVERY ONE BUT RIZZO

Over 25,000 citizens of Philadelphia have been involved in MAP in its two decades of existence. There are more than 2,500 murals in virtually every urban area of the city, but primarily in the more troubled neighborhoods—more murals than any other city in the world.[28] Some murals have been lost when buildings were torn down, but most survive. The themes of the murals are as diverse as the communities that have produced them. Some have offered tributes to local social, political, sports, and arts heroes like the basketball star Dr. J, Broadway star and activist Paul Robeson, and opera figure Mario Lanza. Some murals are metaphorical reflections on values like hope, peace, and love. Others have produced romantic visions of natural

landscapes that differ significantly from the squalor of the slums. Still others resulted in abstract designs. For the most part, the themes of the murals arise from within the neighborhoods that sponsor them and reflect the voices of those engaged in designing them. Even those that are funded by foundations or governmental agencies work with the local artists and the contributions of the citizens where the mural will be painted.

During Maureen O'Connell's presentation on MAP during the Society for the Arts in Religious and Theological Studies meeting (a part of the November 2007 AAR meeting in San Diego), a member of the audience asked about vandalism to the completed murals. The success of MAP had not resulted in eradicating crime, drugs, or gang activity—and the graffiti that had long symbolized this malaise was still a problem in the city. Would those who seemingly held little value for public property not simply reclaim their territory and *tag* the murals?

O'Connell reported there has been little vandalism to the completed murals in the 24 years of MAP. In fact, the mural that has been vandalized more frequently than any other over the years is the tribute to Frank Rizzo, the controversial former officer, police commissioner, and mayor, who grew up in the South Philadelphia neighborhood called the Italian Market.[29] While Rizzo was an important figure to the citizens of this particular community and its Italian residents, memories of his reign as head of Philadelphia's police as well as City Hall still draw the ire of those victimized by his domination of Philadelphia politics.

Golden and others believe that the program's commitment to engaging the community in the development of the murals has given the people who live in the neighborhoods *ownership* in the finished product. Since the faces in the images reflect the children and the elderly from the neighborhoods and have grown from a collaborative approach to community organization, the neighborhoods see the murals as expressions of their hopes and dreams and the pride in their histories. The murals embody the voices of the people who participated in the program. Applicants for murals are required to make a commitment to keep up the area around the murals, and this commitment has been, for the most part, followed. In fact, many murals have spun off the development of community-designed gardens, which have been maintained meticulously by the residents of the neighborhoods. Bringing beauty and meaning into the block has resulted in a renewed commitment to the neighborhood; the community organization that has accompanied the mural projects has resulted in hope and transformation. Where trash-strewn lots and bare walls once stood, inspiring murals now gleam.

## MAP AS PRACTICAL THEOLOGY

Philadelphia's Mural Arts Program has used the arts in a creative way. Rather than art functioning as an elite, conceptual, *l'art pour l'art* MAP

has engaged in the collaborative work of community transformation using murals as both a means of facilitating dialogue and the method of expressing the product of that dialogue. The dialogical character of the process utilized by MAP provides an excellent illustration of how a practical theology of the arts functions in a community.

Paul Ballard and John Pritchard have identified four models of the relationship between theory and practice that characterizes practical theology: practice as *applied* theology; dialogue between tradition and contemporary reality (what they identify as the critical correlation or hermeneutical model); a praxis model that regards faith as *transformative* activity; and truth that is found within a community of shared meaning that can lead to a growth in community wisdom (a habitus or virtue model of practical theology).[30] Practical theology sits at the intersection of the classic theological task of "faith seeking understanding" and a faith that engages in action to join in partnership with God in the transformation of persons and of the world.[31] A practical theology of the arts provides an approach to overcoming the dichotomy between theory and practice that remains from the effects of modern theology by engaging the "affective heart" rather than the "cognitive mind." Ballard and Pritchard claim that it is the nature of the arts to force the "participant to work in new ways and therefore to be at the same time clearer in what she wants to say and also more opaque in allowing the art form to have its own communicative power."[32]

It is the nature of the arts to "bring one up short" and to shock one's prejudices by the communicative power in the sheer otherness of their claim to truth. Philadelphia's Mural Arts Program has drawn upon the ability of larger-than-life, yet fully true-to-life murals to offer a counterclaim to the sense of abandonment and indifference that can characterize blighted urban neighborhoods. Emmanuel Levinas states that it is impossible to remain indifferent when one truly regards the face of the other because of the summons the other makes to one's own claim to truth.[33] The murals produced by the intentional process of dialogue among the residents of each neighborhood and the cooperative production of impressive art that reflects the dialogue can result in a new kind of community wisdom and transformed ways of living together that characterize the fourth of Ballard and Pritchard's models of practical theology.

Among Paolo Freire's initial insights was the distinction he drew between what he called the banking concept of education and a problem-posing education.[34] In the banking concept, the teacher serves as the active agent who deposits information into the passive student, thereby objectifying him or her. The direction of the teaching learning process is a top-down hierarchy in which value is conferred by the only subjects involved in the process. Only that which the teacher deems valuable is taught; what the learner knows or understands is not valued.

In problem-posing education, teacher and learner engage one another as fellow subjects who each enter into dialogue around a shared subject matter,

with a shared goal that new knowledge about the subject matter will emerge from the dialectic. He states:

> Through dialogue, the teacher-of-the-students and the students-of-the-teacher cease to exist and a new term emerges: teacher-student with students-teachers. The teacher is no longer merely the-one-who-teaches, but one who is himself taught in dialogue with the students, who in turn while being taught also teach. They become jointly responsible for a process in which all grow.[35]

In MAP, professional artists work on every mural that is produced. Most of these artists have had a studio career and bring a national reputation to the process, but they do not impose their ideas upon the community. The work on the murals is collaborative from the beginning of the process to the dedication of the finished product. The design of the mural emerges from an intentional dialogical process in which those in the neighborhood bring their own subjectivity to the process and share their fears, their sorrows, as well as their hopes and dreams. The artists and other members of MAP involved in the process are trained to practice active listening skills and hear the others into speech.[36] Once a concept, an image, or a theme has emerged from the dialogue, the artist returns with sketches that embody what the initial dialogue has produced, and the dialogue continues.

The design process is a horizontal one, as Freire phrased it, rather than a vertical one characteristic of the banking concept of education.[37] The artists, MAP volunteers, and community members become collaborators, codesigners, and partners at every stage of the process of producing a mural. They work together in sketching the outlines, mixing the paint, following the grid laid out by the artist, and painting the walls. In the process, each person is—ideally, at least—valued and humanized. The voice of each participant is heard and honored.

The first task of a practical theology of the arts is to establish a relationship of dialogue within a community that facilitates the emergence of the collective voice of the community formed by the MAP partnership. True dialogue requires an attitude of intersubjective relationships, of mutuality, and of intentional, humanizing listening to voice of the other. A practical theology of the arts cannot be a top-down, hierarchical imposition of authoritative knowledge from on high without reducing the learner to an objective status. Only the kind of horizontal, dialogical model of problem-posing education that Freire developed can succeed in treating each participant as a subject and achieving humanization.

The murals produced from this dialogical approach are representative of what Freire called "generative words."[38] Generative words are words that persons in a community use to name their world and make sense of their experience. Freire engaged in dialogue with the residents of communities, worked alongside them, ate with them—and listened to their voices. In the

long-term dialogue he established with these communities, generative words that reflected the consciousness of the people emerged. Freire organized the generative words into a series of generative themes, which were illustrated by photographs or paintings that represented the themes. Freire led the people in reflecting on *their* experience, rather than learning the experience of the Brazilian Education Ministry and its educational experts. The continued dialogue on these shared experiences led to the emergence of actions designed to transform the situations of oppression and dehumanization the communities had experienced.

The MAP experience engaged in a similarly dialogical relationship that listened for the generative words and themes that were being used over and over again by the people. The long process also allowed what was designed to be the words and images and concepts that named their world. One reason there are over 2,500 murals all over Philadelphia and no two are copies of others is that each mural was an expression of the generative words and themes unique to each community that produced it.

What began as a simple effort to clean up graffiti in Philadelphia has become an independent community organizing, educational, transformative art movement in the city. Wonderful community works of art have resulted from MAP, as the thousands of tourists each year can attest. But the success of MAP has been the action that has been taken to transform the neighborhoods of Philadelphia and to redeem thousands of taggers, criminals, victims, poor people, and homeless and hopeless residents of these communities. The number of children and youth who have used what they have learned in MAP to finish school, attend college—with many attending art school—has been impressive. So has the effect of youth taking up a paintbrush instead of taking up a gun. When those who have worked on the murals or participated in one of the several community programs generated by MAP see the works of art, they recognize that they have been changed as well as the neighborhoods. The real work of MAP has been bringing those who live in these neighborhoods to consciousness that they are persons of worth, that their voices matter, and that they can engage in meaningful action in dialogue with their emerging constructions of the world.

A practical theology of the arts brings members of communities into critical reflection on their own actions that allow them to transform their experience and the world in which they live. Conscientization is not just about changing what goes on inside one's mind. Rather, conscientization engages in those practices that actively change the realities of the world in which one lives. Philadelphia's Mural Arts Program helps to "create a space in which the community of truth is practiced."[39] Only in such a community, and in such a space, can persons come to a consciousness that is more than simply cognition or understanding—it has become transformative action.

Hans-Georg Gadamer's hermeneutical philosophy provides a helpful discussion of intersubjectivity as a precondition for praxis. When the artists and MAP staffers take the community members with whom they work seriously

as persons and as real partners in the projects on which they work they, at least at one basic level, participate in the process of humanizing them—for many, for the first time in their lives. Living in these neighborhoods is tough, and it can suck the personhood right out of an individual. Treating the MAP participants as subjects—as persons—allows them to find their voices once again. Praxis works through an intentional dialogue among fellow subjects engaged in reflection on a shared subject matter. Praxis is possible only when the partners in dialogue treat one another as persons of worth and as ones who speak their own truth. The community of truth of which Palmer speaks empowers the partners in the dialogue to listen carefully to the other's claim to truth. What emerges from the dialogue is never the product of one voice alone; a new, intersubjective voice emerges out of the dialogue. In Philadelphia's Mural Arts Program, a dialogical community in which truth is practiced and voices are nurtured has replaced the Cartesian subject-object dichotomy. Each of the 2,500 murals is a voice that has been honored and a community that has been heard.

# 5   Fabric Arts in Peru as Identity

The *cuadros*—embroidered and appliquéd fabric wall hangings—produced by collectives of women in the shantytowns that surround the capital city of Lima, Peru, present vividly colored expressions of the work of transformation being undertaken in communities like Pamplona Alta, Peru. Barbara Cervenka, who first encountered the effects of the *cuadros* during a visit to Pamplona Alta in 1989, describes *cuadros* as "a wonderful combination of collaboration, creativity, and an ingenious use of simple materials to respond to difficult and harsh life situations."[1] Cervenka created an exhibit entitled "Cuadros of Pamplona Alta: Textile Pictures by Women of Peru" that introduced these art works in gallery settings in the United States.

Similarly, Rebecca Berru Davis's exhibit she called "Picturing Paradise: Cuadros by the Peruvian Women of Pamplona Alta as Visions of Hope" was shown on the campus of the Dominican School of Philosophy and Religion in Berkeley, California, in 2006. This exhibit featured the work of two of the cooperatives—Compacto Humano and Manos Ancashinas— that place "emphasis on the women as artists and the way their art reflects a profound sense of resilience, spirituality, and hope despite the harsh conditions of their lives."[2] Davis was the recipient of a 2006 Luce Grant from the Society for the Arts in Religious and Theological Studies and presented the results of her work in Peru to the society's meeting in San Diego in November 2007.

Both exhibits, along with others at galleries of the Princeton Theological Seminary, Wesley Theological Seminary, and other academic institutions in the United States, have brought attention to what the United Nations has declared a "human disaster area."[3] The development of the collectives that produce *cuadros* has begun to give the women of this ring of slums that surround Lima an income where little existed before. But, even more importantly, these textile products have begun to make the women who produce them aware of their own voice that had been silenced by cultural traditions while helping them establish a sense of personal identity.

## "A HUMAN DISASTER AREA"

Pamplona Alta is one of several *pueblos jovenes* ("young towns") that have sprung up as a result of what has been called an "invasion" of persons displaced from the countryside of Peru. In stark contrast to the well-watered coastline, complete with skyscrapers and sufficient infrastructure, the *pueblos jovenes* were settled quickly on dry, rocky, dusty land that had been abandoned by absentee landlords or ignored by the government. "You would drop a spoon and it would be swallowed up by the sand," said Hilda Quintana.[4] As Simone Francis states, "there isn't one blade of grass to be seen."[5]

Taking advantage of a general lack of police presence on the weekends and during holidays, entire communities of squatters "invade" a selected plot of land as a single unit and hastily erect huts made of *esteras* (a rough, woven straw mat material) and pieces of cardboard, plastic, and corrugated metal scavenged from nearby garbage dumps.[6] Since many of the invasions have occurred on civic and religious holidays, these "young towns" are frequently named in honor of a saint's day close to the day the invasion begins or for a political leader from the nation's past whose accomplishments occurred near the date.[7] It is estimated that nearly one half of Lima's six million-plus residents (roughly 30% of Peru's total population) live in one of these shantytowns. Pamplona Alta alone is home to, by some estimates, up to 300,000 persons.[8]

Pamplona Alta has virtually no electricity, no water supply, and no sewers. Trucks from the city bring water to fill large barrels from which families draw for their needs.[9] Unemployment in the village has been as high as 80%. The residents of Pamplona Alta are among the 50% of Peru's population that live in poverty; 25% of that population average less than $1 a day.[10] Not surprisingly, street gangs have developed quickly, bringing with them the expected issues of crime, drugs, and violence.[11] Volunteers who have brought much-needed medical care to the area report "loads of street gangs that use football (soccer) as an excuse to start fights. Many boys in gangs here [...] some with guns, are only 15 or 16 years old, and will attack others just because they are on a different football team."[12]

The squatters or invaders who created Pamplona Alta around 1970 came as a part of an identifiable migration pattern characteristic of Peru's recent history. A high percentage of these invaders originated in either Peru's *selva* (the Amazonian jungle region of the country) or the highlands of the Andes (known as the *altaplano*.) Both of these locales are featured prominently in the *cuadros*. Some left their homelands because of the disappearance of adequate farmland while others left because of a lack of employment options. Some were driven away by the increasing violence spawned by battles between the leftist guerilla group the "Shining Path" (*Sendero Luminoso*) and the right-wing military. Others have gravitated to Lima in hopes of economic improvement.

The end result has been the displacement of entire towns and villages all over Peru and their resettlement in *pueblos jovenes*.[13] Sociologists note

that a unique feature of the "invasions" has been that the inhabitants rarely moved to the new towns as individuals. Rather, groups of migrants left their villages together and moved en masse into the new territories as collective units—creating a sense of regional identity that is bilingual and bicultural— a marked difference from the relative homogeneity characteristic of the cities. These invasions were composed of groups of persons with contacts, social roles, and strong cultural and family ties.[14] Pamplona Alta is home to persons who speak Quechua or Aymara languages rather than Lima's dominant Spanish.

Once a village identity was established in towns like Pamplona Alta, sub- sequent migrants from those same villages made their way to where their *paisanos* had set up their huts. Henry Dietz has commented on the charac- teristic of these culturally similar groups to gather themselves into social and political organizations that can advocate for empowerment for persons who are otherwise denied a base in the political system of the capital city.[15] This emerging organization has, over the years, resulted in many of the residents being given title to their land, allowing them to gain credit.[16]

## MARGINALIZATION IN PAMPLONA ALTA

The people who live in Pamplona Alta and their sister "new towns" are clearly marginalized by the crushing effects of poverty and the lack of any significant infrastructure. But there are additional factors that make this marginalization more acute.

Since colonial times, the city of Lima has been the central "primate city" of Peru.[17] According to sociologists, the centrality of Lima was

> so significant that persons committing crimes were often punished by exiling them from the capital for various periods of time; the farther away, the worse the penalty. This notion still underlies much of the cul- tural concept of social value in Peru today. Everyone living outside of greater Lima is automatically a provincial (*provinciano*), a person defined as being disadvantaged and, perhaps, not quite as civilized as a *limeño*.[18]

Thus, those who settled Pamplona Alta and similar new towns—who came to Lima from the rural areas of the country—have been considered *proven- cianos* even after moving to the outskirts of Lima. The stereotyping of those from the provinces as persons of lower intelligence, sophistication, educa- tion level, and social value has deep roots in Peru's colonial past.

The relative isolation of Pamplona Alta from nearby Lima (whose sky- scrapers can be seen through the urban haze from the slum's high elevation) has led to cultural solidarity within Pamplona Alta itself. Families that were neighbors in the *selva* built their huts as neighbors when they moved to the new town. The rather homogeneous communities within Pamplona Alta still

communicate with one another in Quechua and Aymara.[19] Many residents of the town never learn Spanish, which is the language of commerce, social roles, and political influence in Lima. The tendency toward cultural identity in these towns extends to dress, which still favors the fabrics, colors, and designs characteristic of the *selva* and the *altaplano*. These factors tend to further isolate the residents from access to power and acceptance.

The women of Pamplona Alta face a cultural struggle common in traditional cultures around the world: patriarchy. The work of these women has been devalued in Peruvian society.[20] Simone Francis claims,

> Most mothers share one room with there [*sic*] children, and cook and eat all in the same room. Some even have seven children, and must share the same bed. A lot of young women (15–16 years old) have children to their male family members. An example of this is perhaps an uncle getting so drunk that he forgets his relation to his niece, and rapes her. He may not even remember what he did when the morning comes.[21]

Barbara Cervenka states that

> women often shoulder both the burdens and responsibilities of the society. Their homes are usually without plumbing, water, or electricity and provide little protection against the cold, wind, or damp. Most of the day is spent providing for basic necessities, cooking, washing, child care. Their constant battle against hunger and illness consumes much of life.[22]

When the men find work (with an 80% unemployment rate, this is rare) it is the women who are left to defend the neighborhoods when the police arrive to try to evict the squatters. The women make most of the trails through the constantly expanding town as they carry water from central storage barrels, scavenge for food, and gather firewood from among the refuse that litters the slums.[23] Paths develop from these trails; streets from the paths; and, as new huts are hastily assembled on the streets, new trails, paths, and streets appear.

Spousal abuse is common. Skin diseases; stomach problems; chest, throat, and lung infections; and tuberculosis are common medical complaints. It is rare to see a woman in Pamplona Alta who does not have several children.

## CUADROS AS TRANSFORMATIVE WORK

The *cuadros* produced by the women of Pamplona Alta are similar in form to the *arpilleras* that "originated in Chile, where women political prisoners who were held during the Pinochet regime used them to camouflage notes sent to helpers outside."[24] Because the Chilean authorities considered these colorful fabric weavings to be nothing but "women's work," the banned messages hidden inside them were never discovered.

There are significant distinctions between *cuadros* and *arpilleras*. First, the word *arpillera* is a literal reference to burlap or jute, a coarse loosely woven material that is used as the backing for the fabric art itself. Most *cuadros* are backed by a simple cotton fabric. Both use a variety of salvaged scraps of fabric that are appliquéd to this simple backing.[25] However, the *arpilleras* from Chile, which began appearing in 1974–1975 shortly after the beginning of Augusto Pinochet's brutal repression, frequently took their "scraps" from the clothing left behind by those who had been kidnapped and murdered: the *desaparecidos*.[26] *Cuadros* are more typically created from random pieces of material found among debris from the neighborhood.

More importantly, Chilean *arpilleras* have been intentionally political and ideological, depicting scenes of resistance, guerilla warfare, and demonstrations against a brutal political regime. The women who were responsible for the Chilean products were known as *las madres de los desaparecidos* (Mothers of the Disappeared); their fabric work was a form of protest and a cry for justice. Isabel Allende describes the work of the *arpilleristas*:

> In these hard circumstances, a unique form of protest was born: the *arpilleras*, small pieces of cloth sewn together, like primitive quilts. Each one of these modest tapestries narrated something about the misery and oppression that the women endured during that time. With leftovers of fabric and simple stitches, the women embroidered what could not be told in words, and thus the *arpilleras* became powerful forms of political resistance.[27]

By contrast, most of the Peruvian *cuadros* present more nostalgic themes. They romanticize previous lives in the *selva* or the *altaplano*, illustrate the joys of village life, express the colors and energy of the marketplace, or share the solemnity of a religious festival. As Michael Meyer and Michael Smith suggest, *cuadros* are "perhaps a subliminal compensation for the day-to-day scarcity of the shantytowns."[28]

## HEARING INTO SPEECH

The Peruvian textiles are romantic, but they are not politically or socially silent; they depict the "social problems facing their community as well as the ways in which women have been struggling to improve their communities."[29] Barbara Cervenka calls these works of art "heroic texts of courage, solidarity, and survival" that serve as a "collective voice for those who [. . .] work to create a future for themselves and their children."[30] In her discussion of practical theology, Charlotte Caron echoes Cervenka's description of the work of these Peruvian women by claiming that

> Feminism seeks healing from personal pain and social injustice especially as it relates to women, transforms values toward community,

equality and inclusion, advocates the free and public participation by
all in decisions that affect their lives, discovers and affirms the goodness
of creation and ourselves as women and finds a new politic of gender
relations.[31]

The collective voice represented by the Women's Clubs in places like Pam-
plona Alta presents the primary theme of a practical theology of the arts for
this chapter: Nelle Morton's claim that women's communities can serve to
"hear" one another "into speech."[32]

With the daunting effect of unemployment in Pamplona Alta, many
women in the town have banded together into collectives called *tallers* or
"Mother's Clubs." Many of the clubs are named after the dates of the inva-
sions that began the villages. Some have been named for heroes from Peru's
history—especially those who led the country toward its independence from
Spain. One such Mother's Club is the 50-member "Michaela Bastidas"
group named for a Peruvian woman who led a rebellion against the Spanish
in 1781.[33]

The Mother's Clubs in Pamplona Alta began when a German artist
introduced Chilean *arpilleras* to several women of the pueblo.[34] Luzinda
Florindez, a member of the "Michaela Bastidas" group, says, "We wanted
to do something to help ourselves. We couldn't afford to sit around with our
arms crossed."[35]

A *taller* is a multipurpose organization. On the one hand, it serves as a
workshop where the women of Peru create the *cuadros*. Much of the fabric
used in these artifacts has been found by scavenging for discarded scraps of
material; some from the ubiquitous garbage dumps; and, more frequently,
from the volumes of litter encountered in the slums. Just as the huts in which
the women live have been assembled from trash found on the streets and
in the dumps, the raw material from which the *cuadros* have been made
has been the detritus of the populace. Much of the work of a *taller* is spent
gathering material, sorting it by color and texture, sharing the simple cot-
ton backing material, providing sewing tips and artistic suggestions, and
providing needles and thread for the work of assembling the textiles. All of
the women share in this community work. A *taller* has no formal organiza-
tion—no officers are elected, and no one assumes supervisory status. Any
woman who expresses interest and commits herself to the shared work of
the club may participate. When persons like Barbara Cervenka or Rebecca
Davis or members of numerous volunteer groups arrive to work with the
Mother's Clubs, they provide assistance with issues like marketing and tech-
nology that are not otherwise available to the women of the community.

While each *cuadro* is the work of a single woman and is unique and hand
made, the design ideas are the collective work of the Mother's Club.[36] The
design process begins with the women discussing their lives and the chal-
lenges of poverty and oppression. As the women engage in a dialogue of
memory, images of meaningful experiences shared in their native villages

emerge. Sometimes, the chatter of the collective results in visions of hope for the future. Other times, the conversation centers on their own, shared experiences as poor women living in the slums. There are certainly repeated artistic images in the *cuadros,* and these wall hangings as a whole have become somewhat stylized as they have become more commercial. When a woman begins work in a *taller,* commercial appeal is not the primary focus of her work. Rather, the design of the *cuadro* emerges from the work of dialogue within the community of the Mother's Club. Barbara Cervenka claims:

> The cuadros depict life as it was and as it has become. They are texts which reveal, beneath their brilliant colors and playful exterior, both the intensity and darkness of life in Third World Peru. From religious festivals and processions, harvests and history, the cuadros celebrate traditions and connections to a rich past. But they also present life as the women experience it: strikes and marches, common kitchens and domestic violence, building huts and planting gardens in the desert.[37]

The more experienced artists among the group offer suggestions for stitching, for folding the material so it can be stuffed with batting to make it three dimensional (one of the identifying features of both *cuadros* and *arpilleras*), choice of fabric that better matches the texture being sought, and for layout of the design itself. As Rita Serapión says, "The more we work, the more creativity we find in ourselves. The fact that [the *cuadros*] are exported is a big compensation: it animates us. We all have a little art in our minds and in our hands; we will leave something as a legacy for society. It will stay behind us, in another place, in another time."[38] Personal competency complements the development of identity as the women come into their own voices through this form of the arts.

As a collective organization, the *taller* also serves other community needs besides artistic ones. One feature of the *taller* is community child care: a necessity for the women who spend their time in the shared work of the *taller.* The women take turns looking after the needs of each other's children when not working on their own artworks, freeing others to focus on their textile work and their dialogue within the community. This sense of the shared work of the community is also reflected in the common noontime meals that are prepared by club members and volunteers on behalf of the workers—both artists and child care workers. This community table provides a majority of the meals some families in Pamplona Alta will eat in a given day. Three traditional "works" of women—child care, cooking, and sewing—have been transformed from oppressive duties to shared work. Marjorie Agosín states:

> We should try not to see the *arpilleras* as artifacts narrating a history, but as works of art describing historical circumstances illustrated in fabric, in the care of the stitching, and in the making of the personal tokens that have created a space for the disappeared. We should also see

the way this work utilizes the feminine by articulating the most intimate gestures, such as the long hours of dedication to manual work in order to create textiles that, from the universal and feminine perspectives, tell a story of the war, horror, and violence created by men.[39]

The women of the Mother's Clubs have become a community that engages in collective work for the betterment of each worker in the common cause of the *taller*.[40]

At the same time, other forms of self-improvement are being offered within the *taller*. Women like Juliana Quijano teach the illiterate women of the collective to read and write Spanish, thus giving them a voice in the language of commerce in Peru. Becoming bilingual allows the women to become proficient as marketers of their own work while also helping them escape the discrimination they had previously experienced as those who only spoke their native Quechua and Aymara languages.[41] Such competence empowers the women of the Mother's Clubs.

The *taller* has become a safe space within a dangerous, bleak world. Rebecca Davis claims:

> In the process of negotiating safe public space, women have sought out each other as a means of support. Many women's groups that were initially created as a means of support and to share basic resources later evolved into associations that fostered consciousness-raising and empowerment. Here is where group identity was often shaped and a sense of common purpose was formed.[42]

Nelle Morton described a similar character in the groups of women with whom she worked in San Diego. It was specifically the support, deep friendship, and willingness to listen intently as well as silently as each woman shared her own experience of pain that allowed each to find her own voice and be "heard into speech."[43] The wall hangings created in places like Pamplona Alta are more than commercial products for an international market; they reflect the stories, the identities, and the voices of the individual women who create them.

## MOTHER'S CLUBS AND THE FACE OF THE OTHER

Parker Palmer has called for education to be engaged within a "community of truth" that empowers partners in dialogue to listen carefully to the other's "claim to truth." The kind of dialogical community of which Palmer speaks is characterized by focusing on the *practice* of truth, rather than on a theoretical construct of the *concept* of truth. The work of this kind of community is to "clear a space where the community of truth can be practiced."[44] The Mother's Clubs of Pamplona Alta have become communities of truth.

The work on *cuadros* within the Mother's Club cooperatives has been collaborative. Rather than a top-down, hierarchical action of experts from outside Peru coming to save the backward *provincianos*, the workshops have operated with a sense of shared leadership and partnership. The *horizontal* flow of knowledge and of power within the *taller* contrasts with a hierarchical, *vertical* flow characteristic of oppressive societies, which is similar to the critical consciousness discussed by Paolo Freire.[45] Even though a single woman sews each *cuadro* or *arpillera*, the work of the cooperative is engaged within a community of women who form a community of truth. When the Mother's Clubs function properly, it is because the women within the clubs consider one another partners and equals. There is an egalitarian feel to the work of a cooperative that is based on mutual respect and a willingness to regard the other as a fellow subject. It is rare to have a member of the workshop take the role of boss. A sense of partnership is far more common an experience in the *taller* than a hierarchy of power. The learning that occurs within the communities is what Freire called education for critical consciousness.

> Through dialogue, the teacher-of-the-students and the students-of-the-teacher cease to exist and a new term emerges: teacher-student with students-teachers. The teacher is no longer merely the-one-who-teaches, but one who is himself taught in dialogue with the students, who in turn while being taught also teach. They become jointly responsible for a process in which all grow.[46]

It is only as each woman engages the Face of the other women *as other*, as Levinas emphasizes, that a horizontal, dialogical relationship among the women of the *taller* is made possible. It is the interaction with the "me that is not me," experienced in the Face of the other that allows a sense of respect, openness, and responsibility to the other to become the character of the community.[47]

The intimacy, dialogue, and shared responsibility for each other's child care needs, community meals, and educational opportunities enables the emergence of a radical sense of partnership within the Mother's Clubs. Because the women listen to one another and to the claims to truth being made by the other, they regard one another as persons of worth; in the realization of the face of the other, one experiences oneself summoned into a relationship that is an epiphany and a self-revelation.[48] When one takes seriously the Face of the other, the instrumental use of another person for one's own purposes (which is characteristic of I-It relationships as well as abusive relationships) becomes unlikely. For a community of persons who have been marginalized by poverty, displacement, language, culture, and gender the gentle laughter, chatter, and exchange of goods within the group humanizes ones for whom dehumanization has been a way of life.

Levinas's discussion of the Face also emphasizes that the face of the other is no idealized, hypothetical *concept* of an other. Rather, one encounters the other as a real-life, flesh-and-blood person whose alterity summons one

to pay attention to the claim to truth the other brings to a responsible relationship.[49] The literature of feminist theology, and especially of a feminist *practical* theology of the arts, highlights ways the arts "suspend our self-absorption. They help us 'pay attention to something other than ourselves' and connect us to the participation of the other *as other.*"[50] The women who participate in the Mother's Clubs in Pamplona Alta enter into an intimate, person-to-person, face-to-face encounter with persons whose presence calls into question each woman's claims to truth. The alterity that comes through the aesthetic distance of the unique art form known as *cuadros* summons one to regard each woman in her own unique identity and hear her own distinctive voice with each stitch of the vibrant fabric in her hands.

The discussion within the cooperatives is more than idle talk. When the women begin to regard each person as a subject—as one with a Face—their discussion can become a dialogue. Dialogue moves horizontally among the members of a community, not vertically from ones with the "truth" to passive recipients—what Freire called the "banking model" of education.[51] As Hans-Georg Gadamer claimed, dialogue begins when each person engaged in conversation regards the other as a subject with something significant to say about the subject matter under discussion. Meaning and truth emerge from the dialogue when one subject listens to the truth claims brought to the conversation by the face of the other subject and opens herself or himself to the voice of the other partner. The truth that emerges from dialogue is always a new truth that is encountered as the two separate horizons of the dialogue partners are fused to create what is true, there and then.[52]

## A "DE-CENTERED" COMMUNITY

One major characteristic of what Jean François Lyotard described as the "postmodern condition" is that the institutions that dominated the modern era—Church, State, proletariat—no longer function as the center of meaning making.[53] Feminists, liberation theologians, third world leaders, Eastern cultures, and those living alternative lifestyles have emerged to positions of leadership on the world stage. Economists, scientists, educators, and politicians are now listening to voices from what had previously been regarded as marginal communities. The voice of the other has become an important partner in dialogue. These postmodern challenges have emphasized the importance of taking the voice of the other seriously as persons strive toward full humanization and the recovery of identity.

The making of *cuadros* demonstrates the wisdom of the arts as a practice of transformation that we claim is characteristic of a practical theology of the arts. Bonnie Miller-McLemore claims:

> If one of the goals of practical theology is to foster transformation, then the heart of practical theology lies as much with imagination as with

interpretation, even though we have largely failed to anticipate the relationship between practical theology as a hermeneutical discipline and practical theology as art.[54]

Ballard and Pritchard argue that the arts are transformational because they require both new ways of making sense of the world and critical ways of processing the understanding of this new epistemology. They claim art, "forces the participant to work in new ways and to be at the same time clearer in what she wants to say and also more opaque in allowing the art form to have its own communicative power."[55] The Peruvian artists have been enabled to reflect critically upon their experiences of poverty and dehumanization and to both engage in dangerous memory of an idealized past in light of a vision of what their world could become precisely because of the transformative function of their fabric art.

As communities with questionable legal standing, the pueblos receive virtually no infrastructure assistance from their metropolitan center. The average of $1.50 per day a member of a Mother's Club may earn making *cuadros* is frequently the only income available to the entire extended family.[56] As *women* in these conditions of poverty and isolation, the textile artists are further marginalized by a culture that still exhibits a male-centered worldview. Rebecca Davis claims the workshops "that were initially created as a means of support and to share basic resources later evolved into associations that fostered consciousness-raising and empowerment. Here is where group identity was often shaped and a sense of common purpose was formed."[57] Marjorie Agosín states, "Women have historically been the ones who guard memory, and the same women have been placed in minor roles throughout history."[58]

The work of producing *cuadros* has begun to move the women of Pamplona Alta from a condition of powerlessness and poverty to voice and identity. The *cuadros* they make emerge from the dialogue of the women in the cooperative sharing their lives, their stories, and their experiences. There are few persons in the world more marginalized than these women; yet, the regular dialogue that exists among the women who work alongside one another on a daily basis serves to empower them to name their oppression and to claim their voices to transform their local situations.

## "WOMEN'S WORK"

Marjorie Agosín has called attention to the significance of the use of fabric and sewing as a means of artistic self-expression and a tool of memory. Chilean *arpilleras* emerged out of the rage and grief experienced by women whose loved ones were kidnapped, tortured, and murdered by Augusto Pinochet's brutal regime. She claims that the *arpillera*

[B]elongs to a category of objects that remember, and sometimes it has the ability to recall the loved possessions of the missing. They are objects

similar to the ones belonging to Holocaust survivors, such as eyeglasses, tokens, clothing, and luggage, but at the same time they have a unique component. [. . .] The women making an *arpillera* are working among the rituals of memory, but while they are creating *arpilleras*, they are also re-creating life. Each stitch and figure reconnects the history of a truncated life. [. . .] But, above all, the *arpilleras* are sent into the world, outside of the personal body of the creator, so the recipient receives and can feel history. When I look at *arpilleras*, I feel as though I am part of someone's truncated life.[59]

Because the military junta considered these textile wall hangings as mere women's work, the *arpilleras* were not considered a political threat and were allowed to be distributed freely.[60] Yet, the act of discounting these seemingly innocent works of folk art allowed subversive banned messages to be passed to others among the resistance movement that eventually led to Pinochet's downfall.[61]

Robin Jensen recalls that "Art's purpose is not to imitate life. Art's true function is to externalize, shape, and present a particular view of life and thus to achieve its own reality."[62] While *cuadros* from places like Pamplona Alta are not as intentionally subversive and political as the Chilean *arpilleras*, they represent the specificity of the experience of *this* particular group of women and reflect the dangerous memory of those dehumanized by marginalization and oppression. Agosín states that "even the domesticity of fabric takes us back to the ancient history of women weaving in order to tell a history, such as in the myth of Filomena when she tells her story through fabric after being raped by her nephew and having her tongue cut off."[63] In the women's work of sewing, using discarded scraps scavenged from litter, filth, and horror, each woman's story becomes externalized and shared with the world. *Cuadros* represent a memory that looks backward, but also becomes an expression of hope for a future of humanization and freedom.

The variety of textures and the three-dimensional character of this form of fabric arts invite a visceral experience for persons who touch them. Like quilts from the American experience, it is the warmth of the fabric, the commitment of the persons who stitched them, and the stories behind the fabric scraps used to make a *cuadro* that engages one. Agosín claims:

> The fabric of the *arpillera* is meant to be touched. Many times, it is found in a bag of donated clothing brought by the Vicariate of Solidarity. These remnants allude to a domestic space valuing homemade works of art and the slow, careful attention the work demands, which helps us recognize the intimacy of particular lives brought to us by globalization and the world market.[64]

In a world dominated by the verbal, the tactile richness of a *cuadro* calls upon a form of memory that is centered within the home. In an art form that

has been associated with women in a limiting, almost derogatory way, the very act of working with fabric; color; texture; layout; design; and careful, painstakingly exacting stitching brings the stories of the women who make them powerfully to the fore.

## OUR STORY, NOT *THE* STORY

One unmistakable characteristic of the postmodern condition is its challenge to the metanarrative characteristic of the modern era. In the place of this hegemony, postmodern approaches recognize that there are *multiple* narratives that exist and operate alongside one another. Robert Schreiter has claimed that this postmodern approach is also characteristic of Latin American liberation theologies, which are always contextual and local.[65]

The emerging literature in practical theology also emphasizes the *thereness* of theology within particular communities of truth and/or faith.[66] Joyce Ann Mercer offers a feminist practical theology of childhood that she describes as "a way of thinking about God and human experience in which actual, present-tense human experience and practices matter."[67] Paul Ballard and John Pritchard contend that practical theology "compels [persons] to work out of the concrete reality in which God has placed us."[68] In its various forms, practical theology takes seriously each person *as* a person, while also recognizing that each individual resides and comes to her own sense of self in a particular context. Emmanuel Lartey claims, "[t]he task of the practical theologian then will include that of the creation and critique of the cultural symbols by which people may in their different societies live with dignity and integrity."[69] The cultural symbols embedded in each *cuadro* represent the unique story of each artist as well as of the community in which she lives and works. The particularity of each artifact reflects the extent to which each artist is grounded in the reality of her historical community and has become engaged in her own practice of personal, communal, and financial transformation through the art of *cuadros*.

The women of Pamplona Alta work with one another in the task of naming their own experience. Each *cuadro* tells the story of the particular woman who creates it from the fabric gathered and sorted by the collective. A *cuadro* might picture a market in a Peruvian village. In the background are the Andes, with their hillsides bursting with fruited vegetation; a brightly smiling sun; and rainfall coming from a single cloud, watering the productive mountains. The market itself is filled with *provincianos* with native dress, Peruvian pipe flutes, and smiling faces. Llamas wander among woven baskets, strawberries, carrots, cabbages, grapes, potatoes, radishes, and other produce. Among the fruits and vegetables there are bags of *tela* (fabric) and large bolts of whole cloth. Prominent in the right center of the wall hanging is the red tile roof of the village church. Such a scene is reflective of the world in which its artist lives, or the life she envisions. This is *her* story.

Its artist is not attempting to describe a universal human experience; she is sharing *her* experience and her dreams. The scene could be from Pamplona Alta and her present world; it could also be a memory from her village in the Andean foothills and a life she lost but still loves.

*Cuadros* are stylized and have repeated themes and artistic features. But each is also unique because the story behind the *cuadro* does not belong to the collective experience as much as the experience of the woman who makes it. There are clearly universal themes that may be found in the *cuadros* as a whole, but each *cuadro* is reflective of the *particular* experience of its artist. Common themes include the market, religious festivals ("The Day of the Dead" is a recurring religious theme), life in the jungles (the *selva*) or villages in the Andean mountains, significant historical events in the history of Peru or scenes from the life of historical figures revered by a particular community, and *fútbol* matches in the streets.[70] Some reflect an idealized portrait of current villages like Pamplona Alta that envisions what life could become. Others are romantic memories of the idyllic world of their villages of origin. The women are not using their stitches to present universal claims about absolutes like justice, truth, or freedom; they are crying to be treated justly, to be allowed to give voice to their own claims to truth, and to be free to survive in a harsh world. The figures they stitch on their *cuadros* are their own voices being shared with the world, and their claims to truth reflect their experiences as well as their artistry.

Douglas Wingeier commented upon Freire's principle of conscientization by analyzing the "generative words" that humanize those who have been dehumanized by poverty.[71] When persons in these conditions are listened to, are given respect as persons, are treated as subjects with a face rather than as inanimate objects, their voices are honored and, in some cases, heard for the first time. The women of Pamplona Alta, through their work in Mother's Clubs, have been heard into speech and, through their own restored voices have begun to not only break down the myths of their objectification but to re-mythologize their worlds and participate in transforming their experience.[72] The dialogue among the women whose tangible work created *cuadros* also cleared a space that allowed the meaningful work of empowerment and consciousness raising to take place.

## BECOMING PERSONS OF "SUBSTANCE," RATHER THAN SUBSISTENCE

The women of the Mother's Clubs had little money in their communities of origin. The poverty rate in the scattered *pueblos jovenes* is staggering. Over 25% of Peru's residents live on less than $1 per day. The unemployment rate in Pamplona Alta is nearly 80%. Many of the men of the pueblo have become so discouraged by the poor economic conditions that they have given up hope of finding gainful employment. At the same time, as products

of their culture, these same men expect their women to limit themselves to domestic work and devotion to their families.

Over the past several years, an emerging international trade in *cuadros* has developed. Religiously affiliated organizations like 10,000 Villages have marketed the free trade goods through a variety of church and other religious agencies worldwide and have recently opened retail stores in the United States. *Cuadros* and *arpilleras* are marketed online through companies like crossroadstrade.com.

The growth of this cottage industry has afforded the women who work in the workshops a better economic status than their contemporaries in the shantytowns. Each completed *cuadro* earns its artisan approximately $1.50. A skilled artist is capable of producing several completed wall hangings, numerous eyeglass cases, or a handful of embroidered scarves or jackets each day. The economic impact of the women who participate in Mother's Clubs has transformed many communities and the persons who live and work in them.

The women who make these products are not wealthy by Western standards. However, they are generally able to escape subsistence income for their families with the money they have earned and provide their families with clean clothes. The income they have earned also lessens the problems with hunger and nutrition that plague others in the slums, giving them more access to regular medical care than their neighbors who have not participated in the workshops.

The international recognition that has come to Pamplona Alta and other similar pueblos surrounding Lima through the marketing of *cuadros* has brought attention to the plight of these shantytowns and their residents. Through the sharing of their stories and the experiences behind them, Pamplona Alta has become a popular destination for relief work through churches and international volunteer groups. Alternative spring break options for college students from the United States, group mission trips, medical volunteers—such as "Med to One," and similar organizations have provided opportunities for persons from the United States and other countries to work alongside the women in *tallers*.

The work of persons like Rebecca Davis and Barbara Cervenka as well as religious orders like the Sisters of Charity of the Incarnate Word has brought these extraordinary wall hangings to the United States for major art shows. Princeton Theological Seminary, Wesley Theological Seminary, the University of Detroit-Mercy, the University of Michigan, and the Pacific School of Religion/Graduate Theological Seminary have all presented major art shows featuring *cuadros* from Pamplona Alta and its neighboring *pueblos jovenes*.

Women's Clubs illustrate what can happen when a group of women use the arts as a form of resistance that leads to their own transformation and that of their communities. These communities are an example of what Roman Catholic theologian Paul Lakeland calls "faithful sociality," in which each community develops its own narrative, expresses its own values,

and its own way of regulating power. The power of society as a whole, and especially of religious communities, is consistent with intersubjective dialogue as discussed by Gadamer, Freire, and many others.[73]

Bonnie Miller-McLemore recognizes the role of the arts as an alternative process of "discernment, wisdom and critical vigilance" that can escape the modern prejudice that any experience that is expressive is, at the same time inevitably antirational and anticritical. Miller-McLemore claims, along with Sallie McFague and many others that the arts (and, more generally aesthetics) present a "powerful way of arresting our attention. The arts suspend our self-absorption. They help us 'pay attention to something other than ourselves' and connect us with the particulars of the other *as other*." As such, she maintains, "[a]rt itself can function subversively and prophetically" as the face of the other represented in a *cuadro* summons the self to a new and different claim to a truth that challenges oppression, dehumanization, and abuse toward the emergence of a voice empowered through the gift of the arts.[74]

# 6  Literature as a Scene for Dialogue

"I am obsessed with complexity," Eric-Emmanuel Schmitt exclaims passionately in an interview, conducted at the author's office in Brussels in June 2008. "For me," he continues, "it is a mistake to desire a simple solution, a unique algebraist formula; it is terrible because it is impossible." In his opinion, therefore, one must "fight against the obsession of simple ideas and accept complexity."[1]

Complexity forms the red thread running through the production of the French author Schmitt, whose symbolically dense, warm, and humorous tales of encounters between persons of different cultures, religions, and ages has reached a worldwide audience, been translated into several languages, and adapted to stage and film. Schmitt has devoted much of his writing to the topics of religion, spirituality, and interreligious dialogue. His way of placing the heroes of his tales at the crossroads of faith traditions, generational breaches, personal development, and spiritual sensitivity reveals a narrative universe where interpersonal and interreligious encounters are not reduced to "simple ideas" as claimed above, but rather are honored as the multifaceted, creative, but challenging scenes for transformation that they, in his opinion, amount to.

A central thesis developed in this book is that the arts can provide a context within which the emergence of a practical theology with emphasis on praxis can be facilitated. Practicing theology, it has been argued, is not merely a cognitive enterprise but also an engagement that bears significant emotional imprints and that empowers ethical action. By giving precedence to issues of ethics, everyday relationships and emotions over normative ideas and systematic structures, the theological approach developed by Schmitt in his written work can aptly be described as a theology of *habitus*, as suggested in this book. As a writer, Schmitt strives to further the readers' understanding of a religiously and culturally plural reality in which people encounter each other, themselves, and the divine.

Schmitt has chosen to place his stories in mundane settings of everyday life where the characters speak about existential issues, the divine, and spiritual experiences in a simple, straightforward language without theological concepts, truth claims, and academic jargon. This, however, is not due to a lack

of access or insight into the world of academic discourse. Quite the contrary;
Eric-Emmanuel Schmitt became a writer of fiction rather than a scholar as a
result of a personal spiritual development. Born in 1960 in an atheist home
in Lyon, he grew up in an atmosphere where "it was obvious that God was
dead and religions were agonizing or dying."[2] After finishing school, Schmitt
entered university to study philosophy and earned his doctoral degree, at
the age of 27, on the topic of Enlightenment philosophy. A few years later,
however, a journey to Sahara changed his life forever. In the desert, Schmitt
experienced a personal mystical awakening and, according to his biographi-
cal description, he received faith. This, however, was not a simple faith in the
God of Judaism, Christianity, Islam, or any other religion: "I did not recog-
nize him, God. It was [. . .] a mystic and monotheistic experience of God and
very surprising for me. It was difficult for me to put a name on it."[3] Hence,
today, he prefers to describe himself as a monotheist believer, but refrains
from defining his stance in any more particular manner.

To describe the unity and fulfillment he had sensed in this spiritual
encounter, Schmitt decided to abandon his academic career to become a
writer of fiction. Academic writing must abide by the rules of logic and con-
sistency, and thus, it cannot portray the world of spiritual and interpersonal
encounters in an apt way, he claims. In literature, however, the world can
remain complicated and paradoxical, filled with emotions and trivial details.
In writing fiction, therefore, Schmitt can explore questions of religion, faith,
and interreligious encounters in a way that reflects his own—inclusive, flex-
ible, and thoroughly praxis oriented—theology. Gradually over the years,
his study of founding texts and mystical poetry of major world religions has
grown into a personal faith. It was a long journey, he says, and even today
God remains "very exotic." Thus, as stated above, he describes himself as a
monotheist believer, but regards spirituality as a positive and personal ele-
ment that cannot be limited to organizational structures.[4]

## *LE CYCLE DE L'INVISIBLE*

Eric-Emmanuel Schmitt's narrative journey into the creative landscape of
interreligious encounters has thus far resulted in a vast number of novels,
short stories, essays, and plays. The collection of six short fiction stories called
*Le Cycle de l'invisible* are of immediate interest for the questions under study
in this book, and will therefore constitute the core of the following analysis.
How can a practical theology of the arts be understood to unfold in these
novellas? How is complexity maintained throughout the narratives, and what
impetus for transformation can be discovered in this particular selection of lit-
erature? These questions will form the frame of our discussion in this chapter,
focusing on literature as context for a practical theology of the arts.

The six short books included in *Le Cycle de l'invisible* have reached
a wide and varied audience, both in their original French editions and

translated into several other languages. Some of the stories have also been performed in theatres and reworked into films.[5] According to the website of Eric-Emmanuel Schmitt, millions of readers of all ages have read the stories and found spiritual and intellectual inspiration in them. The novellas included in the cycle are, at this point in time: *Milarepa* (1997); *Monsieur Ibrahim and the Flowers of the Koran* (1999); *Oscar and the Lady in Pink* (2003); *L'enfant de Noé* (2004), *Le sumo qui ne pouvait pas grossir* (2009); and *Les dix enfants que madame Ming n'a jamais eus* (2012).[6]

Several common features relating to the topic of this study unite the five novellas: they all deal with interreligious encounters in a practical way, concentrating on the human beings involved, their emotions, and inter-pretations. They all deal with difficult subjects—such as hatred, disease, death, loneliness, envy, genocide, war—but do so in a warm and tender, even humorous way. The encounters often cross several lines of difference simultaneously, for example religion, culture, generation, and attitude. Thus, the stories underline the complexity and richness of interpersonal relations as well as the centrality of emotions, ethics, and praxis in these encounters. A recurring theme in Schmitt's stories is the young hero full of questions and hesitation who meets an older, wiser, and more reflective person who lives deeply embedded in a religious tradition but still has no intention of convert-ing or forcing her/his own worldview on the young adept.

The opening story, *Milarepa*, was initially written as a theatre monologue on the theme of Buddhist wisdom and mysticism. Mystics are often easiest to relate to in other faith traditions, Schmitt states in a comment to this text.[7] The book presents Simon, an ordinary, stressed-out Western atheist who is harassed by a recurring dream of an ancient Buddhist hermit who cannot come to peace due to the hatred he bore in life toward his nephew Milarepa. Now, Simon must tell the story of both these characters, identifying himself closely with their destinies, in order to end the cycle of reincarnation. During the process, he discovers the wisdom of several Buddhist traditions that are applicable to his own anguished existence.

The second narrative of the cycle, *Monsieur Ibrahim and the Flowers of the Koran*, is probably Schmitt's most acclaimed publication; the film based on the book has become an international success. The story follows an extraordinary friendship between the lonely and depressed Jewish boy Momo, who is seriously skeptical toward all aspects of religion; and the elderly Muslim man Ibrahim, a warm and calm Sufi sage who runs a grocery store in a gloomy suburb of Paris in the 1960s.[8] Through Monsieur Ibrahim and his attitude toward life, Momo learns to apprehend novel aspects of reality, including beauty, joy, love, and spirituality. As the story develops, several stereotypes of interreligious encounters are challenged, and complex-ity is celebrated as boundaries of otherness are questioned and conquered in every new turn of events.

*Oscar and the Lady in Pink* is Schmitt's third contribution to the series.[9] Yet again, it is a tale of an encounter between a child and an elderly person,

this time an atheist and a spiritually mature Christian. This text consists of letters, written by 10-year-old Oscar and addressed to God. Oscar is dying of cancer, and the only person who seems able to answer his questions of life and death is a lady dressed in pink, Mamie-Rose, who visits the children's ward as a voluntary aid. Despite the tragic theme, the novella is a warm and humorous tale of love, friendship, and respect. As the story opens, Mamie-Rose is convinced and Oscar confused; in the end, Oscar seems more calm and convinced—although not in the same way as his mentor—while Mamie-Rose has been challenged in her faith. The novella presents a thoroughly humanist understanding of God and religion: the vital question is not whether God is real or imaginary, but to receive confidence and calm.[10]

The fourth contribution to the cycle, *L'enfant de Noé*, deals with the Holocaust. It recounts the story of the Jewish boy Joseph and his encounter with the Catholic Priest Père Pons. Joseph is separated from his parents as they abandon their Brussels home to escape the Nazis and is taken care of by the priest, who runs a boarding school where he rescues Jewish boys from the Nazis by claiming them to be Catholic orphans. Père Pons makes great efforts not only to keep the young Jews alive, but also to uphold their religion and culture. Instead of convincing them of the superiority of his own faith, he teaches them the richness of their own heritage, even constructing a secret synagogue in the crypt beneath his church and risking his life on several occasions. Difference *within* religious traditions is also a central theme of this book, underlining the importance of complexity as a red thread in Schmitt's authorship.

The novella *Le sumo qui ne pouvait pas grossir* is set in present-day Japan and elaborates on the mysteries of Zen Buddhism. It is the story of the rebellious but sad teenager Jun who has run away from his family and supports himself by selling smuggled goods on the streets of Tokyo. Here, he encounters the master sumo wrestler Shomintsu, who tries to tempt him to become his apprentice. Jun—who is thin, pale, and sincerely hostile toward any person approaching him with kindness—finds the idea ridiculous, but Shomintsu keeps returning and repeating his hopes for Jun: "Je vois un gros en toi" ("I see a great one in you"—the French "gros" can signify both physically large and describe one's personality).[11] Eventually, Jun collects courage enough to enter Shomintsu's sumo school. Through physical and meditative practices he gradually learns to see the potential in himself to become "big" that his master tries to refine; he discovers a world of strength, wisdom and self-acceptance in his inner self.

The latest addition to the series, *Les dix enfants que madame Ming n'a jamais eus*, is likewise concerned with the encounter between European atheism, ancient Eastern traditions of wisdom, and modernity. It is the story of a French businessman who finds himself based in the rapidly industrializing city of Yunhai in Guangdong, China, working as a sales representative for his multinational employer in the toy industry. At the hotel where he is staying, he becomes acquainted with Madame Ming, a worker who is

slight in the eyes of the world—she tends to the hotel toilets—but great in spiritual strength, presenting the Frenchman with Confucian words of eternal wisdom during their short conversations. Above all, however, Madame Ming talks affectionately about her 10 children: stories that her European interlocutor presumes are fantasies as they clearly defy the nativity politics of present-day China. For Madame Ming, this aspect of the matter seems utterly irrelevant; to her, an uncompromising idolatry of truth is far more brutal than the Confucian ideal of humble and compassionate sincerity. Truth is often uninteresting, at times even deceitful, hurtful, and violent, she claims, thus opening up the eyes of her European friend toward values and views completely different to his own rational, career-driven and materialistic approach. "Aprés tout, peu importe la vérité, seul compte le Bonheur, non?" ("After all, the truth is of less importance, the only thing that counts is happiness, don't you think?")[12]

The encounters portrayed in the five narratives constituting *Le cycle de l'invisible* consequently enrich the persons involved, widen their perspectives, and strengthen their self-respect and worth. Nevertheless, these encounters never lead to conversion. Thus, the novellas depict a practical theological stance where the interreligious realm is developed as a thoroughly human interaction of seeing and accepting: not of settling issues of truth, right and wrong, or struggling with difference. Complexity is presented through several of the channels available to literature: imaginative and emotionally evocative language; harrowing and humorous tales of destinies that engage, amuse, and call for consideration. Difference, hence, exists in its own right in these novellas: not as a problem to be solved but as a context to be explored.

## KEY THEME: ENGAGING IN DIALOGUE

In the philosophies of Martin Buber, Emmanuel Levinas, Knut Løgstrup, and Hans-Georg Gadamer, difference was characterized as one of the constitutive features of the practical theology of the arts developed in this book. For these thinkers, engaging in dialogue is primarily an engagement with difference—not in order to harmonize it by leveling difficult incongruence into comfortable similarity but in order to facilitate understanding beyond and despite variations in faith, culture, time, and place.

Levinas's proposition of the term *alterity* is perhaps the strongest claim for such an approach. As described above, his understanding of alterity acknowledges the radical and unabridged difference of the other who always defies one's own dominion and categorizations. The other owns an inviolable right to remain other. This, however, does not mean that human beings are condemned to existential loneliness. By focusing on alterity, Levinas moves the center of attention in dialogue from similarity to responsibility. Thus, alterity introduces an ethical and practical dimension to the

discussion, which we have found to be vital for our argument for a practical theology of the arts. While emphasizing reciprocity to a much higher degree than Levinas, Buber still regards difference as a crucial feature of dialogical relationships. The Thou, he claims, is experienced as "inseparable, incomparable, irreducible" in dialogue, but the I, as well, appears on the scene as a unique being, "existing but once, single, unique, irreducible."[13] As a bridge between these two arguments, Løgstrup relates the question of honoring difference to the overlapping dimensions of power and vulnerability in all interpersonal relationships.

Schmitt's "obsession" with complexity offers an apt illustration of and commentary to the lines of argument developed by these philosophers of dialogue. As mentioned above, his stories depict an interpersonal world, which is anything but neatly black and white. In the practical settings he depicts, choices are seldom made between a clearly distinguishable either/or (this tradition or that, faith or disbelief); neither are such choices portrayed against the background of a clear before and after. No single line of difference is crossed in the encounters portrayed in his novellas, but several.

Indeed, a number of encounters across "conventional" lines of difference take place in Schmitt's stories. At a first glance, this is the major feature of the story about Momo and the shopkeeper Monsieur Ibrahim: Momo is Jewish and Ibrahim is Muslim. But soon, other complicating features enter the story. Momo is approaching his teens while Ibrahim is an old man, and Momo walks the streets with his eyes fixed sullenly to the ground while Ibrahim constantly has a curious smile playing in his eyes. For Momo and Ibrahim, the encounter is essentially a question of seeing each other, not of settling issues of right and wrong or struggling with difference. The two friends identify with as well as detach themselves from each other in a dynamic and evolving, sometimes even turbulent, interpersonal relationship. Ibrahim takes the initiative: he reaches out to Momo and, suddenly, the barriers between them start to evaporate.

The first line to break down is that of adults against children: "Thanks to Monsieur Ibrahim's intercession, the adult world cracked, it no longer presented the same rock-solid wall I was always running into; a hand was held out to me through the crack."[14] Guided by this hand, Momo learns to look at the world with new eyes. He realizes that not all adults are cast in the same mold. Momo's relationship with his father, the lawyer, is cold and distanced; with Ibrahim, he feels warmer and more intimate. At the same time, other conventional truths about young and old are called into question. Ibrahim is the one who suggests exciting ideas and throws himself into adventures. Momo is the one who dreams of past times, fears change, and takes care of his household.

Momo and Ibrahim also test the boundaries between Judaism and Islam. Momo assumes that being Muslim includes being Arab, keeping one's shop open on Sundays, and abstaining from alcohol. Ibrahim, however, clearly does not fit this image: he is not an Arab, and he enjoys an anise Suze from

time to time. It is true that Muslims do not drink alcohol, Ibrahim confirms, but adds that he, however, is a Sufi.[15] Momo has to consult a dictionary to find out what Sufism is, and thus starts apprehending the many different nuances a Muslim religious engagement can take. This gives Momo a chance to scrutinize his own Jewish identity as well. One evening he asks his father whether he believes in God. "I never managed to do that," his father answers. For him, whose parents perished in the gas chambers, being Jewish no longer has anything to do with God, only with bad memories.[16]

As a result, when Momo compares his father to Ibrahim, it looks as if Muslim means happy and Jew sad. Monsieur Ibrahim always explains his cheerful attitude to life by saying, "I know what it says in my Koran." Momo's father, on the other hand, seems to equate his Jewish identity with being depressed all day.[17] Nevertheless, Monsieur Ibrahim explains, the truth of the matter is not simple enough to fit into such neat patterns. Actually, Jews, Muslims, and Christians have had many great men in common "before they began to beat up on each other."[18] Momo's worldview is severely shaken: Jews and Muslims are no longer simple, definitive opposites—an idea that has been self-evident to him. But somehow that feels good, he confirms, even though his orderly world has been shattered.

Similarly, *L'enfent de Noé* seems to describe a traditional interreligious encounter between a Catholic priest, Père Pons; and a young Jewish boy, Joseph. But when the boy wants to know which religion is true, Judaism or Christianity, the priest gives him a surprising answer: neither the Jews nor the Christians have the truth, he claims; different religions simply represent different ways of living. Joseph is puzzled: if that is the case, why should one respect religions at all? If you only respect the truth, Père Pons retorts, you do not respect much. And he continues: in life one will encounter a number of uncertain elements: emotions, values, choices; dimensions that are fragile and fluctuating but nevertheless earn our respect as different perspectives on human existence.[19]

This novella also describes an encounter crossing the lines of difference *within* one tradition. Not only does the narrative illuminate differences between Christians supporting anti-Semitism and Christians ferociously opposing it, but also the complexity of Jewish personalities. At the boarding school, Joseph meets Rudy, a boy who is his opposite in age, size, attitude, fears—everything. But instead of separating them, Joseph remarks, their differences brought them closer and made them love each other.[20] It is only later that Joseph discovers that Rudy, too, is a Jew in hiding. After the war, which they both survive, they continue to lead very different Jewish lives, but still remain close and dear to one another: "Rudy et moi nous montrons différents en tout. Et nous nous aimons autant." ("Rudy and I are different in everything. And we love each other so much.")[21]

In the novella *Oscar and the Lady in Pink*, the lines of difference challenged in the encounter are also those between young and old, as in the narratives described above. In this tale, however, it is confidence and faith

that encounters confusion and skepticism. As mentioned above, the encounter depicted in this book brings together a young boy, dying of cancer and reluctant to believe that any divine powers whatsoever are at work in the world; and an old lady who has a personal, warm, and straightforward Christian faith. Initially, young Oscar gets upset when Mamie-Rose, who claims to be a former wrestler with spectacular stories and bad language, suggests that he should write to God. God is a lie just like Santa Claus, Oscar states. But things change when Mamie-Rose, whom Oscar admires greatly, pronounces with authority that she believes in God even if she does not believe in Santa Claus. According to Mamie-Rose, writing to God would make Oscar feel less alone:

> —Less alone with someone who doesn't exist?
>
> —Make him exist.
>
> She leaned over to me.
>
> —Each time that you believe in him, he'll exist a little bit more. If you persist, he'll exist completely. And then he can do you some good.[22]

Gradually, the letters reveal how the loving attention of Mamie-Rose, and the simple fact that she takes the child's questions seriously, transforms Oscar's view of the spiritual dimension. Writing the letters provides him with serenity, joy, and even appetite during the last days of his life and makes the approaching end bearable. Mamie-Rose thus helps Oscar make God a reality in his life: a tangible reality to whom he can address his anger, fear, and most practical wishes. Through the interpersonal dialogue between the boy and the lady in pink, the divine dimension is invoked as a third party in the conversations and the letters Oscar writes to God actually bring about a transformation, perhaps not as a move from doubt to faith but nevertheless from hostility to greater acceptance. The encounter between Oscar and Mamie-Rose aptly illustrates the Buberian idea that the path to the Eternal Thou goes through practical engagement with another Thou. In Buber's view, one cannot reach another person if one excludes God, but neither can one reach God if one excludes the persons with whom one interacts in "lived actuality."[23]

Anger and aggressive hostility are also pertinent features of the dialogical relationship narrated in the novella *Milarepa*, which deals with the encounter between modern-day, materialistic Western values and Buddhist spirituality. The story follows a man called Simon who struggles with dreams that seem to make a claim on him; by bringing the encounter between an ancient Tibetan hermit and his nephew Milarepa to life again in his dreams, Simon is to liberate the hermit from the bonds of hatred that prevents him from entering into *samsara*. Simon is a convinced atheist himself, but in the monologue presented in the novella, he describes how the dream sequences teach him a new approach to his own empty and distressed life: he learns how to renounce hatred and envy, to be truly present in his own life, to leave his

illusions behind, and to practice generosity and compassion. Nothing in life is permanent, Simon concludes. Therefore, he states: by practicing another way of life other horizons of meaning and value become visible; by singing the songs of love, he found he could forgot about polemics; by being tender, he could forgot the difference between self and other.[24]

The novella *Le sumo qui ne pouvait pas grossir* deals with the encounter between a confident and calm conviction on the one hand and anxious and distressed cynicism on the other. As mentioned above, the story follows a young, disillusioned, and lonely boy called Jun who lives a tough life in the streets of Tokyo. At first, he experiences the encounters with the sumo master Shomintsu as irritating and disturbing, but the teacher refuses to let his optimism fade and gradually makes the boy realize that his own bitterness and hate are the greatest obstacles to transformation in his life. By becoming an apprentice in Shomintsu's sumo school, performing the practical chores at the school, practicing meditation, and learning to relate to—even trusting—the other students, Jun experiences a spiritual awakening that enables him to accept his destiny, forgive his family, and love others. The greatest sumo wrestler is not the largest of them but the most skilled, concentrated, and meditative one, Jun realizes. Similarly, the greatest person is not the vanquisher of others, but the vanquisher of the self.[25] Consequently, the optimistic anticipations of Shomintsu come to life as they are enacted in practice and as Jun accepts responsibility for himself and the persons he encounter.

Eric-Emmanuel Schmitt closely identifies with such a position. He describes himself as a "voluntary optimist," who has chosen to believe in the ability of art to function as a creative and uniting counterpower to the economic rules and political tyranny of our contemporary society. Optimism is often regarded as a naïve position, he admits; but he regards this as too simplistic a conclusion. Both pessimism and optimism grows out of the observation that life is cruel and unfair, but while the pessimist responds with indifference the optimist shows courage and cleverness, he claims: "A pessimist says: 'OK Satan, do your work, I don't care.' But I care. And if there is something I can do, I will. That's optimism."[26]

In addition to complexity and emotions, the dialogues described by Schmitt are also characterized by a focus on minute details of everyday praxis. The encounters depicted in his novellas are utterly practical, including not only grand, heroic efforts, but also seemingly trivial forms of attention that, taken together, show the importance of accepting responsibility. Momo, for example, harbors a deep need to be seen, and Ibrahim answers to this need mostly by concrete action: he helps Momo to find quick-witted ways of tricking his suspicious father, he teaches Momo to smile, takes him on trips, and listens to his thoughts and questions. Ibrahim does not only carry his responsibility in everyday situations, however. When Momo's father kills himself, Ibrahim decides to adopt Momo—to the great surprise of the public authorities.[27] When the topics they discuss become too profound or too

painful, Ibrahim guides Momo through his existential anguish by focusing on practicalities, handing him the small change from the register to put into rolls as they discuss. The ultimate questions of life are thus evoked in the flow of everyday life, as in the following scene. Ibrahim asks Momo what being Jewish means to him, and the boy hesitates to formulate an answer to such a monumental question:

> —For me . . . it's simply something that keeps me from being anything else.
>
> Monsieur Ibrahim gave me a peanut.
>
> —Your shoes are in bad shape, Momo. Tomorrow we'll go and buy you some new ones.[28]

Like Ibrahim, Mamie-Rose is skilled at bringing together theologically decisive questions with mundane praxis. When Oscar asks her why he has to die and why she wants to believe in a God that makes children suffer, she answers by telling him thrilling stories from her imaginative past as a famous wrestler—not belittling or dismissing the child's fear and doubt, but rather opening the world of religious contemplation to him in a way that speaks to him.[29] Père Pons, the Catholic father in the novella *L'enfant de Noé* manages to describe the relationship between Judaism and Christianity in words that are meaningful in the everyday life of young Joseph. We are all the children of Noah, he tells Joseph with reference to their shared endeavor, but unfortunately, a cruise with the ark is not always a joyride.[30] Père Pons is also skilled at working out witty ways to let the Jewish boys in his orphanage lead Jewish lives without the other boys knowing about it, including a Hanukkah celebration in what seems to be an ordinary Christmas festivity and making sure that the Jewish boys learn just enough about the Catholic tradition to be able to hide the fact that they have never been to mass before—no more is needed.[31]

## IMAGINATION, EMOTIONS, AND COMPLEXITY

Relating these descriptions to the theoretical framework of this study, we argue that the encounters portrayed in the novella cycle by Eric-Emmanuel Schmitt can, in different ways, shed light on the practice of dialogue as we envision it in relation to our claims for a practical theology of the arts. The experience gained by the characters from their encounters enable them to alter many of their own preconceived ideas about difference. It is often clear that the persons of the stories initially define themselves as very distant from one another, almost as opposites, separated as they usually are by age, culture, attitude, and religion. As the plot evolves, however, the perspective slowly changes. Something urges them to step out of their conventional

roles, to give up their previous understanding of boundaries, and to look at each other with new eyes.

Hence, the stories of the cycle are not about conquering difference. Difference prevails, but not as a relativizing aspect of religious faith. Schmitt's encounters are not beset by theological speculation, comparisons of truth claims, or rational reasoning. Neither is difference made into a topic for argument, to be defended as valuable, or to be refuted as unwanted. As stated before, difference is just there, in its own right. These encounters are practical and probing, but still, the lines of integrity are not blurred as the persons involved see no need to respond to difference by showing indifference or insecurity. Hence, the novellas manage to preserve the complex character of the relationship to difference: emotional, attitudinal, intellectual, and societal aspects are depicted in the language of compassion and humor. Such a perspective, we believe, can illuminate the turn toward comprehensive, ethically informed, and practically oriented discourses within theology today.

By focusing on praxis and everyday contextualization, Schmitt's theological stance is clearly centered on ethical and interpersonal issues rather than epistemological theorizing. Furthermore, by invoking a deliberately plural—although not relativistic—perspective, Schmitt makes a conscious effort to acknowledge difference as a valuable asset of human existence. His emphasis on complexity bears many similarities with the treatment of alterity as an aspect of dialogue philosophy introduced in this study. Furthermore, the colorful and amusing descriptions of unusual friendships and surprising human encounters aptly illustrate what a fusion of horizons can mean in a practical context of art and theological reflection.

According to Schmitt, encounters of the kind he describes in his stories can be seen as "marvelous enrichments" for all parties involved. In his view, fear of otherness can be dismissed by understanding and respect when difference occurs in beings of "flesh and blood with emotions like our own."[32] This, we believe, is precisely what takes place in his novellas. Hence, his authorship shows how well-equipped literature is to clear a space for dialogue and to create communities of truth where the praxis of theology can be explored, enacted, and diversified. "Art is useful for life," to use the words of Schmitt: in his view, art enables persons to live together. Through poems, music and literature one may catch a glimpse of the indiscernible and discover a world where the shared vulnerability and interdependence of humanity replaces individual selves as the central axis.[33]

At this point, it is also interesting to return to the personal religious position of the author, presented on the basis of interview material in the introduction of the chapter and propagated by several of the characters in the novellas. Schmitt is prone to talk about spirituality rather than religion in describing his engagement, and claims to be inspired by religions rather than defining himself as a religious person: a "believing agnostic." When asked if God exists, Schmitt simply responds: I don't know. Believing and

knowing are different approaches, he says, but at least in his experience, God is present in every human being in her questions. If God is just fiction, Schmitt concludes, it is useful fiction.[34]

It seems fruitful to note the parallels to the topic of post-secularity that this worldview and literary corpus presents. In Schmitt's universe, the secular and the religious (or spiritual) are no longer fashioned as binary opposites or as steps that follow each other as a natural progression of development. Hence, it illustrates José Casanova's description of the post-secular situation as a context where the idea of secular and religious as mutually exclusive categories is revisited.[35] It also exemplifies the argument put forward in chapter 1 that contemporary theology must account for a pluralism that is in constant flux—theology as a "cross-difference enterprise," as Michael S. Hogue phrased it.[36] Schmitt's writings can offer an open and creative way to approach the multifaceted notion of religious pluralism that fits within the framework of a practical theology of the arts developed in this book. To clarify, our stance is important, as the study of pluralism is advanced according to different theoretical parameters within different academic fields.[37] As modernity and globalization bring new, pluralizing features to contemporary religious pluralism, it seems adequate to talk about a "plurality of pluralisms" rather than a unified pattern. Pluralism is also interchangeably used both in a descriptive and in a normative sense.[38]

This intermingling of normative and evaluative descriptions is found within sociological and philosophical as well as theological approaches to religious pluralism. In theological studies, pluralism often denotes a view of religious diversity that regards the world religions as different, equally valid ways of formulating the same ultimate truth, colored and shaped by time and place. Pluralism is thus normatively presented as a tolerant, respectful attitude suitable for a globalized world. This approach has been criticized as an unfortunate remnant from Enlightenment thinking hampered by a narrow focus on truth and uniformity, diminishing difference into a superficial appearance, covering an "essence" of unity underneath itself.[39] Rather than offering an alternative to nonnegotiable absolutes, this position only introduces yet another normative claim: that of multiple legacies. Pluralism claims to affirm the truth of multiple religions, but instead affirms only itself as the correct metaphysical worldview.[40]

Another trajectory is found in the philosophy of religion where pluralism is often approached from an ethical perspective, focusing on the question of whether difference in moral attitudes are merely contextual (revealing at its heart a shared core of basic human needs and values) or if human beings are fundamentally split over issues of morality.[41] The idea of moral relativism, that is, the assumption that each religion has its own moral rules and that the morality of an individual is to be evaluated in light of the specific moral island she is seen to inhabit, is clearly normative in nature. It presupposes an understanding of cultures and religions as static and unchangeable units with an undisputed set of morals that all members implement in similar

fashions in their lives.[42] Furthermore, the idea as such of comparing morals and deciding whether or not they differ from place to place can be regarded as a normative approach to pluralism.[43]

Thus, the theological discussion of religious pluralism is a mix of evaluative and normative claims, and researchers engaging with the subject will always need to equip their analyses with clarifying definitions. The epistemological and ontological claims included, at least implicitly, in these approaches can be seen as a serious shortcoming. For pluralism to prevail in the fashion outlined above, one must begin by defining and categorizing individuals as representatives of historical institutions, arranged side by side in a neat pattern of mutually exclusive categories. Thus, a view of religions as static, clearly separated entities of monolithic character is implied.[44] As shown in Schmitt's novellas however, contemporary believers are not necessarily interested in defining themselves according to such predetermined patterns: the bricolage of their spiritual lives moves beyond a simple combination of elements taken from here and there.[45] Furthermore, the interface between religious and secular values and motivations is transformed as the strict dichotomy between these two perspectives becomes increasingly difficult to uphold in the contemporary landscape of post-secular spirituality.[46]

As a response to such critical evaluations, several reformulations of the pluralist stance have been undertaken during recent years, for example, the introduction of "new religious pluralism,"[47] William E. Connolly's notion of "deep pluralism,"[48] or the theological concept of "post-pluralism."[49] These concepts offer strategies for unpacking concepts that previously were seen as necessarily accompanying each other (such as pluralism, modernity, and secularism) as well as redefining established concepts, thus adding nuance and depth to their scopes. Pluralism is no longer regarded merely from the point of view of quantitative alterations in population statistics, but also the shifting assortment of individual choices, identifications, and combinations made possible in the contemporary religious field are acknowledged. Furthermore, the "uneven playing field" where religious persons interact is taken into account by paying attention that the power structures of pluralism in contemporary societies are taken into account. Thus, pluralism today portrays an active interaction among a vast variety of agents in a diverse and plural landscape.[50]

According to Aimee Upjohn Light, the post-pluralist theological stance builds on "the demise of the pluralist hypothesis" claiming to represent all religions by suggesting a common core of faith: a position that rather *misrepresents* the religions by assuming a religious object that is "other than what Jews, Christians, Muslims, Hindus and Buddhists take themselves to be worshipping or in relationship with."[51] As noted earlier in this book, Light holds that the difficulty included in the pluralist position is based on the taken for granted idea of religious difference as a "problem" to be solved. The problem of the religious other is "the result of our dichotomous structures of thought" rather than an objective fact, she claims. Thus, her

way of engaging with the challenge of religious difference is not to search for a fundamental essence of unity within plurality, but to engage practically and ethically with the religious other:

> Instead of tackling the project of overcoming difference, in post-modernity we are now free to start with our experience of our religious neighbor as an absolute demand for ethical treatment. Given her witness of an ethically engaged life, participation in ritual and witness to spiritual experience, we may now come to abide by the subject's claim on us as 'person' rather than enslave ourselves to binary oppositions in which the other must, always and everywhere, serve in the role of absence to our presence. The rightness of our metaphysics and ways of life no longer has to signify the wrongness of what is different and the consequent devaluation of persons who believe differently than we do.[52]

Regarding the phenomenon of pluralism, thus, it seems that the post-secular era has not given us just a new way of doing an old puzzle. Rather, it exchanges the entire game and reshapes the rules. Therefore, pieces that fitted together yesterday are now at odds while previously incompatible ones now make successful matches. The entire idea of pluralism as a combination of values taken from clearly separated entities of faith or ideology, monoliths of religious or secular origin, is challenged.[53]

These conclusions are important in order to grasp the depth of the complexity described by Schmitt. To account for the pluralism described in his novellas, one must take into account the implications of conceptual developments such as the post-pluralism describe above. This is not the same as lending support to a relativistic worldview; it is rather a way of attaching greater importance to the unfinished and incomplete character of human knowledge and existence, as proposed by Kate Siejk earlier in this book. Theological scholarship is no one-dimensional intellectual activity; it is always also concerned with aspects of human life that move beyond exact measures and explanations.[54] In line with Aimee Upjohn Light's proposition, hence, a dual perspective on difference seems inadequate to account for the kind of theological thinking proposed in the novellas analyzed in this chapter.[55] A more fruitful endeavor would be to exchange the discourse on plurality based on difference as a problem and either-or thinking, for a more practical and ethically engaged exploration, as suggested by the practical theology of the arts developed in this book.

# 7 Eliminating Walls, Honoring Stories
## Improvised Theatre "Creating Space"

Among the plenary sessions during the November 2007 annual meeting of the Religious Education Association (the REA) in Boston, Massachusetts, was a performance by a local theatre company known as "True Story Theatre." The company—part of a larger international movement known as "Playback Theatre" (or, simply, Playback)—set up a rather bare performance space in the convention hotel, with only a few plastic milk crates placed in random locations, some scarves and other pieces of clothing, and a sampling of percussion equipment. To one side of the stage, company members placed two bar stools. As the members of the company worked, they also interacted with the members of the REA who began to make their way into the space. Some members of the REA came into the performance space to chat about the setup; a few members of the company moved into the audience space to engage in casual conversation.

The process of setting up for the performance was not unusual. But the performance itself was unlike anything those in attendance had expected to experience. There was no script used; no lines had been memorized by the players in the company; no plot had been arranged in advance. Rather, following several minutes of exchange between audience members and company members that began to establish community, Christopher Ellinger—in a role the company calls the "conductor"—stood next to one of the stools on stage, addressed the audience, made eye contact with a select number of persons who had been especially responsive during the opening exercises, and asked: "Who has a story you would like to share with this group?" Thus began an unexpected evening of non-scripted theatre in which the content of the performance was improvised upon the stories brought by members of the audience.

## PLAYBACK THEATRE AND "NON-SCRIPTED THEATRE"

The standard features of what Jonathan Fox has called "literary theatre"[1] are recognizable. One might expect to encounter a story constructed by an author or playwright in which the play's characters interact to develop the plot of the story. In such an entertainment-based performance, a faceless and

silent audience sits anonymously in the dark and receives what is being performed by the actors passively. When a performance is successful, the reason for success can be seen as a combination of a good script, engaging acting, solid direction, effective technical spectacle, and a responsive audience.

Playback Theatre is a movement in non-scripted theatre, which has over 100 companies on seven continents.[2] Playback is the brainchild of Jonathan Fox and his wife, Jo Salas. Fox was trained in the psychodrama techniques of J. L. Moreno (the subject of Fox's 1987 book, *The Essential Moreno*[3]), and much of Fox's critique of traditional theatre can be traced to this early training.[4] He has also spent decades studying the tradition of oral storytelling and especially the role of the *shaman*.[5] His work with the Peace Corps in Nepal and his intentional study of the writings of Paulo Freire contribute to the approach to non-scripted theatre that he eventually developed.

Salas was trained as a musician and, eventually, focused her work on music therapy.[6] Her two major books describe the ways her work with music therapy in children's mental hospitals became combined with the emerging techniques of Playback Theatre.[7] According to Salas, Playback Theatre "celebrates individual experience and the connections between people—their collective experience—through their stories. [. . .] It is artistic, healing, community-building, visionary, all at the same time."[8]

Performances by Playback Theatre companies are rarely presented for entertainment purposes alone. A quick survey of the numerous articles in the online archives of the organization lists performances in hospitals, women's prisons, nursing homes, conversations between Protestants and Catholics in Northern Ireland, halfway houses, mental hospitals, and meetings of organizations like the Religious Education Association.[9] The players—all of whom work full-time jobs in their chosen professions in addition to their commitment to Playback—know as they prepare for a performance the nature of the group with whom they will interact and something about the issues that are current for each audience. Preparation for the character and potential agenda of the audiences is one of the major elements of the intensive and ongoing training for members of the company. The performance in Boston was in the context of an international meeting of religious education professionals from a variety of religious traditions, and the interaction the company had with the audience was engaged with that knowledge.

Fox encourages players in Playback to continue in their careers outside the theatre because this practice keeps the players "in the world." Rather than existing in an arts community that is insulated from the larger communities in which members of the audience live and work, players in Playback participate fully in the work, energy, and messiness of life in the city. Fox believes this practice keeps members of the company from being "forced to become exotic, hothouse flowers. [. . .] I wanted them to live in the world and be like their audiences, men and women of common work, family responsibilities, and civic duty."[10] Referring to the work of Paulo Freire, Fox describes the "being" of the actor "that neither promotes feelings without mind, nor mind without

feelings"[11] and encourages the actor to "not just be in the world, but be able to be in the world and at the same time be aware of our position. [Freire] would have us be actors in history, performers in the human story."[12]

## A BREACH OF THE "FOURTH WALL"; THE CREATION
## OF A "THIRD SPACE"

For Fox and others associated with Playback Theatre, the Western "literary" approach to theatre emerged as a response to the formality of 17th and 18th-century European theatre. Denis Diderot, an 18th-century French philosopher and art critic proposed a "realistic" approach to theatre that demarcated the interior of a theatre into two distinct "spaces": one for the stage, the players, and the action in service of the plot of the play; the other, a space designated for the audience members who could watch from the vantage point of one seeing the "real events" unfolding before them through an invisible "fourth wall."[13]

The fourth wall in this scenario is, effectively, the proscenium arch common in most contemporary stages. On one side of the arch, the space is defined by the set designer and contains furniture, drapery, false walls and windows, and enough props and costuming to allow the presentation of the play. The lighting in the room is directed toward the action and the actors on stage to accentuate the unfolding plot. On the other side of the arch, the audience sits in silence and darkness and watches the play as passive observers.

As theatre became more *realistic*, the role of the audience became more controlled and detached.[14] John Stevenson links this historical reimagining of the theatre with a sense of estrangement and aesthetic distance that establishes clear distinctions between the audience and the actors—both physically and psychologically.[15]

David Charles claims the proscenium arch "bisects the event (of theatre performance) separating the performed fictional action from the factual world of the auditorium and the audience."[16] In this traditional design of the theatre space, the sight lines are straight ahead, with the actors addressing their actions (as well as their lines) "open to the fourth wall. It is as if the play were being poured into the audience."[17] While it is clear that members of the audience actively respond to moving moments in a play, there remains an element of aesthetic distance associated with the creation of two distinct spaces within the theatre.[18]

## THE "THIRD SPACE" AS "BREACH" OF THE "FOURTH WALL"

Playback Theatre offers an alternative to the estrangement, objectification, and distance that characterizes the active stage/passive audience dichotomy of much of traditional Western theatre. Arlene Kiely refers to Parker Palmer

and his description of "clearing a space where the community of truth can be practiced"[19] as she summarizes the experience of Playback Theatre within a congregation of the United Methodist Church. Kiely claims the transgressive function of breaking down the fourth wall can facilitate the emergence of an interactive, dialogical experience of hospitality, inclusion, creativity, and service.[20] John Stevenson believes the *third* space created by Playback Theatre "offers one of the most effective solutions to [the] problem of estrangement" characteristic of traditional theatre.[21]

Playback Theatre alters the physical arrangement of the interior of the theatre. Rather than a space that has been "bisected" into stage and auditorium, Playback expands on its minimalist approach to staging by placing the players and musician to one side of the stage (e.g., upstage right), then creating a symmetrically balanced space on stage by installing two empty chairs or stools on the opposing side of the stage (e.g., upstage left). This physical arrangement creates *three* spaces in which the event of theatre can be experienced: the players, the audience, and the *third* space. The space of the theatre has been triangulated, and in some performance venues the arrangement allows for a more circular staging of the event.

This third space is occupied by the conductor, who serves as a combination of emcee, shaman, priest, and weaver of stories[22] that will be shared in the theatre event. The initial moment of breaking down the walls of separation between audience members and the players in a Playback performance occurs when the conductor leads a series of acting exercises and "icebreakers" involving both populations. As the conductor elicits initial comments from audience members and introduces the players on stage, the movement of the event alternates among the three spaces that have been created. Company members, who had interacted with persons from the audience during setup of the performance space moved easily between the space of the audience and the reserved space of the stage, transgressing the boundaries generally expected in a theatre event.

The conductor stands at the edge of the traditional action of the stage, but also serves as the conduit through which all of the action of the performance flows. As Stevenson claims, the conductor serves as a bridge that spans the traditional chasm between audience members and players.[23] In Victor Turner's terminology, the third space Playback creates is a "liminal space" between the existential experience(s) of the audience members and of the player(s). A liminal space is a place where ritual brings the common experiences of the audience members in touch with deeply symbolic, metaphorical, and revelatory moments by honoring a pregnant pause between one state of existence and another.[24] Charlotte Caron claims rituals create a strong group bond, help build community, create a meeting place for sharing, and become the occasion for enacting myths and sharing the stories of a community that invites the holy into the midst of lived experience.[25] Bernard Reymond identifies the ritual function of theatre as one factor that makes theatre the art form most closely related to religious experience and practice.[26]

Jonathan Fox, Heinrich Dauber, and others associated with Playback describe the conductor as a shaman who self-consciously leads this ritualized action of bridging the aesthetic distance one usually associates with a theatre performance.[27] The conductor functions like the conductor of an orchestra, who facilitates the event of a musical performance by enabling the various members of the orchestra to share their individual voices in a collective musical statement.[28]

The ritual facilitated by the conductor and enacted by the partnership between audience and players can become a sacred moment. Fox describes a mystical trance that can occur as a teller opens himself and his story up to those gathered in this community of truth.[29] The conductor "stands at the center of community life" in a way that mirrors the function of a priest and clears an opening within the community that allows truth as the "Secret [that] sits in the middle and knows" to emerge from the encounter.[30] Heinrich Dauber asserts that shamans have the personal task of "establishing ties between the individual and the community, between the dead and the living people, between the past and the future, between all that has gone and all that is going to be."[31] Kiely describes a Playback performance as a "real and spiritual space in which the conductor, storyteller, players, and audience find themselves" connected, thus enabling grace to break through.[32]

An empty stool or chair stands next to the conductor in this third space. As Stevenson says, "The conductor sits down in one of these chairs and invites someone from the audience to join her. This is a generous and courageous act. Playback's strength is that people will so often respond in kind to courage and generosity."[33] When a person from the audience—hesitatingly at first—leaves the safety of her seat and steps to the stage to enter the third space and assume a seat next to the conductor, she breaches the fourth wall, and the estrangement and aesthetic distance between performers and audience typical of a theatre performance has been bridged and transformed both kinesthetically and emotionally.[34]

## THE TELLER AND THE THIRD SPACE

One of the distinctive features of Playback Theatre is that members of the audience who breach the fourth wall tell their *own* stories in response to the prompting of the conductor. Once a teller steps into the third space, he brings his ordinary world into a space made *sacred* by the ritual function of the shaman/conductor. Jo Salas describes Playback Theatre as a new kind of theatre that

> celebrates the true stories of ordinary people instead of fictional heroes and heroines. Together we developed a practice to embody this idea in an improvised format in which members of our audiences told brief moments or whole episodes from their lives, then watched them acted out on the spot with dialogue, movement, and music.[35]

The players or actors who hear these stories respond to each story through a spontaneous *retelling* that attempts to mirror each story faithfully and accurately.

The content of the *play* in Playback is not a work like Moliere's *Tartuffe*, Sartre's *No Exit*, or Mamet's *American Buffalo*. Rather, Playback company members improvise the real-life dramas and comedies brought from the *safe space* of the audience into the third space the teller now shares with the conductor. John Stevenson presents the connection this way:

> Instead of trying to tear [the fourth wall] down or bend it into new shapes as so many other theatres have done, Playback deals with the space between the audience and performers by expanding upon it, paying attention to it and making it a third place, the place of transfer where someone comes forward from among the performers and meets with someone from the audience. In this 'third space' they have a public creative dialogue suitable as the basis of theatre. The performance and audience spaces are not altered or turned inside out. Playback's solution to estrangement is, simply, to build a bridge.[36]

## BY SHARING THEIR STORIES, "TELLERS" HAVE THEIR VOICES AFFIRMED

Fox insists that an oppressed person is one who has nowhere to tell her story. The mission of Playback Theatre has been "to provide a space for anyone and everyone to be heard."[37] As Linda Park-Fuller states, the open invitation offered by the conductor—"Who has a story they wish to share?"—summons an "egalitarian form of performance" in which the personhood and worth of each individual is recognized: "Since everyone's story is important, Playback Theatre disrupts our notions of whose stories are worth telling and worth hearing."[38]

Jürgen Habermas's theory of communicative action takes place within communities in which partners in a relationship of intersubjective dialogue engage one another as equals and attempt to reach a common understanding on matters of shared concern. "Communicative action" occurs through interaction as the partners in dialogue attempt to achieve consensual understanding, which Habermas sees as the inherent *telos* of communicative action.[39] Playback's egalitarian openness to the voices and stories of the audience reflect this kind of interaction. The sacred space of the stage no longer belongs exclusively to the players; the power inherent in this crucible of truth is now shared horizontally among the players and members of the audience as they collaborate in a partnership that breaks down the barriers so typical of traditional theatre.

The openness of the conductor's invitation to tell one's *own* story validates each voice that is shared and, consequently, the personhood of each

person who tells. Once one crosses the liminal threshold (the fourth wall) that separates audience members from actors to enter the third space, the story shared by a teller becomes the content of a theatrical event. Within this third space, there is a creative collaboration in which both the power of the event and its potential risks are shared.[40]

The eyes of the audience members no longer focus on the actors and musicians on the stage alone; their *gaze* is now directed toward the *teller* and what the teller has to share from her life. Jo Salas states that training of members of a Playback company teaches them to "listen deeply to the teller so that they could absorb both meaning and details; they developed the aesthetic sense of story through which a raw-edged piece of life might be transformed into theatre."[41] By listening actively to the voice of the other and mirroring each story faithfully through their spontaneous enactment, the players "hear [the other] into speech."[42] The teller is no longer a *cipher* for humanity in general; she becomes *embodied* in claiming her voice and sharing her story. This event of theatre does not focus on a concept or an idea; rather, the performance meets the teller face to face as a *subject*—a person with a story that is meaningful and real.

The openness to the voice of the other characteristic of Playback reflects the thought of Levinas, Buber, and Gadamer. In the encounter with what Emmanuel Levinas calls the "me that is not me," in the face of the other the embodied person of the teller begins to claim his personhood and function as a subject and a self.[43] One may be capable of ignoring or marginalizing a concept; one must regard the face of the other as a claim and a summons one cannot ignore. Lori Wynters suggests: "There can be room for all telling and it seems that when we shift to hearing each other's stories we can begin to see ourselves in the 'other.'"[44]

By stepping into the third space and telling her story, the teller engages in an act of critical consciousness. Linda Park-Fuller describes what she calls the "third space of performativity for pedagogy—a site where identities and social structures are composed and re-constructed through joint performances of personal experience and expression."[45] Once a teller has shared his story, the conductor asks questions to clarify the story. The teller is then invited to select a cast from the collection of performers, each of whom will play a character in the story.

With the minimal stage set and all three spaces occupied, the conductor addresses the teller, and the members of the audience say the magic words— 'Let's watch"—and the players begin enacting the story.[46] When the story brought by the teller is improvised by the selected performers, the teller has the occasion to be both the subject of his own narrative and a character in the spontaneously constructed play that mirrors his experience back to him. Park-Fuller points out that this aspect of Playback allows the teller a moment of critical reflection on his own story and, as a result, on his own personhood: "It also allows tellers to distance themselves from their experience so that they can gain a broader perspective on an intimate conflict or issue."[47]

As Di Adderley notes, an actor plays the role of the teller, who is—as a result of the conceit of Playback—"observing her/himself in a mirror. The subject becomes an object" in an authentic form of aesthetic distance, which "may be defined as the simultaneous and equal experience of being both participant and observer" in the story shared on stage.[48] Darby Hayes notes that the teller becomes the ultimate observer of his own story and can, as a result, begin to take ownership of his own reality: "By virtue of 'watching' the playback story, the teller experiences it from a more detached perspective," and this detachment provides a pedagogically rich opportunity for personal, transformative insight.[49] By "seeing it externalized and physically separate from herself and then by the opportunity to re-imagine the scenario," Playback can result in personal transformation.[50]

The teller's voice—perhaps silenced or ignored in the past—is affirmed and has become a tool in what may become the construction of wholeness. Jonathan Fox connects this self-reflective moment with the therapeutic process of *catharsis*.[51] Lori Wynters claims that one of "the radical tenets of playback theatre is that the learning process is therapeutic so to provide the student with a form of therapy in that moment is congruent with playback."[52] Each person who comes forward and breaches the fourth wall to enter the third space can experience a time of personal healing.

Fox has stated that the act of telling one's story and seeing it replayed by the performers is "always an experience of critical consciousness" that has vicarious benefits for the members of the audience as well.[53] The moment of mirroring that Playback makes possible not only clarifies the facts contained in a story, but also affirms the person of the teller.[54] As Park-Fuller says,

> If we can watch our stories—our real life, personal, true stories—deconstructed and transformed on stage and know them as our own, as real, as changed but true, we can understand the constructedness of our stories, and with that recognition we can more easily see that our reality is similarly constructed. With that insight, comes motivation to change both the story and the construction of reality.[55]

The performers and members of the audience turn their attention back to the teller, and the conductor speaks directly to her by asking, "Was that *your* story?" The question reflects fidelity to the *story*, not to the artistic quality of the performance that is the point of Playback Theatre; attention to the story also becomes attention to the personhood of the one who tells the story.

David Charles claims that "Playback Theatre's *raison d'etre* [. . .] is to share the stories of those assembled," thereby "freeing the voice of those who do not usually have access to the means for public performative catharsis."[56] The teller is thus involved in a dialectical experience of sharing her subjective voice, experiencing it objectified before her as a work of art, and being encouraged to continue in a dialogue with the conductor, the players, and members of the audience that can accomplish a transformative

experience for the teller as well as for members of the audience. The teller in a Playback performance has been "heard into speech." Lori Wynters identifies "the truth that is encouraged to emerge in the story" of the teller as a unique feature of Playback.[57]

## A "RED THREAD" OF CONNECTION ALLOWS "MY STORY" TO BECOME THE "COMMUNITY'S STORY"

Folma Hoesch identifies a *red thread* that can occur in Playback performances; this thread is a metaphor from weaving, "in which a red thread allows the weaver to follow the pattern, and is a common phrase in German for 'the connecting element.'"[58] Many have remarked how one teller's story can encourage another member of the audience to come forward, create a second breach in the fourth wall, and share an additional story that connects with the ones that have preceded it. As Hoesch mentions, "the stories talk to each other."[59] Bev Hosking observes that

> the story of an individual is personal, particular and specific. At the same time it is a social document about culture and a moment. And each story absorbs an archetype that resonates with every human being. Watching her/his experience enacting is healing to the teller. Witnessing an experience made into art is unifying for the group. Touching the archetype.[60]

Di Adderly believes that "witnessing the previous teller's experience of telling 'can get another teller out of her chair.'"[61] Each story shared has an opportunity to provide "counterpoint to or an amplification of an idea contained in a story told earlier."[62] By seeing themselves in their neighbors' stories and experiencing an environment in which persons feel safe and welcome to share each others' joys and trials, Playback can foster a sense of community.[63] The red thread that seems to weave through Playback performances is a form of what Jo Salas calls "community dialogue": "It is not a process of discussion, of thought and logic [. . .] but is dialogue in the realm of story, image, emotion, and physical action; an embodied, imaginative dialogue."[64]

The communal nature of a Playback event distinguishes it from Boal's Theatre of the Oppressed, which Hannah Fox regards as a "cousin" of Playback.[65] Both forms of theatre feature spontaneous, improvised performances. They share a common source in Paolo Freire's concept of the "citizen actor." Like Theatre of the Oppressed, Playback seeks to clear a space where empowerment is made accessible to members of the gathered community. Each sees theatre as a vehicle for change. Both base their approach to theatre around the sharing of personal stories.[66]

But Boal has made it clear that every performance of theatre is a political event. Consequently, the primary focus of a story presented in Theatre of the Oppressed (also known as TO) is not the story *itself* or the personal

experience of the person who brings the story to the third space; the purpose of a TO activity is to raise the consciousness of the community around social and political issues addressed by the story a teller brings. In TO, each story points to a wider social agenda; thus, the teller is not a subject who shares her own story as much as an instrument through which social change can be engaged. Hannah Fox sees Playback as being devoted to the personal, emotional, and self-revelatory potential of sharing one's own deep story in a way that makes it distinct from the agenda of TO.[67] Lori Wynters maintains, "What is missing in Boal's work and highly present in Playback is the attention to the group, the holding ground for the complex emotionality that is part of the human experience and a place where role reversal is constantly in process. It is to this power of role reversal that I attribute the opening of our minds to the 'other.'"[68]

## SPONTANEITY AND IMPROVISATION ENABLE PLAYBACK TO "HEAR ONE ANOTHER TO SPEECH"

Playback emphasizes improvisation rather than memorization of the lines from a published script. David Charles claims that improvisation "assumes a powerfully prosaic orientation, valuing the experiences, language and stories of the everyday. It is a people's theatre, created by, for and with the communities in which it finds itself."[69] Playback Theatre attempts to locate the creative impulse of theatre in the dialogue the company develops with those who share their own stories from the teller's chair.

In response to criticism that improvisational theatre can be mindless, Fox draws upon the work of Victor Turner: "Spontaneity, then, to connect Turner's thinking with our discussion so far, can be thought of as a creative response to a liminal condition."[70] This "liminal state" is experienced at the threshold between existential planes of existence or, as Martin Buber and Emmanuel Levinas call it, in the "between."[71]

Linda Park-Fuller contends that Playback's attention to learning through improvisation and spontaneity "demands a full commitment, no matter what the test. It quickly vanishes in the face of dogmatic ideas, fixed roles, rigid discipline, or a structure of authority that discourages the unexpected."[72] David Charles claims that "true improvisation is a dialogue between people. . . . In a dialogue, something happens to the participants. It's not what I know and what you know; it's something that happens between us that's a discovery."[73] Improvisation and spontaneity are, thus, not gimmicks to make Playback seem unique. Playback expresses the centrality of each teller's story through the spontaneous, improvised "mirror" of its well-trained players.

Jari Aho contends Playback's focus on improvised stories brings attention to "the many voices, and recognizes no fundamental distinction in function between members of the audience and the performers."[74] By effectively

merging the audience with the performers, critical reflection and analysis of the story is no longer the exclusive privilege of the professional actors. Power no longer resides with the experts or the privileged elite. Rather, meaning emerges out of the collaborative efforts of the newly formed community of truth that involves everyone who participates in the performance.[75] Folma Hoesch comments, "It seems to me that there are forces of the soul working which are not planned and cannot be planned. In playback theatre we use the word spontaneity for this."[76] Others, including Fox, Kiely, and Alexandra Kedrock recognize the work of grace in these forces of the soul.[77]

## PLAYBACK THEATRE IS A FORM OF POSTMODERN DIALOGUE

Linda Park-Fuller describes the work of Playback as a form of "dialogic exchange" reminiscent of Jean François Lyotard's discussion of the "postmodern condition." Postmodernism rejects metanarratives (what Park-Fuller calls "grand narratives") and their dominant discourses because these metanarratives intend to "create situations of privilege, determining whose voices get heard. They affect what gets storied in the telling, what gets left out."[78] Playback is, in her view, an example of *alternative discourses*, which are

> creative ways of thinking and speaking that give voice to the silenced, that hear what isn't spoken, that re-position identities in positive ways. These discourses break through the grand narratives, and can result in the construction of a new story [. . .] that arise[s] not from grand narratives but local story-threads of resistance [. . .] to the dominant story.[79]

The ritual and practice of Playback Theatre is an example of the kind of intersubjective dialogue we have described at the heart of a practical theology of the arts. A Playback event involves a dialogue between company members and members of the audience that results in cocreation of the story threads Park-Fuller describes.[80]

The broadly democratic approach of Playback, combined with the commitment to hear all stories shared faithfully radically redefines the power relationship within theatre (and the society it reflects). The result, Wynters believes, is an alternative understanding of power:

> What if we defined power as something that each person was entitled to, that power was not defined as power over another, but a force from within that gave each person the strength and freedom to engage her or his creative self? This means more than bringing students into the teacher script: It means co-creation and giving voice to all members. The authoritative voice is no longer held by only one person; it is lodged in the discourse.[81]

## ELIMINATING WALLS, HONORING STORIES

Playback Theatre is a splendid example of a "practical theology of the arts," as we have described it. The numerous mentions of the spiritual *trance* experienced by tellers, players, and members of the audience; the attention to ritual and the significance of the power of story for personal transformation; the priestly, shamanic functions attributed to the conductor; and the consistent identification of the role of grace operative within Playback performances make the theology part of our title clear.

The radically and intentionally democratic openness to all stories that are brought to a Playback performance by members of the audience serves as a powerful indicator of the commitment to the voice of those who contribute to this event. Jo Salas claims that "the most therapeutic effect of all [in PT] was the experience of being heard, fully, respectfully, and without analysis or judgment."[82] The voice of each teller is valued; the only prerequisite Playback identifies is that each teller bring a story that is personal and true.[83]

Playback Theatre reflects the realm of the between that is so characteristic of our discussion of Levinas, Buber, Løgstrup, and Gadamer. In Playback, truth and meaning are not dogmatic statements of an authoritative agency—be that agency the Church, the university, or actor's equity. Truth emerges when the teller encounters a community of truth like a Playback community that looks him directly in the Face, opens itself to his claim to truth and says, "Tell us your story." By arranging the space where theatre occurs so that the conductor, the members of the audience, and the players can engage the teller face to face and eye to eye, Playback Theatre honors the Face of the teller and—as a result—honors the personhood of the teller. Through the ritual of Playback, the teller can encounter truth and meaning that may have been blocked or suppressed before the telling. Because every personal story is honored, each person is regarded as a person of worth and as a cocreator of the event of theatre. Each voice shared is heard; each Face that breaches the fourth wall and enters the third space is received as a partner in the dialogue that is Playback. The between, the liminal space that is honored as the teller shares his life becomes the occasion for the emergence of meaning.

Playback is intentionally contextual. Because the plays performed arise from the stories brought by members of the audience, each Playback performance is unique. Many of the audiences for Playback are already communities of truth that are enabled to share their truth through the self-reflective work of Playback. The content of Playback performance emerges exclusively from the context of the community that gathers for that particular event. The intense and intentional listening we have described as characteristic of a practical theology of the arts is present in a powerful way as players concentrate on each story shared to ensure they get the story right in the retelling.

A Playback event creates a faithful community—what Palmer calls a community of truth—through its rituals. Di Adderley claims, "we create

our own 'sacred space' by the very participatory arrangement of stage and audience."[84] She claims the four key concepts in Jonathan Fox's *Acts of Service*—spontaneity, performance, service, and grace end, appropriately, in an emphasis on grace. A Playback community can become a gathering of partners that "does not seek for perfection so much as finds the perfect in what is . . . this is what art does: describe the most difficult truths in a way we can bear to remember because the rendition is beautiful."[85]

It is also worth noting that Playback emphasizes the central importance of service—practices of faithful sociality Fox associates with Paolo Freire's work. As one of the four key concepts that Adderley mentions, Playback's commitment to service is a response to Freire's "citizen actor" who performs as needed by the community, then fades back into the social fabric of the gathered community.[86] By honoring all of the stories that are brought to the event, Playback embodies its commitment to the egalitarian, horizontal form of community Freire has advocated. Playback makes it clear that its performances are more than simply theoretical in nature. It is in the practices of a faithful community that is committed to the experience of grace and truth that true transformation may occur.

Playback regards personal transformation as the essential building block of social and community transformation. Playback's commitment to the Face of the other, to hearing and faithfully reflecting the voices of those who have had no place to share their stories of struggle and joy, to transgressing the constraints of traditional Western theatre by creating a third space, and to encouraging critical reflection on personal and community practices can—and should—lead to practices that transform the community gathered in the space where Playback is experienced. Through this transformed consciousness, participants may lead to the transformation of other communities in which these persons participate. Critical reflection on practices and stories is at the heart of liberation theologies; it is also at the heart of Playback Theatre.

Playback's commitment to the kind of dialogue that allows something new and transformative to emerge from the community of truth gathered for a performance reflects our discussion of dialogue found in the work of Gadamer, Buber, Løgstrup, and Levinas. The practices in which Playback engages are dialogical in nature. Each voice—and through this activity, each person who tells—is honored as a partner in intersubjective dialogue. Truth and meaning emerge as the community of truth that is a Playback community engages in the kind of to-and-fro, back-and-forth dialogue that we find discussed in our primary philosophical partners in the first section of the book.

Finally, by creating a third space that alters the expectations of a theatrical event and encourages a participatory experience for all involved in the performance, Playback Theatre "clears a space where the community of truth can be practiced." The third space is a physical transformation that opens up the possibility of a kinesthetic breach of the fourth wall as

the tellers cross the threshold of the proscenium and bring the daily and ordinary into the *sacred space* of the stage and sacredness to the experience of the audience. Playback Theatre's *conceit* of creating a third space and committing to spontaneous, improvised performances of stories from the audience clears a space on multiple levels of meaning, and as a result opens those participating in the event to the emergence of a community of truth through its practices of honoring the voices of the members of each unique community.

# 8  Film as an Embodiment
of Interpersonal Relations

One of the metaphors used to formulate a practical theology of the arts in our work was borrowed from Bonnie Miller-McLemore, who depicted the insights needed for such a comprehensive, empathic understanding as a "living human web." Such an interpersonal net of interconnectedness, she declared, consists of relationships and contacts building on "compassionate resistance, empowerment, nurturance, and liberation."[1] These words offer an apt description of the work and artistic ambition of the Swedish visual artist and filmmaker Cecilia Parsberg, whose documentary film *A Heart from Jenin* serves as the empirical scene of this étude. The main aspects of the theoretical argument to be developed and illustrated in this chapter include, above all, the aspect of embodiment, but notions such as dialogue, responsibility, power, trust and mercy will also enter the discussion to further elaborate on the practical theology of the arts developed in this book.

Cecilia Parsberg was born in Sweden in 1963. She received a university degree in visual arts, earning an additional diploma in electronic imaging. However, she felt that the traditional role of the visual artist, working alone with her paintings, was too rigid and narrow for her. Thus, she continued her work among the emerging electronic art forms, within the academic milieu but at times also as a full-time artist in different parts of the world: London, Soweto, Palestine. This period in life strengthened Parsberg's interest in intercultural and interreligious issues, and taught her important lessons on power and racism. Since then, Parsberg has worked as a freelance artist, PhD student, and art educator.[2]

Cecilia Parsberg has pursued several large-scale art projects focusing on intercultural and interreligious issues. In a biographical statement, she sums up her experience of project work in areas of international conflict, including several projects in South Africa, the Middle East, Israel, and Palestine, touching on such controversial issues as power and justice as well as the promising potential embedded in creative cooperation. These projects have given Parsberg a specific understanding of art and its meaning as an event and a situation created in the encounter between human beings rather than simply an image or an object produced by an artist.[3]

A contemporary artist, Parsberg claims, should strive to observe relations to history, search for the sources of views and values taken for granted in contemporary society, and visualize the future. Thus, the artist is able to span a limitless zone of time and space in her work, sometimes combining theoretical and factual elements with creative expressions, as Parsberg herself often does.[4] In previous chapters of the book, the views of dialogue and human interdependence brought forth by Martin Buber have been presented. In his view, human beings are always incorporated in a situation, which can neither be resisted nor escaped. Thus, dialogue arises from the combination of personal decision and situation.[5] This embodied and contextual view of human dialogues where the participants are indeed bound by cultural, historical, and political circumstances yet are simultaneously independently responsible agents—situated but free to act—describes the attitude of Parsberg toward her art in an illuminating way.

## RELATIONAL AESTHETICS AND RELIGION IN CONTEMPORARY FILM

The art form of film first drew the interest of researchers in religion and theology in the 1970s, and since the 1990s the field has become increasingly popular. Films have caught the attention of scholars from a variety of areas within theological research, ranging from biblical studies to ethics and the psychology of religion. As a representative of popular culture, the cinematic world has been a partner in frequent conflict with theological perspectives. Yet the two disciplines have shared numerous values and interests along the way. As John Lyden claims, films have often taken the role of constructive dialogue partners for ethical, religious, and theological discussions.[6] To quote Christopher Deacy, one can even assert: "some of the most fertile and intellectually challenging sites of religious significance in contemporary western culture can be located in the medium of film."[7]

Films may serve numerous theological ends, such as providing a basis for contemplation, shared reflection, and faithful practice. The importance of film for theological reflection has become more obvious in today's media-dominated world. As Clive Marsh puts it, participation in theology in a media age is no longer a passive cognitive effort; rather: "doing theology is an active process."[8] For a practical theology of the arts, the empirical context of film is essential.

Films may present religious themes and ethical dilemmas explicitly, but the ultimate questions of life may also be represented through a subtler, more implicit treatment. Furthermore, films can encourage dialogue between different faith perspectives and views of life as well as fortify prejudices and carry on traditions of misrepresentation of various minorities in society.[9] Lyden claims such hegemonic alienation has frequently produced prejudiced representations of Islam and Muslims in the Western film world. As a counterpart

to such tendencies toward estrangement, films may also serve as occasions for ethical reflection by contesting the glorification of violence, suggesting new angles to questions of right and wrong and shedding light on injustices, competing values, and irresolvable conflicts.[10] It is this critical and challenging undertaking that engages Cecilia Parsberg in her work as a filmmaker.

In 2002, Parsberg made her first trip to Israel and Palestine, visiting Jenin refugee camp together with the author Ana Valdés. Projects such as *A wall is a wall is a wall is a wall, Jenin,* and *I can see the House/To Rachel* documented, in words and images, the experiences of human rights violations and oppression they witnessed during their visit.[11] This work was followed by several other projects dealing with the Palestinian situation on the West Bank and the Gaza Strip, frequently focusing on the everyday life of ordinary civilians who try to make their way in a harsh and unfair world. This chapter focuses on one of these projects: the documentary film *A Heart from Jenin.* In this film, Parsberg combines documentary material with fiction, animation, poetry, and music to recount the sad but hopeful story of Ahmed: a boy who is killed by Israeli soldiers in the streets of Jenin. Following Ahmed's death, his parents donate the heart of their dead son to Israel as a testimony of peace, to show that Palestinians are no barbarians but human beings who want to live in peace and mourn their children infinitely. The film follows Ahmed's heart as it travels beyond the wall that today separates the Palestinian territories from Israel and finally reaches Samah, a Druze girl who receives Ahmed's heart and with it the opportunity to continue her curious and engaging exploration of life. The heart, Parsberg concludes, is a gift that drills a hole in the wall.[12]

In making the film *A Heart from Jenin,* Parsberg intends to create an encounter with ordinary Palestinian civilians in their everyday life, rather than with dramatic persons carrying weapons or fighters with scarred faces and adventurous tales. The film documents families living their day-to-day lives in a mixture of fear and hope. As an artist, she claims she wants to collect stories about the "small things" that people are touched and engaged by. By dealing with such embodied and heartfelt themes, you can find your own worth and contribution as an artist, Parsberg proposes. As mentioned above, Parsberg has never adjusted to the lonely work of an artist in a closed-off atelier; rather, she claims to become "full of life" when she encounters other people. Therefore, interpersonal dialogue is a necessary source of inspiration and creativity in her work. "Without others I could do nothing," she explains: the ideas realized in her artworks are always developed in dialogue with others. According to Parsberg, the filmmaker is a creative mediator of the story she presents, but not a single, self-sufficient or autonomous actor. Her work is based on trust and dialogue with others.[13]

As a consequence of this conviction, Parsberg refuses to be an invisible, unattached mediator of the story she presents—as if she only made objective observations of a world unaffected by her presence. In *A Heart from Jenin,* one can see her shadow in the corner of the screen and hear her voice asking questions and taking part in discussions. At times, Parsberg also lets the

participants in the film take the camera in order for them to be a part of the making of their own story. Parsberg calls this attached approach *relational art* or *relational aesthetics.*

Relational aesthetics is interested in the shortcomings of everyday life, she states: no well-directed shows, no facades but horizontal encounters where the other is allowed to influence the aesthetic expression. Relational aesthetics is not about bringing art to people, she states; it is about creating art together with them.[14]

This relational way of making art is above all embodied; it is a thoroughly practical endeavor. As presented earlier in this book, Gadamer understood praxis as a way of knowing related to *phronēsis* (moral knowledge); that is, the art of bringing universal moral principles into dialogue with concrete historical experiences. For Gadamer, praxis always involves interaction between practice and theory, action and reflection. It is in this sense that the relational aesthetics described by Parsberg should be understood: as an embodied ethics. Thus, the film *A Heart from Jenin* brings out the embodied aspects of the transformative processes discussed throughout this book, but also the ethical implications of such an argument: the heart is not just a romantic and innocent symbol, but a beating, bleeding, and struggling presence.

## A HEART FROM JENIN

The documentary film *A Heart from Jenin* was the major artistic project occupying Parsberg between 2005 and 2008. The filming spanned several visits to the West Bank and Israel. Human Rights TV today distributes the film without charge over the Internet,[15] and Parsberg has shown it at several international conferences, public discussions, and exhibition halls in Sweden and abroad. The film gives a broad view of life in the contemporary Palestinian territory and follows the lives of several persons. This short synopsis of the film focuses on the turn of events in Jenin unfolding around a boy called Ahmed and his family.

The film opens with a view of the waves of the Mediterranean, rolling in over a deserted sandy beach in the silvery light of a pale moon. The rushing of the waves is accompanied by the words of a local poet, recited in a melodic Arabic and translated into English in the subtitles:

> Your face painted with
> The words of Allah on the red foam
> Half murdered
> Quarter transparent
> And the rest written in grass
> Stretched to the dawn
> To be read in the pulse
> A moon bleeding clouds[16]

The recitation is followed by a procession of images from present-day Palestine: the ever-present wall between Israeli and Palestinian territory; people in transit at checkpoints; graffiti art on the wall; and a young boy playing football, smiling. This is Ahmed. From this initial encounter, the story moves on to Jenin Camp and the living room of the family Khatib. Ahmed's father, Ismail Khatib, urges his wife to tell the story, saying: "It's better you tell her, you have style and talk better. They will appreciate a woman speaking." The mother, Abla Khatib, modestly adjusts her veil and hesitates, but resolutely sits down, facing Parsberg and the camera. Her tormented gaze meets the camera and she speaks in a low, plain voice, telling the story of how the life of her son was lost.

On that day, Ahmed was 12 years old and, as any ordinary day, he went out to play with his friends. This time, however, his friends returned only a short while later, anxiously telling the mother that Ahmed had been shot by Israeli snipers. Ahmed had received two mortal bullet wounds, one in the head and one in the waist. The boy was immediately taken to the local hospital, but as the severity of his condition was established, he was transferred to the larger and better-equipped Rambam Hospital in Haifa, Israel. Abla Khatib recounts how she rushed to the hospital only to find her son dying, bleeding to death before her eyes. Ahmed was still breathing, but all other vital bodily functions had ceased; he was clinically dead. This tragedy caused his mother to collapse, and she says: "When I saw this, my legs wouldn't carry me."

In a sequence that powerfully portrays the feebleness of human life and the vulnerability of parents who are inseparably bound by love to their children, the camera rests on the motionless, distressed face of the mother for what seems to be an eternity. The red silhouette of a dead boy's body moves across the screen, over her heartbroken eyes, which she slowly closes. Her entire being radiates overwhelming pain and sorrow; she seems tired and disoriented. But she continues to tell the story to the camera. As the parents realized that their son would not recover or ever return to consciousness, they made the groundbreaking decision to donate his organs to the Israeli hospital. The reasons behind this courageous and surprising act were, according to Abla Khatib, both private and political. For her husband Ismail, the death of his son brought back painful memories from the past: as a young boy, he had lost his brother to a fatal kidney disease because no donor was found to facilitate the badly needed organ transplantation. The decision was also inspired by the current situation in Palestine, the mother adds: their act was intended as a message of peace to Israel and the rest of the world. "We Palestinians love peace and we are not terrorists or killers," she says emphatically. Thus, their wish was that the organs of their dead child be used for the benefit of any person in need, regardless of religion.

The camera moves along the brightly lit morning streets of Jenin, stopping at a nearby cemetery. Two young boys have paused there on their way to school, satchels thrown on the dusty pathway, to clean earth and dried leaves from a grave with their hands. They smile timidly as the camera

approaches. One of the boys is holding a picture in his hand, and at Pars-berg's request he shows it to the camera. It is Ahmed. The sound of a beating heart overtakes the scene, a rhythmical and persistent pulse accompanied by the image of a red heart muscle. The heart, it seems, is flying through the streets of Jenin, approaching the wall. At one place, the wall has been decorated with graffiti; a man pulls open the concrete like opening a heavy curtain to let in the sunlight. Suddenly, the heart pushes its way through the opening and out in the open air, floating freely away across the sky.

A map shows the route of the heart: following the Israeli coast to the north and landing in the Druze[17] village of Peki'in. The first image catch-ing the attention of the camera in this village is a gigantic pomegranate tree swaying softly in the wind. Nearby, a young woman is sitting in the back seat of a car, holding a shy and giggling girl in her arms. This is Samah, sitting next to her older sister Hanadi. "She changed her heart without say-ing *ay*," Hanadi explains, tenderly caressing her sister's long, curly hair. Ahmed's traveling heart had found its destination in Samah's chest.

Samah is the daughter of the Druze family Gadban, whose home opens up to the camera as a lively, noisy, and welcoming place. Samah's father Riyad is constantly singing, talking, or playing his ney flute, and a number of younger and older siblings come and go in the open rooms. The mother of the house, Yossor, is bustling about in the kitchen, filling a large spoon with pills in different colors and sizes. "Come take your medicine. Come on, *jalla*!" she calls out to Samah, who reluctantly enters the kitchen, takes a glass of water, and swallows a mouthful of medicine with one eye on the TV. This is the only instance in the film revealing the serious heart condition Samah suffers from, a disease that would have ended her life had it not been for the new heart she received from Palestine. In all other scenes, she seems to impersonate health, joy of living, strength, and happiness. She boxes jok-ingly with the camera, laughs and clowns about, plays football in the street, wrestles with and kisses her little sister, jumps in the waves of the sea. The family seems to take her illness, the transplantation and the ties of gratitude that now binds them to a Muslim family with cheerful humor. Perhaps, you will start throwing stones now, her mother jokes one evening as they gather in the living room. "Before she changed her heart she was a small, kind girl," her father teasingly complains. "Now she is a very strong and crazy girl, after she changed her heart. The heart of the Palestinian boy, from Jenin."

Samah herself seems to have a practical take on the new situation: as her body now, in a very concrete sense, harbors the Palestinian boy's heart, she also regards herself as part of his family, addressing Ahmed's parents as Mother and Father and keeping up regular contact with them. The family Khatib, on their part, seems to greet her with open arms. The conversations portrayed in the film—over the phone as well as during eye-to-eye encoun-ters—are carried out in a warm and caring spirit. Samah tells them over the phone how much she misses them. "We miss you more," they reply. Despite Samah's playful mood—the jokes and the air of happiness—it becomes clear

that the Gadban family is deeply aware of the gravity of the situation and the immeasurable value of the gift they have received. The oldest son in the family, Sameh, died from the same heart condition years earlier as no heart donor was found, or in the words of his father, "There was no gift." The parallel to Ahmed's family is striking: just the same, there was no gift for Ahmed's uncle, the brother of Ismail Khatib, when he needed kidney transplantation. The shared experience of losing a family member due to similar circumstances makes the value of the gift seem even more immeasurable.

Because for Samah there was the gift of Ahmed's heart, and now the two families are tied to one another in a bond of mutual trust and unity. Indeed, these seem to have been prominent values in the Gadban family already before the interreligious heart transplantation. Samah's father Riyad Gadban is an active promoter of interreligious understanding at the local level, inviting Jewish and Muslim school children to a small exhibition hall adjacent to his home. Here, the groups get to experience a presentation of the Druze religion and its traditions presented through images, music, dance, and food. His motivation comes from the wish to fight against prejudices, to improve the relationship between Israelis and Palestinians of different faiths, and to inform children about the shared roots of the Abrahamic traditions: the prophets are the same and the people are the same, he asserts. Looking straight into the camera he gives a short summary of his philosophy of life: For me, he says, you are not a stranger but a human being. That means I must give you full respect, so that you can feel human like me. This is the basic rule of life.

*A Heart from Jenin* portrays the tragic loss of the life of a child through violence and the life-saving consequences of a courageous act carried out by grief-stricken parents. According to the peace researcher Marc Gopin, occasional reports from Palestine present stories of interreligious heart transplants. Thus, the practice seems to be more widespread than the event caught in Parsberg's film. In Gopin's view, such startling, compassionate gestures become powerful incarnations of common humanity. The image of grieving parents who create tangible symbols of unity and trust in the bodies of their loved ones is strong and jarring.[18] Thus Parsberg's film, where the heart becomes a symbolic image of dialogue and empathy crossing the lines of faith can be regarded as a poignant and urgent account, touching upon several vital questions relevant within the broader discussions initiated in this book. The film ends as it began: with the waves of the Mediterranean rolling in over nightly shores and a poem of Ahmed recited by a local Palestinian poet:

Ahmed, how will my memory begin the thought of you?
Patience of water, purified with blood.
Dryness of an eye, behind the gun sight, chasing your head [. . .]
How do I embrace you? A rose for the wounds when you are the garden in absence.
How do I walk toward your grave when you are buried in my heart without your heart?[19]

## KEY THEME: EMBODIMENT

The key theme of this chapter, embodiment, is tangibly illustrated in Parsberg's documentary film. A heart transplant joins together families living on different sides of the wall that today has become the root metaphor of one of the most enduring conflicts between cultures, religions, and neighboring communities of our time. The film presents a visual confirmation of the claim that art as practical theology gives physical, visceral, or sensual form to abstract concepts and ideas. By doing so, it opens up new possibilities for experiencing and understanding other human beings, but it also offers a forum for addressing questions of ultimate, existential importance. This, in turn, can eventually facilitate a transformation of previous perspectives and points of view. Parsberg's documentary moves the tragedies of the Israeli-Palestinian conflict from the hypothetical and theoretical level to the deeply personal, presenting a thoroughly embodied vision of reconciliation, hope, and beauty.

The embodied character of the theological vision presented in this documentary is above all tied to the extraordinary symbolic meanings attached to the heart in cultures and traditions all over the world. A simple definition of a symbol describes it as an object, a word, an image, or a role that conveys something *more* than the obvious features meeting the eye at first glance. A symbol stretches beyond the immediately given, to something richer in meaning. It describes a situation or a person, conveying the meaning it has for us, and the emotions it awakes.[20] As such, symbols are signs of various, at times ambiguous, meanings incorporating emotional qualities as well as cultural norms and personal interpretations. They allow one to come in touch with aspects of reality that are unreachable to other, more straightforward forms of inquiry; they open up gateways to the existential realms of human life where questions of ultimate concern can be dealt with in ways that are both deeply personal and simultaneously related to religious and cultural traditions.[21]

Due to their multifaceted character, symbols can become important elements in intercultural and interreligious exchange.[22] Returning to Ahmed and Samah, the heart symbol that connects their stories represents a powerful interpretive image with meanings stretching over the limits of time, cultures, and religions. Even though the symbol has been "muted by sentimentalism" in contemporary popular culture, it is a pervasive and globally recognized image.[23] In the film, several symbolic aspects come into play as the heart symbol is used both explicitly and implicitly to form an embodied piece of art. In the film, the idea of the heart as the bodily location of our emotions—of wisdom and compassion, love, trust, and affection—is combined with very physical and concrete images of a heart. As commonly in everyday usage and figurative speech, the bodily organ is certainly relevant for the comprehensive symbolism evoked by the use of the heart in this film. The beating heart maintains life; it denotes energy, strength, vitality, and power pulsing through the veins of an active being.[24]

The heart is a pertinent focal point of the story of Ahmed and Samah, saturated as it is by ethical implications and emotions. The film alludes to general ideas of the heart as an emotional center for goodness, bravery, truthfulness, and love as well as the more tangible symbolism of the red, pulsating, and bleeding heart muscle that enters the screen intermittently, often accompanied by the sound of anxious heartbeats. But the symbol can also be understood from an internal perspective. Ahmed's heart develops from a common, almost banal and worn-out symbol to a personal and pressing image. Ahmed's mother utilizes the heart as a message of peace. Ahmed's father makes it a posthumous tribute to his late brother. Samah radiates with joy simply because the heart works as it should. And Samah's father transforms it into an interreligious bond between the families and an ongoing symbol of his community work of peace and understanding.

The almost brutal tangibility of the bleeding heart thus allows for inner as well as outer transformations, brought to the fore by the artistic medium of the film. As highlighted by K. E. Løgstrup, artworks often incorporate a transformative capacity: the aesthetic expression can make a reader, an interlocutor, or a spectator sensitive to realities other than her or his own.[25] The symbolic element of the heart as embodied in the film harbors the ability to initiate a transformation of boundaries between self and other, family and enemy, identification and otherness—all central aspects of the theoretical framework developed in this book.

The poems recited in the film offer another source of tangible embodiment in this piece of art. Words that *remember* the bleeding heart abound in the dramatic readings distributed throughout the film: "The words of Allah on the red foam" are brought forth under "a moon bleeding clouds," and the memory of Ahmed is said to begin with the "patience of water, purified with blood." Furthermore, the poet uses painfully straightforward language lacking any soothing paraphrases when describing the violence inflicted on Ahmed's body: he is described as "half murdered" and thus made "quarter transparent" by the perpetrator, who, with dry eyes behind the gun sight, chased his target's head. The death of Ahmed brings about a very concrete absence, a lack of qualified presence and an empty space in existence. How, the poet asks, can a rose be dedicated to the memory of his wounds when Ahmed in fact is the entire "garden in absence"? The concluding line of one of the poems recited in the film gives harrowing testimony to the universal experience of infinite sorrow and physical pain caused by the loss of an irreplaceable individual, contextualized in the story of Ahmed and his lost heart: "How do I walk toward your grave when you are buried in my heart without your heart?" To call the story heartbreaking is thus descriptive in more than a metaphoric sense in this richly embodied narrative.

To conclude, the artistic treatment of the tragic but hope-rendering story of Ahmed in Parsberg's film brings to mind the fundamentally embodied understanding of otherness, represented by Buber and the feminist theologians discussed in the introductory section of this book. To them, the

other is both a basic aspect of human existence as such and a thoroughly tangible Other—another person of flesh and blood. The subject of the film is not Palestinian identity in general; the story is about Ahmed and Samah. In this context, it is important to recollect Buber's acknowledgment that no dialogue is acted out in a vacuum. Rather, he claims a person "gains his world by seeing, listening, feeling, forming."[26] This embodied character of interpersonal encounters, we argue, can be illustrated in a clearer relief within artistic frameworks such as Parsberg's film.

## THE GIFTS OF TRUST AND MERCY

Among the other key elements identified in the introductory chapters of this book that are made topical by the film *A Heart from Jenin*, the most relevant include the notion of trust as well as the phrase "mercy" introduced by Parsberg herself. A thought-provoking allusion can be drawn between Løgstrup's ethics of trust and interdependence, on the one hand, and Parsberg's film on the other. Løgstrup described trust as an encounter where one is willing to take the risk of placing something of one's own life in the hands of another person.[27] In this film, it is the very real heart of a murdered child that is literally and figuratively placed in the hands of the enemy, giving a thoroughly embodied example of what Løgstrup's existential claim might mean in practice. Hence, the mutual trust discussed by Løgstrup, but also Emmanuel Levinas, is powerfully enacted and exemplified in the film.

The acts and emotions represented in the film can be rendered comprehensible through the idea of interdependence presented by these two philosophers. They can also be understood in relation to the idea of a basic trust toward human beings in general, not only toward close and loved ones but also strangers on the other side of the wall (the one of steel and concrete surrounding the West Bank, but also walls of cultural and religious difference). The story of the traveling heart begins, to paraphrase Levinas, with the face of the other calling from afar, and this personalized and familiarized stranger is not satisfied with anything less than a *whole-hearted* and engaged answer. The spirit of togetherness uniting the two families, facilitated by the offering and accepting of an extraordinary gift, gives concrete testimony to how human beings "indeed constitute one another's world and destiny."[28]

Cecilia Parsberg herself regards the theme of the gift as central to her film. In an interview, she comments on the role of the gift, tying it to the discourse of trust as well as to the concept of mercy. The latter concept is especially interesting in this context, as Parsberg does not regard herself as religious in any traditional sense. Still, she feels that this religiously saturated notion provides the most accurate and meaningful description of the transformative process depicted in her film.

A gift, Parsberg holds, is a personal expression of one's need to give. Thus, the gift comes into being only in the moment that it is received. In

a society so strictly governed by rules of friends and foes, it was not self-evident that the Palestinian family would find such a receiver on the other side of the wall. Indeed, both families had previously experienced that in the death of other family members. The Khatib family was able to give the heart only because someone was willing to receive it.[29] The heart of the matter, we can aptly conclude with Jean-Luc Marion, lies not in the object being transferred but in its *givability*.[30]

Parsberg has developed this idea of the reciprocity and shared mercy tied to giving and receiving gifts in a sermon she delivered in a Lutheran church in Stockholm on the first Sunday in Advent, 2007. By showing the film, she explains she wants to demonstrate how ordinary people have the power to create new possibilities and attachments. These two families demonstrate how a gift, if it is received, can force an opening in walls that separate persons.[31] Thus, the *givenness* of this act of courage and peace opens a new horizon of visibility, yielding to "the joy beneath my heart, this thing in us that gives."[32]

Parsberg uses the word "mercy" to describe the unfathomable and unpredictable circumstances surrounding this gift. This is an apt expression for the transformative power of art discussed in the book. The complex circumstances surrounding the heart transplant are depicted in a way that illuminates the centrality of giving rather than the gift itself, as the process includes both things to be given and selves to do the giving and receiving. In the words of Marion, the experience includes the giver's decision to give the gift but also, and even more importantly, "givability deciding the giver to give."[33] For the Gadban family, the heart becomes a mercy liberating their daughter from a fatal disease; for the Khatib family, the heart becomes a mercy liberating them from hatred, vengeance, and suffering. To quote Parsberg's conclusion:

> The gift, as mercy, intervenes in life without demanding a favor in return. It happens because it is necessary; therefore, it is an intervention of love. [. . .] Mercy intervenes and helps this family not to hate, something happens that we could not have foreseen, planned or deserved. Therefore, no one is judged—mercy is for all.[34]

The notions of trust and mercy can also be understood in relation to Levinas's description of the Face presented elsewhere. The Other is characterized above all by its having a Face. By resisting its powers and representing the otherwise, the Face of the Other presents the self with a personal demand for recognition and trust. This perspective also adds an inherently moral dimension to the encounter as the Face of the Other, which, in Levinas's words "tolerates only a personal response, that is, an ethical act."[35] Thus, the transformative process of encountering the Other is asymmetrical in Levinas's view: the Other summons the self and posits it as responsible by demanding a "non-indifferent" response.[36] This is the kind of trust that is portrayed in Parsberg's film. By making themselves vulnerable to the quintessential Others of their concrete situation and by acknowledging their

rights as ethical subjects, the families involved in the interreligious heart transplant can be said to illustrate the basic ideas of the practical, ethically informed, theology of the arts proposed in this book. The vulnerability of their situations can only be bridged by trust, and the reciprocal reply by the Other can only be anticipated as mercy.

This way of understanding the interpersonal relationships portrayed in the film *A Heart from Jenin* reflects our earlier discussions of acknowledging the *voices* of those who had been silenced. The film constitutes a forum where the voices of the Gadban and Khatib families can be heard in a very concrete and embodied sense. The radical contextualization of the symbol of the heart in the realized lives of these two neighboring—yet historically alienated—families creates a new, transformed interreligious family through the *givenness* of this very real drama in a war-torn culture.

## Theology and the Body

The film *A Heart from Jenin* produced by the Swedish visual artist Cecilia Parsberg illustrates how themes such as embodiment, trust, and mercy come into play in the practical theology of the arts we propose. The film embodies the move from *written* to *oral*, from *universal* to *particular*, from *general* to *local*, and from *timeless* to *timely*, proposed by Walter Brueggemann in the introductory chapter as key characteristics of contemporary imaginative approaches to theology and the arts.[37] The story is deeply embedded in a specific time and place; it is embodied and gendered, narrated in an oral way rather than documented in script; it is emotional and extremely personal. Yet, it speaks to a universal audience and engages in ethical questions of timeless relevance. Hence, it presents a transformative perspective on interpersonal encounters.

Parsberg's film aptly illustrates John W. de Gruchy's vision of theological aesthetics, presented in chapter 1, where art becomes "a form of protest against the ills, the meaninglessness, and the blind hypocrisies of society, rather than support for them."[38] Art as a medium of transformation that can enable disadvantaged communities to find ways of expressing their voice— and be heard—is central to his vision of an ethically and socially engaged theology of the arts. All art is contextually bound, he underlines; it is formed by the artist, her or his personality and artistic merit, but also by the cultural and religious context as well as the political, social, and economic frameworks within which the artistic process takes place. Key values in such creative processes are the democratic strivings to honor and advance human freedom and public good, he concludes.[39] In our view, these values find a tangible expression in the film *A Heart from Jenin*.

# 9 Music as an Attentive and Creative Interplay

> Music becomes the indispensible means of achieving a genuine intercultural dialogue between human beings from very different nations and religions, but who nevertheless share a common language of music, spirituality and beauty.[1]

These hopeful words can be read in the program booklet accompanying the CD recording of the concert project *Jerusalem: The City of the Two Peaces*—a musical journey to the capital of holy union and bitter conflict between the three Abrahamic faiths: Judaism, Christianity, and Islam. The driving force behind this musical encounter, viol player, conductor, and early music specialist Jordi Savall has for several years dedicated his artistic efforts to creating musical projects with intercultural and interreligious aims. Hence, *Jerusalem* does not only unite melodies, traditions, sentiments, and images of holiness shared by the three religions in a musical encounter. It is also a very practical encounter between musicians who represent different viewpoints and relationships to this holy city: men and women, young and old, instrumentalists and vocalists, Jews, Christians and Muslims, Europeans, Israelis, Palestinians, Syrians, Armenians, Iraqis.

In Savall's vision, music is used as a tool for bringing together persons of different faiths, in line with the ideal expressed by the artist in the introductory quote. The concert *Jerusalem* is a tangible expression of how religious similarities and difference can coexist and become mutually transformative in a fruitful, practical way. In our interpretation, Savall's vision of musical dialogue takes form as a union of integrity and interdependence distinguishing the dialogical encounter from the polemical, conversional, compliant, or competitive one.

Jordi Savall, born in Catalonia in 1941, discovered music at a young age and specialized in early music at *Schola Cantorum Basiliensis* in Switzerland, his main instrument being the viola da gamba.[2] The rediscovery of neglected musical treasures of the past has developed into a lifetime project for Savall, including research work and writing as well as interpreting, directing, and performing early music; organizing concert projects; and recordings. His eager work has led to a considerable renaissance for historical music in

general and the viola da gamba as an instrument in particular. Above all, Alain Corneau's film *Tous le matins du monde* brought world fame to Savall in 1991: more than one million copies of the sound track were sold, and Savall received the French César film award for the film music. Together with his wife, the soprano Montserrat Figueras, Savall has formed several successful ensembles to promote music from the medieval, renaissance, and baroque eras. He has also created a global channel for early music through his record label Alia Vox.[3]

Jordi Savall is a versatile and active musician, giving around 140 concerts worldwide and implementing approximately 6 recording projects each year. Several of Savall's latest projects have focused on interreligious dialogue and peace, resulting in comprehensive recordings accompanied by so-called CD-books where the music is presented alongside original texts from the time, comments by artists and researchers, images and photographs. "History without music is something very cold," Savall states.[4] Therefore, he regards historical research and the artistic expression as intrinsically interdependent. Music, however, is no absolute science, Savall underlines: "Music is art; and creative art at that." Creativity rather than authenticity is thus the main focus of his musical vision: being as faithful as possible to the historical heritage but simultaneously striving to present the music to the audience in all its beauty and in a fashion that speaks expressively to contemporary listeners.[5]

This chapter focuses on Savall's *Jerusalem* and analyzes the potential of this concert project to embody and exemplify the kind of practical theology of the arts explored in this book. The group of musicians taking part in performing the concert can, we argue, be understood as one of those communities of truth where difference prevails while a transformation toward greater understanding proceeds—through responsible action and engagement but also through creative and playful improvisation. Above all, the focus of this chapter is directed toward the dimension of *praxis* as a key aspect of the particular practical theology of the arts proposed in this book. The following presentation and discussion of the concert is based on personal experiences of the concert at the world premiere in Barcelona in April 2008 and in Helsinki three years later: in September 2011. Furthermore, the chapter is based on an in-depth interview conducted with the maestro on the day of the opening concert in Barcelona as well as on a number of published interviews and texts written by Savall himself.[6]

## JERUSALEM: THE CITY OF THE TWO PEACES

The extensive concert project *Jerusalem: The City of the Two Peaces*, which serves as the empirical focal point of this chapter, was initiated in 2007 by La Cité de la Musique in Paris. The concert organizers invited Jordi Savall to prepare a project on the three major monotheistic religions of Judaism, Christianity, and Islam, and Savall took the challenge to implement a vision

he had developed in his mind for several years.[7] According to Savall, the rich mythologies and religious history of Jerusalem soon appeared as the ideal focus of such an effort. For thousands of years, and even today, he claims:

> [Jerusalem] continues to mark the limits and weaknesses of our civiliza-
> tion, particularly amid the search for a peace that is just and valid for
> all, and the difficulty in reaching agreement between East and West on
> the very principles of the true spiritual dimension of humanity.[8]

The commission soon developed into one of the largest projects undertaken by Savall and his musical team, including his late wife Montserrat Figueras; the poet and researcher Manuel Forcano; Savall's own ensembles La Capella Reial de Catalunya and Hespèrion XXI; as well as individual musicians and singers from a multitude of countries, musical traditions, and religious backgrounds. The world premiere was given in Savall's hometown of Barcelona in April 2008. The concert is still included in the repertoire of the artist and has by now toured all over the world. It was also performed in Jerusalem in June 2008. The concert was recorded in November 2008 and is available as a double CD accompanied by a comprehensive concert presentation of more than 400 pages in eight languages (including several European languages, Hebrew, and Arabic).

The notion of the "two peaces" included in the title of the project refers to one possible etymological interpretation of the Hebrew word for Jerusalem where, according to Manuel Forcano, a metaphorical reference both to a "heavenly peace" and an "earthly peace" can be discerned. "Desired by all," Forcano writes in his presentation of the concert repertoire, "she has been the goal, aim and destination of pilgrims of all persuasions who flock to her gates in peace, but also the objective of soldiers and armies in pursuit of war." Thus, Jerusalem can be seen as "a holy city or a city bedeviled."[9] According to Savall, the project is a sincere and warm tribute to a city that has always been a sacred, mythical place for the Abrahamic religions. The urgency of the topic is reflected in the intense engagement shown by all participating musicians, whose personal commitment to the idea Savall describes as "crucial and decisive."[10] Furthermore, Savall regards the project as a response to the pressing need for communication and understanding he sees in the world today. In his opinion, the only hope for the planet today lies in a cultural dialogue of equals where no single party is dominant, but all traditions are allowed to have their say. To create possibilities for such creative encounters is therefore one of the key motivations for Savall and his team: "We strongly believe that one of our responsibilities as musicians is to contribute to building bridges."[11]

The music included in the concert presents the history of Jerusalem as a Jewish, a Christian, an Arab, and an Ottoman city. Furthermore, Jerusalem is portrayed as the city of peace and conflict, of asylum and exile. The concert also presents the Jewish and Armenian genocides as well as the

Palestinian exile of today. The concert is divided into seven sequences, each reflecting a key moment in the history of the city. For Savall, the project represents a reflection on the origin of the current conflict, a vision of the world: a way of sensing the heart of monotheistic spirituality and of approaching the religious other.[12]

In the following, a brief outline of the concert structure is described. Thereafter, it is analyzed in greater detail in the following section of the chapter. It is clear that the concert structure has varied somewhat between the different empirical vantage points used in this analysis; during the three-and-a-half years that passed between the performance in Barcelona, the recording, and the tour to Finland, the program has naturally been developed and modified due to practical considerations and new ideas—improvisation is, after all, a key element in this musical encounter.

The concert starts by the sudden, archaic sound of a single shofar: a roaring cry that is soon answered by several other rams' horns and medieval drums beating a captivating rhythm from balconies on both sides of the stage. This is the "Fanfare of Jericho," a reconstruction of the sounds that tore down the walls of this city more than 3,000 years ago. After the powerful introduction on shofar, the singers of the troop recite prophecies about the coming, heavenly Jerusalem from Jewish, Muslim, and Christian sources, beginning in biblical times and ending with the history of the early Israelites. In this section, for example, Sibylline oracles are sung in Greek, and texts from the Qur'an are recited in Arabic according to traditional Sufi melodies. Biblical psalms are recited in a melodious Hebrew, rejoicing over the peace of Jerusalem as well as lamenting the destruction of the Second Temple and the beginning of the diaspora. "Pray for the peace of Jerusalem: May they prosper who love you!" The recitals are performed by professional singers who form the traditional melodies into a musical experience of highest quality.[13]

As the concert moves forward in the complex historical landscape of Jerusalem, the Jewish and the early Muslim eras come to an abrupt close as a sermon by Pope Urban II (1042–1099) is bellowed out in the concert hall, summoning Christians to take up arms and liberate the Holy Land. The air turns anguished and hostile as the singers and musicians of La Capella Reial de Catalunya, performing the belligerent melodies of the crusaders, rise and circle around the small group of Jewish and Muslim musicians sitting in the middle of the stage. Shortly thereafter, another shift in atmosphere is created as the era of Arab rule in Jerusalem is introduced by a joyful improvisation between the musicians in the group.

As the concert moves into the modern history of Jerusalem, the atrocities of the last century enter the scene. The concert narrator recites the shattering poem "Jerusalem" by Yehuda Amichai depicting the mutual estrangement and sorrow uniting people living on both sides of the divided city. After this, a traditional Palestinian lamentation from the Galilee is followed by an Armenian litany mourning the genocide of its people.[14] The deepest and

darkest point of sorrowful mourning is reached as a historical recording of "El Male Rahamim" fills the concert hall, performed by Shlomo Katz who had recited this Kaddish in Auschwitz in 1941 and later recorded it, just after the end of the war.

After a dark an anguished pause, the lights return to the stage, and the concert moves on to a brighter, more positive finale. The concert *Jerusalem* thus develops into a spiritual journey through bright landscapes of hope as well as dark valleys of despair. The optimistic conclusion is formed around a shared hope and a shared responsibility. Psalm 122 is given voice anew, praying for the peace of Jerusalem, and al-Ghazzali's hopeful poems are sung as they have been recited by Jews, Christians, and Muslims over centuries. The concert ends where it began with the impressive fanfare of the shofars: this time, not to tear down the walls of Jericho but to tear down the walls constructed in and by the human mind.

## KEY THEME: ENGAGING IN PRACTICE

As can be apprehended from the description above, *Jerusalem* is a concert that unites musicians and musical traditions from different religious realms and cultural spheres. However, this unity is not achieved by unassumingly mixing together styles from different traditions and times, nor by simply presenting one tradition after another as clearly separated blocks. The unity achieved through this musical dialogue moves beyond such easy solutions and achieves something richer. Furthermore, one of the most prominent features of this musical dialogue is its tangible presence: the interaction on stage offers a thoroughly concrete image of a transformative intercultural and interreligious encounter to the audience. Similarities and differences are preserved but also challenged in this playful encounter where different images of the divine are shared in an evolving conversation between the musicians, the traditions, and the audience within the symbolic framework of the Jerusalem narrative.

Jordi Savall's vision of music as a transformative practice in multireligious contexts exemplifies the line of thought presented in this book: where ethical, practical, and creative elements are given centrality in the structuring of a contemporary practical theology of the arts. To Savall, a profession in music is the best training available for a dialogue between cultures and religions because it teaches you to listen and to respect difference. "As a musician, the first thing you have to learn is dialogue," he states.[15] In Savall's view, one cannot make music together with someone for whom one does not feel sympathy and friendship. Musicians must always tune their instruments together and play in the same tempo—but still they play different instruments in their own personal way. Autonomy and dependence are intertwined in Savall's vision of dialogue: we are all different, but through music we can communicate without losing our individuality. Thus, neither difference nor similarity is seen as an essential quality but as far ends on a

common relational scale of profound striving for the common good. Both poles are needed, but for Savall, it is the musical journey between them that counts as the transformative practice of dialogue.

Hence, *Jerusalem* should not be understood as a simple compilation of sounds and thoughts from here and there. Indeed, Savall has taken great pains to bring forth the unique voice of all traditions, pointing to their shared images of the divine, of human beings, and of peace as a spiritual and earthly goal. Musical dialogue projects should not, however, aim at presenting only the sounds that are shared, he maintains, but boldly step into the area where traditions collide. Thus, he is guided by the wish to share but not to mix.[16] In connection to an earlier intercultural recording project, *Orient-Occident* from 2006, Savall has emphasized his wish to avoid the "superficialities of cultural crossover, instead endeavoring to re-establish a dialogue that respects the musical identity of each of those spaces and cultures" represented in the program.[17]

Savall's reluctance toward crossover, mixing and fusing traditions is worth noting. Voices are like human beings, he claims: no two are alike, and they may attract or repel in ways we cannot foresee.[18] In the concert *Jerusalem*, this principle is innovatively put into practice by the musicians who remain firmly within the frames of their own traditions but still manage to perform together in a meaningful way. The audience is not presented with an ahistorical blur of genres but with a genuine dialogue through music where the artists listen to one another carefully and humbly follow the melodies of the other without sacrificing their own unique voices. A Sufi dancer whirls across the stage in response to the beat of a Jewish drum. A chant reminiscent of the *muezzin*'s call to prayer from the minaret is followed by recitals from Sephardic texts. The diversity of the performance is not random or chaotic; it is, rather, a meaningful representation of unity in diversity.

Savall's thoughts closely resemble the Buberian perspective introduced in the introductory chapters. The challenge of dialogue, in this view, lies in finding a prolific balance between bonding and autonomy: to create a space where the participants can feel united with one another, can care for others and be cared for, but at the same time find a space to express their own unique individuality and encounter the emergence of truth. As stated before: similarity and difference are complementary elements in dialogue as such an undertaking requires two separate parties who are autonomously themselves but still able to create a community where the integrity and voices of both parties are honored. Under such circumstances, dialogue can grow into a fruitful interplay among similarities and differences where the other is allowed to remain in her otherness while also being welcomed to share the world of the I.[19] In projects like *Jerusalem*, the musicians come from different backgrounds, and they regard their music in different ways. This is no problem to Savall, who rather regards this alterity as an advantage to respect and cherish. By focusing on the tangible practice of music, difference is transformed from a limitation to a positive likelihood.

Not only does the emphasis on practice give Savall an opportunity to demonstrate transformative encounters in the making; it also offers a context in which the inhumane atrocities and acts of violent hate that have lined the history of Jerusalem can be presented and acknowledged in a reconciliatory and respectful manner. The community created during the performance of the concert, including the musicians as well as the audience, is open and inclusive enough to bear the weight of feelings of despair and destruction, brought to the fore at certain, dark points in the musical exposé. Furthermore, the concert does not become a "competition in suffering" as no comparative perspective is applied: suffering and loss is respected and acknowledged in all its forms.

Therefore, the concert project *Jerusalem* can be understood as a way of demonstrating how complex emotions and hostile pre-understandings— what Gadamer would call prejudice—can be dealt with in a creative context of shared practice. Savall strongly emphasizes that music and other art forms can bring inspiring elements to dialogue, thus giving expression to the inexpressible and making the partakers sensitive to the "artistic and spiritual value of the intangible."[20]

Savall's approach to art in general and music in specific as a spiritual bridge between human beings and the divine shows great similarity with the arguments for a practical theology of the arts put forward by Jeremy Begbie, introduced in chapter 3. As noted there, Begbie holds that music is particularly proficient in bringing forth the spiritual dimension of the human encounter with the divine, offering a way to express such experiences and to share them with others.[21] Both Begbie and Savall regard dogmatic frameworks as second in interest and importance to the engaged practice of persons, laypersons as well as professional theologians, who embody their faith within the variegated framework of music, ranging from the immortal overtures of great composers to the simple melodies of solitary prayers. For Begbie, practicing theology meant "fostering a wisdom" that could guide actions and decisions in everyday life. The role of the arts in this process was imperative, he claimed, as they offered a context rather than a text, a set of practices rather than cognitive claims.[22]

Begbie insists that art is not bound to the spoken word, exact definitions, and rational solutions. Rather, art can engage all the senses, taking the dialogue to a higher dimension, which Savall calls spiritual. Music goes directly to our hearts, he believes, and therefore we cannot tell lies with music as we can with words.[23] Perhaps, this is why the practical treatment of distressing themes such as exile, human suffering, and injustice become so powerfully moving in the *Jerusalem* concert: through the music, feelings of anguish and hopelessness are brought to the fore, but these streams are united with the growing current of hope and anticipation as the concert proceeds toward increased understanding, unity, and peace. Such an emotional transformation can be experienced during the recitation of the biblical psalms early in the concert. The passionate interpretation of the Hebrew psalms depicting

the exile and suffering of the Jewish people in history—in Barcelona performed by Dvir Cohen, in Helsinki by Lior Elmalich—is accompanied on ney flute by Usama Ghanayim Abu Ali, a Palestinian currently living the exile of his own people so closely tied to the very same story. But the musicians refuse to surrender to past and present atrocities, performing their music together in spite of the sordid history each community has experienced. The musical interplay becomes a powerful and moving image of the reciprocal and respectful dialogue that tears down walls of estrangement, leaving aside for the moment the burning question of who is right and who is wrong, who owns the land and who does not, merely expressing a joint acknowledgment of the pains and losses suffered on both sides.

The shared remorse over lives lost through human hatred, violence, and war becomes even more palpable in the section of the concert dealing with the atrocities and genocides of the 20th century. As mentioned above, this section joins together a Palestinian lament, following a distinctly Qur'anic reference to yielding to divine consolation, with a lament for the Armenian—Christian—victims of the early 20th-century genocide in the city of Ani and, finally, with one of the most mournful laments known to Jewish liturgy, "El Male Rahamim." It also includes a reading of the poem "Jerusalem," written by the Israeli poet and peace activist Yehuda Amichai. In a few lines, Amichai captures the essence of how the distrust and division that rules in Jerusalem to this day tears down human spirits on both sides of the wall and equally denies all of its inhabitants their human dignity.

> On a roof in the Old City
> laundry hanging in the late afternoon sunlight:
> the white sheet of a woman who is my enemy,
> the towel of a man who is my enemy,
> to wipe off the sweat of his brow.
> In the sky of the Old City
> a kite.
> At the other end of the string,
> a child
> I can't see
> because of the wall.
> We have put up many flags,
> they have put up many flags.
> To make us think that they're happy.
> To make them think that we're happy.[24]

At many levels, the poem of Amichai can be seen to fill the role assigned to art by Savall in his intercultural project of creative dialogue; it succeeds in expressing the inexpressible and opening a door for the audience to experience the "value of the intangible," to use Savall's own phrase. In the words of the poet, the tragedy of what has become ordinary life and mundane

observations in the divided city becomes devastatingly obvious. This impression becomes even more powerful as the lights on the stage die out, and the traditional Jewish prayer "El Male Rahamim" is presented. In the wording it is given at this specific occasion, the Kaddish is recited for those who were "murdered, slaughtered, burnt and exterminated for the Sanctification of the Name" in the Nazi concentration camps fills the concert hall.[25] Sitting in the audience, one is overwhelmed by a feeling of heartbreaking despair. But even these unfathomable crimes committed by human beings against one another in history can be shared in this trustful context. The dialogue witnessed on stage does not dissipate as the topics become too devastating—on the contrary, the interaction between the musicians creates a space where the voices of the suffering from all traditions can be acknowledged, respected, and heard.

On a more positive and playful note, the generous space given to improvisation and cross-cultural creativity within the frames of *Jerusalem* illustrates the visions of shared praxis and tangible transformation proposed as part of the practical theology of the arts in this study. The theological approach suggested by Savall in his project takes form as a shared praxis on the stage: the musicians perform rhythms, melodies and lyrics from their respective traditions but also accompany the musical performances of one another, thus taking part in shaping the praxis well outside the borders of any given tradition. Above all, a creative element is introduced through the many improvisatory bridges built between and within different elements of the concert.

As mentioned above, the brutal and militaristic melodies of the Crusaders introduce a threatening atmosphere in the concert hall, and the superior powers of the Christian soldiers of the era is powerfully illustrated by the singers and musicians of La Capella Reial de Catalunya, who gather above and around the Jewish and Muslim musicians on stage. As a counterbalance to the tunes of antagonism and animosity, however, the story moves on and continues on a totally different note. The following section depicts Jerusalem as a city of pilgrimage, introducing dreams of encountering the divine, of peace and beauty—themes that transcend any boundaries of time and tradition. This musical thread is taken up by the two *oud* players on stage, Omar Bashir from Iraq and Yair Dalal from Israel. As the Israeli percussionist Erez Schmuel Mounk joins in, the competitive and excluding musical currents that characterized the Crusader section are definitively broken and replaced by a beautiful, lighthearted interaction among the musicians. Nevertheless, the element of play is not imposed at the expense of the mutual respect for the other and his tradition so vividly enacted by the musicians.

At first glance, this creative interplay appears similar in spirit to several other parts of the concert where musicians cross the boundaries of traditions and join each other in mutual interpretations that move beyond previous horizons of understanding in very tangible ways, as, for example, the reciting of the Hebrew psalms of exile depicted above. The striking feature of

this arrangement is that an Iraqi and an Israeli musician are playing music together, utilizing the same kind of instrument and joining their talents in adorning a prelude from the Ottoman era. At closer examination, however, this particular encounter reveals another, less obvious crossroads: actually, the two musicians are not each other's opposites—Jew against Muslim—but rather draw their cultural inspiration and heritage from the same wells. The Dalal family came to Israel from Baghdad when the new state of Israel was founded in 1948. Yair Dalal himself was born after the emigration, but in his musical work he still preserves the traditions from his family's previous homeland. As stated on his website, he aims at "interweaving the traditions of Iraqi and Jewish Arabic music."[26] Similarly, Omar Bashir was born outside of Iraq (in Hungary) but has maintained a strong bond to his father's native land, treasuring the Arabic traditions but combining elements of improvisation and cross-cultural references in his mastering of the oud.[27] The improvised duet on oud thus reveals that binary ways of thinking about cultural and religious boundaries seldom are fruitful in practice—not in the Middle East, not between the Abrahamic traditions, and certainly not in art.

## A DIALOGUE OF SOULS

In conclusion, Jordi Savall's concert project *Jerusalem* illustrates a practical theology of the arts on at least three different levels. First, attention was directed toward a balance between similarity and difference created as an intricate web of musical strands, melodies, and narrative motives from different cultural and religious sources that support, parallel, and give nuance to one another but are never forced to merge or meet in a competitive setting. Second, the inclusion of strong and complex emotions in the conversation by engaging in a musical practice like the one described above was highlighted. Third, the concrete dimension of a shared undertaking was emphasized, focusing on the tangible aspect of performing music together, improvising and playing together in an attentive and appreciative way.

In the theological language of Jordi Savall, engaging in practice in the way described above amounts to what he refers to as a "dialogue of souls." With this phrase, Savall refers to ways of communicating that reach beyond superficialities to what he describes as the spiritual level. A dialogue of souls, he clarifies, is a genuine dialogue where we "communicate with music, with art, with love and with other things that include spiritual and sensitive contents within the person."[28] A dialogue of souls can be understood to include both intrapersonal and interpersonal dimensions, applying a language comprising "more than words"—such as creative art forms. In such conversations, difference and integrity are maintained but simultaneously, a context of understanding, interconnectedness, and peace is facilitated.

By advocating a dialogue of souls, Savall's perspective challenges the common discourse on dialogue and difference, where religions are treated

as monolithic units to be reconciled on an abstract level. As noted earlier, binary thinking is seldom fruitful when faced with theology in practice: neither in art nor in our day-to-day encounters with one another. Recalling the statement by David Tracy, one is not only challenged by cognitive ambiguity in facing the religious other, but also by moral ambiguity.[29] Encountering a religion means engaging in practice: to encounter persons with multifaceted identities, worldviews, emotions, and experiences. By acknowledging the thoroughly tangible and human aspects of the encounter, a more compassionate interpersonal ethics can be built, concerned with the meeting of living beings rather than theoretical abstractions. The creative cooperation witnessed during the concert *Jerusalem* can, we believe, be seen as an example of Savall's vision of a "dialogue of souls."

In his introductory comments to the Jerusalem project, Savall maintains that music is a powerful tool. It may be deployed in the service of war, as by the Christian crusaders whose songs are included in the concert program, but it can also be used to express unity and visions for heavenly and earthly peace. By using traditional melodies handed down through the oral traditions of the Mediterranean cultures and religious melodies, described by Savall as "votive pleas for peace," the power of music to reconcile is symbolized. The aim of the concert is to demonstrate that "far from being a utopia, union and harmony are a reality that is attainable if we allow ourselves to experience the power of music to the full."[30]

# 10 Embodied Grace
## Dance—An Art Form That *Trans*forms

**PRELUDE**

On June 30, 2011, Sonsherée Giles and Rodney Bell—two members of an Oakland, California-based ensemble called AXIS Dance Company—were guest artists dancing on the FOX television show, *So You Think You Can Dance*. Performing to J.S. Bach's Partita for Violin, No. 2 in D minor (recorded by Janine Jansen), Giles and Bell translated Bach's flowing, rhythmic solo music into a sequence of steps, lifts, rises and falls, lines, and angles that embodied the music as a complex relationship of conflict and resolution between two partners. Giles's lithe body, graceful limbs, and auburn hair floated through Alex Ketley's choreography—the very epitome of a female schooled in modern and contemporary dance. Bell was muscular—an assured male who exhibited confidence, strength, responsiveness, skill, and served as a true partner in the realization of the performance. Together, the two interpreted Bach's music and embodied Ketley's choreography to the enjoyment of the audience.

But the performance was not simply delightful; the members of the audience were "brought up short" by the unexpected nature of what they witnessed.[1] Sonsherée Giles was exactly what the viewing audience had come to expect after weeks of following the competition show; she was a talented dancer who had clearly trained for years in contemporary dance. But Rodney Bell was not at all what one would anticipate as a part of an internationally known and multiple award-winning professional dance company. While Bell's upper body bore witness to the years of intentional bodybuilding necessary to accommodate the challenges of lifting dance partners like Giles with no apparent strain or exertion, he accomplished his portion of the choreography from a wheelchair. As Caroline Chen remarked, "Rodney Bell is paralyzed from the waist down. He is also a dancer. That combination might surprise a lot of people."[2] Watching the pair perform seamlessly as partners in one excerpt from Ketley's longer piece, "to color me differently" was not an experience of observing one *dancer* and one live *apparatus* around whom she danced. Rather, it was an experience of being engaged by two professional dancers at the top of their form—one of whom responded to the music with her legs and her body, the other who incorporated his

powerful upper body and a wheelchair. The gasp from the audience members was audible and palpable. This was athletic, powerful, beautiful dance—a shocking thing to witness for those who expect to see physically perfect bodies on a professional dance floor. It was surprising, indeed.[3]

AXIS Dance Company is one local expression of a growing movement known as *physically integrated dance*.[4] A typical configuration of the company would include between seven and a dozen dancers, nearly half of whom might perform in wheelchairs or with other devices such as crutches or walkers. The commitment to collaboration among the members of the company and the choreographers with whom they work is a hallmark of the more than 40 companies worldwide who have embraced this unique approach to dance. AXIS combines virtuosity in the art form known as dance with an educational mission as they develop performances that incorporate people with and without disabilities.[5]

One distinguishing feature of AXIS's self-identity since their reorganization in 1997 has been its commitment to commissioning choreography by some of the dance world's most respected artists—such as Bill T. Jones, Margaret Jenkins, Ann Carlson, Victoria Marks, Katie Faulkner, and Alex Ketley (who designed the piece performed by Giles and Bell).[6] This bold decision reflects the commitment AXIS and their artistic director, Judith Smith, have made to performing at the highest possible level of their art form. AXIS is a professional *dance* company that fully incorporates dancers with and without disabilities.[7] The company's educational mission is to "Challenge our perceptions about what dance is and can be, about what is beautiful and not, and about disability without allowing it to be the focus of the dance except to open people's minds to the possibilities of what we are capable of, including our strengths and weaknesses."[8]

## DANCE AS AN ART FORM

The Teacher's Guide for AXIS's educational emphasis defines dance as "movement used as a form of expression, social interaction or presented in a spiritual or performance setting."[9] At its most basic level, "dance appears almost surprisingly innocuous; to move the body and feet in rhythm, ordinarily to music, to move lightly and gaily, to bob up and down, or to be stirred into rapid movement, like leaves in the wind."[10] Dance is a living example of the dialogical, intersubjective approach we identify as a practical theology of the arts. Dance combines the engaged, transgressive space of theatre with the emotional dialogue between composer and audience that is music, set within the embodied context of organized movement. The physically integrated dance approach utilized as the organizing principle behind AXIS Dance Company honors the voices of dancers whom many would consider the *other* by engaging persons with and without disabilities in a collaborative dialogue that results in performance as practice. The end result

of this commitment to physically integrated dance is a transformation of popular expectations of dance, of traditional understandings of beauty, and of what is meant by the term *disability*.[11]

It is possible to argue that dance is the most ancient form of the arts.[12] Ted Shawn, one of the founders of the dance community known as Jacob's Pillow (located in Western Massachusetts) has claimed, "Dance is the only art in which we ourselves are the stuff of which it is made."[13] The body is the person's most basic contact with the earth. Awareness of one's physicality and mastering the ability to use body parts to move from one place to another or to acquire objects for one's own needs seems to have been a part of the human psyche long before the development of speech. Gerardus van der Leeuw has suggested that dance precedes verbal arts in human development because of "the fundamental human need to communicate [through bodily gestures] with other human beings and with the gods."[14]

The progression from simple human movement to the symbolic movement of gesture has been identified by the philosopher Susanne Langer as the characteristic element of dance as an aesthetic experience.[15] Langer's use of the term "virtual gesture" as a description of dance is based upon the ability of the dancer to utilize the body's movements to communicate nonverbally emotions the dancer herself may (or may not) feel in reality.[16] What distinguishes dance from other forms of movement is that dance goes beyond the simple physical action of moving a limb or turning a head for functional purposes toward the utilization of the same mechanical actions to make a statement, portray an emotion, or signify an idea. Graham McFee highlights two key facets that transform ordinary movements into dance: first, the *sequencing* of specific instances of movement that might occur in making a sweeping motion with the arm (for example)—when utilized in a dance—is no longer *mere* movement. It has become what Arthur Danto calls the "transfiguration of the 'ordinary activity' into dance." Secondly, this transfiguration "makes the dance not just action that makes sense as *intended* [. . .], but also renders it more strongly meaning-bearing: as intentionally *art*, with whatever character flows from that."[17]

## DANCE AS EMBODIMENT

There is general agreement that the basic elements of dance are time, space, energy, body, relationships, and movement.[18] In this context, body is not viewed simply in a biological and functional way; rather, body is regarded as an integrated, living, breathing, sentient, and responsive self. The structure of the body; the posture of the dancer; the strength of the arches within one's feet; the tone of the muscles in the leg, the core, and the upper body; the shape and size of the hips and numerous other physical characteristics provide the raw material upon which dance is constructed. Dancing—as an art form—involves responding to music, to the spoken word, or to internal

concepts by embodying the claims to truth encountered there in the fiber of one's self. The graceful movements of a skilled dancer can inhabit and be inhabited by "a musical line, breathing with the swell of sound, touching a note, opening our ears so that we can relate what we see and feel in our bodies from her, the dancer, to what we hear."[19]

Jane Elin and Boni Boswell have advocated for a "re-visioning" of dance by "perceiving the aesthetics of disability."[20] The "new way of seeing both dance and disability" the two present is characteristic of the work of AXIS Dance Company and other similar dance troupes. But their description of the embodied character of dance is not limited to the character of dance by one who is disabled; it is true of the nature of dance itself:

> The performative exploration of the movement elements and flow effort actions, and affinities give us a sense of totality of body-mind or embodiment moments when the dance and the dancer are inseparable. Embodiment is the lived movement experience. Embodiment involves consciously and intentionally assuming an indivisible unity of body, mind, and creative spirit.

> Becoming one with the danced material is what the dancer has to do. It is not easy for everyone to make the leap from doing movements to dancing the dance. If you separate what is done from who is doing it you lose the dance. That is what a dancer has to understand . . . [d]ancing is feeling-thinking-sensing-doing with imagination.[21]

Dance only exists as it is *instantiated*.[22] The claims to truth in dance cannot be limited to cognitive and intellectual concepts; it is only as claims to truth are embodied in the performance of the dancer as a flesh-and-blood self that dance shares the truth.

It is well established that the significance of the body is among the reasons the field of dance has been a relative latecomer in acceptance as a form of art.[23] The hegemony of reason and its connection with the spoken word during the Enlightenment led to a devaluing of both the body and the emotions in favor of the rational mind. Likewise, the Protestant Reformation, with its emphasis on the Word—arguably at the expense of the Table—was translated into an evaluation of anything embodied as somehow lowly and profane.[24] The body became suspect because of its connections with base emotions and even baser appetites and desires. But Christian theologians including Douglas Adams, Diane Apostolos-Cappadona, Carla De Sola, and Martha Ann Kirk have argued more recently for the embodied nature of dance as a powerful reflection of the incarnation that Jeremy Begbie and others see to be the clue to the development of a Christian theology of the arts.[25]

With its commitment to "creating and presenting cutting-edge, contemporary works by dancers with and without disabilities," AXIS Dance Company radically transforms common expectations about embodiment.[26]

The prevailing image is typically a tall, slim, erect, fit young woman in a leotard with hair pulled back tightly in a bun and shod in satin toe shoes. The male dancer is imagined as broad shouldered with a narrow waist and heavily muscled legs capable of breathtaking leaps.[27]

The current Media Kit for AXIS Dance Company opens with the statement, "Prepare to leave all your preconceptions at the door. . ."[28] In a performance by this company, the wheelchair is no longer a cumbersome obstacle around which dancing must work; the wheelchair in which Rodney Bell is seated in his duet with Sonsherée Giles becomes an extension of his body in a way analogous to the way Giles's legs function for her.

The radical redefinition of the kind of embodiment appropriate to dance as art that AXIS presents in all its choreographed pieces "brings us up short," as Osmer has suggested.[29] The preconceptions about *body* one might bring to a dance performance must, indeed, be checked at the door in the physically integrated dance form of AXIS Dance Company.

## DANCE AND THE FACE OF THE OTHER

Uli Schmitz was disabled by childhood polio. The annual ball in his German village was a reflection of the village's social structure, the dynamics of social location, and served as a rite of passage into adulthood.[30] Because of his physical limitations, Schmitz felt out of place in the dances that had become so central to his community's life. As an adult, Schmitz began to visit ballet and modern dance performances; the sameness of the dancers' athletic bodies made him conscious of his own difference from the stereotypical dancer's body: "To me, it all looked very similar, all dancers looked the same, had the same, skinny bodies. I walked heavily, was heavy and slow, and could not leave the ground. My body was the extreme other, not the desirable end of the spectrum. I felt like another species."[31]

After moving to the San Francisco area, Schmitz became a member of AXIS Dance Company and discovered that the otherness of disability did not have to be an impediment to one's self-identity as a dancer. With physically integrated dance, he found:

> The wheelchairs were no more than all the other props used in the production. To see wheelchair dancers in this context made it easy to realize and appreciate the different qualities of their movement; the fluidity, the effortlessness and the power that can be unleashed by an electric wheelchair. It became clear to me that this particular image of power, for example, becomes emotionally gripping because it contradicts the usual stereotype of the helpless disabled person. I would add to the definition of dance that it has the power to present a new angle of looking at large, convoluted issues, for decoding and challenging stereotypical notions.[32]

Emmanuel Levinas's discussion of the Face of the other as an epiphany that makes dialogue possible is a significant part of a practical theology of the arts. Levinas emphasizes the role of the Face because to gaze upon the face of another human being is to be close up rather than distanced, personal rather than aloof, intimate rather than removed, and face to face rather than alienated. There is an underlying sense of partnership—self *and* other; I *and* Thou—at the core of dance that mirrors Levinas's insights about the face of the other. In the performance from *So You Think You Can Dance*, Giles and Bell do not dance solos that happen to be on the same stage at the same time. They engage one another—physically through touch and interpersonally through their consistent eye contact. Each retains her or his own self-identity (Levinas insists neither the self nor the other loses itself in dialogue).[33] The face of the other in their dance performance is a real, flesh-and-blood encounter with another self. The encounter with the other summons each to a new understanding of the truth their conflicted relationship embodies.

The fact that the dance (and the mission of AXIS as a whole) utilizes one performer who is disabled and one who is not further illustrates the shocking function of the other for Levinas. Dance as a form of communication has had a traditional language that has assumed a certain level of physical perfection.

In a dance by AXIS, the performance of disabled as well as nondisabled dancers emphasizes the otherness of the dancers involved in the piece. One cannot be indifferent to the wheelchair in which Rodney Bell performs. It is precisely the shock of *his* dancing from the wheelchair that makes the viewer aware of the otherness of *Giles's* embodiment of the classic dancer form (ironically, the *norm* has become the *other*). The visual otherness of Bell's use of a wheelchair opens the space that exists between the dancers to allow the viewer to experience a new understanding of what it means to dance. Each gazes into the face of the other and regards the other as a knowing, capable subject. As partners in the dance, their *virtual* relationship emerges as each regards the face of the other *as* other.

The wheelchair is not simply a piece of equipment. It is an extension of Bell's body and performs more like another dance partner than a mobility device. The choreography of the piece calls for Giles to stand on one wheel, to spin Bell around to face her, and to roll across his seated back. She enters his space as he enters hers. The flowing movement that results from their interaction challenges members of the audience to "view mobility aids not as obstacles, but as vehicles for an expanded movement vocabulary."[34] Regarding the other *as* other—as a self with a face is, for Levinas, a necessary precondition for dialogue to be possible. The image of the face of the other illustrates the transgressive nature of the other that breaks into one's world and calls out a summons to recognize the other's *otherness*. Levinas claims it is impossible to be indifferent toward the other when standing face to face with her.[35] In a *pas de deux* like the one featuring Giles and Bell, the energy of the encounter between the two is far from indifferent.

## DANCE AND THE VOICE OF THE OTHER

The relationships among performers in a dance ensemble illustrate the horizontal character of partnership. The call-and-response, summons-and-reply dialogue among the members of AXIS Dance Company is a moving, "living human web" of relationships.[36] The kind of collaboration and responsiveness that makes any professional dance company successful artistically can only occur when each member of the company receives the other as a dialogue partner and opens himself or herself to the *voice* each brings to the conversation about the subject matter they share together.[37]

Numerous reviews of performances by AXIS have remarked on the collaboration that takes place in each performed piece. On one level, the dancers collaborate with *one another*. Eric Kupers, a choreographer with the Dandelion Dance Theatre, worked with AXIS and commented that the work between the dancers with disabilities and those without demonstrated full partnership: "I found the separation between dancers in wheelchairs and dancers not in chairs to almost completely dissolve as I watched these four powerful dancers ride what felt like a tornado or tidal wave through the space, raw and authentically engaging momentum and emotion and chaos."[38]

Others have discussed the level of sharing and collaboration between the choreographer of a piece and the dancers.[39] The sense of shared development of a dance performance is only possible when those who contribute to the finished product listen intently to one another; this kind of deep listening goes beyond the physical act associated with the sense of hearing itself to regarding the other—the partner—as one with a voice to be heard, and a voice that may make a significant contribution to the emergence of truth and beauty in the dance.

Nelle Morton identifies the partnership possible within a supportive group of women as a result of a kind of hearing that regards the other as a person of worth whose speech matters. Morton points out that a necessary precondition for a woman who has been dehumanized and marginalized to begin to speak her own voice is a community acting in solidarity with her that is a "depth hearing that takes place before speaking [. . .] that evokes speech."[40] When a community of truth develops the kind of partnership that can evoke a suppressed voice to expression, something transformative occurs. When the community of women Morton describes enfolded the woman in emotional pain, treated her as a partner whose voice mattered, and engaged in dialogue with her, that long-silenced voice was "heard to her own speech."[41]

Because AXIS is characterized by a collaboration that incorporates persons considered able bodied and those who are not, the concept of dance itself is challenged. Prior to the emergence of physically integrated dance companies like AXIS, persons like Judith Smith (the artistic director of AXIS who was injured in a car accident), Claire Cunningham (disabled by osteoporosis), Stephanie Bastos (who is missing the lower part of one leg), and

Rodney Bell (who has been confined to a wheelchair) would not have been considered likely candidates for inclusion in a dance company. The level of their inclusion as choreographers, collaborators, and *dancers* in AXIS, Moving Wheels, England's Blue Eyed Soul Dance Company, and others "shakes up the very concept of dance," according to Lucia Mauro.[42]

By defining themselves as a *dance* company composed of dancers with and without disabilities, rather than a *disabled* performing group that dances, AXIS has honored the voice of an entire community of persons with a variety of disabling conditions for which dance had been an inaccessible form of artistic expression. By including dancers whose movements are impaired in one way or another as integral to a choreographed piece that also includes persons whose bodies fit the stereotypical form of the dancer, a voice that had been otherwise excluded from the dance vocabulary is both honored and evoked. What one understands about dance is challenged and redefined by this conscious choice. It is not just the dancers with disabilities whose voices are heard. As Cunningham states:

> To find that even the 'non-disabled' dancers (that appear to me to have a similar high level of fitness) are in fact reconciling their movement to the (perhaps more subtle) limitations of their bodies was vital for me. Likewise learning to distinguish when something is uncomfortable or difficult for everyone and not just me (i.e. a stretch) made a big difference. [ . . . ] I think in terms of working with people with physical impairments in dance this is a crucial factor.[43]

In her commentary on Cunningham's participation in the dance company Under the Radar, Mary Brennan states, "Clair's way of moving—her intention of, as she says, 'making disability an ability'—has a distinctive aesthetic that is truly groundbreaking, not least because it takes her, and us, out of dance-theatre's comfort zone."[44]

By honoring the voice of those who are disabled and including them in every aspect of the creative work of the company, AXIS advocates for a *"new way of seeing* both dance and disability."[45] Jane Elin and Boni Boswell have developed a process called *Re-envisioning Dance* that expands the common understanding of disability and the availability of dance opportunities for those who are disabled beyond its physical and biological assumptions: "accessibility means more than physical access; it relates to a deeper level of the meaning of disability that challenges our perception of what is valuable and what is inferior."[46]

## DANCE AS DIALOGUE

In the second of three DVDs in which Yo-Yo Ma collaborates with several artists from other art forms, Ma works with choreographer Mark Morris and the Mark Morris Dance Group to bring Bach's Suite No. 3 for Unaccompanied

Cello to embodied form. The theme of dialogue is present throughout the video: through documentary footage, Ma and Morris are filmed in conversation about the meaning of the music, the rhythmic character of the Suite, the dance-like feel of Bach's composition, the embodiment of music that Morris experiences in dance, and other related topics. The film itself serves as an art form in dialogue with music and dance, making the filmmaker Barbara Willis Sweetie a partner in the project's conversation as well. Isaac Mizrahi is pictured designing the costumes worn in the production and collaborating with both Ma and Morris—thus adding one more layer of dialogue to the rich mix of the episode. The dancers interact with Ma, Morris, Mizrahi, and Sweetie as well as the stage personnel to embody the shared vision of the creative contributors. And the viewing audience is enriched by the final performance, which is entitled "Falling Down Stairs"—a title that reflects Morris's nightmare inspired by the Suite in which he envisions the descending arpeggios of a major section of the music as a person falling down a set of stairs.[47]

The discussion between Morris and Ma reflects intense study of Bach's score by each dialogue partner. Ma states his intention of capturing the central claim of Bach's music in both his performance and the dance; Morris claims his purpose is to take a piece of well-made music and add to it in the new medium of dance without, in his words, "obfuscating the music with what I do with dance." At another point in the dialogue, Ma asks, "How about if I hang around to be influenced by the choreography?" The ensuing dialogue among the creative partners demonstrates that Ma's interpretation of Bach's music has emerged from the active collaboration engaged in the facilities of Jacob's Pillow Dance in western Massachusetts.

In a similar fashion, both the choreography and performance of dance pieces developed by AXIS Dance Company result from a full collaboration with the musicians that affects the claim to truth being offered by each partner in artistic dialogue. The music affects the craft of the dancers; the choreography, done in collaboration with the dancers as well as the creativity of the choreographer, frequently affects the voice shared by the musicians and composers. When Eve Beglarian composed the music for AXIS's setting of "Dust," she brought a sketch of the completed work to rehearsal with the company, then completed her composition by "watching the dancers, incorporating all the sounds of movement in the final composition, even the hums and clicks of the wheelchairs."[48]

In her study of the physically integrated dance company Dancing Wheels, Patricia McMahon quotes founder Mary Verdi-Fletcher discussing the dialogue that is at the heart of dance: "Try to think of it as a series of questions and answers [. . .] One dancer's movement asks a question; the other's movement answers the question. Learn to trust the other dancer."[49] Furthermore, the dialogue is extended in the relationship between dance and the music to which it responds. Stephanie Jordan refers to Nijinska's claim that dance and music speak as two *voices*, each of which reflects on a shared, emerging *subjectivity*. She continues to claim that this dialogue between music

and dance is an extension of the dialogue that already exists in the different voices within the music itself—a dialogue that is "highlighted when dance and music are combined."[50]

AXIS Dance Company engages in a dialogical relationship in which those dancers who have disabilities work with those without disabilities as full partners in the rehearsal and performance of the pieces that are performed. Each responds to the actions and movements of the other while also making his or her own gestures and claims. When the dancers in AXIS work with a choreographer like Bill T. Jones or Victoria Marks, the dance is not composed *on* them by an authoritarian figure imposing his or her vision upon the passive dancers. Rather, the choreography emerges out of the collaborative and dialogical process of rehearsal. Similarly—although some of the music that serves as dialogue partner in dance is a baroque work by Bach or Handel or a contemporary jazz or pop recording—many of the musicians who have worked with AXIS have composed their music by watching the dancers move and responding to the summons of the dancers' voice.

Patricia Ready adds to the dialogue partners the subjectivity of the member of the audience that witnesses (and witnesses to) the performance as the third member of a triadic relationship of dialogue: "When one can acknowledge that 'truth' does not lie in the domain of any one part of the triad, but flows in its midst, then growth and change can occur."[51] When audience members who are themselves persons with disabilities witness the skill of Rodney Bell or Judith Smith who dance with their wheelchairs as partners as well as devices, the meaning of dance is extended—and so is the meaning of disability.

## DANCE AS PERFORMANCE/PRACTICE

Graham McFee claims that dance shares numerous philosophical issues with other performing arts—especially theatre and music, the latter of which he sees as dance's primary dialogue partner. "Like music, dance typically exists 'at a perpetual vanishing point': one encounters the art work in the evanescence of performances."[52] A dance like Ketley's "to color me differently" is more than a cognitive, intellectualized concept; it exists to be shared in performance. McFee claims that, like other performing arts, the art of dance is encountered only when one encounters a performance of it.[53] Further, since Ketley's piece involving Giles and Bell has been featured in numerous settings since it was composed, each time it is performed is both the *same* dance (the one Ketley choreographed with the collaboration of Giles and Bell) and a *new* instantiation of the dance (specific to that particular time, place, and audience).[54]

There seems to be a desire to share one's experience of the world and one's response to the summons of the other that is deeply embedded in the person of a dancer. Dancers—whether in a company like the Alvin Ailey American

Dance Theatre or in AXIS Dance Company—study the music or the text with which they dialogue in a way analogous to a musical ensemble's work with a score.[55] Like musicians or actors, the purpose of this concentrated effort to understand the critical claim to truth of their dialogue partners is not simply to understand the "text" conceptually; once the dancer has interpreted the music, the poem, or the spoken word, that word cries out to be heard. The truth experienced in dialogue with the partners in dialogue must be performed—regardless of the size or composition of the audience. As de Sola claims, "In performance, the dancer shares what has been discovered about the 'inexpressible' part of his or her being, and who he or she has become [. . .] Dance is a language, drawing both performer and onlooker into its story."[56]

The performative character of dance is illustrative of the theme of practice that helps comprise a practical theology of the arts. It is not enough to develop a *theory* about dance; dance exists in its fullest form only when one engages in the practice of dancing. While there is clearly intense scholarship and careful reflection present in the response to music or other artistic partners, the emergence of the truth claims of dance occurs only as dance is performed. It is the practices of the performers that comprise the dance. When the performers involve persons in wheelchairs and using other movement aids as well as those who rely only on their own bodies, the performances can transform everything one might know about dance as well as about disability.

## DANCE CLEARS SPACE

Space and the use of space by dancers is one of the basic elements that constitute this form of the arts.[57] The movement of dancers on the stage occupies both time and space and sets apart the dance performance as an *instantiated* event. Patricia Ready claims that the awareness of the basic elements of dance—body, moving, in space, in time, with energy—allows for the emergence of meaning making.[58] The dancer is not simply embodied; she is embodied here and now, in this particular place. If, as van der Leeuw claims, the body represents the most fundamental of human forms of communication[59] and provides the basic human connection with the earth, there is also a *thereness* implied in that embodiment.

Parker Palmer's claim about clearing "a space where the community of truth can be practiced" has informed our understanding of a practical theology of the arts.[60] In their examination of electronic dance music and the rave community that employs it, Dewi Jaimangal-Jones and his research partners identify a definition of space that is based on Victor Turner's discussion of liminality. "Today, we understand space as a site, which we not only physically inhabit, but which all of us, differentially empowered and socially positioned, actively construct and invest with meaning."[61]

In our discussion of theatre in chapter 7, the use of space is verbal, visual, and metaphorical in character. In dance, movement *transforms* the space of the stage into an opening for visceral and intuitive engagement with the claims to truth being offered by the dancers. Dancers and the choreographers who work with them utilize the space of a stage in a manner analogous to theatre, and generally use the same terminology in describing the primary locations of the designated performance space: upstage, downstage, stage left and right, etc. The identification of personal space in both forms of art is generally defined as that spherical space surrounding the performer's body within the reach of the performer's arms when extended.[62] Staging a play or a dance performance makes similar use of sharing the stage space through the placement and interaction of the personal space of the performers.[63] Dance scholars have begun to speak of *spatiotemporal* elements of dance and to use "point clouds" to plot the placement of each dancer on the stage throughout dance performances.[64]

While a theatre company like True Story Theatre might transgress the fourth wall through its improvised approach to performance, the stage is utilized primarily as a setting on which the claim to truth is being presented through the spoken word. The word contains the occasion for the emergence of the truth, not movement on the stage. A dance company occupies the stage by moving across its surface, and moving continuously. Dance performances are composed of a series of entrances and exits, with individual dancers tracing "a lateral trajectory across the stage."[65] When that space is occupied by wheelchairs—sometimes motorized and other times not—that are used skillfully to race, pirouette, and occasionally to rear up into the air as one might pose with one leg raised, the movement-centered nature of dance is striking.[66]

Karen Kaufmann recognizes that different dance styles use space differently from one another, but is also convinced that "[i]n dance, we define space by our presence in the room."[67] By not only constructing space through lighting and props but through an intentional use of movement, dance makes the stage a dynamic space, rather than a static space. By clearing a space from its pedestrian, everyday use and dedicating that same space to the flow of dance truth and meaning may emerge in an engaging way.

Many dancers make reference to yet another understanding of space that begins with what they consider the inherent spirituality that comes from the connection of body, mind, and soul or spirit. Contemporary choreographer Ronald K. Brown sees no separation between body and spirit, dance and prayer in the embodied nature of dance: "Spirituality is always with us and it's always a part of my work . . . For me, love and God are the same."[68] Carla De Sola, Douglas Adams, Judith Rock, Rosalie Brannigan, Diane Apostolos-Cappadona, Mary Ann Kirk, and many others agree with Brown's claims about this spirit/body connection and consider the space in which dance is performed to become *sacred* space because of this embodied spirituality. For those whose spirituality is informed by Christianity, the space of the stage becomes an effective way of connecting the members

of the congregation with the spirit and the "exquisite grace of the human body" through liturgical dance: "the dancer connects the same elements with the viewer who empathetically feels the ground, the weight, the movements in space, the feelings of the body, and the movements of the spirit."[69]

Similarly, scholars who have studied the spirituality of dance in religions other than Christianity have indicated the many ways the embodiment in dance of a spiritual experience with a sacred text or reflective music can become a worshipful or meditative connection with the divine. George Pati describes the effect of dance in Hinduism, which serves as "the medium of divine and human transformation, which enables the audience to enjoy the essence of the text. In this vein, the dancer becomes a medium for dancer and spectator union, and human and divine union that leads to *prapatti.*"[70] Hiroko Ikuta offers a similar argument about the spirituality of dance among indigenous tribes of Alaska,[71] and Julie Pearson-Little Thunder describes Native American dance as a form of prayer.[72] Brian Rill and Pedro Ferreira both study electronic dance music and the rave culture and comment on the spiritual experience of dance, music, and sacred space—including a shared sense of quasi-religious pilgrimage associated with these large gatherings.[73]

In each example, the uniting of body and spirit in dance transforms the space in which dance is performed into a *sacred* space. The transformation of space that is made visceral in the merging of body and spirit through dance overcomes the Western, modern prejudice toward the intellectual and dogmatic claims of faith—regardless of the kind of faith one might intend.

## DANCE THAT TRANSFORMS

In her approach to teaching modern dance, Rebecca Gose Enghauser encourages teachers to give opportunities that help "students to find unique ways of moving through space by transforming or reinventing existing modes" of dance.[74] Her suggestion is at the heart of the advocacy element of the mission of AXIS Dance Company. By demonstrating that movement and the effective combination of personal space with general space are tasks that can be accomplished—and accomplished well—by persons with disabilities, both one's understandings of dance and of disability are called into question. While wheelchairs, crutches, and balancing on one leg occupy and bring life to space *differently* from the ways those without disabilities do, the differences are in no way *inferior* to what one would expect. Numerous reviewers of AXIS performances have noted the consistent level of expertise throughout the members of the ensemble. The ability of Rodney Bell to roll his chair in response to the two-legged movement of Sonsherée Giles stretches one's stereotypical understanding of the movement one expects in contemporary dance. It also requires a reconceptualization of what one understands about disability. As the flyer for AXIS states, "Prepare to leave your preconceptions at the door . . ."

# 11 Finale and Recapitulation
## Engaging Faith

Perhaps a musical setting is appropriate as a conclusion to the practical theology of the arts that has been presented over the previous 10 chapters. In orchestral music a *finale* is, simply, the last movement in a composed piece—an apt description of the purpose of this entry. At the same time, it seems appropriate to engage in a bit of what is known, musically, as *recapitulation*—a restatement of musical theme toward the end of a composition that serves to refer the hearer back to claims to truth that had previously been offered by the composer. As we conclude our efforts in *Theology and the Arts: Engaging Faith*, we are, indeed, at the point of offering our concluding statements in this last movement of our contribution to the dialogue around this emerging field of theology. It is also appropriate to revisit the key themes that have guided the ways we have developed the practical theology of the arts presented in the first portion of the book through the seven études that compose part II.

In the introduction, we offered a brief set of aims that identify the vision that has guided our exploration of the subject:

1. To discuss contemporary theological research on the arts, especially focusing on critical perspectives acknowledging the role of gender, pluralism, and postmodern/post-secular perspectives on theological thinking.
2. To discuss the emerging literature in practical theology and evaluate the current direction of dialogue on theology that takes seriously the role of *praxis* and faith that is embodied in the critical practices of communities of truth from multiple religions and in a variety of international cultures.
3. To develop a practical approach to theology and the arts on the basis of the research by incorporating perspectives from dialogue philosophy, hermeneutics, and other relational ways of addressing theological research.
4. To make these theoretical reflections truly practical by analyzing seven empirical case studies we refer to as études: projects where the arts have

become integral in practicing a responsible and interpersonal theology that empowers transformational communities of truth toward greater justice, hope, understanding, respect, and integrity.

As we conclude our proposal, it is good to revisit these aims.

1. *To discuss contemporary theological research on the arts, especially focusing on critical perspectives acknowledging the role of gender, pluralism, and postmodern/post-secular perspectives on theological thinking.*

In the introduction, we identified our discomfort with the positivistic, absolute, and doctrinal stance that has been characteristic of modern theology. From the beginning of the book and the art of Charles Schulz's *Peanuts* comic strip, we have engaged the contemporary literature around theology of the arts as both a hermeneutical tool for our response to modern theology and as an epistemological lens through which we examine and understand a practical theology of the arts.

This reaction to the shortcomings of modern theology is discussed more fully in chapters 1 and 2, where we bring the voices of feminist, liberation, postmodern/post-secular, and hermeneutical theology, as well as the dialogue philosophies of Martin Buber, Emmanuel Levinas, Hans-Georg Gadamer, and Knud Løgstrup into dialogue with our claim that the arts can become a dynamic partner in practical theology. We began our explorations of the connections between practical theology and theology of the arts because we are practitioners and *connoisseurs* of the arts ourselves as well as scholars of each of the separate theological disciplines we address. It has been our engagement with a variety of art forms from multiple religious and national backgrounds that has caught our attention. The more we have encountered extraordinary communities and individuals allowing their art to affect the practice of their faith (and vice versa), the more we have noticed similar themes emerging from our investigation of those communities of truth— themes that are also present in the literature of practical theology.

As we have excavated (the allusion to Foucault is intentional) the études that comprise the second part of the book, we have discovered the rich and transformative possibilities that can emerge when one does practical theology from the perspective of engagement with the arts. It is not an exaggeration to claim that the genesis of the book was in the reverse order to its current form: the themes that we have fleshed out in the first section were encountered as we conducted our initial explorations of the communities of truth analyzed in the études. Our scholarly curiosity around these themes led to the academic dialogue that comprises the first four chapters of the book.

We have surveyed contemporary literature from theology of the arts in multiple places in the book—and that is intentional. As we made our way through the dense language of dialogue philosophy, we made certain to do so in conversation with discussions of theology of the arts. As we engaged with feminist theological claims, we were careful to relate these insights to complementary claims from theology of the arts. As we were reminded of the ethical

dimensions of theology found in the thought of Emmanuel Levinas as well as in liberation theology—especially the praxis approaches of Paolo Freire—we found similar dimensions within the literature around the role of the arts. We believe the arts can be an approach to the world that humanizes, liberates, and encourages wholeness and transcendence; we find the same aims to be constitutive of practical theology. The significant work of the Society for the Arts in Religious and Theological Studies and its members has informed much of our understanding of the current state of theology of the arts.

2. *To discuss the emerging literature in practical theology and evaluate the current direction of dialogue on theology that takes seriously the role of praxis and faith that is embodied in the critical practices of communities of truth from multiple religions and in a variety of international cultures.*

We have made it clear from the beginning of the book that we are not content to simply criticize the deficiencies in a theological tradition that was centered in the hegemony of white, Anglo-Saxon, Protestant, Western, male views of the world. We have offered as an alternative to this dominant theological approach of the 19th and 20th centuries the emerging discipline of practical theology. It is, finally, within the faithful practices of specific communities and their engagement with the presence of the divine as well as with one another that truth is enabled to emerge.

At its most basic level, a practical theology of the arts—as we have presented it—is derived from several theological voices. One key dialogue partner is the gentle, yet profound, witness of American Quaker thinker Parker Palmer. Palmer's thoughtful phrase "community of truth" appears in every chapter of the book. We have intentionally selected communities from a variety of religious perspectives: Protestant and Catholic Christians, Muslim, indigenous Peruvian, Jewish—and sometimes agnostic and skeptical—in which the arts have helped to liberate and transform their members. The richness of Palmer's phrase "community of truth" is an apt description that can cover the diverse theological landscape we have in mind better than the more common "community of faith."

A second common voice is the collective witness of 20th-century philosophy that insists on the indispensable significance of dialogue. The practical theology of the arts we offer owes much to the claim that in intentional and committed dialogue, a new understanding of truth always emerges from the critical reflection upon action and the actions one takes based upon new insights. Our theological training has brought us—individually and separately—in contact with the thought of Emmanuel Levinas, Martin Buber, Hans-Georg Gadamer, and Knut Løgstrup. But it has been our contact with these seven communities in which the arts have made interpersonal dialogue not only possible but characteristic of their experience that has led us to ground the practical theology of the arts we propose in the complex philosophical and theological claims of these iconic figures.

A third voice that helps define our understanding of practical theology is the role of praxis as the way of knowing characteristic of the communities of

truth on which we draw our theological claims. The call for *conscientization* that comes from the work of Brazilian educator and theologian Paolo Freire has shaped much of what we discuss when we use the term *praxis*. The kind of critical consciousness that transforms persons as well as communities that Freire spent a lifetime developing is also at the root of feminist theology from Nelle Morton, Rebecca Chopp, Sharon Welch, Rita Nakashima Brock, Bonnie Miller-McLemore, Joyce Ann Mercer, and many others we have examined. Rather than fixed, absolute, positivistic doctrinal claims, we experience the truth of theological claims within the faithful practices of specific communities of truth.

We also find the emerging literature of practical theology itself a valuable voice with which we engage in dialogue. The members of the *Association for Practical Theology* have provided us with direction for the development of our understanding of practical theology. The reader will encounter the numerous ways this theological discipline has affected what we offer in Chapters 1 and 2 as well as in the description of a practical theology of the arts presented in chapter 3. As we read the contributions of practical theologians like Miller-McLemore, Chopp, Mercer, and others, the striking similarity of the thought of theologians of the arts like Robin Jensen, Deborah Haynes, Frank Burch Brown, and Richard Viladesau has become not just apparent, but glaring.

3. *To develop a practical approach to theology and the arts on the basis of the research by incorporating perspectives from dialogue philosophy, hermeneutics, and other relational ways of addressing theological research.*

It is in chapter 3 that we integrate the disparate elements of our research and develop a practical theology of the arts. We have taken the counsel of those whom we have studied and have created as much dialogue among the sources of our research as possible. The proposal we make in this chapter is not a simple comparison of two fields of study within the larger discipline of theology. We are attempting to accomplish the kind of "fusion of horizons" about which Gadamer spoke so eloquently. As the voice of practical theology and that of theology of the arts have met in our shared thought and conversations, we have sought to create a context of partnership that would allow both disciplines to maintain their own voices while honoring the process of dialogue that allows something new and significant to emerge from the encounter.

It is this intersubjective dialogue and its resultant and emergent new claim to truth that pushes us toward the approaches to reading the études in the second section of the book. The practical theology of the arts that we have developed out of the impetus of our encounters with these seven communities of truth has become the hermeneutical devices by which we have explored the significance of each artistic community. That, in the final analysis, is the genius of praxis—whether as discussed by Aristotle, Karl Marx, Paolo Freire, Rebecca Chopp, Kwame Anthony Appiah, or Jonathan Fox—every theoretical construct of the world is confronted by actions and

practices that call the construct into question and thus into revision; every new theory requires new practices to enflesh its place in the world.

The seven key themes we have developed in chapter 3 have emerged out of dialogue: the four-year collaboration of a young Scandinavian woman and an American man in the seventh-decade of his life that has led to this place; the career-long dialogue of each author with treasured academic partners; the dialogue among several religious and philosophical traditions; and the dialogue with each of the communities of truth. We end the work with a sense that we did not create a practical theology of the arts as much as we have been encountered by it.

4. *To make these theoretical reflections truly practical by analyzing seven empirical case studies we refer to as études: projects where the arts have become integral in practicing a responsible and interpersonal theology that empowers transformational communities of truth toward greater justice, hope, understanding, respect, and integrity.*

The seven études are key elements of a practical theology of the arts. A common misconception of practical theology as a whole has been that it refers to the application of the *real* work of theology to the life of the community of faith. That is, the historical, exegetical, and systematic work of those of faith is *theology*, while the practical disciplines of the field have become mere delivery devices to connect the work of the *doctors of the church* with the persons from the laity.

Central to our claim is the belief that it is only within the embodied, flesh-and-blood, real-life *practices* of faith within committed intersubjective communities that theology as *habitus*—as a way of living in relationship with God in the context of that community—can exist. The arts help one understand that the voice of the other—so powerfully described by Levinas and others—summons one to live faithfully, truthfully, and with integrity in relationship toward that partner in dialogue. Theology cannot remain removed and detached from the lived experience of a community that seeks to embody the truth claims shared—and sometimes struggled with—by those who profess those truths. Theology that only speaks *about* God and a community constituted and called by God is hollow. We are calling for a theology that begins with the practices of a community that has opened itself to be challenged by, shaped by, informed by, and constituted by a sense of critical listening to the voice of the other and the cry for justice, wholeness, and integrity being shouted by that voice.

To reiterate the key themes identified in chapter 3, our practical theology of the arts was proposed to be embodied; to have a "face"; to acknowledge the voice of those who had been silenced; to be accomplished through dialogue as well as through the *practice* of theology; to clear a space; and, finally, to be committed to transformation. Here, at the end of our investigation and against the background of the analytical results presented in the chapters dealing with practical art projects from around the world, we find it legitimate to maintain that these features are indeed characteristic of the

field we have investigated. Thus, we maintain that the analytical approach developed in the first part of the book and employed in the second part has achieved its goal. It has shed a clarifying light on practices, communities, and points of view that together form the vibrant and multifaceted field of theology in practice today. Hence, it is our hope that it will also enrich the academic study of practical theology and the arts.

## ENGAGING FAITH

The subtitle to the book is *Engaging Faith*. As we suggested in the introduction, the term "engaging" can be read as an adjective, describing the kind of faith one might exhibit—one that is vibrant, alive, inviting, and open to participation (e.g., "This is an engaging conversation we are having."). It can also be read as a verb, with the sense of attracting persons to or involving persons in an activity or a topic (e.g., "Mr. Green was engaging Ms. Brown in a game of chess.").

We have used the phrase in both senses throughout the book. We believe that a practical theology of the arts is one that is vibrant and alive. The arts themselves have a property of difference that causes those who are open to their voice and their claims to truth to become enchanted by the sheer otherness of their view of the world. The arts prod, beguile, tease, challenge, and sometimes confront those who encounter them. The arts reach us at an emotional level that is too frequently discouraged by the distant, objectified world of modernity. The arts are, simply, engaging.

A practical theology of the arts can be engaging as well. If the reader were to log onto one of the websites linked with the communities of truth we have examined, the truth of the adjectival sense of "engaging" will become readily evident. Look, for example, at the link to Cecilia Parsberg's stunning documentary film, *A Heart from Jenin* and the claims about the significance of this form of the arts made in chapter 8 will invite one to experience the emotional power of this real-life incident in a war-torn country. If one were to follow the link for the AXIS Dance Company, the power and otherness of this unique dance company from Oakland, California, that is presented in chapter 10 would be confirmed by selecting a few of the video performances available there. The practical theology of the arts we are proposing is *engaging* theology.

A practical theology of the arts is also engaging in the verbal sense. We have claimed that the character of practical theology in general—and of a practical theology of the arts in particular—is realized only in the practices of real-life, embodied persons within dialogical communities of truth. The arts are invitational and open themselves to the participation of their audience. It is only as one becomes responsive to the claims to truth of the arts that the voice of the artist becomes a partner in a dialogue about the nature of truth. The arts engage their partners in a back-and-forth, to-and-

fro dialogue in a way that is more transparent than the typical intellectual distancing of contemporary theology and philosophy. A practical theology of the arts is constituted by the claim that doing theology from the perspective of the arts engages one in the important work of theology in a way that is more practical—and therefore, more transformative—than other contemporary approaches to theology.

It is, after all, "faith" that is engaging in both senses of the phrase. Each community of truth we have chosen to investigate in the second section of the book deals—at one level or another—with the issue of faith. Some of them are representatives of particular communities of faith: Jewish, Christian, Muslim, and variations within each of these religious traditions. Others seem secular in their lack of specific reference to anything formally religious—yet continue in their artistic practices to seek for transcendence, wholeness, justice, and honoring the voices of those otherwise silenced. Faith, in one sense or another, is crucial for each community. The faith we are identifying in the book is one that is *engaging*, in every sense of that term.

Writing a book includes many decisions on what to include—and, simultaneously, what one needs to exclude. Many interesting theoretical discussions have only been mentioned in passing on these pages, and some readers may find that contributions they regard as significant to the field have not been given due attention. As we have decided to continue along other routes, several important and enriching pathways have been left unexplored; this is one of the inevitable disadvantages of putting a scholarly dialogue, which by its nature is ongoing and unbounded, between covers. The selection we have made of scholars and theoretical perspectives to present in this book represents what we have found to be the most valuable contributions to the field as well as what has influenced our own thinking most profoundly.

A similar selection has also taken place in relation to the art forms presented in this book. Obviously, there is an abundance of art forms that would have merited inclusion in this analysis: poetry, architecture, multimedia art, graphic art, garden art, to mention only a few. We can only regret that these fascinating forms of art could not be explored in the limited space available to us in this publication. The selection of art forms to be included in the analysis is practical—relating to our own knowledge and experience—rather than evaluative. It is not intended as hierarchical rating of art forms into more or less "theological" ones. The same needs to be stated about the specific art projects presented in the études of this book: for every project selected, a vast number of other astounding examples were available. Fortunately, other scholars have made serious and valuable studies on many of the resources we have left untapped, and we refer readers who wish to deepen their knowledge to our bibliography where many examples of parallel studies can be found.

We end our book where we began it: with Charlie Brown and his friends from the comic strip *Peanuts*. In the introduction, our antagonist was unhappy to discover that his ball team resembled a theological seminary

more than a vigilant troupe of athletes on the sports field, engaged in speculations about sin, the meaning of life, and other existential questions as they were. Perhaps, however, Charlie Brown would be comforted to learn that theology certainly has a place outside the academic halls he so clearly associates it with: that theology can be practical, embodied, engaged, on the move—all those aspects needed to form a successful baseball team as well as a fruitful theology of the arts.

# Notes

NOTES TO THE INTRODUCTION

1. Robert Short, *The Gospel According to "Peanuts"* (Louisville, KY: Westminster John Knox Press, 1965).
2. Charles Schulz, *United Feature Syndicate*, September 17, 1967.
3. Charles Schulz, *United Feature Syndicate*, September 5, 1967.
4. Frank Burch Brown, *Good Taste, Bad Taste, and Christian Taste* (New York: Oxford University Press, 2000), 7. Brown discusses the postmodern "fascination with artistic rupture, fragmentation, and fallibility."
5. Don Browning, *A Fundamental Practical Theology: Descriptive and Strategic Proposals* (Minneapolis, MN: Fortress Press, 1991), 3.
6. Edward Farley, "Theology and Practice outside the Clerical Paradigm," in *Practical Theology*, ed. Don Browning (San Francisco: Harper & Row, 1983), 21–41.
7. Farley, "Theology and Practice," 22–24. Farley's "clerical paradigm" has been the organizing topic, once again, in the 2010 meeting of the Association for Practical Theology as a part of the Annual Meeting of the American Academy of Religion in Atlanta.
8. Robin Lovin, "The Real Task of Practical Theology," *Christian Century*, February 5–12, 1992, 126.
9. Farley, "Theology and Practice," 27.
10. Thomas Groome, *Christian Religious Education: Sharing our Story and Vision* (San Francisco: Harper & Row, 1980), 141.
11. Groome, *Christian Religious Education*, 27.
12. Ray Anderson, *The Shape of Practical Theology: Empowering Ministry with Theological Process* (Downer's Grove, IL: Inter Varsity Press, 2001), 14. Anderson claims Karl Barth saw the task of theology as the clarification of the presuppositions of the church's praxis.
13. For a recent comprehensive critique along these lines, see Bonnie J. Miller-McLemore (ed.), *The Wiley-Blackwell Companion to Practical Theology* (Malden, MA: Wiley-Blackwell, 2012).
14. Kate Siejk, "Wonder: The Creative Condition for Interreligious Dialogue," *Religious Education* 90/2 (1995): 233.
15. For a convincing critique in relation to theology and architecture, see John W. de Gruchy, *Christianity, Art and Transformation. Theological Aesthetics in the Struggle for Justice* (Cambridge: Cambridge University Press, 2001), 174–176.
16. Comments made by Dr. Rubenstein during theology courses in the Department of Religion at Florida State University during the early 1970s.

17. Ninian Smart, "The Scientific Study of Religion in its Plurality," in *Theory and Method in the Religious Studies. Contemporary Approaches to the Study of Religion*, ed. Frank Whaling (Berlin: Mouton de Gruyter, 1995), 177.
18. Michael Barnes, "Religious Pluralism," in *The Routledge Companion to the Study of Religion*, ed. John Hinnells (New York: Routledge, 2005), 407.
19. Miroslav Volf, "A Voice of One's Own: Public Faith in a Pluralistic World," In *Democracy and the New Religious Pluralism*, ed. Thomas Banchoff (Oxford: Oxford University Press, 2007), 276.
20. Linda Woodhead, "Modern Contexts of Religion," in *Religions in the Modern World*, eds. Linda Woodhead, Hiroshi Kawanami & Christopher Partridge (New York: Routledge, 2009), 9–11.
21. Jolyon Mitchell, "Questioning Media and Religion," in *Between Sacred and Profane. Researching Religion and Popular Culture*, ed. Gordon Lynch (London: I. B. Tauris, 2007). 44.
22. Smart, "The Scientific Study of Religion," 188.
23  Siejk, "Wonder," 237.
24. Alma Espinosa, "Music: A Bridge between Two Cultures," *Forum on Public Policy Online*, Summer 2007 edition (2008), accessed November 28, 2008. *http://forumonpublicpolicy.com/archivesum07/espinoza.pdf.*
25. Abraham Joshua Heschel, "No Religion is an Island," In *Jewish Perspectives on Christianity*, ed. Fritz A. Rothschild (New York: Continuum, [1965] 2000), 312.
26. Aimee Upjohn Light, "Post-Pluralism through the Lens of Post-Modernity," *Journal of Inter-Religious Dialogue* 1 (2009): 73.
27. de Gruchy, *Christianity, Art and Transformation*, 178.
28. Inger Furseth, *From Quest for Truth to Being Oneself. Religious Change in Life Stories* (Frankfurt am Main: Peter Lang, 2006), 296.
29. Ibid.
30. See Brian D. McLaren, *A New Kind of Christianity* (San Francisco: Harper-One, 2010); Leonard Sweet (ed.), *Church in Emerging Culture: Five Perspectives* (Grand Rapids, MI: Zondervan, 2003); and Rob Bell, *Love Wins* (San Francisco: HarperOne, 2011).
31. Martin Buber, "Man and his Image-Work," in *The Knowledge of Man. Selected Essays*, ed. Maurice Friedman (Atlantic Highlands, NJ: Humanities Press International, 1965), 158.
32. Hans Georg Gadamer, *Truth and Method* (New York: Continuum, [1970] 2002), 269–71.
33. Gadamer, *Truth and Method*, 360.
34. Ibid., 306–307.
35. Ibid., 375–376.
36. Dewi Z. Phillips, *Religion and the Hermeneutics of Contemplation* (Cambridge: Cambridge University Press, 2001), 6, 16, 315.
37. Charles Taylor, *Philosophical Papers 2: Philosophy and the Human Sciences* (Cambridge: Cambridge University Press, 1995), 24, 53.
38. Egon G. Guba & Yvonna S. Lincoln, "Competing Paradigms in Qualitative Research: Theory and Issues," in *Approaches to Qualitative Research. A Reader on Theory and Practice*, eds. Sharlene N. Hesse-Biber & Patricia Leavy (Oxford: Oxford University Press, 2004), 20.
39. Taylor, *Philosophical Papers*, 21, 55; Phillips, *Hermeneutics of Contemplation*, 311.
40. Taylor, *Philosophical Papers*, 16, 18, 22–23.
41. Hans-Günther Heimbrock and Peter Meyer, "A Demanding Practice," in *Perceiving the Other. Case Studies and Theories of Respectful Action*, eds. Trygve Wyller and Hans-Günther Heimbrock (Göttingen: Vandenhoeck & Ruprecht, 2010), 25.

42. Charlotte A. Davies, *Reflexive Ethnography. A Guide to Researching Selves and Others* (London: Routledge, 1999), 10.

43. Sharlene N. Hesse-Biber and Patricia Leavy, "Interaction and Positionality within Qualitative Research," in *Approaches to Qualitative Research. A Reader on Theory and Practice*, eds. Sharlene N. Hesse-Biber and Patricia Leavy (Oxford: Oxford University Press, 2004), 133–134.

44. Patti Lather, "Getting Lost: Critiquing across Difference as Methodological Practice," in *The Methodological Dilemma. Creative, Critical and Collaborative Approaches to Qualitative Research*, ed. Kathleen Gallagher (London: Routledge, 2008), 227.

45. Heimbrock and Meyer, "A Demanding Practice," 25.

46. Lather, "Getting Lost," 227.

47. Parker Palmer, *The Courage to Teach: Exploring the Inner Landscape of a Teacher's Life* (San Francisco: Jossey-Bass, 1998), 90.

48. Heimbrock and Meyer, "A Demanding Practice," 22.

49. Paolo Freire, *Education for Critical Consciousness* (New York: Continuum, 1987), 49.

50. Nelle Morton, *The Journey Is Home* (Boston: Beacon, 1985), 147–175.

## NOTES TO CHAPTER 1

1. Walter Brueggemann, *Texts under Negotiation: The Bible and Postmodern Imagination* (Minneapolis, MN: Fortress Press, 1993), 10–11.

2. Jean François Lyotard, *The Postmodern Condition: A Report on Knowledge* (Minneapolis: University of Minnesota Press, 1984).

3. Richard Rorty, "Postmodern Bourgeois Liberalism," in *Hermeneutics and Praxis*, ed. Robert Hollinger (Notre Dame, IN: University of Notre Dame Press, 1985), 217–218.

4. Bonnie J. Miller-McLemore, "The Contributions of Practical Theology," in *The Wiley-Blackwell Companion to Practical Theology*, ed. Bonnie J. Miller-McLemore (Malden, MA: Wiley-Blackwell, 2012), 2.

5. Rorty, "Postmodern Bourgeois Liberalism," 76. Lyotard comments: "it must be recalled that science and industry are no more free of the suspicion which concerns reality than are art and writing."

6. Paul Lakeland, *Postmodernity: A Christian Identity in a Fragmented Age* (Minneapolis, MN: Fortress Press, 1997), 32.

7. Harold Horell, "Fostering Hope: Christian Religious Education in a Postmodern Age," *Religious Education* 99/1 (2004): 8.

8. Ibid.

9. Carl Raschke, "The De-construction of God," in *De-construction and Theology*, ed. Carl Raschke (New York: Crossroads: 1982), 3–4.

10. Gordon Kaufman, *In Face of Mystery: A Constructive Theology* (Cambridge, MA: Harvard University Press, 1993). Quoted in Deborah Haynes, "The Place of Art," in *Arts, Theology, and the Church*, eds. Kimberly Vrudny and Wilson Yates (Cleveland, OH: Pilgrim Press, 2005), 164.

11. Michael Hogue, "After the Secular. Toward a Pragmatic Public Theology," *Journal of the American Academy of Religion* 78/2 (2010): 354.

12. Volf, "A Voice of One's Own," 271.

13. Furseth, "Quest for Truth," 302.

14. Peter L. Berger, "Pluralism, Protestantization, and the Voluntary Principle," in *Democracy and the New Religious Pluralism*, ed. Thomas Banchoff (Oxford: Oxford University Press, 2007), 23.

15. Charles Taylor, *A Secular Age* (Cambridge, MA: The Belknap Press of Harvard University Press, 2007), 11.

16. Jürgen Habermas, "Notes on Post-Secular Society," *New Perspectives Quarterly* 25/4 (2007): 17–18.
17. Marcus Moberg, Kennet Granholm and Peter Nynäs, "Trajectories of Post-Secular Complexity: An Introduction," in *Post-Secular Society*, eds. Peter Nynäs, Mika Lassander and Terhi Utriainen (New Brunswick, NJ: Transaction Publishers, 2012), 3–5.
18. Sarah Bracke, "Conjugating the Modern/Religious, Conceptualizing Female Religious Agency: Contours of a 'Post-secular' Conjuncture," *Theory, Culture & Society* 25/6 (2008): 57, 59.
19. Ingolf U. Dalferth, "Post-secular Society: Christianity and the Dialectics of the Secular," *Journal of the American Academy of Religion* 78/2 (2010): 322.
20. Moberg, Granholm and Nynäs, "Trajectories of Post-Secular Complexity," 6.
21. Judith Butler, "Sexual Politics, Torture, and Secular Time," *The British Journal of Sociology* 59/1 (2008): 20.
22. Hogue, "After the Secular," 360; Light, "Post-Pluralism," 72.
23. Moberg, Granholm and Nynäs, "Trajectories of Post-Secular Complexity," 16–17.
24. Rosi Braidotti, "In Spite of the Times: The Postsecular Turn in Feminism," *Theory, Culture & Society* 25/1(2008): 11.
25. José Casanova, "Are We Still Secular? Explorations on the Secular and the Post-Secular," in *Post-Secular Society*, eds. Peter Nynäs, Mika Lassander and Terhi Utriainen (New Brunswick, NJ: Transaction Publishers, 2012), 29–30.
26. Volf, "A Voice of One's Own," 276.
27. Hogue, "After the Secular," 353.
28. Taylor, "A Post-Secular Age," 535.
29. Dalferth, "Post-Secular Society," 321–322.
30. Volf, "A Voice of One's Own," 271.
31. Brueggemann, *Texts under Negotiation*, 6.
32. Moberg, Granholm and Nynäs, "Trajectories of Post-Secular Complexity," 12.
33. Hogue, "After the Secular," 357.
34. Horell, "Fostering Hope," 11.
35. Ibid., 20.
36. Alejandro R. García Rivera, *A Wounded Innocence. Sketches for a Theology of Art* (Collegeville, MN: The Liturgical Press, 2003), viii.
37. Ibid., 6.
38. Lakeland, "Postmodernity," 16. See also Michel Foucault, *Power/Knowledge: Selected Interviews & Other Writings, 1972–1977*, ed. Colin Gordon (New York: Pantheon Books, 1980).
39. Ibid., 32.
40. Ibid., 63.
41. Rebecca Chopp, "When the Center Cannot Contain the Margin," in *The Education of Practical Theologians*, eds. Don S. Browning, David Polk and Ian S. Evison (Atlanta: Scholars Press, 1989), 66.
42. Mary Daly, *Beyond God the Father: Toward a Philosophy of Women's Liberation* (Boston: Beacon Press, 1973), 19.
43. Nelle Morton, *The Journey Is Home*, 147–175.
44. Rosemary Radford Ruether, *Women-Church: Theology and Practice of Feminist Liturgical Communities* (San Francisco: Harper & Row, 1985).
45. Phyllis Trible, *God and the Rhetoric of Sexuality*. In the series *Overtures to Biblical Theology* (Philadelphia: Fortress Press, 1978); Phyllis Trible, *Texts of Terror: Literary-Feminist Readings of Biblical Narratives*. In the series *Overtures to Biblical Theology* (Philadelphia: Fortress Press, 1984).

46. Elisabeth Schüssler-Fiorenza, *In Memory of Her: A Feminist Theological Reconstruction of Christian Origins* (New York: Crossroads, 1984).
47. Kristine Kulp, "The Nature of Christian Community," in *Setting the Table: Women in Theological Conversation*, eds. Rita Nakashima Brock, Claudia Camp and Serene Jones (St. Louis, MO: Chalice Press, 1995), 162–163.
48. Rita Nakashima Brock, "The Greening of the Soul: A Feminist Theological Paradigm of the Web of Life," in *Setting the Table: Women in Theological Conversation*, eds. Rita Nakashima Brock, Claudia Camp and Serene Jones (St. Louis, MO: Chalice Press, 1995), 133–154.
49. Ibid., 17.
50. Nelle Morton, *The Journey Is Home*, 125–128.
51. Ibid., 125.
52. Ibid., 127–128.
53. Rebecca Chopp, *The Power to Speak: Feminism, Language, God* (New York: Crossroads, 1989), 85–96. See also Rebecca Chopp, *The Praxis of Suffering: An Interpretation of Liberation and Political Theologies* (Maryknoll, NY: Orbis, 1989); and Rebecca Chopp, *Saving Work: Feminist Practices of Theological Education* (Louisville, KY: Westminster John Knox, 1995).
54. Morton, *The Journey Is Home*, 67. Quoted in Rita Nakashima Brock, "Oh, Honey, NO!" in *Kitchen Talk: Sharing Our Stories of Faith*, ed. Jane McAvoy, (St. Louis, MO: Chalice Press, 2003), 13.
55. Sharon Welch, *Communities of Resistance and Solidarity: A Feminist Theology of Liberation* (Maryknoll, NY: Orbis Books, 1985), 18.
56. Marjorie Agosín, *Tapestries of Hope, Threads of Love: The Arpillera Movement in Chile* (Lanham, MD: Rowman and Littlefield Publishers, 2008), 25.
57. See her installation, entitled *The Dinner Party*, which was first produced in 1979 and is still on display at the Brooklyn Museum. The installation fills a gallery room, with 39 places set—each of which represents a historically significant woman. The tablecloths and the floor covering contain names of additional women from history and myth.
58. Robin Jensen, *The Substance of Things Seen: Art, Faith, and the Christian Community* (Grand Rapids, MI: Eerdman's, 2004), 18.
59. Ibid., 25.
60. Sidney Fowler, "Revealings: Exploring the Practice of Prayer and Photographic Images," in *Arts, Theology, and the Church*, eds. Kimberly Vrudny and Wilson Yates (Cleveland, OH: Pilgrim Press, 2005), 239.
61. Bonnie Miller-McLemore, "Response," in *Practical Theology in Action: Christian Thinking in the Service of Church and Society*, eds. Paul Ballard and John Pritchard (London: SPCK, 2006), 21.
62. Jeremy Begbie, *Voicing Creation's Praise: Towards a Theology of the Arts* (Edinburgh: T&T Clark, 1991), 252.
63. Begbie, *Voicing Creation's Praise*, 257.
64. Gustavo Gutierrez, *A Theology of Liberation* (Maryknoll, NY: Orbis Books, 1984); Clodovis Boff, *Theology and Praxis: Epistemological Foundations* (Maryknoll, NY: Orbis Books, 1978); and Leonardo Boff and Clodovis Boff, *Introducing Liberation Theology* (Maryknoll, NY: Orbis Books, 1988). Ernesto Cardenal, *The Gospel in Solentiname* (Maryknoll, NY: Orbis Books, 1982).
65. Robert McAfee Brown, *Unexpected News: Reading the Bible with Third World Eyes* (Louisville, KY: Westminster John Knox Press, 1984).
66. Gutierrez, *A Theology of Liberation*.
67. Robert Schreiter, *Constructing Local Theologies* (Maryknoll, NY: Orbis Press, 1985), 15.

68. Karl Marx, "Theses on Feuerbach," in *Writings of the Young Marx on Philosophy and Society*, eds. Loyd Easton and Kurt Guddat (Garden City, NY: Anchor Books, 1997), 402.
69. Paolo Freire, *Education for Critical Consciousness*.
70. Paolo Freire, "Education, Liberation and the Church," *Study Encounter* 9/1 (1973): 2–4.
71. Freire, *Education for Critical Consciousness*, 57–74.
72. Ibid., 49.
73. Douglas Wingeier, "Generative Words in Six Cultures," *Religious Education* 75 (1980): 575.
74. Ibid.
75. Bruce Birch, "The Arts, Midrash, and Biblical Teaching," in *Arts, Theology, and the Church*, eds. Kimberly Vrudny and Wilson Yates (Cleveland, OH: Pilgrim Press, 2005), 112.
76. Ibid., 117–118.
77. Paolo Freire, *Pedagogy of the Oppressed* (New York: Continuum, 1983).
78. Phillip and Sally Scharper, eds., *The Gospel in Art by the Peasants of Solentiname* (Maryknoll, NY: Orbis Books, 1984).
79. de Gruchy, *Christianity, Art and Transformation*, 197.
80. Barnes, "Religious Pluralism," 412.
81. Martin Buber, "The Two Foci of the Jewish Soul," in *Jewish Perspectives on Christianity*, ed. Fritz A. Rothschild (New York: Continuum, [1930] 2000), 131.
82. Siejk, "Wonder," 233.
83. Willy Pfändtner, *Understanding Religious Diversity. A Contribution to Interreligious Dialogue from the Viewpoint of Existential Philosophy* (Uppsala: Uppsala University, 2005), 16, 19.
84. Ibid., 59.
85. Pfändtner, *Understanding Religious Diversity*, 88.
86. Martin Buber, *I and Thou* (New York: Touchstone, [1923] 1970), 138.
87. S. Wesley Ariarajah, *Not without My Neighbour. Issues in Interfaith Relations* (Geneva: WCC Publications, 1999), 112.
88. Pfändtner, *Understanding Religious Diversity*, 87.
89. Lyotard, *The Postmodern Condition*, 77.
90. Richard R. Osmer, *Practical Theology: An Introduction* (Grand Rapids, MI: Eerdman's, 2008), 22.
91. Burch Brown, *Good Taste, Bad Taste*, 88–89.
92. Ibid., 14.
93. Ibid., 86–87.
94. Richard Viladesau, *Theology and the Arts: Encountering God through Music, Art and Rhetoric* (New York: Paulist Press, 2000), 100. See Wassily Kandinsky, *Concerning the Spiritual in Art* (New York: Dover, 1977), 1–5.
95. Viladesau, *Theology and the Arts*, 101.
96. Gadamer, *Truth and Method*, 302 passim. A clear discussion of Gadamer's understanding of the "horizon" can be found in Dale Stover, "Linguisticality and Theology: Applying the Hermeneutics of Hans-Georg Gadamer," *Studies in Religion* 5/1 (1975–1976): 34–44.
97. Gadamer, *Truth and Method*, 302.
98. Begbie, *Voicing Creation's Praise*, 257.
99. Robin Jensen, *The Substance of Things Seen*, 14.
100. See Hans-Georg Gadamer, "What Is Practice? The Conditions of Social Reason," 69–87; "Hermeneutics as Practical Philosophy," 88–112; "Hermeneutics as a Theoretical and Practical Task," 113–138, all in *Reason in the Age of*

Science (Cambridge, MA: MIT Press, 1981). See also Hans-Georg Gadamer, "Aesthetic and Religious Experience," in *The Relevance of the Beautiful and Other Essays*," ed. Robert Bernasconi (Cambridge: Cambridge University Press, 1986).

101. Richard Bernstein, "From Hermeneutics to Praxis," in *Hermeneutics and Praxis*, ed. Robert Hollinger (Notre Dame, IN: University of Notre Dame Press, 1985), 90.

102. David Tracy, *Dialogue with the Other. The Interreligious Dialogue* (Louvain: Peeters Press, 1990), 59.

## NOTES TO CHAPTER 2

1. Emmanuel Levinas, *Of God Who Comes to Mind* (Stanford, CA: Stanford University Press, 1986), 137.
2. Miller-McLemore, "The Contributions of Practical Theology," 3.
3. Neve Gordon, "Ethics and the Place of the Other," in *Levinas and Buber: Dialogue and Difference*, eds. Peter Atterton, Matthew Calarco and Maurice Friedman (Pittsburgh: Duquesne University Press, 2004), 99–100.
4. Emmanuel Levinas, *Totality and Infinity. An Essay on Exteriority* (Pittsburgh: Duquesne University Press, 1969), 215, 247.
5. Martin Buber, "Dialogue," in *Between Man and Man*, ed. Martin Buber (New York: Routledge, [1932] 2002), 23.
6. Gordon, "Ethics and the Place of the Other," 99.
7. Buber "Dialogue," 11.
8. Buber, *I and Thou*, 53. Buber's use of the word "Du" is mostly translated as "Thou" in English. In his English translation of the book *Ich und Du*, dating from 1970, Walter Kaufmann nevertheless chooses to use the word "You." I-You sounds unfamiliar, he admits, but "Thou" is actually quite different from the German "Du": "German lovers say *Du* to one another, and so do friends. *Du* is spontaneous and unpretentious, remote from formality, pomp, and dignity. What lovers and friends say Thou to one another?" (Kaufmann in Buber, *I and Thou*, 14). Furthermore, "Thou" immediately brings God to mind, Kaufmann notes. Buber's use of the word "Du" both for our relations to other persons and to God is nevertheless an immensely important aspect of his philosophy. We find these comments fundamental for the understanding of Buber's thoughts, but still choose to use the conventional notion of Thou in referring to Buber's philosophy.
9. Buber, *I and Thou*, 59, 84–85.
10. Ibid., 23.
11. Buber, "Dialogue," 5.
12. Buber, "Dialogue," 9; Gordon, "Ethics and the Place of the Other," 100.
13. Buber, *I and Thou*, 60, 67.
14. Martin Buber, "Genuine Dialogue," in *The Martin Buber Reader*, ed. Asher D. Biemann (New York: Palgrave Macmillan, [1954] 2002b), 214.
15. Ludwig Wittgenstein, *Vermischte Bemerkungen* (Frankfurt am Main: Suhrkamp Verlag, 1977), 11. The English translation of the original phrase "den *Menschen* im Menschen erkennen" is offered by Peter Winch, *Trying to Make Sense* (Oxford: Basil Blackwell, 1987), 175. He admits that this translation is unsatisfactory in its abstractness, but stresses that the English language can offer no better way of expressing this idea. Hence, we follow his translation.
16. Buber, "Dialogue," 15, 29.

17. Buber, *I and Thou*, 89.
18. Raimond Gaita, *Romulus, My Father* (London: Review, 1998), 73.
19. Raimond Gaita, *Common Humanity. Thinking about Love and Truth and Justice* (New York: Routledge, 2002), 34.
20. Buber, *I and Thou*, 15.
21. Maurice Friedman, *A Heart of Wisdom. Religion and Human Wholeness* (Albany: State University of New York Press, 1992), 204.
22. Buber, *I and Thou*, 62.
23. Ibid., 57–59.
24. Buber, "Man and his Image-Work," 147.
25. Buber, Ibid., 149.
26. Gadamer, *Truth and Method*, 106–107.
27. Hans-Georg Gadamer, *Philosophical Hermeneutics*, trans. and ed. David E. Linge (Berkeley: University of California Press, 1976), 9.
28. Ibid.
29. Gadamer, *Truth and Method*, 269–271.
30. Buber, "Dialogue," 24.
31. Ibid., 12.
32. Tracy, *Dialogue with the Other*, 42.
33. Palmer, *The Courage to Teach*, 90.
34. Ibid., 97.
35. Ibid., 102.
36. Ibid., 101.
37. Ibid., 110.
38. Emmanuel Levinas, *Alterity and Transcendence* (New York: Columbia University Press, 1999), 100.
39. Levinas, "Time and the Other," in *The Levinas Reader*, ed. Seán Hand (Oxford: Basil Blackwell, 1989), 50.
40. Levinas, *Of God Who Comes to Mind*, 143.
41. Levinas, *Totality and Infinity*, 46.
42. Emmanuel Levinas, *Emmanuel Levinas: Basic Philosophical Writings* (Bloomington: Indiana University Press, 1996), 9.
43. Levinas, *Totality and Infinity*, 193.
44. Ibid., 197.
45. Seán Hand, "Introduction," in *The Levinas Reader*, ed. Seán Hand (Oxford: Basil Blackwell, 1989), 5.
46. H. Richard Niebuhr, *The Responsible Self: An Essay in Christian Moral Philosophy* (New York: Harper & Row, 1963). Here, Niebuhr placed the relationship of response to the other (or responsibility) at the center of ethics.
47. Levinas, *Of God Who Comes to Mind*, 145–146.
48. Emmanuel Levinas, "Beyond Intentionality," in *Philosophy in France Today*, ed. Alan Montefiore (Cambridge: Cambridge University Press, 1983), 112–113.
49. Drew Dalton, *Longing for the Other: Levinas and Metaphysical Desire* (Pittsburgh: Duquesne University Press, 2009), 39. Imbedded quotation from Levinas, *Totality and Infinity*, 86. Note the similarity to Lyotard's comments about Kandinsky's understanding of the "gaze" of the artist.
50. Dalton, *Longing for the Other*, 39.
51. Levinas, *Of God Who Comes to Mind*, 150.
52. Ibid., 147.
53. Levinas, *Totality and Infinity*, 215.
54. Levinas, "Time and the Other," 43.
55. Levinas, *Totality and Infinity*, 219, 304.

56. Levinas, *Of God Who Comes to Mind*, 141.
57. Ibid., 147.
58. Jensen, *The Substance of Things Seen*, 3.
59. Amos N. Wilder, "Foreword," in *Grace Confounding: Poems* (Minneapolis, MN: Fortress Press 1972), ix.
60. Jensen, *The Substance of Things Seen*, 146.
61. Siejk, "Wonder," 237.
62. Viladesau, *Theology and the Arts*, 123.
63. Fowler, *Revealings*, 239.
64. Levinas, *Of God Who Comes to Mind*, 150.
65. Knud E. Løgstrup, *The Ethical Demand* (Philadelphia: Fortress Press, 1971), 21.
66. Svend Andersen, *Løgstrup* (Frederiksberg: Forlaget Anis, 1995), 66.
67. Løgstrup, *The Ethical Demand*, 75.
68. Ibid., 134, 136.
69. Ibid.,17.
70. Erik Erikson, *Identity and the Life Cycle* (New York: International Universities Press, 1959). See also Erik Erikson, *Childhood and Society* (New York: W. W. Norton and Company, 1950).
71. Andersen, *Løgstrup*, 61–62.
72. Løgstrup, *The Ethical Demand*, 8, 19.
73. Ibid., 17.
74. Ibid., 10.
75. Ibid.
76. Ibid., 19.
77. Ole Wivel, *Sansning og symbol. Om kunst og digtning i K.E. Løgstrups filosofi* (Copenhagen: Centrum, 1985), 68.
78. Løgstrup, *The Ethical Demand*, 218.
79. Ibid., 205–206.
80. Ibid., 207.
81. Wivel, *Sansning og symbol*, 70.
82. Løgstrup, *The Ethical Demand*, 208.
83. Light, "Post-Pluralism," 71–72.
84. Barnes, "Religious Pluralism," 417–418.
85. Gadamer, *Truth and Method*, 97.
86. Viladesau, *Theology and the Arts*, 180.
87. Haynes, "The Place of Art," 174.
88. Ibid.
89. Birch, "The Arts, Midrash, and Biblical Teaching," 112.
90. Jensen, *The Substance of Things Seen*, 133.
91. de Gruchy, "Christianity, Art and Transformation," 200.

## NOTES TO CHAPTER 3

1. Browning, *A Fundamental Practical Theology*, 3.
2. Friedrich Schleiermacher, *A Brief Outline of the Study of Theology, Drawn up to Serve as the Basis of Introductory Lectures*, trans. William Farrer (Eugene, OR: Wipf and Stock Publishers [1850] 2007). Schleiermacher's metaphors for this division of theological disciplines also included a wheel with three spokes: one for each of the forms of theology, with the ministry of the church as the hub to which each was joined. Many contemporary scholars focus on a tree metaphor for the same three forms of theology.
3. Anderson, *The Shape of Practical Theology*, 7.

4. Lovin, "The Real Task," 126.
5. Mary McClintock Fulkerson, "Systematic Theology," in *The Wiley-Blackwell Companion to Practical Theology*, ed. Bonnie J. Miller-McLemore (Malden, MA: Wiley-Blackwell, 2012), 357.
6. Miller-McLemore, "The Contribution of Practical Theology," 5. A similar list is offered by Paul Ballard and John Pritchard, *Practical Theology in Action: Christian Thinking in the Service of Church and Society* (London: SPCK, 2006), 57.
7. Miller-McLemore, "The Contribution of Practical Theology," 14.
8. Friedrich Schweitzer, "Creativity, Imagination and Criticism," in *Creativity, Imagination and Criticism: The Expressive Dimension in Practical Theology*, eds. Paul Ballard and Pamela Couture (Cardiff, Wales: Cardiff Academic Press, 2001), 1–16.
9. Ibid., 6, 13.
10. Ballard and Pritchard, *Practical Theology in Action*, 18.
11. Ibid., 33.
12. Ibid., 177.
13. Ibid., 55. Elizabeth Conde-Frazier, "Participatory-Action Research," in *The Wiley-Blackwell Companion to Practical Theology*, ed. Bonnie J. Miller-McLemore (Malden, MA: Wiley-Blackwell, 2012), 234, claims that practical theology requires that the practical theologian reads the context of daily living and remains committed to a close reading of the world that is always contextual and never neutral.
14. Robert Mager, "Action Theories," in *The Wiley-Blackwell Companion to Practical Theology*, ed. Bonnie J. Miller-McLemore (Malden, MA: Wiley-Blackwell, 2012), 255.
15. Norbert Mette, "Practical Theology: Theory of Aesthetics or Theory of Action?" in *Creativity, Imagination and Criticism: The Expressive Dimension in Practical Theology*, eds. Paul Ballard and Pamela Couture (Cardiff, Wales: Cardiff Academic Press, 2001), 49.
16. Levinas discusses God as "otherwise than Being" and emphasizes that persons encounter the transcendent and infinite Other in the summons of the immanent other whom one encounters in everyday life. See Levinas, *Of God Who Comes to Mind* and Levinas, *Otherwise Than Being*.
17. Ballard and Pritchard, *Practical Theology in Action*, 54–55.
18. Joyce Ann Mercer, *Welcoming Children: A Practical Theology of Childhood*. Foreword by Bonnie J. Miller-McLemore (St. Louis, MO: Chalice Press, 2005), 12.
19. Ibid., 16.
20. Ibid., 36–37.
21. Denise M. Ackermann, "Narratives of Resistance and Hope: Women Doing Theology in Community," in *Creativity, Imagination and Criticism: The Expressive Dimension in Practical Theology*, eds. Paul Ballard and Pamela Couture (Cardiff, Wales: Cardiff Academic Press, 2001), 146–147. Compare her discussion with the work of Nelle Morton, "Beloved Image," 122–146.
22. Ackermann, "Narratives of Resistance," 147–148.
23. Ibid., 147.
24. Terence Kennedy, "Practice as a Foundation for Practical Theology," *Creativity, Imagination and Criticism: The Expressive Dimension in Practical Theology*, eds. Paul Ballard and Pamela Couture (Cardiff, Wales: Cardiff Academic Press, 2001), 120.
25. Schreiter, *Constructing Local Theologies*, 91.

26. Chopp, "When the Center Cannot Contain," 85.
27. Osmer, *Practical Theology*, 4.
28. Miller-McLemore, "The Living Human Web," 80.
29. Ackermann, "Narratives of Resistance," 143–152.
30. Begbie, *Voicing Creation's Praise*, 220.
31. Richard Bernstein, *Beyond Objectivism and Relativism: Science, Hermeneutics, and Praxis* (Philadelphia: University of Pennsylvania Press, 1985), 40, claims that Gadamer's treatment of Aristotle's *Nicomachean Ethics* is an excellent example of the dialogical character of Gadamer's approach.
32. Gadamer, *Reason in the Age of Science*, 81.
33. Sally Brown, "Hermeneutical Theory," in *The Wiley-Blackwell Companion to Practical Theology*, ed. Bonnie J. Miller-McLemore (Malden, MA: Wiley-Blackwell, 2012), 115.
34. Ibid., 117–118.
35. Groome, *Christian Religious Education*, 149.
36. Ibid., 118. See Groome's most recent book for a reiteration of his practical theology of Christian religious education: Thomas Groome, *Will There Be Faith?* (New York: Harper One, 2011).
37. Eric J. Sharpe, "Dialogue of Religions," in *Encyclopedia of Religion*, ed. Lindsay Jones (Detroit: Macmillan References, 2005), 2344.
38. Buber, *I and Thou*, 77.
39. Ibid., 89.
40. Ibid., 105, 109.
41. Buber, "Genuine Dialogue," 9; Buber, *I and Thou*, 128, 137.
42. Kwame A. Appiah, *Cosmopolitanism. Ethics in a World of Strangers* (New York: W. W. Norton & Company, 2006), 85.
43. Thomas Groome, "A Religious Educator's Response," in *The Education of the Practical Theologian*, eds. Don Browning, David Polk and Ian Evison (Atlanta: Scholars Press, 1989), 88.
44. Paul Ballard "The Practical Theologian as Artist," 133.
45. Ballard and Pritchard, *Practical Theology in Action*, 74–75.
46. Farley, "Theology and Practice," 27. See also Edward Farley, *Theologia: The Fragmentation and Unity of Theological Education* (Philadelphia: Fortress Press, 1983).
47. Schweitzer, "Creativity, Imagination and Criticism," 13.
48. Emmanuel Lartey, "The Aesthetic as Critical Tool in Practical Theology," in *Creativity, Imagination and Criticism: The Expressive Dimension in Practical Theology*, eds. Paul Ballard and Pamela Couture (Cardiff, Wales: Cardiff Academic Press, 2001), 32.
49. Kennedy, "Practice as a Foundation," 119–120.
50. Ibid., 126.
51. Ibid., 124.
52. Ballard and Pritchard, *Practical Theology in Action*, 75.
53. Jeanne Stevenson-Moessner, *Prelude to Practical Theology: Variations on Theory and Practice* (Nashville, TN: Abingdon, 2008), 37.
54. Ballard and Pritchard, *Practical Theology in Action*, 140–141.
55. Among recent books offering a theology of the arts would be the following: Doug Adams, *The Art of Living: Aesthetic Values and the Quality of Life* (Bellingham: Western Washington University Press, 1980); Frank Burch Brown, *Religious Aesthetics: A Theological Study of Making and Meaning* (Princeton, NJ: Princeton University Press, 1989); Brown, *Good Taste, Bad Taste*; García-Rivera, *A Wounded Innocence*; de Gruchy, *Christianity, Art and Transformation*; Jensen, *The Substance of Things Seen*; Don Saliers, *Worship as Theology:*

*Foretaste of Glory Divine* (Nashville, TN: Abingdon Press, 1994); Viladesau, *Theology and the Arts*; Vrudny and Yates, *Arts, Theology, and the Church*.

56. Paul Tillich, *Theology of Culture* (New York: Oxford University Press, 1959), 69.
57. Ibid., 70.
58. Paul Tillich, "Religion and Art," in *On Art and Architecture*, eds. John Dillenberger and Jane Dillenberger (New York: Crossroads, 1989), 36.
59. Colin Gunton, Foreword to *Voicing Creation's Praise: Towards a Theology of the Arts* by Jeremy Begbie (Edinburgh: T&T Clark, 1991), xii.
60. Begbie, *Voicing Creation's Praise*, 167.
61. Ibid., 177.
62. Wilson Yates, "The Theology and Arts Legacy," in *Arts, Theology, and the Church*, eds. Kimberly Vrudny and Wilson Yates (Cleveland, OH: Pilgrim Press, 2005), 16–18.
63. Ibid., 17.
64. Bonnie Miller-McLemore, "Aesthetics, Hermeneutics and Practical Theology," 19, 21.
65. Ibid., 21.
66. Ibid.
67. Begbie, *Voicing Creation's Praise*, 247.
68. Ibid., xvii.
69. Jeremy Begbie, *Resounding Truth: Christian Wisdom in the World of Music* (London: SPCK, 2007), 15–18.
70. Ibid., 19.
71. Ibid., 20.
72. Viladesau, *Theology and the Arts*, 221.
73. Ibid., 227.
74. Ibid., 228.
75. Jensen, *The Substance of Things Seen*, 146.
76. Paul Ballard and Pamela Couture, "Setting the Scene," in *Creativity, Imagination and Criticism: The Expressive Dimension in Practical Theology*, eds. Paul Ballard and Pamela Couture (Cardiff, Wales: Cardiff Academic Press, 2001).
77. Bernard Reymond, "Theatre and Practical Theology," in *Creativity, Imagination and Criticism: The Expressive Dimension in Practical Theology*, eds. Paul Ballard and Pamela Couture (Cardiff, Wales: Cardiff Academic Press, 2001), 192.
78. Paul Ballard, "The Practical Theologian as Artist," 134.
79. Ibid., 134–135.
80. Begbie, *Voicing Creation's Praise*, 199.
81. Ibid., 220.
82. Mette, "Practical Theology," 49.
83. Lartey, "The Aesthetic as Critical Tool," 32.
84. Osmer, *Practical Theology*, 22.
85. Miller-McLemore, "Aesthetics, Hermeneutics and Practical Theology," 21.
86. Brown, *Good Taste, Bad Taste*, 119–121.
87. Haynes, "The Place of Art," 165–167.
88. Palmer, *The Courage to Teach*, 90.
89. Stevenson-Moessner, *Prelude to Practical Theology*, 20 passim.
90. Barnes, "Religious Pluralism," 417–418.
91. Begbie, *Voicing Creation's Praise*, 212.
92. Marx, "Theses on Feuerbach," 402.
93. Palmer, *The Courage to Teach*, 90.

94. Daniel S. Schipani, "Case Study Method," in *The Wiley-Blackwell Companion to Practical Theology*, ed. Bonnie J. Miller-McLemore (Malden, MA: Wiley-Blackwell, 2012), 91–92.

## NOTES TO CHAPTER 4

1. Jane Golden, Robin Rice and Natalie Pompilio, *More Philadelphia Murals and the Stories They Tell* (Philadelphia: Temple University Press, 2006), 12.
2. Jane Golden, Robin Rice and Monica Yant Kinney, *Philadelphia Murals and the Stories They Tell* (Philadelphia: Temple University Press, 2002), 80.
3. Golden, Rice and Pompilio, *More Philadelphia Murals*, 10.
4. Ibid.
5. Natalie Pompilio, "A Son's Legacy of Forgiveness," *The Philadelphia Inquirer*, October 21, 2007, B6.
6. Ibid.
7. Morton, *The Journey Is Home*, 127–128.
8. Palmer, *The Courage to Teach*, 90.
9. Frederic Jameson, "Postmodernism," in *Contextualizing Aesthetics: From Plato to Lyotard*, eds. H. Gene Blocker and Jennifer M. Jeffers (Belmont, CA: Wadsworth, 1999), 325.
10. Golden, Rice and Pompilio, *More Philadelphia Murals*, 23.
11. Ibid.
12. Golden, Rice and Kinney, *Philadelphia Murals*, 42.
13. Golden, Rice and Pompilio, *More Philadelphia Murals*, 26.
14. Golden, Rice and Kinney, *Philadelphia Murals*, 40.
15. Brendan Lowe, "Postcard: Philadelphia," *Time.com*, August 2, 2007, accessed February 10, 2008. *http://www.time.com/time/printout/o,8816,1655717,00.html*.
16. Golden, Rice and Kinney, *Philadelphia Murals*.
17. Golden, Rice and Pompilio, *More Philadelphia Murals*, 27.
18. Ibid., 7.
19. Ibid., 8.
20. "How to Request a Mural, Mural Application," official website of the Mural Arts Program, accessed February 28, 2008. *http://www.muralarts.org/request*.
21. Golden, Rice and Kinney, *Philadelphia Murals*, 55.
22. Ibid., 57.
23. Maureen H. O'Connell, *Commonweal: A Review of Religion, Politics & Culture*, accessed February 28, 2008. *http://www.commonwealmagazine.com*.
24. Golden, Rice and Pompilio, *More Philadelphia Murals*, 108.
25. Ibid., 110.
26. Ibid., 116.
27. Ibid.
28. Lowe, "Postcard: Philadelphia."
29. Golden, Rice and Kinney, *Philadelphia Murals*, 99.
30. Ballard and Pritchard, *Practical Theology in Action*, 57. Miller-McLemore, "The Contributions of Practical Theology," 1–20, offers a similar set of models.
31. Ballard and Pritchard, *Practical Theology in Action*, 25.
32. Ibid., 140–141.
33. Hand, *Levinas Reader*, 207.

34. Freire, *Pedagogy of the Oppressed*, 57–74.
35. Ibid., 67.
36. Morton, *The Journey Is Home*, 127–128.
37. Freire, *Education for Critical Consciousness*, 45.
38. Ibid., 49.
39. Palmer, *The Courage to Teach*, 90.

## NOTES TO CHAPTER 5

1. "Lane Hall Gallery Exhibits Textiles by Peruvian Women," *News from the University of Michigan's Institute for Research on Women and Gender*, Fall (2003): 6.
2. Rebecca Berru Davis, "Picturing Paradise: Cuadros by the Peruvian Women of the Pamplona Alta as Visions of Hope," *An Interfaith Project: January 12, 2009–May 12, 2009* (Dominican School of Philosophy and Religion, 2009), accessed September 8, 2009. *http://www.dspt.edu/197810619144042730/blank/browse.asp?a=383&BMDRN=2000&BC.*
3. "The Pamplona Alta Cuadro," *University of the Immaculate Word* (2008): 1, accessed September 8, 2009. *http://www.uiwtx.edu/!agott/cuadros/new_page_5.htm.*
4. Michael R. Meyer and Michael Smith, "Peru's Booming Trade in 'Art Naif,'" *Newsweek*, June 24, 1985, accessed September 8, 2009. *http://www.gci275.com/news/nwswk03.shtml.*
5. Simone Francis, "Nomadic Hands: Carmen Gomez—Pamplona," 2008, accessed September 8, 2009. *http://www.journals.worldnomads.com/simonefrancis/post/19687.aspx.*
6. Henry A. Dietz, *Urban Poverty, Political Participation, and the State: Lima, 1970–1990* (Pittsburgh, PA: University of Pittsburgh Press, 1998), 77–78.
7. "An Invasion: Pamplona Alta, Peru," *University of the Immaculate Word* (2008), accessed September 8, 2009. *http://www.uiwtx.edu/˜agott/cuadros/pamplona_alta.htm.*
8. Samantha Stewart, "Students Document Volunteer Service in Peru," *DU Today*, September 8, 2009: 1, accessed September 8, 2009. *http://www.du.edu/today/stories/2009/08/2009–08–25peru.html.*
9. "Stories—Lima & Pamplona Alta," *Med to One* (2009), accessed September 8, 2009. *http://www.med2one.org/Stories/LimaPamplona.html.*
10. Ibid.
11. John Crabtree, *Peru* (Oxford: Oxfam Country Profile, 2002), 59–60.
12. Francis, "Nomadic Hands," 1.
13. "Peru—Lima and the Patterns of Migration" (2009), accessed September 8, 2009. *http://www.country-data.com/cgi-bin/query/r-10240.html.*
14. Ibid., 2.
15. Dietz, *Urban Poverty*, 78.
16. Paulo Gianturco and Toby Tuttle, *In Her Hands: Craftswomen Changing the World* (New York: Monacelli Press, 2000), 75.
17. "Peru—Lima and the Patterns of Migration," 1.
18. Ibid., 2.
19. Gianturco and Tuttle, *In Her Hands*, 80.
20. Ibid., 75.
21. Francis, "Nomadic Hands," 2.
22. Barbara Cervenka, "Cuadros of Pamplona: Textile Pictures by Women of Peru," *The Institute for Research on Women and Gender* (2003): 1, accessed

September 8, 2009. *http://irwg.research.umich.edu/events/exhibits/cuadros.html*.

23. "The Vaso de Leche Cuadro," *University of the Immaculate Word* (2008), accessed September 8, 2009. *http://www.uiwtx.edu/˜agott/cuadros/new_page_3.htm*.
24. Gianturco and Tuttle, *In Her Hands*, 75.
25. "Patchwork Art: The Arpilleras or Patchworks," *El Pico Flor* (2009), accessed September 8, 2009. *http://www.elpicaflor.com/patchworkart2.htm.http://www.elpicaflor.com/patchworkart2.htm*.
26. Agosín, *Tapestries of Hope*, 33.
27. Isabel Allende "Foreword" in *Tapestries of Hope, Threads of Love: The Arpillera Movement in Chile*, ed. Marjorie Agosín (Lanham, MD: Rowman & Littlefield Publishers, 2008), x.
28. Meyer and Smith, "Peru's Booming Trade," 2.
29. "CLASA Art Exhibit Closing Event" (University of Detroit Mercy, 2007), accessed September 8, 2009. *http://www.udmercy.edu/news-events/event.php?id=1169243105608*.
30. Cervenka, "Cuadros of Pamplona," 1.
31. Charlotte Caron, "Feminist Rituals for Social Change," in *Creativity, Imagination and Criticism: The Expressive Dimension in Practical Theology*, eds. Paul Ballard and Pamela Couture (Cardiff, Wales: Cardiff Academic Press, 2001), 161.
32. Nelle Morton, *The Journey Is Home*, 127–128.
33. Meyer and Smith, "Peru's Booming Trade," 1.
34. "Patchwork Art," 1.
35. Meyer and Smith, "Peru's Booming Trade,"1.
36. Jane Dalton, "Arpilleras: Stories in Cloth," *School Arts* 107/2 (2008): 50.
37. Cervenka, "Cuadros of Pamplona," 1.
38. Gianturco and Tuttle, *In Her Hands*, 83.
39. Agosín, *Tapestries of Hope*, 19.
40. Gianturco and Tuttle, *In Her Hands*, 80.
41. Ibid.
42. Davis, "Picturing Paradise," 1.
43. Morton, *The Journey Is Home*, 122–146.
44. Palmer, *The Courage to Teach*, 90.
45. Freire, *Education for Critical Consciousness*, 45.
46. Ibid., 67.
47. Levinas uses this phrase frequently. Dalton, *Longing for the Other*, 39, quotes the phrase and discusses its implications.
48. Levinas, *Totality and Infinity*, 193.
49. Levinas, Emmanuel, "Beyond Intentionality," 112–113.
50. Miller-McLemore, *The Living Human Web*, 21.
51. Ibid., 57–74.
52. Stover, "Lingusiticality and Theology," 35.
53. Lyotard, *The Postmodern Condition*.
54. Miller-McLemore, "Aesthetics, Hermeneutics and Practical Theology," 19.
55. Ballard and Pritchard, *Practical Theology in Action*, 141.
56. Gianturco and Tuttle, *In Her Hands*, 83.
57. Rebecca Berru Davis, "Creative Arts of Survival, Conscious Acts of Subversion: Textile Pictures by the Peruvian Women of the Pamplona Alta," accessed February 27, 2008. *http://www.stthomas.edu/arthistory/graduate/students/files/DavisAbstract.pdf*.
58. Agosín, *Tapestries of Hope*, 25.

59. Ibid., 24.
60. Gianturco and Tuttle, *In Her Hands*, 75.
61. Arpilleras—A Guide to Peruvian Handicrafts and Souvenirs (2008), accessed September 8, 2009. *http://www.andeantravelweb.com/peru/handicrafts/arpilleras_handicrafts_peru.html*.
62. Jensen, *The Substance of Things Seen*, 14.
63. Agosín, *Tapestries of Hope*, 25.
64. Ibid., 26.
65. Schreiter, *Constructing Local Theologies*.
66. Miller-McLemore, "Aesthetics, Hermeneutics and Practical Theology," 17–24.
67. Mercer, *Welcoming Children*, 15.
68. Ballard and Pritchard, *Practical Theology in Action*, 94.
69. Lartey, "The Aesthetic as Critical Tool," 33.
70. Dalton, "Arpilleras: Stories in Cloth," 50.
71. Wingeier, "Generative Words," 564.
72. Ibid., 575.
73. Lakeland, *Postmodernity*, 63.
74. Miller-McLemore, "Aesthetics, Hermeneutics and Practical Theology," 22.

## NOTES TO CHAPTER 6

1. Interview with Eric-Emmanuel Schmitt, June 2008, Brussels (see bibliography for details).
2. Schmitt, "Interview."
3. Ibid.
4. Ibid.
5. *Milarepa* was first written as a play, and *Monsieur Ibrahim and the Flowers of the Koran* as well as *Oscar and the Lady in Pink* have both been developed into plays and films.
6. Schmitt's books are originally written in French, and not all have been translated into English. References in this text are selected from the English translations where available; otherwise the French original has been solicited. It should also be underlined that *Le Cycle de l'invisible* represents only a small fraction of Schmitt's vast literary production. In addition to these five novellas, he has written plays, novels, essays, and short stories, which have been translated into several languages.
7. Schmitt, "Interview."
8. Eric-Emmanuel Schmitt, *Monsieur Ibrahim and the Flowers of the Koran* (New York: Other Press, 2003).
9. The book has also been made into a French language film under the same title, released in December 2009.
10. Schmitt, "Interview."
11. Eric-Emmanuel Schmitt, *Le sumo qui ne pouvait pas grossir* (Paris: Albin Michel, 2009), 8. Translation by current authors.
12. Eric-Emmanuel Schmitt, *Le dix enfants que madame Ming n'a jamais eus* (Paris: Albin Michel, 2012), 79. Translation by current authors.
13. Buber, "Dialogue," 15, 29.
14. Schmitt, *Monsieur Ibrahim*, 12.
15. Ibid.
16. Ibid., 23.
17. Ibid., 25.
18. Ibid., 30.

19. Eric-Emmanuel Schmitt, *L'enfant de Noé* (Paris: Albin Michel, 2004), 65.
20. Ibid., 79.
21. Ibid., 118. Translation by current authors.
22. Eric-Emmanuel Schmitt, *Oscar and the Lady in Pink* (New York: Other Press, 2003), 64.
23. Buber, "Dialogue," 9; Buber, *I and Thou*, 128, 137.
24. Eric-Emmanuel Schmitt, *Milarepa* (Paris: Albin Michel, 1997), 62.
25. Schmitt, *Le sumo*, 95.
26. Schmitt, "Interview."
27. Schmitt, *Monsieur Ibrahim*, 38–39.
28. Ibid., 25.
29. Schmitt, *Oscar*, 70.
30. Schmitt, *L'enfant de Noé*, 94.
31. Ibid., 65.
32. Schmitt, "Interview."
33. Eric-Emmanuel Schmitt, *Ma vie avec Mozart* (Paris: Albin Michel, 2005), 50–51, 111.
34. Schmitt, "Interview."
35. Casanova, "Are We Still Secular?," 29–30.
36. Hogue, "After the Secular," 353.
37. Thomas Banchoff, "Introduction," in *Democracy and the New Religious Pluralism*, ed. Thomas Banchoff (Oxford: Oxford University Press, 2007), 5.
38. Laura Wickström and Ruth Illman, "Environmentalism as a Trend in Post-Secular Society," in *Post-Secular Society*, eds. Peter Nynäs, Mika Lassander and Terhi Utriainen (New Brunswick, NJ: Transaction Publishers, 2012), 220.
39. Willy Pfändtner, "Constructive Dialogical Pluralism: A Context of Interreligious Relations," *Sophia* 49 (2009): 68–69.
40. Stanley Hauerwas, "The End of Religious Pluralism: A Tribute to David Burrell," in *Democracy and the New Religious Pluralism*, ed. Thomas Banchoff (Oxford: Oxford University Press, 2007), 287; Light, "Post-Pluralism," 67.
41. Wickström and Illman, "Environmentalism as a Trend in Post-Secular Society," 227–228.
42. Hauerwas, "The End," 283.
43. Volf, "A Voice of One's Own," 276.
44. Pfändtner, "Constructive Dialogical Pluralism," 71.
45. Wickström and Illman, "Environmentalism," 228.
46. Casanova, "Are We Still Secular?," 30.
47. Banchoff, "Introduction," 6.
48. William E. Connolly, *Pluralism* (Durham, NC: Duke University Press, 2005).
49. Light, "Post-Pluralism."
50. Banchoff, "Introduction," 6.
51. Light, "Post-Pluralism," 67.
52. Ibid, 68.
53. Moberg, Granholm and Nynäs, "Trajectories of Post-Secular Complexity," 32–33; Wickström and Illman, "Environmentalism," 232–233.
54. Siejk, "Wonder," 233.
55. Light, "Post-Pluralism," 71–72.

## NOTES TO CHAPTER 7

1. Jonathan Fox, *Acts of Service: Spontaneity, Commitment, Tradition in the Non-Scripted Theatre* (New Paltz, NY: Tusitala Press, 1994), 85.

2. Playback Center, accessed May 23, 2008. *http://www.playbackschool.org/about_us_about_playback_theatre.htm.*
3. Jonathan Fox, *The Essential Moreno: Writings in Psychodrama, Group Method, and Spontaneity* (New York: Springer Publishing Company, 1987).
4. Fox, *Acts of Service.* Fox identifies his approach to the theatre as better associated with Moreno's early theatre group in Vienna (the Stegreiftehater) than with the later therapy approach of psychodrama.
5. "Playback Center."
6. Jo Salas, *Improvising Real Life: Personal Story in Playback Theatre* (New Paltz, NY: Tusitala Press, 1996), 113.
7. Salas, *Improvising Real Life.* See also Jo Salas, *Do My Story, Sing My Song: Music Therapy and Playback Theatre with Troubled Children* (New Paltz, NY: Tusitala Press, 2007).
8. Salas, *Improvising Real Life,* 1.
9. See the archived articles at *http://www.playbackcentre.org* or at *http://www.playbacktheatre.org,* accessed December 4, 2012.
10. Fox, *Acts of Service,* 2–3.
11. Ibid., 151.
12. Ibid., 153.
13. John Stevenson, "The Fourth Wall and the Third Space," *Centre for Playback Theatre* (1995): 4, accessed December 3, 2012. *http://playbacktheatre.org/wp-content/uploads/2010/04/Stevenson_Fourth.pdf.*
14. Ibid., 5.
15. Ibid., 3.
16. David Charles, "A New Paradigm of Popular Play: Playback as Bakhtinian Novelistic Theatre," *Centre for Playback Theatre* (2005): 3, accessed December 3, 2012. *http://www.playbacktheatre.org/wp-content/uploads/2010/04/Charles-ANewParadigmOfPopularPlayPlayback.pdf.*
17. Stevenson, "The Fourth Wall," 7.
18. Since Edward Bullough's 1912–1913 article entitled "'Psychic Distance' as a Factor in Art and an Aesthetic Principle," in *The British Journal of Psychology* 5 (1912/1913): 87–118, philosophers have debated the influence of "aesthetic distance" that Bullough argued created a sense of "objectivity" that allowed the viewer of art to examine objects of art without the interference of "subjective" feelings. George Dickie, "The Myth of the Aesthetic Attitude," *American Philosophical Quarterly* 1/1 (1964): 56–65 is among more recent critics of this "aesthetic distance."
19. Palmer, *The Courage to Teach.* See also Arlene Kiely, "Playback within a Faith Community. School of Playback Theater Leadership," *Centre for Playback Theatre* (2004): 9, accessed December 3, 2012. *http://www.playbacktheatre.org/resources/articles-and-books/.*
20. Kiely, "Playback within a Faith Community," 7.
21. Stevenson, "The Fourth Wall," 2.
22. Kimberley Rattley, "Using Playback Theatre to Explore African American Identity," *Centre for Playback Theatre* (1997): 4, accessed December 4, 2012. *http://www.playbacktheatre.org/resources/articles-and-books/.*
23. Stevenson, "The Fourth Wall," 3.
24. Victor Turner, *The Forest of Symbols* (Ithaca, NY: Cornell University Press, 1967).
25. Caron, "Feminist Rituals for Social Change," 163–164.
26. Bernard, "Theatre and Practical Theology," 192.
27. Heinrich Dauber, "Gathering Voices—Essays on Playback Theatre," in *How Playback Theatre Works: A Matter for Practical Research,* eds. Jonathan Fox and Heinrich Dauber (New Paltz, NY: Tusitala Press, 1999), 2. It is

worth noting that the Latin word for the Pope—a priest to the priests and the recognized leader of Roman Catholicism—is *pontifex*, a word that derives from *ponte*, which is translated as "bridge." The priest serves as a bridge between the sacred and the profane.

28. Fox, *Acts of Service*, 121.
29. Ibid., 134.
30. Palmer, *The Courage to Teach*. 105. This is an image Palmer borrows from the poet Robert Frost.
31. Dauber, "Gathering Voices," 2.
32. Kiely, "Playback within a Faith Community," 11.
33. Stevenson, "The Fourth Wall," 7.
34. Charles, "A New Paradigm," 5.
35. Salas, *Improvising Real Life*, 14.
36. Stevenson, "The Fourth Wall," 3.
37. Fox, *Acts of Service*, 6.
38. Linda Park-Fuller, "Beyond Role Play: Playback Theatre and Conflict Transformation," *Centre for Playback Theatre* (2005): 13, accessed December 4, 2012. *http://www.playbacktheatre.org/wp-content/uploads/2010/04/LindaPark-Fuller-Beyond-Role-Play-Playback-Theatre-and-Confl.pdf*.
39. Jürgen Habermas, *Theory of Communicative Action* (Boston: Beacon Press, 1987).
40. Stevenson, "The Fourth Wall," 7.
41. Salas, *Improvising Real Life*, 95.
42. Morton, *The Journey Is Home*, 127–128.
43. Levinas, *Totality and Infinity. As Essay on Exteriority*, 193.
44. Lori Wynters, "Constructing Knowledge through Playback Theatre," *Centre for Playback Theatre* (1996): 6, accessed December 3, 2012. *http://www.playbacktheatre.org/resources/articles-and-books/*.
45. Park-Fuller, "Beyond Role Play," 7.
46. Susan Metz, "Fragments towards an Exploration of the Role of Playback Theatre in Societal Transformation," *Centre for Playback Theatre* (2006): 8, accessed December 3, 2012. *http://www.playbacktheatre.org/resources/articles-and-books/*.
47. Ibid., 13.
48. Di Adderley, "Why Do Tellers Tell?," *Centre for Playback Theatre* (2004): 7, accessed December 3, 2012. *http://www.playbacktheatre.org/resources/articles-and-books/*.
49. Darby Hayes, "Empowering the Outcast: Past Versus Future Storytelling," *Centre for Playback Theatre* (2006): 15, accessed December 4, 2012. *http://www.playbacktheatre.org/wp-content/uploads/2010/04/Hayes__Outcasts.pdf*.
50. Salas, *Improvising Real Life*, 75.
51. Fox, *The Essential Moreno*. Moreno understands Aristotle's discussion of *catharsis* as an essential function of theatre is the subject of the first chapter of the book.
52. Wynters, "Constructing Knowledge," 3.
53. Fox, *Acts of Service*, 50.
54. Ibid., 44.
55. Park-Fuller, "Beyond Role Play," 9–10.
56. Ibid., 10.
57. Wynters, "Constructing Knowledge," 5.
58. Folma Hoesch, "The Red Thread: Storytelling as a Healing Process," *Centre for Playback Theatre* (1999): 1, accessed December 10, 2012. *http://www.playbacktheatre.org/wp-content/uploads/2010/04/Red-Thread.pdf*.
59. Ibid., 19.

60. Metz, "Fragments towards an Exploration," 9.
61. Adderley, "Why Do Tellers Tell?," 17.
62. Park-Fuller, "Beyond Role Play," 12.
63. Ibid.,13.
64. Jo Salas, "A Note on What We Mean by 'Dialogue' in Playback Theatre," *Centre for Playback Theatre* (2005): 1, accessed December 4, 2012. *http:// playbacktheatre.org/wp-content/uploads/2010/04/Salas_Noteondialogue. pdf.*
65. Hannah Fox, "Weaving Playback Theatre with Theatre of the Oppressed," *Centre for Playback Theatre* (2007): 1, accessed December 4, 2012. *http:// playbacktheatre.org/wp-content/uploads/2010/04/FoxH_TO.pdf.*
66. Ibid., 3.
67. Ibid.
68. Wynters, "Constructing Knowledge," 6.
69. Charles, "A New Paradigm," 17.
70. Ibid., 99.
71. See our discussion of "the between" in chapter 1. Gadamer's concept of the "fusion of horizons" is also similar.
72. Park-Fuller, "Beyond Role Play," 15.
73. Charles, "A New Paradigm," 14.
74. Ibid., 3–4.
75. Ibid., 5.
76. Hoesch, "The Red Thread," 6.
77. Alexandra Kedrock, "Letting in the Breeze: Playback Theatre as a Spiritual Practice," *Centre for Playback Theatre* (2004): 2, accessed December 3, 2012. *http://www.playbacktheatre.org/resources/articles-and-books/.*
78. Ibid., 7. Eliot Eisner identifies the *null* curriculum as the curriculum that exists because it does *not* exist; in other words, the *null* curriculum is what one teaches by intentionally excluding a subject from discussion or consideration. Eliot Eisner, *The Educational Imagination* (New York: MacMillan, 1979), especially 74–92. See also Maria Harris's discussion in *Teaching and Religious Imagination: An Essay in the Theology of Teaching* (San Francisco: Harper & Row, 1987), 100–101.
79. Ibid., 7.
80. Metz, "Fragments towards an Exploration," 8.
81. Ibid., 7–8.
82. Salas, *Do My Story*, 135.
83. Hoesch, "The Red Thread," 20.
84. Adderley, "Why Do Tellers Tell?," 9.
85. Ibid., 12.
86. Ibid.

## NOTES TO CHAPTER 8

1. Miller-McLemore, "The Living Human," 21. See also her article, "Feminist Theory in Pastoral Theology," in *Feminist and Womanist Pastoral Theology*, eds. Bonnie Miller-McLemore and Brita Gill-Austern (Nashville, TN: Abingdon, 1999), 80.
2. Parsberg's full biography can be found at her personal website: *http://ceci liaparsberg.se*, accessed October 22, 2012.
3. Interview with Cecilia Parsberg, May 2008, Stockholm (see bibliography for details).

4. "4U! What Question Would You Ask Someone Who Is More Powerful Than You?", accessed October 29, 2012. *http://ceciliaparsberg.se/4u/index_main.html*.

5. Buber, *I and Thou*, 105, 109.

6. John Lyden, "Introduction," in *The Routledge Companion to Religion and Film*, ed. John Lyden (London: Routledge, 2009), 1, 3.

7. Christopher Deacy, "Faith in Film," in *The Religion and Film Reader*, eds. Jolyon Mitchell and S. Brent Plate (New York: Routledge, 2007), 310.

8. Clive Marsh. *Theology Goes to the Movies. An Introduction to Critical Christian Thinking* (London: Routledge, 2007), 31.

9. Lyden, "Introduction," 4, 7.

10. Ibid., 9.

11. "Post-2000," accessed October 29, 2012. *http://ceciliaparsberg.se/post-2000/*.

12. Ruth Illman has analyzed this film in two previous, partly similar, publications: Ruth Illman, *Art and Faith. Artists Engaged in Interreligious Dialogue* (London: Equinox Publications, 2012); and Ruth Illman, "A Heart from Jenin. Transformation, Mediation, Vulnerability," in *Transforming Otherness*, eds. Jason Finch and Peter Nynäs (Piscataway, NJ: Transaction Publishers, 2011).

13. Parsberg, "Interview."

14. Ibid.

15. The film can be viewed at the address *http://www.humanrightstv.com/human-rights-artists/cecilia-parsberg/a-heart-from-jenin*, accessed October 26, 2012. The Khatib family presented in the film has also been presented in several other documentaries, for example, the German film *Das Hertz von Jenin* from 2008.

16. Parsberg, *A Heart from Jenin*.

17. The Druze form a monotheistic religious community found mostly in the Middle East. With its roots in 11th-century Islam, the Druze community has approximately 1 million adherents today. They hold several beliefs that are highly contested by other Muslims, and therefore, their relations to other Islamic groups have at times been strained. Samy Swayd, "Druze," in *Encyclopedia of Religion, Second Ed.*, ed. Lindsay Jones (Detroit: Macmillan, 2005), 2502–2504.

18. Marc Gopin, *Holy War, Holy Peace: How Religion Can Bring Peace to the Middle East* (New York: Oxford University Press, 2002), 169–170.

19. Parsberg, "A Heart from Jenin."

20. Nils G. Holm, "An Integrated Role Theory for the Psychology of Religion: Concepts and Perspectives," in *Psychology of Religion. Theoretical Perspectives*, eds. Bernard Spilka and Daniel McIntosh (Denver: Westview Press, 1997), 80.

21. Illman, *A Heart from Jenin*, 80–81.

22. Frank A. Thompson, "Matthew Fox Has an Image Problem," in *Art and Interreligious Dialogue. Six Perspectives*, ed. Michael S. Bird (Lanham, MD: University Press of America, 1995), 55.

23. Heather Höpfl, "Sacred Heart: A Comment on the Heart of Management," *Culture and Organization* 14/3 (2008): 226.

24. Hanno Ehses, "Speaking of the Heart: Some Annotations," *Design Issues* 18/1 (2002): 62.

25. Løgstrup, *The Ethical Demand*, 218.

26. Buber, *I and Thou*, 77.

27. Løgstrup, *The Ethical Demand*, 134, 136.

28. Ibid., 17.
29. Parsberg, "Interview."
30. Jean-Luc Marion, *Being Given. Toward a Phenomenology of Givenness* (Palo Alto, CA: Stanford University Press, 2002), 107.
31. Cecilia Parsberg, "Predikan 1:A advent i Jacobskyrkan, Stockholm," (Unpublished sermon delivered in Stockholm, November 28, 2007).
32. Marion, *Being Given*, 107.
33. Ibid., 108.
34. Parsberg, "Predikan," quote translated by current authors.
35. Levinas, *Totality and Infinity*, 219.
36. Levinas, *Of God*, 147.
37. Brueggemann, *Texts under Negotiation*, 6.
38. de Gruchy, *Christianity, Art and Transformation*, 197.
39. Ibid., 196–197.

## NOTES TO CHAPTER 9

1. Jordi Savall, *Jérusalem. La ville des deux Paix: La paix céleste et la paix terrestre* (Barcelona: Alia Vox, 2008), 109.
2. "Alia Vox," website of Jordi Savall and his record label, accessed March 31, 2010. *http://www.alia-vox.com*.
3. "Alia Vox."
4. Adam Wasserman, "Spanish Master," *Opera News* 72/2 (2007): 35.
5. Philip Sutton, "Jordi Savall," *Goldberg Magazine* 7 (1999): 45.
6. Interview with Jordi Savall, April 2008, Barcelona (see bibliography for details).
7. Elisabeth Haas, "La musique, espoir de paix," *La Liberté*, December 20, 2008, 35.
8. Savall, *Jérusalem*, 106.
9. Savall, *Jérusalem*, 101. According to Samuel Abramsky and Shimon Gibson, the popular explanation of the name Jerusalem as the "foundation of peace (*shalom*)" is of Midrasic origin and is associated with "poetic appellations given to the city." Samuel Abramsky and Shimon Gibson, "Jerusalem," in *Encyclopaedia Judaica*, eds. Michael Berenbaum and Fredrik Skolnik (Detroit: Macmillan Reference, 2007), 144.
10. Savall, *Jérusalem*, 107.
11. Santiago Salaverri and Juan Lucas, "Jordi Savall & Montserrat Figueras: 'Alia Vox Was Born out of our Desire for Freedom,'" *Diverdi* 166 (2008): 14.
12. Haas, "La musique," 35.
13. In the Christian Bible (following the New International Version, NIV), this passage is found in Psalm 122:6.
14. The genocide took place in the early 20th century in present-day Turkey. Many of the surviving Armenians fled to Jerusalem, attaching the memory of yet another atrocity to the city's history.
15. Savall, "Interview."
16. Ibid.
17. Jordi Savall, *Orient-Occident* (Barcelona: Alia Vox, 2006), 18.
18. Sutton, "Jordi Savall," 49.
19. Buber, "Genuine Dialogue," 214–215.
20. Jordi Savall, "Travel Notes II," *Goldberg Magazine* 15 (2001): 116.
21. Begbie, *Resounding Truth*, 18.
22. Ibid., 19.

23. Savall, "Interview."
24. Yehuda Amichai, *The Selected Poetry of Yehuda Amichai, Newly Revised and Expanded edition* (Berkeley: The University of California Press, 1996), 32.
25. "El Male Rahamim" (in Hebrew: God Full of Mercy) is a prayer for the dead that is recited at funerals and anniversaries of the death of loved ones, as well as when visiting graves. It can also be included in the synagogue liturgy at times. It originates as a prayer for the martyrs of the Crusades and Chmielnicki's pogroms (in the 17th century) and has thus also become associated with the Holocaust. In the Ashkenazi tradition, the prayer is often given an elaborate musical form and is often performed by a cantor in a virtuoso style. Bathja Bayer, "*El Male Rahamim*," in *Encyclopaedia Judaica*, eds. Michael Berenbaum and Fredrik Skolnik (Detroit: Macmillan Reference, 2007), 364–365.
26. Website of Yair Dalal, accessed September 28, 2011. *http://www.yairdalal.com/?page_id=108*.
27. Website of Omar Bashir, accessed September 28, 2011. *http://www.omarbashir.hu/content/omar.html*.
28. Savall, "Interview."
29. Tracy, *Dialogue with the Other*, 59.
30. Savall, *Jérusalem*, 108.

## NOTES TO CHAPTER 10

1. Osmer, *Practical Theology*, 22.
2. Caroline Chen, "*So You Think You Can Dance* Spotlights Bay Area Duet, with One Dancer in a Wheelchair," *SF Weekly Blog*, June 30, 2011, accessed June 11, 2012. *http://blogs.sfweekly.com/exhibitionist/2011/06/so_you_think_you_can_dance_wheelchair.html*.
3. "AXIS on SYTYCD," video on YouTube, accessed June 30, 2011. *http://www.youtube.com/watch?v=rdLsRefSh58*.
4. Susan Josephs, "Axis Dance Company Revels in Its Abilities," Special to the *Los Angeles Times*, July 3, 2011, accessed June 11, 2012. *http://articles.latimes.com/print/2011/jul/03/entertainment/la-ca-disabled-dancing-20110703*. This term, which was how Rodney Bell described the approach to dance being used by AXIS, is used consistently to describe AXIS and other dance companies around the world that intentionally integrate dancers who are "differently abled." See also Allan Ulrich, "Review: Axis Dance Company at Malonga Casquelord," *San Francisco Chronicle*, November 9, 2009; Jesse Male, "Wheels Welcome: Axis Dance Company," *Dance Magazine*, October 1–7, 2005; "Bodies in Motion: AXIS Dance Company Features Physically Integrated Dance," *NEA Arts* 2 (2009): 8–9.
5. Mark Beachey, "Dance Review: Axis Dance Company," *Maryland Theatre Guide*, May 20, 2012, accessed June 11, 2012. *http://mdtheatreguide.com/2012/05/dance-review-axis-dance -company/*.
6. Emily Hite, "Axis Dance Company Celebrates 20 Years of Fearless Transcendence," *Voice of Dance*, November 13, 2008, accessed June 11, 2012. *http://www.voiceofdance.com/v1/features.cfm/1652/Axis-Dance-Company-20-Years-of-Fearless-Transcendence/*.
7. Paul Parish, "Home Season," *Dance Review Times*. November 10 (2006): 1, accessed August 6, 2010. *http://archives.dancereviewtimes.com/2006/Autumn/08/axis.html*.
8. *AXIS Dance Company*, "SPARKed: SPARK in Education Educator Guide," (2010): 3.

9. Annika Nonhebel, "Dance Access & Dance Access/KIDS!: Teacher's Guide," (n.d.), 5.

10. Uli Schmitz, "Ways to Dance," Article written for the 1998 Internet Conference on Art & Disability, accessed August 6, 2010. *http://www.axisdance. org/education_uli.php*.

11. Lucia Mauro, "AXIS Troupe Takes Dance to New Level," Special to the *Chicago Tribune* (2005), accessed August 8, 2010. *http://www.axisdance. org/review_chicagotrib_05.php*.

12. Rosalie Bent Branigan, "Movement and Dance in Ministry and Worship," *Liturgy* 22/4 (2007): 33.

13. Carla De Sola, ". . . And the Word Became Dance: A Theory and Practice of Liturgical Dance," in *Dance as Religious Studies*, eds. Douglas Adams and Diane Apostolos-Cappadona (New York: Crossroads, 1990), 155.

14. Diane Apostolos-Cappadona, "Scriptural Women Who Danced," in *Dance as Religious Studies*, eds. Douglas Adams and Diane Apostolos-Cappadona (New York: Crossroads, 1990), 95–96.

15. Susanne K. Langer, "Virtual Powers," in *Aesthetics. A Reader in the Philosophy of the Arts*, Second Edition, eds. David Goldblatt and Lee B. Brown (Upper Saddle River, NJ: Pearson, [1970] 2005), 237–240.

16. Langer, "Virtual Powers," 240. Diane Apostolos-Cappadona quotes the influential choreographer Martha Graham as stating "Gesture is the first [language]," and "movement is the seed of gesture." Diane Apostolos-Cappadona, "Martha Graham and the Quest for the Feminine in Eve, Lilith, and Judith," in *Dance as Religious Studies*, eds. Douglas Adams and Diane Apostolos-Cappadona, (New York: Crossroads, 1990), 131. More recently, Francesca Wilde has also described dance as "virtual movement": "Dancing Yes: Some Thoughts on the Phenomenology of Dancing in the Context of Badiou's *Dance as a Metaphor for Thought*." *Parallax* 16/3 (2010): 132.

17. Graham McFee, "Dance," in *The Routledge Companion to Aesthetics*. Second Edition, eds. Berys Gaut and Dominic McIver Lopes (London: Routledge, 2005), 9–10.

18. Rebecca Gose Enghauser, "Teaching Modern Dance: A Conceptual Approach," *Journal of Physical Education, Recreation and Dance* 79 (2008): 8.

19. Stephanie Jordan, "Choreomusical Conversations: Facing a Double Challenge," *Dance Research Journal* 43/1 (2011): 57.

20. Jane Elin and Boni B. Boswell, *Re-visioning Dance: Perceiving the Aesthetics of Disability* (Dubuque, IA: Kendall/Hunt, 2004).

21. Sondra Fraleigh, *Dance and the Lived Body* (Pittsburgh, PA: University of Pittsburgh Press, 1987), 5. Quoted in Elin and Boswell, *Re-visioning Dance*, 35.

22. See McFee's discussion of this claim, "Dance," 1–3.

23. McFee, "Dance," 2.

24. See Frank Burch Brown's summary of the effects of Enlightenment and Reformation thought on the acceptance of art forms, especially dance and theatre: Brown, *Good Taste, Bad Taste*, 41–42. See also Richard Viladesau, *Theology and the Arts*, 28–32.

25. De Sola, ". . . And the Word," 101. See also Begbie, *Voicing Creation's Praise*; Jeremy Begbie, ed., *Beholding the Glory: Incarnation Through the Arts* (Grand Rapids, MI: DLT/Baker, 2000); and Jeremy Begbie, ed., *Sounding the Depths: Theology Through the Arts* (Norwich, CT: SCM Press, 2002).

26. AXIS Dance Company Media Kit (2008), accessed December 5, 2012. *http:// www.axisdance.org/about-us/media-kit/*.

27. Mauro, "AXIS Troupe," 1.

28. "AXIS Dance Company," website, accessed June 22, 2012. *http://www.axis dance.org/about-us/media-kit/WholePressKitNew_Final.pdf.*
29. Osmer, *Practical Theology*, 22.
30. Schmitz, "Ways to Dance," 1.
31. Ibid., 2.
32. Ibid.
33. NEA Arts, "Bodies in Motion," 9.
34. NEA Arts, "Bodies in Motion," 9.
35. Hand, *Levinas Reader*, 207.
36. Miller-McLemore, "The Living Human Web," 21. See also Nakashima Brock, "The Greening of the Soul," 133–154.
37. See our discussion of the dialogue philosophers in chapter 2.
38. Eric Kupers, "What People Say About Us," *AXIS News* (2010): 4, accessed August 6, 2010. *http://www.axisdance.org/about_news.php.*
39. NEA Arts, "Bodies in Motion," 8.
40. Morton, *The Journey Is Home*, 127–128.
41. Ibid., 128.
42. Mauro, "AXIS Troupe," 1.
43. Claire Cunningham, "Not Laughing, But Dancing," *Dance*, March (2007): 1, accessed August 6, 2010. *http://dancersgroup.org/content/programs/articles/2007/2007March_41.html.*
44. Mary Brennan, "Ways of Looking; Disability as Ability," *Dance*, March (2007): 1, accessed August 6, 2010. *http://dancersgroup.org/content/pro grams/articles/2007/2007March_40.html.*
45. Elin and Boswell, *Re-visioning Dance*, v.
46. Ibid., 4.
47. Volume 2, "Falling Down Stairs," with Mark Morris, choreographer and the Mark Morris Dance Group (2004). A film by Barbara Willis Sweetie.
48. *AXIS Dance Company*, "SPARKed: SPARK in Education Educator Guide," (2010): 3.
49. Patricia McMahon, *Dancing Wheels*. Illus. with photos by John Godt (Boston: Houghton Mifflin Co, 2000), 30.
50. Jordan, *Choreomusical Conversations*, 55.
51. Patricia Ready, *Body, Mind, and Spirit in Action: A Teacher's Guide to Creative Dance* (Berkeley, CA: Luna Kids Dance, 2003), 3.
52. McFee, "Dance," 3.
53. Ibid., 7–8.
54. Ibid., 9. McFee sees the fact that dance movements comprise the dance as the primary difference between music and dance as performing arts.
55. Anna Jenkinson, "All the Right Moves," *The Strad* February (2011): 44–45.
56. De Sola, ". . . And the Word," 101.
57. Bill T. Jones and Susan Kuklin, *Dance* (New York: Hyperion Books for Children, 1998), End paper. See also Mary Wigman, *The Language of Dance* (Middletown, CT: Wesleyan University Press, 1966), 11.
58. Ready, *Body, Mind, and Spirit*, 6.
59. Apostolos-Cappadona, "Scriptural Women Who Danced," 95–96.
60. Palmer, *The Courage to Teach*, 90.
61. Dewi Jaimangal-Jones, Annette Pritchard and Nigel Morgan, "Going the Distance: Locating Journey, Liminality and Rites of passage in Dance Music Experiences," *Leisure Studies* 29/3 (2010): 253.
62. Nonhebel, "Dance Access," 12. Elin and Boswell, *Re-visioning Dance*, 20, claim the basic orientation one has to the natural world is a function of spatial relationships.

63. George Beiswanger, "Chance and Design in Choreography," in *The Dance Experience: Readings in Dance Appreciation*, eds. Myron Howard Nadel and Constance Gwen Nadel (New York: Praeger Publications, 1970), 87.

64. Luiz Naveda and Marc Leman, "The Spatiotemporal Representation of Dance and Music Gestures Using Topological Gesture Analysis (TGA)," *Music Perception* 28/1 (2010): 93–111.

65. Ulrich, "Review."

66. Parish, "Home Season," 3.

67. Karen A. Kaufmann, *Inclusive Creative Movement and Dance* (Auckland: Human Kinetics, 2006), 83.

68. Karyn D. Collins, "Spirit Made Visible," *Dance Magazine*, June (2010): 51.

69. De Sola, ". . . And the Word," 156.

70. George Pati, "Mohiniyâttam: An Embodiment of the Aesthetic and the Religious," *The Journal of Hindu Studies* 91/3 (2010).

71. Hiroko Ikuta, "Embodied Knowledge, Relations with the Environment, and Political Negotiation: St. Lawrence Island Yupik and Inupiaq Dance in Alaska," *Arctic Anthropology* 48/1 (2011): 54–65.

72. Julie Pearson-Little Thunder, "Dancers from Beginning to End: Native-Based Modern Dance and the Storytelling Dance-Drama of Daystar/Rosalie Jones," *Baylor Journal of Theatre and Performance* 4/1 (2007): 41–53.

73. Bryan Rill, "Identity Discourses on the Dance Floor," *Anthropology of Consciousness* 21/2 (2010): 139–162. And Pedro Peixoto Ferreira, "When Sound Meets Movement: Performance in Electronic Dance Music," *Leonardo Music Journal* 18 (2008): 17–20.

74. Enghauser, "Teaching Modern Dance," 39.

# References

UNPUBLISHED INTERVIEWS

All interviews were recorded on Mp3 and later transcribed to text documents. The recordings as well as the transcripts are stored at the Folkloristic Archive, Åbo Akademi University, Finland.

Archive Code:     Description:

IF mgt 2008/17    Interview with Jordi Savall, April 6, 2008, in Barcelona, Spain. Conducted at Hotel Confort Auditori by Ruth Illman. Language: English.

IF mgt 2008/51    Interview with Cecilia Parsberg, May 13, 2008, in Stockholm, Sweden. Conducted at the artist's home by Ruth Illman. Language: Swedish.

IF mgt 2008/52    Interview with Eric-Emmanuel Schmitt, June 5, 2008, in Brussels, Belgium. Conducted at Bureau Antigone by Ruth Illman. Language: English.

Parsberg, Cecilia. "Predikan 1: A advent i Jacobskyrkan, Stockholm." Unpublished sermon delivered in Stockholm, November 28, 2007.

LITERATURE

Abramsky, Samuel and Shimon Gibson. "Jerusalem." In *Encyclopaedia Judaica*, edited by Michael Berenbaum and Fredrik Skolnik, 143–44. Detroit: Macmillan Reference, 2007.
Ackermann, Denise M. "Narratives of Resistance and Hope: Women Doing Theology in Community." In *Creativity, Imagination and Criticism: The Expressive Dimension in Practical Theology*, edited by Paul Ballard and Pamela Couture, 143–52. Cardiff, Wales: Cardiff Academic Press, 2001.
Adams, Doug. *The Art of Living: Aesthetic Values and the Quality of Life*. Bellingham: Western Washington University Press, 1980.
Adderley, Di. "Why Do Tellers Tell?" Centre for Playback Theatre (2004). Accessed December 3, 2012. *http://www.playbacktheatre.org/resources/articles-and-books/*.
Agosín, Marjorie. *Tapestries of Hope, Threads of Love: The Arpillera Movement in Chile*. Second edition. Lanham, MD: Rowman & Littlefield Publishers, 2008.
Allende, Isabel. Foreword to *Tapestries of Hope, Threads of Love: The Arpillera Movement in Chile* by Marjorie Agosín, ix–x. Lanham, MD: Rowman & Littlefield Publishers, 2008.

Amichai, Yehuda. *The Selected Poetry of Yehuda Amichai, Newly Revised and Expanded edition*. Berkeley: The University of California Press, 1996.

Andersen, Svend. *Løgstrup*. Frederiksberg: Forlaget Anis, 1995.

Anderson, Ray. *The Shape of Practical Theology: Empowering Ministry with Theological Process*. Downer's Grove, IL: Inter Varsity Press, 2001.

Apostolos-Cappadona, Diane. "Martha Graham and the Quest for the Feminine in Eve, Lilith, and Judith." In *Dance as Religious Studies*, edited by Douglas Adams and Diane Apostolos-Cappadona, 118–33. New York: Crossroads, 1990.

———. "Scriptural Women Who Danced." In *Dance as Religious Studies*, edited by Douglas Adams and Diane Apostolos-Cappadona, 95–108. New York: Crossroads, 1990.

Appiah, Kwame Anthony. *Cosmopolitanism. Ethics in a World of Strangers*. New York: W. W. Norton & Company, 2006.

Ariarajah, S. Wesley. *Not without My Neighbour. Issues in Interfaith Relations*. Geneva: WCC Publications, 1999.

*AXIS Dance Company*. "SPARKed: SPARK in Education Educator Guide." (2010).

Ballard, Paul. "The Practical Theologian as Artist." In *Creativity, Imagination and Criticism: The Expressive Dimension in Practical Theology*, edited by Paul Ballard and Pamela Couture, 133–42. Cardiff, Wales: Cardiff Academic Press, 2001.

Ballard, Paul and John Pritchard. *Practical Theology in Action: Christian Thinking in the Service of Church and Society*. London: SPCK, 2006.

Ballard, Paul and Pamela Couture. "Setting the Scene." In *Creativity, Imagination and Criticism: The Expressive Dimension in Practical Theology*, edited by Paul Ballard and Pamela Couture, n.p. Cardiff, Wales: Cardiff Academic Press, 2001.

Banchoff, Thomas. "Introduction." In *Democracy and the New Religious Pluralism*, edited by Thomas Banchoff, 3–16. Oxford: Oxford University Press, 2007.

Barnes, Michael. "Religious Pluralism." In *The Routledge Companion to the Study of Religion*, edited by John Hinnells, 407–21. New York: Routledge, 2005.

Bayer, Bathja. "El Male Rahamim." In *Encyclopaedia Judaica*, edited by Michael Berenbaum and Fredrik Skolnik, 364–65. Detroit: Macmillan Reference, 2007.

Beachey, Mark. "Dance Review: Axis Dance Company." *Maryland Theatre Guide*, May 20, 2012. Accessed June 11, 2012. *http://mdtheatreguide.com/2012/05/dance-review-axis-dance -company/*.

Begbie, Jeremy. *Voicing Creation's Praise: Towards a Theology of the Arts*. Edinburgh: T&T Clark, 1991.

Begbie, Jeremy, ed. *Beholding the Glory: Incarnation Through the Arts*. Grand Rapids, MI: DLT/Baker, 2000.

Begbie, Jeremy. *Resounding Truth: Christian Wisdom in the World of Music*. London: SPCK, 2007.

Begbie, Jeremy, ed. *Sounding the Depths: Theology Through the Arts*. Norwich, CT: SCM Press, 2002.

Beiswanger, George. "Chance and Design in Choreography." In *The Dance Experience: Readings in Dance Appreciation*, edited by Myron Howard Nadel and Constance Gwen Nadel, 83–90. New York: Praeger Publications, 1970.

Bell, Rob. *Love Wins*. San Francisco: HarperOne, 2011.

Berger, Peter L. "Pluralism, Protestantization, and the Voluntary Principle." In *Democracy and the New Religious Pluralism*, edited by Thomas Banchoff, 19–30. New York: Oxford University Press, 2007.

Bernstein, Richard J. "From Hermeneutics to Praxis." In *Hermeneutics and Praxis*, edited by Robert Hollinger, 272–96. Notre Dame, IN: University of Notre Dame Press, 1985.

———. *Beyond Objectivism and Relativism: Science, Hermeneutics, and Praxis*. Philadelphia: University of Pennsylvania Press, 1985.

Birch, Bruce. "The Arts, Midrash, and Biblical Teaching." In *Arts, Theology, and the Church*, edited by Kimberley Vrudny and Wilson Yates, 105–24. Cleveland, OH: Pilgrim Press, 2005.

Boff, Clodovis. *Theology and Praxis: Epistemological Foundations*. Maryknoll, NY: Orbis Books, 1987.

Boff, Leonardo and Clodovis Boff. *Introducing Liberation Theology*. Maryknoll, NY: Orbis Books, 1988.

Bracke, Sarah. "Conjugating the Modern/Religious, Conceptualizing Female Religious Agency: Contours of a 'Post-secular' Conjuncture." *Theory, Culture & Society* 25/1 (2008): 51–67.

Braidotti, Rosi. "In Spite of the Times: The Postsecular Turn in Feminism." *Theory, Culture & Society* 25/1(2008): 1–24.

Branigan, Rosalie Bent. "Movement and Dance in Ministry and Worship." *Liturgy* 22/4 (2007): 33–39.

Brennan, Mary. "Ways of Looking; Disability as Ability." *Dance*, March (2007). Accessed August 6, 2010. *http://dancersgroup.org/content/programs/articles/2007/2007March_40.html*.

Brock, Rita Nakashima. "The Greening of the Soul: A Feminist Theological Paradigm of the Web of Life." In *Setting the Table: Women in Theological Conversation*, edited by Rita Nakashima Brock, Claudia Camp and Serene Jones, 133–54. St. Louis, MO: Chalice Press, 1995.

———. "Oh, Honey, NO!" In *Kitchen Talk: Sharing Our Stories of Faith*, edited by Jane McAvoy, 9–19. St. Louis, MO: Chalice Press, 2003.

Brown, Frank Burch. *Good Taste, Bad Taste, and Christian Taste*. New York: Oxford University Press, 2000.

———. *Religious Aesthetics: A Theological Study of Making and Meaning*. Princeton, NJ: Princeton University Press, 1989.

Brown, Sally. "Hermeneutical Theory." In *The Wiley-Blackwell Companion to Practical Theology*, edited by Bonnie J. Miller-McLemore, 112–22. Malden, MA: Wiley-Blackwell, 2012.

Browning, Don. *A Fundamental Practical Theology: Descriptive and Strategic Proposals*. Minneapolis, MN: Fortress Press, 1991.

Brueggemann, Walter. *Texts under Negotiation: The Bible and Postmodern Imagination*. Minneapolis, MN: Fortress Press, 1993.

Buber, Martin. "Dialogue." In *Between Man and Man*, edited by Martin Buber, 1–45. New York: Routledge, [1932] 2002.

———. "Genuine Dialogue." In *The Martin Buber Reader*, edited by Asher D. Biemann, 214–15. New York: Palgrave Macmillan, [1954] 2002.

———. *I and Thou*. New York: Touchstone, [1923] 1970.

———. "Man and his Image-Work." In *The Knowledge of Man. Selected Essays* translated by Maurice Friedman, 139–45. Atlantic Highlands, NJ: Humanities Press International, 1965.

———. "The Two Foci of the Jewish Soul." In *Jewish Perspectives on Christianity*, edited by Fritz A. Rothschild, 122–31. New York: Continuum, [1930] 2000.

Bullough, Edward. "'Psychic Distance' as a Factor in Art and an Aesthetic Principle." *The British Journal of Psychology* 5 (1912/1913): 87–118.

Butler, Judith. "Sexual Politics, Torture, and Secular Time." *The British Journal of Sociology* 59/1 (2008): 1–23.

Cardenal, Ernesto. *The Gospel in Solentiname*. Maryknoll, NY: Orbis Books, 1982.

Caron, Charlotte. "Feminist Rituals for Social Change." In *Creativity, Imagination and Criticism: The Expressive Dimension in Practical Theology*, edited by Paul Ballard and Pamela Couture, 161–74. Cardiff, Wales: Cardiff Academic Press, 2001.

Casanova, José. "Are We Still Secular? Explorations on the Secular and the Post-Secular." In *Post-Secular Society*, edited by Peter Nynäs, Mika Lassander and Terhi Utriainen, 27–46. New Brunswick, NJ: Transaction Publishers, 2012.

Cervenka, Barbara. "Cuadros of Pamplona: Textile Pictures by Women of Peru." *The Institute for Research on Women and Gender* (2003). Accessed September 8, 2009. *http://irwg.research.umich.edu/events/exhibits/cuadros.html.*

Charles, David. "A New Paradigm of Popular Play: Playback as Bakhtinian Novelistic Theatre." *Centre for Playback Theatre* (2005). Accessed December 3, 2012. *http://www.playbacktheatre.org/wp-content/uploads/2010/04/Charles-ANew ParadigmOfPopularPlayPlayback.pdf.*

Chen, Caroline. "*So You Think You Can Dance* Spotlights Bay Area Duet, with One Dancer in a Wheelchair." *SF Weekly Blog*, June 30, 2011. Accessed June 11, 2012. *http://blogs.sfweekly.com/exhibitionist/2011/06/so_you_think_you_can_ dance_wheelchair.html.*

Chopp, Rebecca. *The Power to Speak: Feminism, Language, God.* New York: Crossroads, 1989.

———. *The Praxis of Suffering: An Interpretation of Liberation and Political Theologies.* Maryknoll, NY: Orbis, 1989.

———. "When the Center Cannot Contain the Margins." In *The Education of Practical Theologians*, edited by Don S. Browning, David Polk and Ian S. Evison, 63–76. Atlanta: Scholars Press, 1989.

Collins, Karyn D. "Spirit Made Visible." *Dance Magazine* June (2010).

Conde-Frazier, Elizabeth. "Participatory-Action Research." In *The Wiley-Blackwell Companion to Practical Theology*, edited by Bonnie J. Miller-McLemore, 234–43. Malden, MA: Wiley-Blackwell, 2012.

Connolly, William E. *Pluralism.* Durham, NC: Duke University Press, 2005.

Crabtree, John. *Peru.* Oxford: Oxfam Country Profile, 2002.

Cunningham, Claire. "Not Laughing, But Dancing." *Dance* March (2007). Accessed August 6, 2010. *http://dancersgroup.org/content/programs/articles/2007/2007 March_41.html.*

Dalferth, Ingolf U. "Post-Secular Society: Christianity and the Dialectics of the Secular." *Journal of the American Academy of Religion* 78/2 (2010): 317–45.

Dalton, Drew. *Longing for the Other: Levinas and Metaphysical Desire.* Pittsburgh, PA: Duquesne University Press, 2009.

Dalton, Jane. "Arpilleras: Stories in Cloth." *School Arts* 107/2 (2008):1.

Daly, Mary. *Beyond God the Father: Toward a Philosophy of Women's Liberation.* Boston: Beacon Press, 1973.

Dauber, Heinrich. "Gathering Voices—Essays on Playback Theatre." In *How Playback Theatre Works: A Matter for Practical Research*, edited by Jonathan Fox and Heinrich Dauber, 1–15. New Paltz, NY: Tusitala Press, 1999.

Davies, Charlotte Aull. *Reflexive Ethnography. A Guide to Researching Selves and Others.* London: Routledge, 1999.

Davis, Rebecca Berru. "Creative Arts of Survival, Conscious Acts of Subversion: Textile Pictures by the Peruvian Women of the Pamplona Alta." Accessed February 27, 2008. *http://www.stthomas.edu/arthistory/graduate/students/files/ DavisAbstract.pdf*

———. "Picturing Paradise: Cuadros by the Peruvian Women of the Pamplona Alta as Visions of Hope." *An Interfaith Project: January 12, 2009–May 12, 2009* (Dominican School of Philosophy and Religion). Accessed September 8, 2009. *http://www.dspt.edu/19781061914404273O/blank/browse.asp?a=383& BMDRN=2000&BC.*

De Sola, Carla. ". . . And the Word Became Dance: A Theory and Practice of Liturgical Dance." In *Dance as Religious Studies*, edited by Douglas Adams and Diane Apostolos-Cappadona, 153–66. New York: Crossroads, 1990.

Deacy, Christopher. "Faith in Film." In *The Religion and Film Reader*, edited by Jolyon Mitchell and S. Brent Plate, 306–11. New York: Routledge, 2007.

de Gruchy, John W. *Christianity, Art and Transformation. Theological Aesthetics in the Struggle for Justice.* Cambridge: Cambridge University Press, 2001.

Dickie, George. "The Myth of the Aesthetic Attitude." *American Philosophical Quarterly* 1/1 (1964): 56–65.

Dietz, Henry A. *Urban Poverty, Political Participation, and the State: Lima, 1970–1990.* Pittsburgh, PA: University of Pittsburgh Press, 1998.

Ehses, Hanno. "Speaking of the Heart: Some Annotations." *Design Issues* 18/1 (2002): 62–67.

Eisner, Eliot. *The Educational Imagination.* New York: MacMillan, 1979.

Elin, Jane and Boni B. Boswell. *Re-visioning Dance: Perceiving the Aesthetics of Disability.* Dubuque, IA: Kendall/Hunt, 2004.

Enghauser, Rebecca Gose. "Teaching Modern Dance: A Conceptual Approach." *Journal of Physical Education, Recreation and Dance* 79 (2008): 36–42.

Erikson, Erik. *Childhood and Society.* New York: W. W. Norton & Company, 1950.

——. *Identity and the Life Cycle.* New York: International Universities Press, 1959.

Espinosa, Alma. "Music: A Bridge between Two Cultures." *Forum on Public Policy Online*, Summer 2007 edition (2008). Accessed November 28, 2008. *http://forumonpublicpolicy.com/archivesum07/espinoza.pdf.*

Farley, Edward. *Theologia: The Fragmentation and Unity of Theological Education.* Philadelphia: Fortress Press, 1983.

——. "Theology and Practice Outside the Clerical Paradigm." In *Practical Theology*, edited by Don Browning, 21–41. San Francisco: Harper & Row, 1983.

Ferreira, Pedro Peixoto. "When Sound Meets Movement: Performance in Electronic Dance Music." *Leonardo Music Journal* 18 (2008): 17–20.

Foucault, Michel. *Power/Knowledge: Selected Interviews & Other writings, 1972–1977*, edited by Colin Gordon. New York: Pantheon Books, 1980.

Fowler, Sidney. "Revealings: Exploring the Practice of Prayer and Photographic Images. In *Arts, Theology, and the Church*, edited by Kimberly Vrudny and Wilson Yates, 235–52. Cleveland, OH: Pilgrim Press, 2005.

Fox, Jonathan. *The Essential Moreno: Writings in Psychodrama, Group Method, and Spontaneity.* New York: Springer Publishing Company, 1987.

Fox, Hannah. "Weaving Playback Theatre with Theatre of the Oppressed." *Centre for Playback Theatre* (2007). Accessed December 4, 2012. *http://playbacktheatre.org/wp-content/uploads/2010/04/FoxH_TO.pdf.*

Fox, Jonathan. *Acts of Service: Spontaneity, Commitment, Tradition in the Non-Scripted Theatre.* New Paltz, NY: Tusitala Press, 1994.

Fraleigh, Sondra. *Dance and the Lived Body.* Pittsburgh, PA: University of Pittsburgh Press, 1987.

Freire, Paolo. *Education for Critical Consciousness.* New York: Continuum, 1987.

——. "Education, Liberation and the Church." *Study Encounter* 9/1 (1973).

——. *Pedagogy of the Oppressed.* Translated by M. B. Ramos. New York: Continuum, 1983.

Friedman, Maurice. *A Heart of Wisdom. Religion and Human Wholeness.* Albany: State University of New York Press, 1992.

Furseth, Inger. *From Quest for Truth to Being Oneself. Religious Change in Life Stories.* Frankfurt am Main: Peter Lang, 2006.

Gadamer, Hans-Georg. "Aesthetic and Religious Experience." In *The Relevance of the Beautiful and Other Essays*, edited by Robert Bernasconi, 140–54. Cambridge: Cambridge University Press, 1986.

——. *Philosophical Hermeneutics.* Translated and edited by David E. Linge. Berkeley: University of California Press, 1976.

———. *Reason in the Age of Science*. Cambridge, MA: MIT Press, 1981.

———. *Truth and Method*. New York: Continuum, [1970] 2002.

Gaita, Raimond. *Common Humanity. Thinking about Love and Truth and Justice*. New York: Routledge, 2002.

———. *Romulus, My Father*. London: Review, 1998.

García Rivera, Alejandro R. *A Wounded Innocence. Sketches for a Theology of Art*. Collegeville, MN: The Liturgical Press, 2003.

Gianturco, Paulo and Toby Tuttle. *In Her Hands: Craftswomen Changing the World*. New York: Monacelli Press, 2000.

Golden, Jane, Robin Rice and Monica Yant Kinney. *Philadelphia Murals and the Stories They Tell*. Philadelphia: Temple University Press, 2002.

Golden, Jane, Robin Rice and Natalie Pompilio. *More Philadelphia Murals and the Stories They Tell*. Philadelphia: Temple University Press, 2006.

Gopin, Marc. *Holy War, Holy Peace: How Religion Can Bring Peace to the Middle East*. New York: Oxford University Press, 2002.

Gordon, Neve. "Ethics and the Place of the Other." In *Levinas and Buber: Dialogue and Difference*, edited by Peter Atterton, Matthew Calarco and Maurice Friedman, 98–115. Pittsburgh, PA: Duquesne University Press, 2004.

Groome, Thomas. "A Religious Educator's Response." In *The Education of Practical Theologians*, edited by Don S. Browning, David Polk and Ian S. Evison, 77–92. Atlanta: Scholars Press, 1989.

———. *Christian Religious Education: Sharing Our Story and Vision*. San Francisco: Harper & Row, 1980.

———. *Will There Be Faith?* New York: Harper One, 2011.

Guba, Egon G. and Yvonna S. Lincoln. "Competing Paradigms in Qualitative Research: Theory and Issues." In *Approaches to Qualitative Research. A Reader on Theory and Practice*, edited by Sharlene N. Hesse-Biber and Patricia Leavy, 17–38. Oxford: Oxford University Press, 2004.

Gunton, Colin. Foreword to *Voicing Creation's Praise: Towards a Theology of the Arts* by Jeremy Begbie, xi–xix. Edinburgh: T&T Clark, 1991.

Gutierrez, Gustavo. *A Theology of Liberation*. Maryknoll, NY: Orbis Books, 1984.

Haas, Elisabeth. "La musique, espoir de paix." *La Liberté*, December 20, 2008.

Habermas, Jürgen. "Notes on Post-Secular Society." *New Perspectives Quarterly* 25/4 (2008): 17–29.

———. *Theory of Communicative Action*. Boston: Beacon Press, 1987.

Hand, Seán. "Introduction." In *The Levinas Reader*, edited by Seán Hand, 1–8. Oxford: Basil Blackwell, 1989.

Harris, Maria. *Teaching and Religious Imagination: An Essay in the Theology of Teaching*. San Francisco: Harper & Row, 1987.

Hauerwas, Stanley. "The End of Religious Pluralism: A Tribute to David Burrell." In *Democracy and the New Religious Pluralism*, edited by Thomas Banchoff, 283–300. Oxford: Oxford University Press, 2007.

Hayes, Darby. "Empowering the Outcast: Past Versus Future Storytelling." *Centre for Playback Theatre* (2006). Accessed December 4, 2012. *http://www.playback theatre.org/wp-content/uploads/2010/04/Hayes__Outcasts.pdf*.

Haynes, Deborah. "The Place of Art." In *Arts, Theology, and the Church*, edited by Kimberly Vrudny and Wilson Yates, 158–75. Cleveland, OH: Pilgrim Press, 2005.

Heimbrock, Hans-Günter and Peter Meyer. "A Demanding Practice." In *Perceiving the Other. Case Studies and Theories of Respectful Action*, edited by Trygve Wyller and Hans-Günter Heimbrock, 11–39. Göttingen: Vandenhoeck & Ruprecht, 2010.

Heschel, Abraham Joshua. "No Religion Is an Island." In *Jewish Perspectives on Christianity*, edited by Fritz A. Rothschild, 309–24. New York: Continuum, [1965] 2000.

Hesse-Biber, Sharlene N. and Patricia Leavy. "Interaction and Positionality within Qualitative Research." In *Approaches to Qualitative Research. A Reader on Theory and Practice*, edited by Sharlene N. Hesse-Biber and Patricia Leavy, 131–48. Oxford: Oxford University Press, 2004.

Hite, Emily. "Axis Dance Company Celebrates 20 Years of Fearless Transcendence." *Voice of Dance*, November 13, 2008. Accessed June 11, 2012. *http://www.voiceofdance.com/v1/features.cfm/1652/Axis-Dance-Company-20-Years-of-Fearless-Transcendence/*

Hoesch, Folma. "The Red Thread: Storytelling as a Healing Process." *Centre for Playback Theatre* (1999). Accessed December 10, 2012. *http://www.playbacktheatre.org/wp-content/uploads/2010/04/Red-Thread.pdf.*

Hogue, Michael S. "After the Secular. Toward a Pragmatic Public Theology." *Journal of the American Academy of Religion* 78/2 (2010): 346–74.

Holm, Nils G. "An Integrated Role Theory for the Psychology of Religion: Concepts and Perspectives." In *Psychology of Religion. Theoretical Perspectives*, edited by Bernard Spilka and Daniel McIntosh, 73–85. Denver: Westview Press, 1997.

Horell, Harold. "Fostering Hope: Christian Religious Education in a Postmodern Age." *Religious Education* 99/1 (2004): 5–22.

Höpfl, Heather. "Sacred Heart: A Comment on the Heart of Management." *Culture and Organization* 14/3 (2008): 225–40.

Ikuta, Hiroko. "Embodied Knowledge, Relations with the Environment, and Political Negotiation: St. Lawrence Island Yupik and Inupiaq Dance in Alaska." *Arctic Anthropology* 48/1 (2011): 54–65.

Illman, Ruth. "A Heart from Jenin. Transformation, Mediation, Vulnerability." In *Transforming Otherness*, edited by Jason Finch and Peter Nynäs, 75–98. Piscataway, NJ: Transaction Publishers, 2011.

———. *Art and Belief. Artists Engaged in Interreligious Dialogue.* London: Equinox Publications, 2012.

Jaimangal-Jones, Dewi, Annette Pritchard and Nigel Morgan. "Going the Distance: Locating Journey, Liminality and Rites of Passage in Dance Music Experiences." *Leisure Studies* 29/3 (2010): 253–68.

Jameson, Frederic. "Postmodernism." In *Contextualizing Aesthetics: From Plato to Lyotard*, edited by H. Gene Blocker and Jennifer M. Jeffers, 321–30. Belmont, CA: Wadsworth, 1999.

Jenkinson, Anna. "All the Right Moves." *The Strad*, February (2011): 42–45.

Jensen, Robin. *The Substance of Things Seen: Art, Faith, and the Christian Community.* Grand Rapids, MI: Eerdman's, 2004.

Jones, Bill T. and Susan Kuklin. *Dance.* New York: Hyperion Books for Children, 1998.

Jordan, Stephanie. "Choreomusical Conversations: Facing a Double Challenge." *Dance Research Journal* 43/1 (2011): 43–64.

Josephs, Susan. "Axis Dance Company Revels in its Abilities." Special to the *Los Angeles Times*, July 3, 2011. Accessed June 11, 2012. *http://articles.latimes.com/print/2011/jul/03/entertainment/la-ca-disabled-dancing-20110703.*

Kandinsky, Wassily. *Concerning the Spiritual in Art.* Translated by M.T.H. Sadler. New York: Dover Publications, 1977.

Kaufman, Gordon. *In Face of Mystery: A Constructive Theology.* Cambridge, MA: Harvard University Press, 1993.

Kaufmann, Karen A. *Inclusive Creative Movement and Dance.* Auckland: Human Kinetics, 2006.

Kedrock, Alexandra. "Letting in the Breeze: Playback Theatre as a Spiritual Practice." *Centre for Playback Theatre* (2004). Accessed December 3, 2012. *http://www.playbacktheatre.org/resources/articles-and-books/.*

Kennedy, Terence. "Practice as a Foundation for Practical Theology." In *Creativity, Imagination and Criticism: The Expressive Dimension in Practical Theology,*

edited by Paul Ballard and Pamela Couture, 117–32. Cardiff, Wales: Cardiff Academic Press, 2001.

Kiely, Arlene. "Playback within a Faith Community. School of Playback Theater Leadership." *Centre for Playback Theatre* (2004). Accessed December 3, 2012. *http://www.playbacktheatre.org/resources/articles-and-books/*.

Kulp, Kristine. "The Nature of Christian Community." In *Setting the Table: Women in Theological Conversation*, edited by Rita Nakashima Brock, Claudia Camp and Serene Jones, 155–74. St. Louis, MO: Chalice Press, 1995.

Kupers, Eric. "What People Say About Us," *AXIS News* (2010). Accessed August 6, 2010. *http://www.axisdance.org/about_news.php*.

Lakeland, Paul. *Postmodernity: A Christian Identity in a Fragmented Age*. Minneapolis, MN: Fortress Press, 1997.

Langer, Susanne K. "Virtual Powers." In *Aesthetics. A Reader in the Philosophy of the Arts*, Second Edition, edited by David Goldblatt and Lee B. Brown, 237–40. Upper Saddle River, NJ: Pearson, 1970/2005.

Lartey, Emmanuel. "The Aesthetic as Critical Tool in Practical Theology." In *Creativity, Imagination and Criticism: The Expressive Dimension in Practical Theology*, edited by Paul Ballard and Pamela Couture, 31–36. Cardiff, Wales: Cardiff Academic Press, 2001.

Lather, Patti. "Getting Lost: Critiquing across Difference as Methodological Practice." In *The Methodological Dilemma. Creative, Critical and Collaborative Approaches to Qualitative Research*, edited by Kathleen Gallagher, 219–31. London: Routledge, 2008.

Levinas, Emmanuel. *Totality and Infinity. An Essay on Exteriority*. Pittsburgh, PA: Duquesne University Press, 1969.

———. *Alterity and Transcendence*. New York: Columbia University Press, 1999.

———. "Beyond Intentionality." In *Philosophy in France Today*, edited by Alan Montefiore, 100–115. Cambridge: Cambridge University Press, 1983.

———. *Of God Who Comes to Mind*. Palo Alto, CA: Stanford University Press, 1986.

———. "Time and the Other." In *The Levinas Reader*, edited by Seán Hand, 37–58. Oxford: Basil Blackwell, 1989.

———. *Emmanuel Levinas: Basic Philosophical Writings*. Bloomington: Indiana University Press, 1996.

Light, Aimee Upjohn. "Post-Pluralism through the Lens of Post-Modernity." *Journal of Inter-Religious Dialogue* 1 (2009): 71–74.

Lovin, Robin. "The Real Task of Practical Theology." *Christian Century*, February 5–12 (1992): 125–28.

Lowe, Brendan. "Postcard: Philadelphia," *Time.com*. August 2, 2007. Accessed February 10, 2008. *http://www.time.com/time/printout/o,8816,1655717,00.html*.

Lyden, John. "Introduction." In *The Routledge Companion to Religion and Film*, edited by John Lyden, 1–10. London: Routledge, 2009.

Lyotard, Jean François. *The Postmodern Condition: A Report on Knowledge*. Minneapolis: University of Minnesota Press, 1984.

Løgstrup, Knud E. *The Ethical Demand*. Philadelphia: Fortress Press, 1971.

Mager, Robert. "Action Theories." In *The Wiley-Blackwell Companion to Practical Theology*, edited by Bonnie J. Miller-McLemore, 255–66. Malden, MA: Wiley-Blackwell, 2012.

Male, Jesse. "Wheels Welcome: Axis Dance Company." *Dance Magazine*, October 1–7, 2005.

Marion, Jean-Luc. *Being Given. Toward a Phenomenology of Givenness*. Palo Alto, CA: Stanford University Press, 2002.

Marsh, Clive. *Theology Goes to the Movies. An Introduction to Critical Christian Thinking*. London: Routledge, 2007.

Marx, Karl. "Theses on Feuerbach." In *Writings of the Young Marx on Philosophy and Society*, translated and edited by Loyd Easton and Kurt Guddat. Garden City, NY: Anchor Books, 1997.

Mauro, Lucia. "AXIS Troupe Takes Dance to New Level." Special to the *Chicago Tribune* (2005). Accessed August 8, 2010. *http://www.axisdance.org/review_chicagotrib_05.php*.

McAfee Brown, Robert. *Unexpected News: Reading the Bible with Third World Eyes*. Louisville, KY: Westminster John Knox Press, 1984.

McClintock Fulkerson, Mary. "Systematic Theology." In *The Wiley-Blackwell Companion to Practical Theology*, edited by Bonnie J. Miller-McLemore, 357–66. Malden, MA: Wiley-Blackwell, 2012.

McFee, Graham. "Dance." In *The Routledge Companion to Aesthetics*. Second Edition, edited by Berys Gaut and Dominic McIver Lopes, 545–56. London: Routledge, 2005.

McLaren, Brian D. *A New Kind of Christianity*. San Francisco: HarperOne, 2010.

McMahon, Patricia. *Dancing Wheels*. Ill. with photos by John Godt. Boston: Houghton Mifflin Co, 2000.

Metz, Susan. "Fragments towards an Exploration of the Role of Playback Theatre in Societal Transformation." *Centre for Playback Theatre* (2006). Accessed December 3, 2012. *http://www.playbacktheatre.org/resources/articles-and-books/*.

Meyer, Michael R. and Michael Smith. "Peru's Booming Trade in 'Art Naif.'" *Newsweek*, June 24, 1985. Accessed September 8, 2009. *http://www.gci275.com/news/nwswk03.shtml*.

Mette, Norbert. "Practical Theology: Theory of Aesthetics or Theory of Action?" In *Creativity, Imagination and Criticism: The Expressive Dimension in Practical Theology*, edited by Paul Ballard and Pamela Couture, 49–64. Cardiff, Wales: Cardiff Academic Press, 2001.

Mercer, Joyce Ann. *Welcoming Children: A Practical Theology of Childhood*. St. Louis, MO: Chalice Press, 2005.

Miller-McLemore, Bonnie J. "Aesthetics, Hermeneutics and Practical Theology." In *Creativity, Imagination and Criticism: The Expressive Dimension in Practical Theology*, edited by Paul Ballard and Pamela Couture, 17–24. Cardiff, Wales: Cardiff Academic Press, 2001.

———. "Feminist Theory in Pastoral Theology." In *Feminist and Womanist Pastoral Theology*, edited by Bonnie Miller-McLemore and Brita Gill-Austern, 77–94. Nashville, TN: Abingdon, 1999.

———. "Response." In *Practical Theology in Action: Christian Thinking in the Service of Church and Society*, edited by Paul Ballard and John Pritchard, 17–24. London: SPCK, 2006.

———. "The Living Human Web: Pastoral Theology at the Turn of the Century." In *Through the Eyes of Women*, edited by Jeanne Stevenson-Moessner, 9–26. Minneapolis, MN: Augsburg, 1996.

Miller-McLemore, Bonnie J., ed. *The Wiley-Blackwell Companion to Practical Theology*. Malden, MA: Wiley-Blackwell, 2012.

Mitchell, Jolyon. "Questioning Media and Religion." In *Between Sacred and Profane. Researching Religion and Popular Culture*, edited by Gordon Lynch, 34–46. London: I. B. Tauris, 2007.

Moberg, Marcus, Kennet Granholm and Peter Nynäs. "Trajectories of Post-Secular Complexity: An Introduction." In *Post-Secular Society*, edited by Peter Nynäs, Mika Lassander and Terhi Utriainen, 1–26. Piscataway, NJ: Transaction Publishers, 2012.

Morton, Nelle. *The Journey Is Home*. Boston: Beacon Press, 1985.

National Endowment for the Arts. "Bodies in Motion: AXIS Dance Company Features Physically Integrated Dance," *NEA Arts* 2 (2009): 8–9.

Naveda, Luiz and Marc Leman. "The Spatiotemporal Representation of Dance and Music Gestures Using Topological Gesture Analysis (TGA)." *Music Perception* 28/1 (2010): 93–111.

*News from the University of Michigan's Institute for Research on Women and Gender.* "Lane Hall Gallery Exhibits Textiles by Peruvian Women." Fall 2003.

Niebuhr, Hans R. *The Responsible Self: An Essay in Christian Moral Philosophy.* New York: Harper & Row, 1963.

Nonhebel, Annika. "Dance Access & Dance Access/KIDS!: Teacher's Guide" (n.d.).

O'Connell, Maureen H. *Commonweal: A Review of Religion, Politics & Culture.* Accessed February 28, 2008. *http://www.commonwealmagazine.com.*

Osmer, Richard R. *Practical Theology: An Introduction.* Grand Rapids, MI: Eerdman's, 2008.

Palmer, Parker. *The Courage to Teach: Exploring the Inner Landscape of a Teacher's Life.* San Francisco: Jossey-Bass, 1998.

Parish, Paul. "Home Season." *Dance Review Times,* November 10, 2006. Accessed August 6, 2010. *http://archives.dancereviewtimes.com/2006/Autumn/08/axis.html.*

Park-Fuller, Linda. "Beyond Role Play: Playback Theatre and Conflict Transformation." *Centre for Playback Theatre* (2005). Accessed December 4, 2012. *http://www.playbacktheatre.org/wp-content/uploads/2010/04/LindaPark-Fuller-Beyond-Role-Play-Playback-Theatre-and-Confl.pdf.*

Pati, George. "Mohiniyāttam: An Embodiment of the Aesthetic and the Religious." *The Journal of Hindu Studies* 91/3 (2010): 91–113.

Pearson-Little Thunder, Julie. "Dancers from Beginning to End: Native-Based Modern Dance and the Storytelling Dance-Drama of Daystar/Rosalie Jones." *Baylor Journal of Theatre and Performance* 4/1 (2007): 41–53.

Pfändtner, Willy. *Understanding Religious Diversity. A Contribution to Interreligious Dialogue from the Viewpoint of Existential Philosophy.* Uppsala, Sweden: Uppsala University, 2005.

———. "Constructive Dialogical Pluralism: A Context of Interreligious Relations." *Sophia* 49 (2009): 65–94.

Phillips, Dewi Z. *Religion and the Hermeneutics of Contemplation.* Cambridge: Cambridge University Press, 2001.

Pompilio, Natalie. "A Son's Legacy of Forgiveness." *The Philadelphia Inquirer,* October 21, 2007.

Radford Ruether, Rosemary. *Women-Church: Theology and Practice of Feminist Liturgical Communities.* San Francisco: Harper & Row, 1985.

Raschke, Carl. "The Deconstruction of God." In *De-construction and Theology,* edited by Carl Raschke, 1–33. New York: Crossroads, 1982.

Rattley, Kimberley. "Using Playback Theatre to Explore African American Identity." *Centre for Playback Theatre* (1997). Accessed December 4, 2012. *http://www.playbacktheatre.org/resources/articles-and-books/.*

Ready, Patricia. *Body, Mind, and Spirit in Action: A Teacher's Guide to Creative Dance.* Berkeley, CA: Luna Kids Dance, 2003.

Reymond, Bernard. "Theatre and Practical Theology." In *Creativity, Imagination and Criticism: The Expressive Dimension in Practical Theology,* edited by Paul Ballard and Pamela Couture, 191–200. Cardiff, Wales: Cardiff Academic Press, 2001.

Rill, Bryan. "Identity Discourses on the Dance Floor." *Anthropology of Consciousness* 21/2 (2010): 139–62.

Rorty, Richard. "Postmodern Bourgeois Liberalism." In *Hermeneutics and Praxis,* edited by Robert Hollinger, 214–21. Notre Dame, IN: University of Notre Dame Press, 1985.

Salas, Jo. *Improvising Real Life: Personal Story in Playback Theatre.* New Paltz, NY: Tusitala Press, 1996.

———. "A Note on What We Mean by 'Dialogue' in Playback Theatre." *Centre for Playback Theatre* (2005). Accessed December 4, 2012. *http://playbacktheatre. org/wp-content/uploads/2010/04/Salas_Noteondialogue.pdf.*

———. *Do My Story, Sing My Song: Music Therapy and Playback Theatre with Troubled Children.* New Paltz, NY: Tusitala Press, 2007.

Salaverri, Santiago and Juan Lucas. "Jordi Savall & Montserrat Figueras: 'Alia Vox Was Born out of our Desire for Freedom.'" *Diverdi* 166 (2008): 12–14.

Saliers, Don E. *Worship as Theology: Foretaste of Glory Divine.* Nashville, TN: Abingdon Press, 1994.

Savall, Jordi. *Jérusalem. La ville des deux Paix: La paix céleste et la paix terrestre.* (CD book accompanying the recording with the same name.) Barcelona: Alia Vox, 2008.

———. *Orient-Occident.* (CD book accompanying the recording with the same name.) Barcelona: Alia Vox, 2006.

———. "Travel Notes II." *Goldberg Magazine* 15 (2001): 116–17.

Scharper, Phillip and Sally Scharper. *The Gospel in Art by the Peasants of Solentiname.* Maryknoll, NY: Orbis Books, 1984.

Schipani, Daniel S. "Case Study Method." In *The Wiley-Blackwell Companion to Practical Theology*, edited by Bonnie J. Miller-McLemore, 91–101. Malden, MA: Wiley-Blackwell, 2012.

Schleiermacher, Friedrich. *A Brief Outline of the Study of Theology, Drawn Up to Serve as the Basis of Introductory Lectures*, translated by William Farrer. Eugene, OR: Wipf and Stock Publishers, [1850] 2007.

Schmitt, Eric-Emmanuel. *Le dix enfants que madame Ming n'a jamais eus.* Paris: Albin Michel, 2012.

———. *L'enfant de Noé.* Paris: Albin Michel, 2004.

———. *Le sumo qui ne pouvait pas grossir.* Paris: Albin Michel, 2009.

———. *Ma vie avec Mozart.* Paris: Albin Michel, 2005.

———. *Milarepa.* Paris: Albin Michel, 1997.

———. *Monsieur Ibrahim and the Flowers of the Koran.* New York: Other Press, 2003.

———. *Oscar and the Lady in Pink.* New York: Other Press, 2003.

Schmitz, Uli. "Ways to Dance." Article written for the *1998 Internet Conference on Art & Disability.* Accessed August 6, 2010. *http://www.axisdance.org/education_uli.php.*

Schreiter, Robert. *Constructing Local Theologies.* Maryknoll, NY: Orbis Press, 1985.

Schulz, Charles. *United Feature Syndicate.* September 5 and 17, 1965.

Schüssler-Fiorenza, Elisabeth. *In Memory of Her: A Feminist Theological Reconstruction of Christian Origins.* New York: Crossroads, 1984.

Schweitzer, Friedrich. "Creativity, Imagination and Criticism." In *Creativity, Imagination and Criticism: The Expressive Dimension in Practical Theology*, edited by Paul Ballard and Pamela Couture, 3–16. Cardiff, Wales: Cardiff Academic Press, 2001.

Sharpe, Eric J. "Dialogue of Religions." In *Encyclopedia of Religion*, Second Edition, edited by Lindsay Jones, 2342–45. Detroit: Macmillan References, 2005.

Short, Robert. *The Gospel According to "Peanuts."* Louisville, KY: Westminster John Knox Press, 1965.

Siejk, Kate. "Wonder: The Creative Condition for Interreligious Dialogue." *Religious Education* 90/2 (1995): 27–40.

Smart, Ninian. "The Scientific Study of Religion in its Plurality." In *Theory and Method in the Religious Studies. Contemporary Approaches to the Study of Religion*, edited by Frank Whaling, 177–90. Berlin: Mouton de Gruyter, 1995.

Stevenson, John. "The Fourth Wall and the Third Space." *Centre for Playback Theatre* (1995). Accessed December 3, 2012. *http://playbacktheatre.org/wp-content/uploads/2010/04/Stevenson_Fourth.pdf.*

Stevenson-Moessner, Jeanne. *Prelude to Practical Theology: Variations on Theory and Practice.* Nashville, TN: Abingdon, 2008.

Stewart, Samantha. "Students Document Volunteer Service in Peru." *DU Today.* September 8, 2009. Accessed September 8, 2009. *http://www.du.edu/today/stories/2009/08/2009-08-25peru.html.*

Stover, Dale. "Linguisticality and Theology: Applying the Hermeneutics of Hans-Georg Gadamer." *Studies in Religion* 5/1 (1975–1976): 34–44.

Sutton, Philip. "Jordi Savall." *Goldberg Magazine* 7 (1999): 43–49.

Swayd, Samy. "Druze." In *Encyclopedia of Religion,* Second Edition, edited by Lindsay Jones, 2502–04. Detroit: Macmillan, 2005.

Sweet, Leonard, ed. *Church in Emerging Culture: Five Perspectives.* Grand Rapids, MI: Zondervan, 2003.

Taylor, Charles. *A Secular Age.* Cambridge, MA: The Belknap Press of Harvard University Press, 2007.

———. *Philosophical Papers 2: Philosophy and the Human Sciences.* Cambridge: Cambridge University Press, 1985.

Thompson, Frank A. "Matthew Fox Has an Image Problem." In *Art and Interreligious Dialogue. Six Perspectives,* edited by Michael S. Bird, 51–67. Lanham, MD: University Press of America, 1995.

Tillich, Paul. "Religion and Art." In *On Art and Architecture,* edited by John Dillenberger and Jane Dillenberger, 31–41. New York: Crossroads, 1989.

———. *Theology of Culture.* New York: Oxford University Press, 1959.

Tracy, David. *Dialogue with the Other. The Interreligious Dialogue.* Louvain: Peeters Press, 1990.

Trible, Phyllis. *God and The Rhetoric of Sexuality.* In the series Overtures to Biblical Theology. Philadelphia: Fortress Press, 1978.

———. *Texts of Terror: Literary-Feminist Readings of Biblical Narratives.* In the series Overtures to Biblical Theology. Philadelphia: Fortress Press, 1984.

Turner, Victor. *The Forest of Symbols.* Ithaca, NY: Cornell University Press, 1967.

Ulrich, Allan. "Review: Axis Dance Company at Malonga Casquelord." *San Francisco Chronicle,* November 9, 2009.

Viladesau, Richard. *Theology and the Arts: Encountering God through Music, Art and Rhetoric.* New York: Paulist Press, 2000.

Volf, Miroslav. "A Voice of One's Own: Public Faith in a Pluralistic World." In *Democracy and the New Religious Pluralism,* edited Thomas Banchoff, 271–82. Oxford: Oxford University Press, 2007.

Wasserman, Adam "Spanish Master." *Opera News* 72/2 (2007): 34–35.

Welch, Sharon. *Communities of Resistance and Solidarity: A Feminist Theology of Liberation.* Maryknoll, NY: Orbis Books, 1985.

Wickström, Laura and Ruth Illman. "Environmentalism as a Trend in Post-Secular Society." In *Post-Secular Society,* edited by Peter Nynäs, Mika Lassander and Terhi Utriainen, 217–38. Piscataway, NJ: Transaction Publishers, 2012.

Wigman, Mary. *The Language of Dance.* Middletown, CT: Wesleyan University Press, 1966.

Wilde, Francesca. "Dancing Yes: Some Thoughts on the Phenomenology of Dancing in the Context of Badiou's *Dance as a Metaphor for Thought.*" *Parallax* 16/3 (2010): 130–32.

Wilder, Amos Niven. Foreword to *Grace Confounding: Poems.* Minneapolis, MN: Fortress Press, 1972.

Winch, Peter. *Trying to Make Sense.* Oxford: Basil Blackwell, 1987.

Wingeier, Douglas. "Generative Words in Six Cultures." *Religious Education* 75 (1980): 563–76.

Wittgenstein, Ludwig. *Vermischte Bemerkungen.* Frankfurt am Main: Suhrkamp Verlag, 1977.

Wivel, Ole. *Sansning og symbol. Om kunst og digtning i K.E. Løgstrups filosofi.* Copenhagen: Centrum, 1985.

Woodhead, Linda. "Modern Contexts of Religion." In *Religions in the Modern World,* edited by Linda Woodhead, Hiroko Kawanami and Christopher Partridge, 1–12. New York: Routledge, 2009.

Wynters, Lori. "Constructing Knowledge through Playback Theatre." *Centre for Playback Theatre* (1996). Accessed December 3, 2012. *http://www.playbackthe atre.org/resources/articles-and-books/.*

Yates, Wilson. "The Theology and Arts Legacy." In *Arts, Theology, and the Church,* edited by Kimberley Vrudny and Wilson Yates, 1–28. Cleveland, OH: Pilgrim Press, 2005.

## WEBSITES

"4U! What Question Would You Ask Someone Who Is More Powerful Than You?" Art project website by Cecilia Parsberg. *http://ceciliaparsberg.se/4u/index_main. html.*

"Alia Vox." Website of conductor Jordi Savall and his record label. *http://www. alia-vox.com.*

"Arpilleras—A Guide to Peruvian Handicrafts and Souvenirs." Website published by Andean Travel Web Guide to Peru (2008). *http://www.andeantravelweb.com/ peru/handicrafts/arpilleras_handicrafts_peru.html.*

"AXIS Dance Company." Website of AXIS Dance Company. *http://www.axisdance. org/about-us/media-kit/WholePressKitNew_Final.pdf.*

"AXIS Dance Company Media Kit." (2008). Website of AXIS Dance Company. *http://www.axisdance.org/about-us/media-kit/.*

"AXIS on SYTYCD." Video of AXIS Dance Company on YouTube. *http://www. youtube.com/watch?v=rdLsRefSh58.*

"Cecilia Parsberg." Website of the visual artist Cecilia Parsberg. *http://ceciliapars berg.se.*

"CLASA Art Exhibit Closing Event." Website by the University of Detroit Mercy (2007). *http://www.udmercy.edu/news-events/event.php?id=1169243105608.*

"How to Request a Mural, Mural Application." Official website of the Mural Arts Program. *http://www.muralarts.org/request.*

"A Heart from Jenin." Website where the film by Cecilia Parsberg can be viewed. *http://www.humanrightstv.com/human-rights-artists/cecilia-parsberg/a-heart- from-jenin.*

"An Invasion: Pamplona Alta, Peru." Website of the University of the Immaculate Word. *http://www.uiwtx.edu/˜agott/cuadros/pamplona_alta.htm.*

"Nomadic Hands: Carmen Gomez—Pamplona." Website by Simone Francis, 2008. *http://www.journals.worldnomads.com/simonefrancis/post/19687.aspx.*

"Omar Bashir." Website of the artist Omar Bashir. *http://www.omarbashir.hu/content/ omar.html.*

"The Pamplona Alta Cuadro." Website by the University of the Immaculate Word (2008). *http://www.uiwtx.edu/!agott/cuadros/new_page_5.htm.*

"Patchwork Art: The Arpilleras or Patchworks." Website of the *El Pica Flor Gallery* (2009). *http://www.elpicaflor.com/patchworkart2.htm.*

"Peru—Lima and the Patterns of Migration." Country data website (2009). *http:// www.country-data.com/cgi-bin/query/r-10240.html.*

"Playback Center." Website of the Playback Theatre. *http://www.playbackschool. org/about_us_about_playback_theatre.htm.*

"Post-2000." Art project website by Cecilia Parsberg. *http://ceciliaparsberg.se/post- 2000/.*

"Stories—Lima & Pamplona Alta." Website by *Med to One. http://www.med2one. org/Stories/LimaPamplona.html.*

"The Vaso de Leche Cuadro." Website by the University of the Immaculate Word (2008). *http://www.uiwtx.edu/~agott/cuadros/new_page_3.htm.*

"Yair Dalal." Website of the artist Yair Dalal. *http://www.yairdalal.com/?page_ id=108.*

# Index of Names

# Index of Subjects